Real Fantasies

Real Fantasies

EDWARD STEICHEN'S

ADVERTISING PHOTOGRAPHY

Patricia Johnston

University of California Press

BERKELEY LOS ANGELES LONDON

University of California Press
Berkeley and Los Angeles, California

University of California Press, Ltd.
London, England

Library of Congress Cataloging-in-Publication Data

Johnston, Patricia A., 1954–
 Real fantasies : Edward Steichen's advertising photography / Patricia
 Johnston.
 p. cm.
 Includes bibliographical references and index.
 ISBN 0-520-07020-8 (alk. paper)
 1. Advertising photography—United States—History. 2. Steichen,
 Edward, 1879–1973. I. Title.
 TR690.4.J65 1998
 779'.092—dc21 97-3747

Printed in the United States of America
9 8 7 6 5 4 3 2 1

The paper used in this publication meets the minimum requirements of
American National Standard for Information Sciences—Permanence of
Paper for Printed Library Materials, ANSI Z39.48-1984.

For Keith, Gerry, and Karl

The publisher gratefully acknowledges the contribution provided by the Art Book Endowment of the Associates of the University of California Press, which is supported by a major gift from the Ahmanson Foundation.

Commercial pressure is an amazing, productive force.
Artists, with rare exceptions, are poor producers.

EDWARD STEICHEN, 1938

Contents

Illustrations

Acknowledgments

Like all projects that span the course of a decade, my work on this book has been assisted greatly by many individuals and institutions. My early research was aided by dissertation support grants from Boston University, a year of research at the National Portrait Gallery as a Smithsonian Institution Pre-doctoral Fellow, a year of writing as a Jacob Javits Fellow of the U.S. Department of Education, and a Henry Luce Foundation Fellowship for photographic expenses. A National Endowment for the Humanities Fellowship for College Teachers was of crucial assistance in the process of transition from dissertation to book. And I am grateful for the assistance of faculty development grants from Salem State College.

I have benefited from the astute comments of many friends and colleagues who have read part or all of the manuscript over the course of its development. In particular, I would like to thank Arlette Klaric, Melissa Dabakis, Joanne Lukitsh, Alan Wallach, Deborah Bright, Anne McCauley, Dan Younger, Kim Sichel, and Bonnie Yochelson. Patricia Hills and Carl Chiarenza encouraged and directed me in this project's early stages. The Salem State College Academic Writers' Workshop helped me examine issues of voice and convinced me of the need to present academic inquiry in an accessible way. I am particularly grateful to Nancy Schultz and Eileen Margerum of the English Department for their careful reading and to Dean Marion Kilson and Vice President Albert Hamilton for their support.

Access to corporate archives was essential for locating and attributing many images and for historical information about their production. My early research was facilitated by Cynthia Swank, when the archives of the J. Walter Thompson Agency were located in New York. Other archivists and librarians were very generous with their time at N. W. Ayer and Son, the Warshaw Collection of the National Museum of American History, the International Museum of Photography at the George Eastman House, and the Archives of the United States. Grace Mayer at the Museum of Modern Art was an expert guide through the Steichen Archives housed there.

In preparing this book for publication, Kim Mimnaugh brought a keen eye and considerable photographic skill to printing most of the photographs for reproduction. At the University of California Press, Sheila Levine guided me through the complexities of publication and Stephanie Fay was perceptive and meticulous in her editing. Many corporations, clients of the ad agencies Steichen worked for, and others kindly gave me permission to reproduce their advertisements. Librarians at the

Brookline Public Library and the Schlesinger Library of Radcliffe College made their periodicals available for photography.

Finally, I am most grateful to my husband, Keith Hersh, for a warm, loving, and stimulating environment, for his thoughtful readings of early versions of this manuscript, and for all the Saturday afternoons with our two boys at the Science Museum that allowed this book to come to completion.

Introduction

Photography began to replace drawing as the primary medium for advertising soon after World War I. In the early 1920s fewer than 15 percent of illustrated advertisements employed photographs (although the technology for halftone reproductions had been available for decades); by 1930 almost 80 percent did. Advertising executives and art directors turned to photography when they discovered its power to convey the joys and benefits of consumerism. Initially they were drawn to photographic "truth" and "realism"—the photograph's ability to obscure its artistic construction with accurate renderings of detail and thus to present emotional appeals in a seemingly objective style. Soon a more manipulative style emerged, which projected obvious fantasies and ideals but made them seem attainable. Photography could make beauty accessible, lead the way to a happier life, map out the possessions required to transcend class status, and project a perfect world and make it seem available. Photography made fantasies real. And it sold goods in the process.

Edward Steichen played a pioneering role in advertising photography. His work appeared regularly in almost every mass-circulation magazine published in the United States, and he became the most successful commercial photographer of the 1920s and 1930s—both artistically and financially—because of his uncanny ability to translate advertising theory into compelling images for popular magazines.

This book considers Steichen's advertising photographs in the context of the advertising industry between the wars. It examines the genesis of Steichen's work through his collaboration with clients, art directors, account executives, copywriters, and others in the advertising agencies. I have identified much of Steichen's advertising production and reproduced the images here in their original contexts, with headlines and copy. Too often such images have been removed from their original environment and exhibited or published as isolated specimens of "fine art." I have used information from corporate archives, including the minutes of agency staff meetings, internal bulletins, and other documents, to assess the strategies, goals, and successes of Steichen's advertising campaigns from the inside. How clearly did the agencies define the issues? How did they perceive consumers? How much of this was communicated to the photographer? What were Steichen's contributions?

This book follows Steichen's stylistic development; traces the distribution of the images through the mass media; situates Steichen's images in their social and cultural contexts; analyzes the targeted audiences' responses; and looks at the relation

between advertising and fine art photography. As much as extant documents allow, I have presented the responses of those outside along with the goals and viewpoints of those inside. Rather than generalize about advertising, I have tied specific images to available historical information about their goals and production. Then I have tried to gauge the audience's reading of particular advertisements at a specific historical moment against the advertising agency's goals. My intent has been to analyze how advertising imagery interacts dynamically with an audience to express, reflect, shape, and challenge social ideas and values.

To pursue these issues, this book combines traditional art-historical questions, such as the stylistic development of the artist and problems of photographic attribution, with newer approaches, introduced into art history through American Studies and Cultural Studies. These newer perspectives question hierarchical definitions of art, analyze popular visual forms for insights into American culture, and suggest ways to assess whether the imagery affected its audience as the producers intended. As the chapters of this book follow Steichen from his earliest photographic practice to the end of his commercial career, they progress methodologically—from biographical information, stylistic analysis, and archival documentation to an analysis of social and historical contexts and postmodern considerations of audience response. This methodological development represents the joining of various historically grounded approaches to examine how images work in culture.

DURING THE 1920S AND 1930S Steichen forged influential styles of advertising photography. He had already built an international reputation in the fine arts as a member of the Photo-Secession. During the first decade of the century he employed a pictorialist style whose soft focus echoed painting techniques and signaled his belief in the photograph's status as art. His World War I experience with the Army Air Service's Photographic Section in France led him to favor a hard-edged, information-oriented approach to photography. The military experience also introduced him to the collaborative production of photographs commissioned to meet a defined need, providing a model for institutional patronage paralleled in his advertising industry employment. Steichen synthesized elements of both his fine art and his military photography in his pioneering advertising work.

Equally important for the development of Steichen's photographic style and his advertising strategies was his collaboration with art directors and clients. Changes in Steichen's commercial imagery and style closely matched changes in the strategies of the advertising industry. In turn, the evolution of Steichen's photographic style taught his art directors how photography might be used.

Steichen's first advertising photographs in 1923 and 1924 exploited the "realism" of photography, probably because his military experience had convinced him of the accessibility of the style and because his art directors still clung to ideas about photography as a recorder of fact and a provider of information. But Steichen's images

soon evolved to elicit emotional responses. His advertising in the mid-1920s exemplified the industry's contemporary understanding of the paradox of photographic "realism." Advertisers came to appreciate that exacting detail could overlay representations of luxury, sophistication, and wealth, providing a persuasive, subliminal, atmospheric sales pitch. These images cajoled the potential buyer with a blend of reasoning and gentle persuasion.

By the late 1920s Steichen's work conformed to the industry's more calculated attempts to manipulate consumers. The photographer developed a reputation as master of illusion; he was able to transform ordinary models into aristocrats and dime-store cosmetics into magical stepping-stones to love and wealth. His photographs in turn convinced advertising agents of the emotional and persuasive advantages that photography had over the more traditional drawn illustration.

Steichen's commercial photography developed at a critical moment in the history of American capitalism, and his photographs identified and expressed the needs, demands, and assumptions of his corporate clients. His photographs helped to transform brand-name products made by small family operations—Welch's grape juice, Fleischmann's yeast, Jergens lotion, and Woodbury's facial soap—into household names across the country. In the early twentieth century, products proliferated and the market for them grew. Businessmen adopted scientific management to increase production efficiency; and by the 1920s many had embraced statistical methods to forecast sales and survey markets. Businesses and advertising agencies increasingly relied on advertising psychologists to develop the most effective campaign strategies for products, and they used the best empirical measures of the day to verify the effectiveness of their ads.

This study of Steichen's work examines some of the alliances between the fine arts and corporate structures between the wars. Rather than seeing commercial and fine arts as completely separate spheres as modernist thought has defined them, this study views the commercial and fine arts on a continuum of visual production that reveals a wider view of the artist's role and how images function in society. While he produced collaborative commercial work, Steichen cultivated his reputation as an "artist." He exhibited, curated, and wrote, even during the years when he enjoyed growing acclaim as a premier commercial photographer and produced very little "fine art." His reputation as an artist increased his commercial marketability and—so advertisers thought—enhanced the sincerity and thus the effectiveness of the advertisement.

Steichen's role in the advertising agency was to develop a visual vocabulary for business strategies that would promote the products to a mass audience believably and persuasively. He was most frequently chosen by agencies for advertisements that targeted women, who, the agencies knew, made most household purchasing decisions. His images often depicted vivacious singles, earnest new mothers, or women in other stereotypically female life stages that reveal the industry's perceptions of

this particular audience. Only happy consumers, or ones about to be made happy, populate these vignettes. Thus Steichen was a specialist in the world of commercial art: advertisers hoped his photographs would groom women for the active consumption of goods.

But his photographs are only credible fictions. Commercial art, like fine art, is a representation of social relations, not a mirror of society.[1] Steichen's images visualized a mythology of social ideals and aspirations structured by a dominant element of American society: the new national corporations. Advertising professionals never questioned that the targeted audience shared these values.

This book investigates how audiences received such imagery. The archives record only the responses of the agencies and their clients; studies of consumer reactions were crude, usually limited to counting returned coupons. The agencies believed that by purchasing the product the audience signaled its acceptance of the social relations and aspirations represented. But this is too easy and superficial a conclusion. Scholars have advanced more complex theories of spectatorship to replace the agencies' model of a simple photographic stimulus-response (see-buy) that would influence consumers to purchase the product: women may look actively as well as passively; they may accept or they may reject the image's premises; they may empathize with or harshly critique the main character. These theories allow the viewer multiple and personal readings.

Despite the variety of potential responses, advertisements seem to achieve their goals. Media theorists have suggested that ads work because they reduce the social apprehension created by unstable economic structures, cultural practices, and gender roles in an industrialized and urbanized society—not because they promise women smooth skin or silky hair, and not because the consumer believes she will become rich and famous. The advertisements hypothesize and promise utopia for women and allay women's self-doubts and dissatisfactions.[2] They reduce social problems to the personal and thus make complex problems seemingly simple to solve.

There can be no definitive answer about how women read advertising in the 1920s and 1930s. There is a cinematic sense to advertising, as if the viewer looked in on someone's real life; and because they are so vivid, advertisements, then as now, may influence how we think of our society and how we formulate our material goals. But contrary to what the advertisers hoped, women, and men for that matter, I believe, viewed advertisements with an active and skeptical gaze. Their reading was a dynamic process, in which viewers were fully aware of the commercial intentions of the maker and the constructed nature of the fiction but chose to participate, just as they may have chosen to become involved with the narrative of a film or novel. Multiple pitches from multiple products, often contradicting one another or making the same claims for vastly different products, along with a clear profit motive and problematic social relations depicted in the ads, only encouraged consumers

to doubt the agencies' claims of sincerity. Because of their own common sense as well as the many published exposés about products that were either useless or harmful, people in the early twentieth century also saw advertising as fiction, although perhaps not with the same degree of cynicism as today.

For viewers in the 1920s and 1930s the decision to participate in the fantasy of advertising was made all the easier because advertisements, then as now, confirmed rather than challenged the dominant social and economic relations. The ads represented authority—an authority derived from the backing of impressive corporate wealth, "scientific" study, patriarchal custom, and simply the authority of print. Despite assurances that ads were developed with attention to science and psychology and the new business efficiency, the debates and tone in internal agency papers and industry trade journals suggest that the social relations depicted in advertising were constructed intuitively. They were class- and gender-specific ideas of what the admen thought made people happy and what, they hoped, would convince them to buy their product. The ads advanced an idealized world in which consumption assured consumers social mobility and rewarded women for conformity to traditional gender roles.

Steichen became expert at crafting images—overtly manipulative and persuasive photographs—to sell his clients' products. Most of his work promoted health and beauty aids, goods usually pitched to women. By the 1930s alluring images of romance and class, developed in collaboration with the agency staff, became his stock-in-trade. Steichen's photographs left the advertising industry no room to doubt the effectiveness of photography in its construction of fantasies.

Patronage and Style in Steichen's Early Work

Commercial applications for art impressed Edward Steichen right from the beginning of his professional experience. Steichen's artistic career began in 1894, when he was fifteen years old, in a Milwaukee commercial lithography firm called the American Fine Art Company. Like the slick New York advertising firms for which he would later work, the Milwaukee firm specialized in designing and printing posters and trade cards for corporate clients. After four years as a general apprentice, Steichen began to design and draft advertisements for the local brewers, flour mills, and pork packers, soon adopting photography as a guide for his illustrations. Decades later Steichen remembered that his "first real effort in photography was to make photographs that were useful." This utilitarian bent was to stay with him throughout his career.[1]

DEVELOPING THE PICTORIALIST AESTHETIC

By day Steichen worked on his commercial assignments, but in his free time he began to make more evocative images of the woods just outside Milwaukee (Fig. 1.1). Steichen himself linked these soft-focused, romantic nature studies to impressionist

landscape painting, but later scholars have discerned a closer connection to the suggestive, intuitive aesthetic of symbolism.[2]

Steichen had had little formal art training. He had taken drawing at the Pio Nono (Pius IX) College Preparatory School, and his early success in it influenced his decision, at age fifteen, to seek the apprenticeship at the American Fine Art Company. During his apprenticeship Steichen took life drawing classes he had helped to organize through the Milwaukee Art Students' League. In the spring of 1900 Steichen studied several weeks of figure drawing at the Académie Julian in Paris.

Steichen was relatively self-taught in photography as well. He practiced techniques described on the packages of commercial products and developed his style from magazines, exhibitions, and exchanges with other artists. Despite his minimal formal art education, Steichen developed a strong self-image as a fine artist early in his career. His photograph *Self-Portrait with Brush and Palette* (Fig. 1.2) depicts him in the traditional pose of an Old Master, confidently gazing into the camera as he loads his brush with paint. He intended, he later said, to make an image that would be "photography's answer to [Titian's] 'A Man with a Glove.'"[3]

This photographic self-portrait exhibits the manipulation of the print characteristic of Steichen's prewar pictorialist work. Steichen became expert in employing the gum-bichromate and cyanotype (ferroprussiate) processes, often on silver or plati-

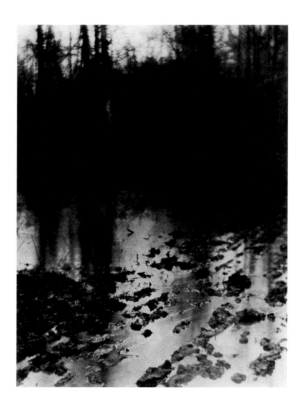

1.1 Edward Steichen, *The Pool,* photogravure in *Camera Work* No. 2 (April 1903), p. 7; from platinum print *The Pool — Evening,* Milwaukee, 1899.

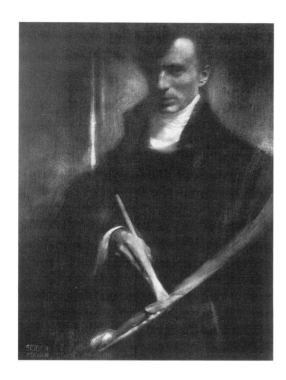

1.2 Edward Steichen, *Self-Portrait,*
photogravure from *Camera Work*
No. 2 (April 1903), p. 9; from a
1901 pigment print.

num papers. He combined media to produce richer tones and a greater range of color. The gum-bichromate process, in particular, enabled him to incorporate brush strokes, apply layers of color, and rework areas of the image. In this process either the whole or parts of the paper could be sensitized and exposed several times during the production of the image, and the wet emulsions could be manipulated with brush or pen.[4] Such manipulation, which recalls painters' handling of paint, also expresses the pictorialist's belief in photography as a fine art.

After spending two years in Paris, Steichen, in late 1902, opened a portrait studio in New York at 291 Fifth Avenue. Through acquaintances he was able to attract enough clients to maintain the studio and support his painting and art photography. When additional space became available in the building in the spring of 1905, he suggested to Alfred Stieglitz that it would be appropriate for a gallery. Stieglitz soon agreed to operate and support the Little Galleries of the Photo-Secession, or 291, which opened in November 1905. Steichen actively participated in the gallery, re-decorating the space and collaborating with Stieglitz on exhibition policy. The next year, seeking a change, Steichen moved to France, where he remained, traveling only occasionally to the United States, until 1914. During those years he took portraits, painted, made and exhibited pictorialist photographs, and supplied Stieglitz with exhibition ideas for 291.[5]

Before World War I, Steichen supported himself, his retired parents, his first wife, Clara, two children (born in 1904 and 1908), and his art almost exclusively through private patronage. He pieced together a living from selling paintings and art photographs, winning "best of show" awards, and taking portraits of wealthy Americans. But that was not enough. For extra income he occasionally took fashion photographs for such magazines as *Art et Décoration* and instructed other photographers. He wrote Stieglitz that he had taken a part-time job with a Parisian photographer who ran an enlarging laboratory:

> Well—I've taken a *job* as a day laborer. I am working for Otto!!! going to put in two days a week for him for a while at $20.00 twenty [sic] dollars a day—"*showing him*" how to do it[.]
> I tell you it is not exactly pleasant but I simply had to do *something*.

Although he had thought of giving up his comfortable apartment, Steichen decided against it for business reasons: "People have more respect in a business way for you if they *think* you have money enough."[6]

Despite prizes and commissions, Steichen led a tenuous existence in the avantgarde art world, one that ultimately made him willing to enter the corporate world and adjust his political outlook. Lacking Stieglitz's private resources and having increased family responsibilities, Steichen found it difficult to adhere to the strict high-art modernist ethos that prohibited commercial applications for art all except portraiture. After 1923 he abandoned the life of an exhibiting artist, dependent on sales, to work almost exclusively for magazine publishers and advertising agencies. This commercial work guaranteed him a larger, more stable income. More important, it reflected a growing discomfort with private patronage and the elite distribution of fine art. At the same time, Steichen's embrace of the corporate world also reflected some reservations about his own family's progressive, egalitarian politics.

Steichen had been born in Luxembourg in 1879. His parents immigrated to the United States in 1881 and raised him in a midwestern working-class environment. Steichen's father worked in copper mines until poor health forced him to retire; for many years his mother supported the family by trimming hats and selling them in her millinery store in Hancock, Michigan. The pressure of the business eventually led the family to resettle on a four-acre farm three miles from Menomonee Falls, fifteen miles from Milwaukee.

Steichen's mother, Marie Kemp Steichen, and his sister, Lilian, called Paus'l (a Luxembourgian term of affection), were socialist activists in Milwaukee.[7] Through her political involvement, in 1907 Lilian met Carl Sandburg, then an organizer for the Social-Democratic Party and later to become a well-known poet. They married

in 1908, and Sandburg continued his constant travel to build the Socialist Party and campaign for presidential candidate Eugene Debs. In 1910 he became secretary to Emil Seidel, the socialist mayor of Milwaukee.[8]

Steichen and Sandburg began an immediate and close friendship that was to last for sixty years and serve both men as a great source of support and encouragement during their careers. They were similar in many ways: the children of immigrants, largely self-educated, ambitious, creative, hardworking. Their politics moved in tandem over the decades as both became more conservative and they came to accept, and benefit from, the capitalist system.

Prior to World War I, Edward Steichen seems to have shared the political beliefs of his mother, sister, and brother-in-law. Lilian proudly claimed responsibility for Steichen's progressive politics; she wrote to Carl Sandburg, "One thing I've done for my brother. I've helped make a socialist of him—just as I helped make one of mother." She expressed the hope that "someday brother will help the movement with his art."[9]

Lilian Steichen and Carl Sandburg saw no conflict between the life of an artist and socialist politics. Although both Sandburg and Edward Steichen later backed away from radical politics to embrace a more populist, nationalist, and conventional liberal public position, in their early years they saw the potential for using art to make a political statement and rally people to the cause. Sandburg wrote to his sister Esther that "almost all of the great artists, painters, musicians, & dramatists, are socialists or in sympathy with us." As he saw it, the marriage of socialism and art brought both aesthetic and populist benefits: it meant "greater art—more of music for more people."[10] Sandburg's own poetry of the time combined his socialist politics with his experiments in the more neutrally descriptive Imagist school. About half the works in his 1916 *Chicago Poems* describe economic and social inequities, with an occasional nod to the forcible actions that might be necessary to right them. In *Chicago Poems* he developed the voice of a committed radical who supported a wide range of positions of the American Socialist Party.[11]

Steichen's early work may be seen as political as well. Although, as I noted earlier, most critics have assessed Steichen's pictorialist photography as simply well-crafted and sensuous imagery reflecting the European vogue for impressionism and symbolism, much of his seemingly apolitical imagery expressed the basic ideals of German-American socialism that dominated Milwaukee during his early years. Melinda Boyd Parsons has convincingly argued that, particularly in his depiction of gender roles, Steichen expressed an "intensely romantic reverence for the 'purity' of women, the sanctity of family, and the 'heroism' of the artisan/worker" that were "at the heart of German-American socialism."[12] More than other social movements of the time, German-American socialism emphasized the separate but equal contributions of men and women to the family and society. Thus Steichen's early images of contented mothers and children, contemplative artistic geniuses, ethereal women as inspiring

muses, and dynamic men as leaders represented the ideals and humanitarian out-look that characterized the political climate of his early adulthood.[13] They prefigure the character typing that would dominate his advertising work.

In Milwaukee in the 1890s the Steichen family had many friends among the city's socialist leadership. They had begun to be politically involved, and their level of activity increased through the first decade of this century. A 1910 letter from Stei-chen to his sister, now in the Carl Sandburg Collection at the University of Illinois, congratulates her on the results of an election she and Sandburg had worked for.[14]

This political world, however, stood in stark contrast to the world of Steichen's patrons, whose comfortable lives impressed him. Observing them may have turned him from his cautious adoption of his working-class family's socialism. Because his financial survival depended on his producing art that appealed to the tastes of the upper class, his position was precarious. His letters to his family about the dif-ficulties and uncertainties of private patronage reveal the emotional and financial strain.[15]

Steichen's success in courting patrons was legendary in art circles before the war. After Steichen and his wife and children were forced to flee their home in Voulangis in 1914, just a few days before German troops arrived, they returned to the United States. During the war, Steichen's family lived in a borrowed cottage in the Con-necticut countryside while the artist spent weekdays in New York looking for work.[16] Alfred Stieglitz's cousin Flick Small predicted that because "Steichen gener-ally manages to stand on Somebody Else's feet . . . I bet . . . he'll be living in some-body's Fifth Avenue mansion (figuratively speaking) with a valet all of his own." [17]

Small was right. Steichen, from his temporary residence with Stieglitz's brother-in-law, Joe Obermeyer, at 57 West Fifty-eighth Street, teased his egalitarian sister about his elaborate lodgings and the valet provided to attend to his needs.[18] Steichen later lived in similar circumstances at the Mount Kisco home of his patrons Agnes and Eugene Meyer.[19]

Steichen relished the attention he commanded as an artist, and he saw the profes-sion as an opportunity for quick upward social mobility. By 1914 he had publicly rejected the socialism of his family.[20] Despite his success selling work, charming his patrons, and the close friendships he enjoyed with some of them, Steichen never seems to have been comfortable with dependency on the whims of others. His dislike of the small audience and restrictive aesthetics imposed by private patronage was a recurrent theme in his articles and speeches of the 1920s and 1930s (see Chapter 2). Yet instead of rejecting the system of patronage as symptomatic of the inability of capitalism to provide art to all, he participated in it. Moreover, he made art a more desirable, elite commodity by charging his private, and later corporate, patrons very high prices.

With the outbreak of the war any lingering socialist sympathies Steichen had were replaced with strong feelings of nationalism.[21] Deeply affected by the war, which he blamed on the general failure of dogmatic politics, he bitterly criticized Stieglitz and

the art community of 291 for their obliviousness: "If ever there came, within our time, a psychological element of universal consequence that could rouse individuals out of themselves as individuals and grip humanity at its very entrails, surely it was this one. '291' continued the process of producing a book about itself,—and calmly continued its state of marking time." [22]

Steichen and Stieglitz differed in their responses to the war because Steichen and his family had been directly threatened by the destruction in France, while the war seemed far more remote to those who lived through it in New York. The conflict between them may also have been intensified by ethnic differences. Although Steichen's first language was a German dialect, his homeland of Luxembourg had a strong French presence and he had lived for many years in France. [23] Stieglitz hesitated to take an anti-German stance because of his German lineage and his own education at a Berlin polytechnical institute. [24]

Steichen enlisted in the army in July 1917, a few months after the first call for American troops, and permanently changed his professional name on entry from Eduard to Edward. [25]

THE TRANSITION TO STRAIGHT PHOTOGRAPHY

The photographs Steichen produced between his departure from Voulangis in 1914 and his induction into the military in 1917 show a decided shift from soft-focus pictorialism to the sharper rendering of straight photography. *Lotus* (1915), for example, is a close-up study of the flower from an oblique vantage point; in it Steichen seems as concerned with the exact replication of the botanical details as with the more abstract design elements of light and shadow and overall composition. The emphasis on mood and expression seen in pictorialist landscapes such as *The Pool* (see Fig. 1.1) is gone.

A number of photographers in Stieglitz's circle in New York were similarly engaged in developing straight photography as art. By 1915 Paul Strand, for example, was constructing radical abstract close-ups of everyday objects such as bowls or porch rails, employing increasingly sharp focus as an expressive element. Because of such work the term "straight photography," which since the 1880s had simply meant an unmanipulated print, began to connote higher contrast, sharper focus, and a direct, uncompromising confrontation of the subject. The photographers did not, however, define the style solely by its formal elements, which for them were a language for translating a metaphysical or moral component into visual terms. [26] Some of Steichen's work around 1920 demonstrates experimentation with this pairing of metaphysics and the formal developments of modernist photography. But in general Steichen seems to have become less comfortable with philosophy as he became more proficient in designing with the surface qualities of his subjects. Steichen has frequently been considered a latecomer to straight photography because he had

drifted away from the Stieglitz circle and spent the war years and after in France.[27] But the vocabulary he developed in his prewar studies of flowers suggests that he moved toward straight photography along with other photographers at the time. And although he himself attributed this transition to the military's demand for sharply focused, information-oriented photographs, Steichen had already begun to incorporate elements of that style into his work before the war.

STEICHEN AND PHOTOGRAPHY IN THE ARMY AIR SERVICE

When Steichen entered active duty as a first lieutenant in the Army Air Service on July 27, 1917, there was no organized photographic department. In earlier wars most photographers had worked freelance: publications contracted with them, and they attached themselves to military units.

The Photographic Section was formed in 1917. It was quickly separated into air and ground units, which required different skills and technology.[28] This controversial decision gave the Signal Corps responsibility for news and publicity photographs, all of which had to pass through the official censors in Europe and again in Washington before release to American and Allied newspapers,[29] while the Photographic Section primarily took aerial photographs for intelligence purposes.

Despite his extensive experience with land photography and his early romantic notion of becoming "a photographic reporter, as Mathew Brady had been in the Civil War," Steichen chose aerial photography, which was more technically challenging and strategically significant.[30] In a report written at the conclusion of the war he explained:

> Aerial photographs are by far the most important, as they have become in modern warfare the chief source of information as to the position, disposition and movements of the enemy all the way from the front line trenches to the most remote rear area of operations. No maps, however accurate they may be, will give as correct an idea of the terrain and objectives as can be gained from good technical aerial photographs. . . . Camouflage which would defy detection by the eye of the best trained observer will show up on the sensitized plate if the proper plate and filter are used.[31]

Thus, in official documents, Steichen prized aerial photographs because they clearly represented detailed information, which surpassed even that obtained by direct live observation.

Although there is no evidence that Steichen took even a single picture during World War I, the photographer was attracted to the aerial division for its military significance, cutting-edge technology, excitement, and the opportunity to coordinate a complex project. By the end of the war he presided over efficiently run training programs, darkroom operations, and supply channels. His administrative expe-

riences crystallized his attitudes toward photography and exposed him to patterns of organization and teamwork. Operating within the rigid bureaucratic structure of the Army Air Service gave him a clear understanding of organizational structures and experience in working on collaborative projects. Both would prove invaluable in his later work for advertising agencies.

The aerial photography division comprised the photographers who flew over the front lines, as well as their laboratory support staff, whom Steichen supervised. Aerial photographers were commissioned officers, most often from the Intelligence Branch. They had to learn diverse skills: observation from an altitude of some fifteen thousand feet; the operation of heavy, complicated cameras before the 1918 introduction of the De Ram automatic camera; and the art of gunnery, since the photographer would be called upon to defend the plane from enemy attack if the pilot had to take evasive action. Steichen dramatically described the difficulties faced by this swashbuckling crew: the photographer operated a "cumbersome camera more or less successfully suspended in the fuselage of an airplane traveling through the air at a good hundred miles per hour. The fuselage receives all the vibrations of a powerful motor whirring off more than a thousand revolutions a minute, as well as the thumps and bumps of air-pockets and exploding enemy anti-aircraft shells."[32] Since few American personnel were skilled in aerial observation and photography, the photographers were usually taught by French instructors.

Darkroom technicians, who processed the negatives and prints, provided ground support for the aerial photographers. Steichen's first responsibilities were to choose and standardize equipment for the photographers and technicians and to open channels to organize and supply them. Each darkroom photo section consisted of approximately twenty-four enlisted men and one officer; they worked in a mobile laboratory truck that accompanied the field forces and produced the first prints from a mission within two hours, working at a frenzied pace (Fig. 1.3).[33]

Figure 1.4 exemplifies the images whose production Steichen supervised during the war. The top half of the illustration is an aerial photograph taken behind German lines. Beneath it one of the draftsmen attached to the Photographic Section has drawn the official "interpretation," which picks out the major natural and artificial features of the landscape. Successive views of such terrain helped track the movement of German troops and matériel. Such original photographs and drawings were reproduced by the thousands and distributed to intelligence and field officers. Clarity was prized in these aerial photographs because the operational staff used them to determine bombing targets.

The aerial photographs delivered volumes of information. For example, in Figure 1.5, taken near Reims at 11:00 A.M. on June 4, 1917,

> a trained interpreter would immediately recognize the wiggly white line in the center of the picture as a major trench; the straight line to its left, dotted with the shadows of poplar trees, is the main road through the area; the longer curve across the picture's lower left-

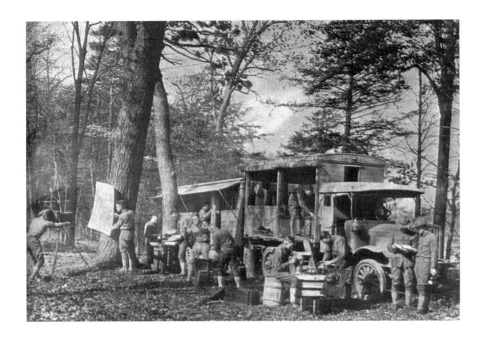

1.3 Photographer unknown, Aerial photographic processing laboratory in the field, 1918. From Colonel E. S. Gorrell, *History of the Army Air Service*. National Archives, Washington, D.C.

hand corner is a railroad, and the crescent that connects the railroad with the highway is a new rail spur under construction; the white starlike figures scattered in the area of the rail spur are shell craters. The small trench leading from the main trench, just to the left of the picture legend, may indicate that the army below is preparing to move eastward. . . . Accurate measurements can be made from this photograph. Since the altitude was 5,000 meters and the lens of 50 centimeters' focal length, the scale of the picture in the contact print is 1 cm = 100 m. By measurements on the print we can thus easily determine that the poplar trees had been planted 10 meters apart.[34]

Obviously, the photographs provided much more information about terrain, construction, and movement than maps alone.

STEICHEN'S ROLE IN THE AMERICAN
EXPEDITIONARY FORCES

Both Steichen's autobiography and Sandburg's 1929 monograph *Steichen the Photographer* give the impression that soon after his induction into the military Steichen

became chief photographer of the Air Service, commanding over a thousand men and holding the rank of lieutenant colonel.[35] Documents in the National Archives of the United States, however, reveal that the noncareer officer received only gradual promotions and that he was discharged with the rank of major. The records also tell the story of a slow and difficult process of organizing training programs, darkroom operations, and supply channels that was just nearing completion at the close of the war.

From the beginning, lack of equipment, supplies, and personnel handicapped the aviation photography program. When the newly promoted Captain Steichen and his supervisor, Major James Barnes, sailed for Europe, they were promised that adequate support would quickly follow. But help was slow in coming. Both officers spent a good deal of their time learning the new technical developments in photographic reconnaissance and standardizing the American equipment to conform to that of the other Allies.[36]

The first dozen photographers and darkroom technicians finally arrived from the American training schools in March 1918, but they brought no photographic ma-

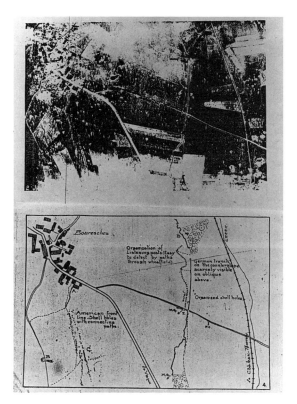

1.4 Photographer unknown, Aerial photograph and interpretation drawing, 1918. From Colonel E. S. Gorrell, *History of the Army Air Service*. National Archives, Washington, D.C.

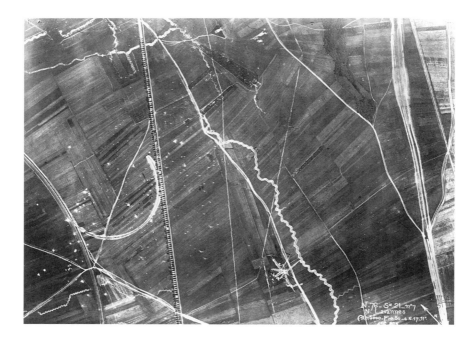

1.5 Photographer unknown, Aerial reconnaissance photograph, Lavannes, 1917. Museum of
Modern Art, gift of Edward Steichen.

terials with them. The struggle to obtain materials sometimes resembled a Keystone
Kops comedy, with obsolete cameras and missing parts. Once shovels arrived in-
stead of cameras! By the time of the armistice, no useful American-made photo-
graphic supplies had reached the front.[37]

Tensions developed between Barnes and Steichen.[38] Barnes remained at the
Air Service Headquarters at Tours, an area outside the fighting called the Service
of Supply (S.O.S.). Steichen took charge of all personnel and equipment in the
Zone of Advance (Z.O.A.) and Colombey-les-Belles, which Barnes considered "the
more important position of the two." When Steichen arrived in the Z.O.A., aerial
photography had not yet begun for lack of trained personnel and insufficient
supplies.[39]

Steichen had little patience for military bureaucracy. After one of several reorga-
nizations he was transferred to the newly merged Photographic, Balloon, Radio, and
Information Section. Steichen chafed at reporting to a military man who had no
training in photography but spent his time reorganizing the office routine and in-
stalling a filing system. But he employed his considerable diplomatic skills to ad-
vantage and mastered the intricacies of military politics.[40] As he later promoted him-

self to advertising agencies and their corporate clients, Steichen constantly reminded his superiors of the value of his work. An unsigned report he wrote at the end of the war described how

> Captain, now Major, Steichen during those critical days was handling the work of two or more men. He had to make constant trips between Headquarters, Air Service, S.O.S., and Headquarters, Advance Section, from which latter point he covered all the zone of activities at the front, organizing, advising, and coordinating matters of policy, technique, supply, and administration. Fortunately for the Photographic Section this officer was a photographer of twenty years experience and international reputation before the war and had been attached to the Section from its conception in Washington in August 1917. His knowledge of French and the French people facilitated greatly the liaison between the Section Photographique of the French Air Service and our own Photographic Section.[41]

Less than two months before the armistice, the Photographic Section was made a fully independent section of the Air Service and Steichen became its chief.[42] On November 13, 1918, two days after the close of the war, Steichen became a major.

At the end of the war, the Photographic Section still functioned far below the level of activity originally envisioned for it. Although in numerous articles and speeches after the war Steichen boasted that he had commanded over a thousand men in the service of photography,[43] when he filed his final report in 1918, he admitted that the organizational charts were never more than "a paper realization." Although technically by the end of the war one thousand members of the Photographic Section had arrived in Europe, most had not yet been trained and assigned. With sparse resources, the section had made over 32,000 negatives and 627,000 prints.[44] Steichen himself had been chief photographic officer for only six weeks. It had taken one full year and a great deal of administrative skill to mobilize a professional Photographic Section, and by the end of the war it was ready for full operation.

After the armistice, Steichen remained in Europe for several months, assessing the performance of the Photographic Section; drafting plans for its ideal, permanent reorganization; and directing the photographic documentation of significant sectors and monuments. When it had become apparent the war would soon end, the General Headquarters staff had initiated a major program of historical documentation.[45] Steichen advised General Mason Patrick, the chief of the Air Service, and Colonel Edgar S. Gorrell, who was charged with implementing the program, that aerial photographs and ground supplements together would constitute "one of the most valuable and important records in the history of this war." General Patrick agreed, telling Steichen that he was "extremely anxious" that "as many records as is possible" be made to confirm the importance of air power in the military.[46]

Steichen developed a plan for systematically photographing the Zone of Advance. Each sector was documented by air, and ten thousand complementary ground photographs were made.[47]

Steichen's efforts to build the Photographic Section into a vital, functioning contributor to the war effort meant he had to defend the value of photographs and teach ways of reading them to frequently skeptical superior officers. In numerous memos he explained the photograph's intelligence, documentary, and historical benefits. He ardently supported using photography for gathering intelligence and drafted plans for systematic photographic reconnaissance, arguing that routine surveillance of all fronts would be efficient and effective because "there is always something happening within the enemy's lines and territory."[48] He developed a well-articulated position that would continue to serve him in the next decade, when he persuaded art directors of photography's value in advertising.

Steichen clearly pictured the Photographic Section in a service/client relationship with the rest of the military. In July 1918 he wrote to General Patrick that all of the efforts of his section were "wasted unless the photographs that are taken meet and serve the military requirements."[49] In a comment surprisingly prescient of his advertising work, Steichen referred to military photography as "a commodity without enough customers." He contended that a well-trained photographic officer, who knew "just how much he could get out of the laboratory," could "drum up trade and . . . show the army what they can get and how they can use it."[50] To demonstrate concretely to his commanding officers the potential of photographic applications, Steichen established a laboratory to test new equipment and experiment with new materials.[51] He took an active personal interest in advancing research on aerial photography techniques and recommended that new forms, such as sector assemblages and stereoscopic aerial views, be adopted by the Intelligence Branch. Although intelligence officers did not order stereoscopic aerial photographs, Steichen considered them such an important tool that "the Photographic Section took the initiative and decided to force the stereographs on the market instead of waiting for the request."[52]

Steichen continually argued that all Air Service personnel should be photo literate. He recommended that "all field officers . . . be given illustrated lectures on what photography can do in the way of aiding them." Steichen argued that such knowledge would enhance defense; soldiers who knew that in enemy aerial photographs careless paths or deteriorated camouflage could give away their location would be less likely to allow them.[53]

But the photograph's power emerged only when it was read properly: "The average vertical aerial photographic print is upon first acquaintance as uninteresting and unimpressive a picture as can be imagined. Without considerable experience and study it is more difficult to read than a map, for it badly represents nature from an angle we do not know."[54] Despite all the rhetoric about the accuracy and information of these photographs commissioned to deliver empirical evidence, multiple

readings were possible for any given image. Steichen saw part of his mission as teaching the military bureaucracy (and later the mass media) to interpret the images' coded information.

THE IMPACT OF AERIAL PHOTOGRAPHY ON STEICHEN'S PHOTOGRAPHIC PHILOSOPHY

Steichen recognized the multiplicity of functions that even such dry and virtually unintelligible images as aerial photographs could deliver. Sometimes Steichen promoted aerial photography for its formal value; at other times he emphasized its documentary value or its emotive power. Foreshadowing the artistic tonal experiments that he would develop after the war in a memo to General Patrick, Steichen defined "photographic quality" as "the best possible rendering of all tone gradations of the object photographed."[55] In an article written for the Air Service's journal and reprinted in the magazine *Camera,* Steichen described the "striking pictorial effects" and "spectacular and dramatic interest" of aerial photography.[56] His appreciation for the aesthetic value of these documents never waivered, and when he was director of the Museum of Modern Art's Department of Photography, he donated several World War I–era aerial photographs to the museum (including Fig. 1.5). This gift to the institutional citadel of modernism demonstrates that for Steichen the images were not only valuable artifacts of American history but also aesthetically significant, embodying the shift from a pictorialist aesthetic to the wide tonal range and sharp focus of straight photography. Because of his insistence on their aesthetic qualities, aerial photographs have been included in later histories of modernist photography, a development that surely would never have taken place without Steichen's influence.[57]

In other instances, Steichen stressed the aerial photographs' documentary value as "an unequalled *historical document* of the great war. *They represent neither opinions nor prejudice, but indisputable facts.*"[58] Forty years later, he still contended: "Any photograph that is made—the very instant it is completed, the very instant the button has been pressed on the camera—becomes a historical document."[59] He considered the photographs taken for aerial reconnaissance during the war as significant as those taken at the end for the official record. They are, he said, "the chief recorder of what was accomplished and how it was accomplished."[60]

Although Steichen described aerial photographs as accurate documents, he considered them to have great emotional power, derived largely from their symbolic significance. Steichen implied that the real power of aerial photographs was in their ability to interpret, even heroicize, human efforts; they contained the story of "all the amazing ingenuity employed in digging, blasting and fighting" during "this titanic struggle."[61] This theme, which Steichen repeated in describing his work as a naval commander during World War II, underlay exhibitions, such as *Power in the*

Pacific, The Road to Victory, and *The Family of Man,* that he curated for the Museum of Modern Art in the 1940s and 1950s.

It is clear from his writing on aerial photography that Steichen emphasized one value or another of aerial photographs for different audiences: their aesthetic significance, their unwavering objectivity, their complex recording function, or their emotive power. Steichen's increasing respect for the photograph as a multivalent document and interpreter helped him to embrace straight photography after the war. Like Paul Strand, who pioneered modernist art photography, and like Georgia O'Keeffe and others in the Stieglitz circle who practiced modernist painting, Steichen understood that images have abstract formal qualities, which are readily apparent, as well as referents in the natural world or inspiration in ideas that might be obscured in the translation to visual object. This perception of the photograph as both a visual representation rooted in nature and a persuasive subjective image became central to Steichen's advertising photography in the next decade. The military's emphasis on the documentary value of photographs reinforced the inspiration, ideology, and belief in accessibility that had led Steichen to sharper focus, greater tonal range, and detailed description of objects in his photographs even before the war. As Steichen changed the style of his advertising work from documentary to more modernist, he did so well understanding the photographer's ability to encode and manipulate, even when his art directors and clients did not.

AFTER THE WAR: EXPERIMENTS AT VOULANGIS

Although he was not a career officer, Steichen stayed in the Air Service for almost a full year after the armistice, receiving an honorable discharge in October 1919. In January 1920 he accepted a commission as lieutenant colonel in the Air Service, Signal Reserve Corps, that he held until December 1924. While never on active duty as a lieutenant colonel, he did use the title in peacetime and even listed himself in the phone book as "Steichen, Col. Edward J." Steichen's rank became part of his persona in the commercial art world after the war. Magazine editors, his darkroom staff, and articles on his work all referred to "the Colonel" or "Colonel Steichen" until the next world war began.[62]

Steichen may have retained his military commission because he was uncertain what direction his art photography should take. The military experience had challenged his notions of photography but did not immediately replace them with a clear artistic direction. The war was a time of personal uncertainty for Steichen as well. His first marriage was failing, and he had no prospect of a stable income outside the Air Service. The military also offered him exciting technical work, recognition, and prestige that could not be equaled by the system of private patronage and the marginal status of the artist in American society.

While Steichen's autobiography does mention his search for an artistic style after the war, it leaves the impression that immediately after the armistice he returned to Voulangis to develop his new artistic direction. In fact, this was for him the time of a bitter public divorce and of great personal and professional searching.[63] After Steichen received his discharge, he stayed in New York at the Camera Club and contemplated a civilian career in aerial photography, landing temporary jobs with the Air Service Engineering Division in Dayton and the aerial photography school at Langley Field, Virginia.[64] Eventually he returned to his prewar home in Voulangis, determined to resolve the direction his photography should take.

Steichen later characterized his postwar life in Voulangis as some of "the most productive years" of his career. He turned his complete attention to the formal and technical problems of photography, seeking methods to reduce nature to abstract form, a problem that absorbed other modernist photographers at the time. He experimented with representing the volume and weight of objects, then produced a series of tonal experiments, which he later described as "sort of a legend," in which he made one thousand exposures of a cup and saucer placed on a graduated gray scale.[65] Carl Sandburg poetically described how Steichen's fascination with the technical enabled him "to get the maximum amount of realism. . . . He was seeking the photographer's controls as between the blackest black velvet and the whitest white paint in the sun."[66] This experiment laid the foundation for the materials and processes Steichen employed in his advertising photography; with it, he developed his characteristic range of tones.[67]

In the early 1920s Steichen brought his new technical expertise and simplified compositions to more intellectually complex abstractions, inventing universal symbols to express life cycle patterns and natural phenomena. In *Diagram of Doom — 2* the silhouetted form of the butterfly and the long shadow it casts suggest a menacing atmosphere. This work and others from the same period explain why Sandburg thought Steichen "profoundly mystical."[68] Eventually, however, Steichen concluded that such personal symbols were not comprehensible to others and decided to incorporate better-known scientific principles, such as the proportions of the golden section, into his abstract work and nature studies. But he quickly realized that even those universal abstract symbols had a very small audience. He noticed people responded more imaginatively to realistic images such as *Wheelbarrow with Flower Pots,* which became one of Steichen's favorites. He "began to reason that, if it was possible to photograph objects in a way that makes them suggest something entirely different, perhaps it would be possible to give abstract meanings to very literal photographs."[69] Thus soon after the war Steichen discovered that his strength lay in presenting the surface and structure of things—rendering and interpreting the people and objects he observed. This strength may explain his extraordinary success as a commercial photographer.

There was little money in experimental compositions and detailed nature studies,

and Steichen found himself in a country where prices for everything had almost doubled since the end of the war.[70] Around late 1922 he decided he needed a steady income and began to investigate possibilities in commercial photography. During an exploratory trip to New York, he wrote to his sister, who had moved to Chicago for Sandburg's journalism career, that because his prospects seemed bleak in New York, he was considering setting up a photographic studio near his family in Chicago.[71] But soon after he wrote to her, he met with Frank Crowninshield and Condé Nast and in March 1923 became chief photographer for *Vogue* and *Vanity Fair*. A few months after his first assignments for those magazines, Steichen began his long association with the J. Walter Thompson advertising agency.[72]

The Age of Corporate Patronage: Advertising Accelerates the Demand for Photography

In 1923, when Steichen began his career as a commercial photographer with New York advertising agencies, modern business practice had reached its maturity and business had become a pervasive force in American culture. Calvin Coolidge's oft-quoted aphorism "The business of America is business" epitomized the prevalent attitudes. The proliferation of products and potential consumers has led scholars to describe the era as the beginning of "consumer culture." With the introduction of radio and the expansion of national magazines, a more shared popular culture evolved, spread via the mass media. People in all parts of the country could buy the same brands, sing the same songs, and listen simultaneously to the World Series or the Democratic National Convention on the radio. [1]

THE MODERN CORPORATION: PRODUCTION AND DISTRIBUTION

By the 1920s, business was well on the road to becoming professionalized. To make their businesses more "efficient," firms manufacturing goods for a national market rationalized and expanded their management, streamlined production through the

division of labor and the introduction of time management, and intensified the empirical study of potential markets. They made use of new methods of accounting, budgeting, organizing labor, forecasting sales, and surveying markets. Universities began to offer business tracks, professional societies formed and sponsored journals, and consultants found plenty of work. American business had the largest and fastest growing market of consumers in the world. Moreover, American consumers, at least those that business and the advertising industry cared about, were more homogeneous and had more evenly distributed incomes and less prominent class differences than consumers in other countries. This domestic market, along with newer, more efficient production and distribution, created a perception of unparalleled plenty.[2]

All the major components of 1920s business practices of production and distribution were present before the war. To lower costs, raise profits, and increase sales, businesses consolidated, developed managerial structures, systematized labor, and vertically integrated production and distribution. The railroads and the telegraph, the first industries to modernize, dramatically improved the infrastructure of the United States; by the late nineteenth century they could be counted on for fast, regular, and dependable transportation and communication. The size and complexity of these private enterprises also provided a model for future corporate strategy and structure: they standardized equipment, cooperated, competed, merged, raised capital, and developed a modern system of professional managers. And they built a comprehensive national network that encouraged the emergence of wholesalers, retail department stores, and mail-order houses to distribute goods.[3]

Mass production followed reliable distribution of raw materials and finished goods. "Big business" was created when companies expanded or merged to control both production and distribution. By the time the United States entered the war, the ownership of food processing, machine making, and heavy industry had been concentrated as a result of turn-of-the-century mergers. As industries grew, they developed modern managerial structures: top managers concentrated on long-term planning and resource allocation, and middle managers took over coordinating the details of production and distribution. After World War I this structure was firmly in place in most American corporations; professional salaried managers had largely replaced independent entrepreneurs.[4]

Conditions for workers also changed as manufacturers sought "efficiencies" among the increased number of workers who toiled in their plants. The Ford Motor Car assembly line is perhaps the most famous example of atomized, rationalized modern factory production.[5] Manufacturers swiftly accepted scientific management, based on the theories of the "efficiency expert" Frederick Winslow Taylor that labor productivity could be increased by continually subdividing the process of manufacture until skill and craft were unnecessary for production.[6] This desire for control over the now-alienated laborers prefigured the corporate desire to control and manipulate consumers to buy their products—the last piece of the production and distribution puzzle.

As industries became concentrated in the hands of a few, they expanded their market share by developing new products. As for distribution, chain stores and suburban branches of department stores, ideas dating back almost to the Civil War, took off. Although some small businesses and legislators tried to halt their growth as unfair competition, by the 1920s chain stores were the fastest-growing mass marketers, quickly turning over a high-volume, low-cost flow of goods.[7]

Advertising was a significant part of the distribution process, and advertising men frequently took partial credit for the prosperity of large corporations. They contended that they helped their clients organize the mass distribution of products and promote products nationally, thus allowing manufacturers to sell more cheaply. The advertising executive Roy Durstine offered a typical argument: although workmen who make "a famous cake of soap . . . are paid three or four times as much as they were fifteen years ago," mass production and advertising enabled the manufacturer to continue selling it for ten cents.[8]

National advertising grew along with the high volume of goods. The new national media provided the opportunity for wide exposure for each advertisement. And just as manufacturing industries had discovered the benefits of size, so did the media. During the 1920s many smaller magazines and daily newspapers ceased production or merged with larger ones. As media outlets decreased, however, total circulation increased, making it easier for the agencies to create national advertising images and ad campaigns.[9]

THE DEMAND FOR COMMERCIAL ART

The boom in business activity generated a phenomenal demand for commercial art: businesses discovered that snappy visuals piqued consumer curiosity. These new visuals were more and more often photographic. From 1910 on, as advertising agencies experimented with different media and styles, it became clear that photography best promoted both product sales and the public image of manufacturers.

Good-quality photographic halftone reproduction had been available since around 1890, but until the 1920s the medium was rarely used in advertising. Whereas in the July 1922 *Ladies' Home Journal* a photograph was included in only 14 percent of all the full-page and half-page advertisements, by July 1927 it was included in 25 percent.[10] By the end of the decade photography had made dramatic gains across the industry. Nearly twice as many photographs as drawings were used for the main illustrations in the J. Walter Thompson Company's magazine campaigns of 1929.[11] And one year later, forty-seven of fifty-six accounts in their New York office used photographs as the major artwork in their advertisements.[12] This was part of an industry-wide trend; the use of photographic advertisements in mainstream magazines increased from under 20 percent in the first two decades of the century to over 60 percent by the mid-1930s.[13] When Steichen, under economic

pressure in the early 1920s, turned to commercial art, he found a ready and rapidly expanding market for his work.

Advertising photography quickly dominated commercial illustration in the 1920s because it satisfied the economic demands and business practices of the moment. Steichen's work, emerging from the desire of business to define corporate identities and improve the national distribution of goods, served the needs of a particular moment in the history of capitalism. Technologically photography was the perfect analogue to a movement toward professionalism in business. For both businessmen and the public photography resonated with an ideology of modernity. In addition, photography's lineage as a fine art—Steichen was popularly acknowledged as a "famous artist"—gave photographic images a prestige that in turn heroicized big business and its products and glamorized the consumer.[14] The visual image was used to establish and reinforce the viewer's identity as a consumer, a task made easier by the medium's transparency. In other words, photographs, with their seemingly natural and neutral representations of social identities and relations, reinforced the values of the corporate age.[15]

Steichen was an industry leader, whose images contributed to the prevailing idea that photography was vital to sales. He was the ideal new corporate man, adept at self-promotion and manipulating his own image as well as constructing identities for his clients. Where Stieglitz embodied the persona of the fine artist who, in the manner of the nineteenth-century bohemians before him, could concentrate solely on expressing his individual vision, Steichen personified a twentieth-century model, the artist in the service of corporate modernism and technology. Steichen was tremendously successful in the commercial world because he provided what the agency and client desired—persuasive, visually sophisticated photographs characterized by novelty, credibility, and emotional appeal.

THE EMERGENCE OF MODERN MARKETING TECHNIQUES

As business practice became professionalized in the early twentieth century, so did advertising and commercial photography.[16] In the first few years after the turn of the century, many manufacturers, advertising agencies, and publishers conducted rudimentary market analysis. The N. W. Ayer and Son advertising agency began basic research by 1910 and developed empirical methods for product analysis in the 1920s. In 1911 Curtis Publications, owners of the *Ladies' Home Journal,* the *Saturday Evening Post,* and other magazines, opened a marketing research arm they claimed was the first in America to advise manufacturers how to use advertising more effectively. In 1912 the J. Walter Thompson Company commissioned and published its first edition of *Population and Its Distribution,* which listed retail outlets by category and location as an aid to their clients. In 1910 Ayer published its first

annual directory of newspapers and magazines, listing media outlets and circulation figures for clients.[17] Consultants and university professors, such as Daniel Starch, George Gallup, George B. Hotchkiss, and Neil Borden, compiled statistical evidence on the effectiveness of advertising, polled consumers on their preferences, and lent new academic credibility to the study of advertising and marketing strategies.[18] At the same time, commercial market research, along with the university-based social sciences of psychology and sociology, began to formulate the empirical methodologies that characterize their current practice.

Methods for gathering statistical information and assuring accurate probability sampling for marketing goods were based on a long legacy of collecting statistical information, from ancient census taking to Progressive Era social surveys.[19] In the twentieth century these methods were put to commercial use. Industrial psychology appeared soon after the turn of the century as an extension of scientific management. This applied psychology offered businessmen advice on how to select workers by measuring aptitude and attitude and how to increase their productivity.[20] During World War I the military commissioned psychological studies to measure the intelligence and personal characteristics of recruits.[21] Military patronage offered psychology as well as photography a way to prove its usefulness to the American economy. Just as Edward Steichen established a leading reputation in both the fine and the applied arts, the early academic psychologists, such as Walter Dill Scott and John B. Watson, who became key players in the development of advertising psychology, moved effortlessly between the university, military, and corporate worlds.

During the 1920s the social sciences evolved into more technocratic sciences of prediction and control: "Only a hard technological science seemed capable of controlling so fast-moving a society or so slow-moving and retrograde a public consciousness as existed in America." Social scientists gained the influence and prestige they desired in part because of the popularly perceived moral authority of science in the 1920s, when intellectuals saw science as a way to sustain order in the modern world. Thus, as photographers adopted a seamless style that made social constructions seem natural, social scientists engaged in an "effort to naturalize the historical world [which] is itself a historical project."[22]

Although advertising agencies employed psychologists and business consultants to translate academic studies into commercial strategies, terms and methods were still imprecise in the 1920s. A "survey" could mean anything empirical; little distinction was made between purposive (selected) and random samples; and (male) college students were the typical stand-ins for the general public because they were handy and inexpensive subjects for university psychologists and sociologists.[23] Statistics became the visible mark of "science," and academic and commercial researchers applied the scientific method with varying degrees of sophistication. Naive empiricism was widespread.[24] But although they largely relied on their own intuitive and practical experience rather than formal sampling theory, early commercial re-

searchers still practiced a more rigorous empiricism than either Progressive Era social survey activists or early academic social scientists. The Thompson agency's executive James Webb Young noted with dismay that "the advertising man of the future will have to learn the language of higher mathematics."[25] By the mid-1930s market researchers standardized questions, developed more sophisticated scales, and employed random sampling. Though preliminary, their achievements underlie today's empirical social science methodologies.[26]

PHOTOGRAPHY AS THE EXPRESSION OF
THE AMERICAN CORPORATE AGE

In this climate of empiricism, the primary reason for incorporating illustrations into advertising was that pictures effectively sold goods. Initially, advertising personnel had intuited the need for illustrations, believing they added attention value to the advertisement. The first advertising illustrations had appeared in newspapers by the early nineteenth century; they were small black-and-white woodcuts that advertisers hoped would make their message stand out in long columns of dense type. Later the halftone process made reproductions cheaper, causing the proliferation of illustrations. While photographs grew more common on the editorial pages of magazines, drawings were more frequently used in advertisements.[27]

Increasingly sophisticated measurements of consumer response demonstrated the influence of illustrations. As early as 1903, a JWT survey demonstrated the public did not like advertisements without illustrations. In 1929 a more empirical survey by the noted advertising pollster Daniel Starch reported "that the use of pictures increased the coupon returns 33% to 50% over the advertisements previously used, with an average of 45% over the average for the year before. . . . The necessary reduction of about 33% in copy seems to have been amply made up in attention value."[28] Further, the survey indicated that all economic classes responded equally to advertising imagery. While some old-timers like the legendary adman A. D. Lasker, president of the Lord and Thomas agency, continued to insist that "a stack of figures a mile high wouldn't change my mind if I didn't agree with them,"[29] the general trend in the industry was decidedly toward empiricism.

Some statistical studies convinced agencies that photography gave advertising greater credibility than advertisements with drawn or painted illustrations or simply text alone. The *JWT News* reported in 1930 that "photographs have time and again proved more effective than drawings," with "a recent test campaign" demonstrating "the photos outpulling drawings two to one." Other studies of specific advertisements, some of which included Steichen photographs, discovered that the style and elegance of his images appealed to a mass audience.[30]

What can account for photography's rapid domination of commercial art? Al-

though it has frequently been attributed to low cost and new technology, it is clear that by the late 1920s advertising executives had come to believe that photographs were the most *effective* medium for advertising art.

Some considered photography a less expensive alternative to drawings that was more quickly executed and allowed a selection from a variety of poses.[31] But star photographers, like Steichen, charged almost as much for a photograph as illustrators did for their drawings.[32] And the lower cost of reproducing black-and-white photographs was negated when they were hand colored in the Mechanical Department, then reproduced by traditional color printing techniques. In any event, the client's major expense was still buying space in the media.

Nor do technological advances in reproduction explain the significant jump in the use of photographic illustrations. The technology for halftone reproduction had been patented in 1852 by William Henry Fox Talbot, who had invented a gravure process in which a photograph was printed separately on coated paper and then tipped into the text. Other inventors soon refined his concept and by the 1880s had developed type-compatible relief halftone processes. The technology was continually improved until 1890, when Louis and Max Levy of Philadelphia developed an excellent quality type-compatible relief halftone process.[33] In the 1920s the process became more economical and further technical refinements were made in ink, paper, plates, photographic emulsions, and press technology, but there was no major technological change.

Magazines routinely used halftones to illustrate news and features before the turn of the century. The first fashion photographs appeared in *Vogue* magazine in 1893, and by 1914 the work of Baron Adolph de Meyer, who was appointed chief photographer, appeared regularly.[34] But advertising agencies used photographs only in isolated cases before World War I. Ralph Hower's history of N. W. Ayer and Son mentions that the agency used halftones of both wash drawings and photographs in the 1890s. Frank Presbrey's 1929 history of advertising described the "sensation" caused in 1897 by a "combination photograph," or photomontage, that invented a scene of President McKinley and Queen Victoria drinking tea.[35] But these instances were sporadic. The earliest use of a photograph recorded in the J. Walter Thompson Archives is in a 1917 trade booklet prepared for the salesmen of Conaphore headlights (see Fig. 4.11).

When corporations turned to photography, however, they turned quickly because they saw photography as the best visual expression of the new American age. Though invented by Daguerre and Talbot—one French, the other British—photography, as the newest artistic medium, was considered naturally American. The preface to the catalogue for a 1930 exhibition of contemporary photographs at the N. W. Ayer and Son advertising agency's art gallery explained that "the traditions of painting and sculpture go back to the academies of Europe, but leadership with the camera belongs to America. This is perhaps natural, a new art is reflecting a

new scene. Skyscraper, grain elevator, dynamo, smoking factory chimneys—these become as appropriately themes for the camera as was the French landscape for the brush of Corot, or the mists of an English harbor for the art of Turner." [36] For this writer photography in advertising was the quintessential expression of the age, suggesting newness, novelty, and industry—the very essence of American culture.

The interactions between modernity, nationalism, and advertising were a source of lively debate in cultural as well as business circles. Many intellectuals applauded the corporate age. Like the advertising men, they associated industrial progress and business with modernity and American nationalism. Articles in the little magazine *Broom,* for example, represented advertising as a thrilling indigenous American art and valorized Henry Ford as an almost godlike genius. [37] Many of Steichen's talks and writings from the period evince a similar deep-seated respect for authority and awe of success in business. As the photographer told an interviewer in 1932, "The owner of a big magazine has reached that position not because he's a darn fool, and it's the same with the head of an advertising agency—because he knows." [38] Others saw advertising as nationalist in a different sense. Ralph Hower, a business historian and Harvard University professor, argued that advertising was a powerful tool for private profit and social control and "essential to a free modern industrial society." He thought that advertising agencies, by their contributions to the free enterprise system, "have helped to build the American nation," equating engagement in business with patriotism. [39]

Beyond its perceived value in epitomizing American modernity, photography became the choice for commercial images of the newly solidified American empire because it affirmed economic and class structures. Its call to spectators to identify with the prosperity and joy of its subjects, its implicit moral relativism in equating social good with "progress," and its obfuscation of social stratifications and disregard for the conditions of the production of goods all worked to reinforce the status quo. Photography sold its ideology by sleight of hand, in which the inscribed social relations were made to seem natural rather than constructed.

BUSINESS AS ART PATRON; ADVERTISING AS ART EDUCATION

With the unprecedented volume of commissions for commercial art, businessmen began to see themselves as the new patrons of the arts. By the 1920s businesses routinely used advertising imagery to solidify their corporate identity and sell goods. In addition, a promotional rhetoric extolling the public benefits of this new corporate patronage peppered business and advertising trade papers, claiming an improvement in the aesthetics of advertising design as well as in the level of public art education. The aim of the rhetoric was to transfer prestige from the fine arts to commercial art.

Throughout the 1920s, writers in the New York Art Directors' Club *Annual of Advertising Art* advanced these arguments. In 1921 Egbert G. Jacobson contended that commercial art patronage had replaced "encouragement from the government, religion and private wealth." He believed that just as business had encouraged modernist architects to develop skyscrapers as the new American architecture, it would "engage the best artists to produce its advertising pictures, and thus a second great national art expression based on usefulness will be developed."[40] In 1927 W. H. Beatty contended that the best advertisements "represent much experimentation and daring, much reaching out for the new, as they should, for they reflect the same churning endlessness that competitive business does, if not American life itself." And Ben Nash observed that when an artist's abilities and business sense clicked, the result was "a more vital kind of art."[41] Thus in the 1920s, the art directors, advertising agency executives, and their business clients valued both the personal expressiveness of the fine arts and business's need for commercial art; they saw the production of each as a different aspect of visual culture. But they saw commercial art as the more direct expression of the American culture and economy.

Advertising art did improve after World War I as agencies hired art directors. Almost immediately the new art directors founded professional organizations to discuss artistic style in commercial art, compare working conditions, organize exhibitions of advertising art, and publish trade journals. The New York Art Directors' Club, founded in 1920, "by a group of men ambitious for the progress of art in advertising and industry," began a series of lectures and annual exhibitions the following year, establishing a pattern for similar clubs in cities across the country.[42]

The slow professionalizing of advertising agencies themselves continued. Having begun in the nineteenth century as space jobbers, agencies offered clients copywriting services by the last decade or two of the nineteenth century and added artwork around the turn of the century. N. W. Ayer and Son added copywriting services in 1892, and J. Walter Thompson became a full-service agency offering copywriting, layout, and package design in 1895. Ayer hired commercial artists to assist with ads as early as 1898 and named its first art director in 1910. By the early 1920s the Thompson agency employed three art directors, Gordon Aymar (ca. 1920–30), Pierce Johnson (1917–27), and John De Vries (1917–25).[43] Prior to 1929, their work was a subsidiary of the Mechanical Department; then a separate Art Department was organized under the leadership of Gordon Aymar.[44]

The agencies came to value the work of the art directors and the freelance artists they hired as the quality of their work improved and as belief in its effectiveness increased. Earnest Elmo Calkins, founder of the advertising agency Calkins and Holden, observed the improved aesthetic quality of commercial art during his long career:

> In the beginning . . . advertising designs and drawings were made by hacks without imagination or talent who did this humble work because they were unable to do anything better. Artists of standing considered it beneath them to sell their services for business purposes,

although there had been notable exceptions. . . . The standard rose no higher than the artistic taste of the average manufacturer, who knew nothing about art. . . . But as advertising grew . . . [b]usiness men began to understand, if not art principles, at least the power of a virile and able picture to influence people's minds, and at the same time a disposition was manifest to pay the artist in proportion to his ability and reputation. Better men were attracted to this profitable field, and they found as time went on an increasing willingness to let them work in their own way and according to their own genius, and less disposition to curb them with meaningless and silly limitations.

Thus Calkins agreed with the prevailing corporate sentiment; because agencies were commissioning an ever increasing volume of commercial art, quality was rising and business was earning a right to call itself the primary patron of art in America. Calkins differentiated little between the fine and applied arts:

Under the double stimulus of adequate reward and freedom to exercise their talents, artists produced work for business that won commendation from hard-boiled critics who for years had sneered at commercial art. . . . An artist who makes advertisements is an artist pure and simple exactly as is an artist who makes murals or portraits. . . . The natural result of drafting the most competent men for business art was that the designing of advertisements attained a remarkable degree of artistic excellence.[45]

Calkins observed that money was the key: when advertisers paid better rates, freelance artwork improved. Steichen agreed; he contended that the client paying a high price was more demanding, and the result was better photography. To Walt Whitman's remark that "to have great poets there must be great audiences" he added, "The same is true of photography."[46]

Along with the argument for quality, apologists for advertising art argued that it increased the public's appreciation for art in general. Merle Thorpe, editor of *Nation's Business,* maintained that "the artist and the art director have the responsibility and privilege to direct public taste toward a higher beauty in the material expressions of our civilization." For Thorpe the rise in artistic standards was at its heart populist and democratic. Advertising professionals could refute the idea that art is "a world apart from the lives of the people—'a highbrow thing, the plaything of opulence.'" He insisted, "This everyday art of the workday world is one of the great fundamentals of our lives. It unites us in common understanding, common feelings, common reactions. It can appeal to the man in the street as knowingly as to class and caste and rank."[47] The educational value of advertising in a modern economy was often defended—in one instance by no less a personage than Calvin Coolidge, who spoke at the tenth annual meeting of the American Association of Advertising Agencies in 1926. Coolidge observed that modern advertising taught people new "habits and modes of life, affecting what we eat, what we wear, and the work and the play of the whole nation."[48]

The democracy of commercial art became an issue because advertising directed

its pitch at the general public or segments of it. Perhaps to rationalize their own role in the industry, advertising personnel defended their ads, no matter how silly, as "educational" or "informative" to the general public.[49] Jackson Lears has argued that because they were "steeped in the Protestant tradition of moral instruction through the printed and spoken word, advertising spokesmen often sought to portray themselves as educators rather than businessmen."[50] Although overall the aesthetics of advertising improved after the war, the defense of business as art patron, educating the public and improving artistic standards, served primarily to justify the use of images to sell products.[51]

STEICHEN'S ADVOCACY OF COMMERCIAL ART

When Steichen gave a talk at the J. Walter Thompson Company in 1928, he told the art directors and account representatives: "Commercial art is the kind of thing which has been looked down upon for a long time." The modernist aversion to it, he argued, was based on a misreading of patronage in the history of art: "There has never been a period that the best thing we had was not commercial art." Making one of his favorite comparisons, Steichen said: "If there ever was a poor harassed artist, more so than Michelangelo, I never heard of him, thrown on this kind of work and never being able to do what he thought he wanted to do himself. I am inclined to be grateful that he did not get the chance."[52] On another occasion, probably for shock value, Steichen coarsely called the traditional old-master painter "a glorified press agent" for the aristocracy.[53] Steichen's speech to a small group of advertising professionals at the Thompson agency foreshadowed the combative public stance he would take on the issue in his writings and in interviews with trade journals and popular magazines. Practically all the articles about him in the late 1920s and early 1930s refer to his rationale for doing commercial art.[54]

Steichen the Photographer, Carl Sandburg's 1929 monograph on his brother-in-law's work, celebrates Steichen's attitude toward commercial art and explains his career change from the fine to the applied arts. Much of Sandburg's monograph is devoted to Steichen's entrepreneurial spirit, including an account of Steichen's earliest income-producing activities: as a child selling vegetables door-to-door, and as a teenager delivering Western Union messages by bicycle, working for the lithography company, and designing posters. Sandburg equates Steichen's artistic success with his financial success, pointing to such events as Rodin's payment of 1,000 francs for Steichen's photographing of *Balzac*, Stieglitz's purchase of prints, the exhibition prizes, the high fees magazines paid for reproduction rights, and his high fees for commercial work.[55] Sandburg's continual insistence on measuring Steichen by his income suggests how thoroughly both men had internalized the values of the business culture of the 1920s. His fees proved both his popular appeal and his artistry.

Steichen told Sandburg that he was working against the tide in the art world: "Practically all artists who do commercial work do it with their noses turned up. They want to earn enough money to get out of commercial art so as to take up pure art for art's sake." He was disillusioned, however, with the idealism of the fine arts: "That viewpoint doesn't interest me. I know what there is to know about it—and I'm through with it. I welcome the chance to work in commercial art. If I can't express the best that's in me through such advertising photographs as 'Hands Kneading Dough,' then I'm no good [see Fig. 3.2]."[56]

Steichen maintained that the best art of each period flowed from and reacted to its context, particularly the economic structure of the culture: "The great art in any period was produced in collaboration with the particular commercialism of that period—or by revolutionists who stood clear and clean outside of that commercialism and fought it tooth and nail and worked for its destruction." Taking a swipe at his former Stieglitz circle associates, and probably mindful of the artistic pressures of private patronage, Steichen declared: "In the twilight zone of the 'art for art's sake' school all things are stillborn."[57] Uneasy with the life of a self-supporting fine artist and aware how artistic success depended on the taste of the elite classes, Steichen undoubtedly overstated his case about the social and populist values of commercial art.

It is not surprising that Sandburg's monograph vigorously promoted commercial art. The Harcourt, Brace Company published it with the financial backing of the J. Walter Thompson advertising agency, with whom Steichen then had an exclusive contract.[58] With its mingling of fine art and advertising illustrations the book proclaimed that Steichen considered his advertising photographs art. And according to Sandburg, all of Steichen's work of the 1920s and 1930s, "except for experiments and diversions," was commercial.[59] Many years later, in his autobiography, Steichen claimed a good deal of the credit for raising the aesthetic level of advertising.[60]

As testimony to his belief in the artistic merit of his commercial photographs, Steichen frequently included them in art exhibitions during the 1920s and 1930s. He sent *Vanity Fair* portraits and *Vogue* fashion photographs to the 1929 *Film und Foto* exhibition in Stuttgart and the 1936 *Exposition Internationale de la Photographie Contemporaine* at the Musée des Arts Décoratifs in Paris. His 1938 retrospective at the Baltimore Museum of Art featured his advertisements for Jergens lotion, Steinway pianos, Douglass lighters, Coty lipstick, Kodak film, and Hexylresorcinol as well as his early landscapes, abstract experiments, and portraits.[61] In this way, Steichen insisted on collapsing the distinctions between the fine and popular arts, challenging modernist ideas by denying the polarity of fine and applied arts. Thus he saw a continuum, unlike the avant-garde modernist artist who raids low culture for ideas to translate into cultural products for the elite.

Steichen also challenged modernism by praising the populist virtues of commercial art: art was not found only in "gold frames," but on the pages of magazines, in industrial designs, and in engineering. Demonstrating his belief in the value of in-

dustrial and product design, he accepted commissions to design two pianos for Hardman, Peck and Company, glass for the Steuben Company, and silk dress fabric for the Stehli Silk Company. In his 1928 talk at the J. Walter Thompson Company, Steichen explained: "When I was putting my soul on to canvas, and wrapping it up in a gold frame, and selling it to a few snob millionaires who could afford it—after I got to thinking about it, I did not feel quite clean. But now I have an exhibition every month that reaches hundreds of thousands of people through editorial and advertising pages." [62]

Despite Steichen's vigorous defense of the quality and wide appeal of applied art, he was well aware that his paycheck from the advertising business depended on the ability of his photographs to sell goods. In his talk to the J. Walter Thompson staff, Steichen made a number of more or less oblique references to the advertising agencies' requirement that photographs persuade consumers. For example, commenting on certain contemporary fabric advertisements, he decided they were ineffective as ads because "everyone comments on how clever and smart the photographs are, but no one remembers what the fabric group is." While retaining his self-identity as an artist, he revealed his keen perception of his own role as a salesman for the product. He told the Thompson staff, "My mother was a milliner. She said anyone can sell a hat to the woman who wants one. It is [an achievement] to sell a hat to the woman who does not want one. When I do this, I feel I am selling hats." [63]

In embracing commercial work Steichen joined ranks with a diverse group of artists and designers who rejected a hierarchical structure for visual practices. In 1914 Clarence White, the pictorialist photographer and former Stieglitz associate, had founded his School of Photography in New York, which trained some of the best-known professional commercial photographers of the 1920s, including Paul Outerbridge, Ralph Steiner, Anton Bruehl, Margaret Bourke-White, and Margaret Watkins. White based the philosophy of his school on Arthur Wesley Dow's democratic ideal of art appreciation and urged the application of fine art principles to industrial and commercial design.[64] Many of the White School artists exhibited at the Art Center, which sponsored lectures, exhibitions, and social events to effect the "fusion of beauty and utility," that is, to unite art and industry.[65]

There seem to have been cross-influences between Steichen and some of White's students. Bruehl, Outerbridge, and Watkins, for example, created advertising photography in a modernist style in the early 1920s, shortly before Steichen entered the arena of commercial photography in New York. Soon after Steichen returned to New York in 1923, he was a guest lecturer at the White School and spoke of his dual conversion to straight photography and its commercial art applications. Certainly his reputation as an art photographer strengthened his endorsement of the White School's efforts in commercial photography.[66] Later Steichen became one of the six members of the Board of Advisors at the White School and by the early 1930s was its "senior advisor." [67]

Among the other established photographers who turned to advertising in the

1920s were Adolph de Meyer, Lewis Hine, and Charles Sheeler. Steichen was simply the best known and best paid, had been closest to Stieglitz, and was the most publicly outspoken about commercial photography of the group. In the United States divisions ran deep between the art-for-art's-sake school of photography, which adjudged the fine and applied arts as polar opposites, and the new group of commercial photographers who blurred these distinctions. But in Europe these divisions were becoming less distinct. In Germany, students of photography at the Bauhaus were instructed in contemporary design, typography, and layout as well as photography and fine art. One of the Bauhaus professors, Walter Peterhans, took modernist advertising photographs for mass media magazines. Other Bauhaus photographers, such as László Moholy-Nagy and Herbert Bayer, produced formally radical photographs in the context of graphic design and printing (rather than fine art for exhibitions). Both Moholy-Nagy and Bayer differentiated little between artistic media, and both also worked in painting, sculpture, graphic design, and filmmaking. The Bauhaus desire to reeducate the public through the mass media and to utilize technological innovations for a better society had particular relevance to advertising.[68]

Other European movements similarly merged the goals of the fine and applied arts. For example, in architecture Le Corbusier's purism combined Platonic idealism with modernist geometric design and utilitarian goals; some of his designs were meant to improve working-class life. In Holland, De Stijl artists and architects combined theosophist mysticism with geometric abstraction in furniture and interior design. And the constructivist movement in the fledgling Soviet Union sought to bring a new artistic vocabulary to a new society, redesigning art, textiles, architecture, and even common objects.[69]

The merger of fine art and commercial art demonstrated an intuitive understanding that the hierarchy of photographic practices (with the fine arts in early-twentieth-century America above the applied arts) was socially produced. Photography itself is simply a medium—no different in its technology whether employed for the fine arts or commerce.[70] Thus the desire of Steichen, the White School, the Bauhaus, and others to blur the modernist separation between the fine and applied arts resulted from social and economic factors, different in each case. As for Steichen, although his immediate salary was undoubtedly important, his lifelong populist sentiments and (perhaps contradictory) growing belief in capitalist enterprise cannot be discounted as motivations.

Steichen insisted that he wanted to create lively commercial art for large audiences, and he seems to have been sincere. His colleague Ralph Steiner remembered him "enjoying the process enormously." Steiner recalled that "there never was a better craftsman, and Steichen, always the charmer with a smile that could melt tool steel, charmed and photographed the newsworthy people of his day characterfully and entertainingly. I think of him as just about the only commercial photographer who made money without letting the process rasp his nervous system."[71] Yet Stei-

chen's frequent justifications of commercial art and corporate patronage during the 1920s and 1930s took on a defensive tone, so much so that one wonders whether he harbored reservations about advertising art.

In the agencies the tension between art and commerce was played out daily. "Advertising art," according to Thomas Erwin, a founder and chief executive of an advertising agency, "has as its sole purpose the hawking of multifarious products and wares of our Republic." Like Steichen, who asserted that commercial art was more relevant to society than the fine arts, Erwin argued that the genre contributed directly to the economic life of the country, carrying out the "essential activity" of "speeding the lagging distribution of Detroit's motors and Pittsburgh's beans." Insensitive to the pride of art directors and freelance artists in the aesthetics of their work, Erwin felt that advertising made no aesthetic contribution. He saw no need to defend advertising art as "high and consequential." Those who work in advertising "need no such alibi. They are doing a useful job and doing it astonishingly well."[72]

William Day, the chief copywriter at J. Walter Thompson, echoed Erwin: "Advertising is written and designed solely for the purpose of making sales."[73] While other executives used softer words, they expressed similar sentiments.

Most art directors, however, had been trained in art schools and maintained second careers as exhibiting artists. For example, J. Walter Thompson's Ross Shattuck and N. W. Ayer and Son's Charles Coiner had a joint exhibition of paintings at the Montross Galleries in 1927; and Gordon Aymar eventually left the graphic design field to pursue a career as a portrait painter. Coiner recalled that at Ayer the art directors Paul Darrow, Walter Reinsel, and Leon Karp were also painters.[74] (Ayer, moreover, led the industry in commissioning fine art for their clients, and from the 1920s on employed, for example, paintings by Georgia O'Keeffe for Dole pineapple, Willem de Kooning for the United Nations, and N. C. Wyeth, Rockwell Kent, and Miguel Covarrubias for Steinway pianos.) Yet the creative staff bent to commercial demands as long as they could maintain what they perceived as artistic quality. In his 1929 textbook, Gordon Aymar advised the aspiring art director that he

> must realize that he is in business and not in art. It is a case of finding a way to serve two masters. He must never relinquish his artistic standards for a moment; if he does he will be unfaithful to his training, and also he will not be doing his best work. But above this, he must understand that he is bound to serve business and accept its realistic conditions. He is no longer making drawings for himself or the enlightened few. He is making them to be seen and understood by different groups of people.[75]

Because of this distinction between serving business and appealing to an elite few, younger members of the profession hotly debated the feasibility of maintaining an artistic career while working in advertising. Conventional wisdom warned them that commercial art could interfere with their fine art ambitions. J. Walter Thompson's George Butler remembered the art director C. O. Woodbury's telling him in 1925 that commercial constraints interfered with creativity: "Stick to this layout work, and do your own painting on the side." Woodbury advised Butler not to do illustrations to support himself because illustrators "all develop mannerisms which they can never free themselves from. And when they want to get on with their own painting in later years they can't shake off the commercial aspect of their work."[76]

Steichen did not encourage younger photographers to go into commercial art. Ralph Steiner remembered that "many young photographers brought their work to Steichen and asked him how to use their cameras for earning a living. Steichen would tell them to wrap packages at Macy's in order to eat, and to photograph in their spare time. He may have realized that what worked for him, and made him happy, might destroy the talent of others."[77] Yet commercial work and Steichen's fine art in the 1920s and 1930s became one and the same thing, and he produced little work that was not directly commissioned. He may have been suggesting to younger photographers that unless they could give up idealistic definitions of the fine arts and accept fine and applied visual production as a continuum, they should avoid commercial work.

The tension between art directors and executives in the agencies grew because creativity in the visual arts was little appreciated by many in leadership positions. Creativity, for executives like Thomas Erwin, meant the originality of the selling pitch, not the image.[78] As Thompson's William Day explained, "Art, layout and typography in advertising are always—and necessarily so—subordinate to the basic theme in the same way and for the same reasons that tactical operations in war are subordinate to the grand strategy of the campaign."[79]

Nonetheless, industry practice during the 1920s increasingly depended on pictures. Although theoretically illustrations were secondary to copy, they were increasingly printed larger and placed more prominently than copy in the advertisement. "An illustration can be so interesting, so compelling in itself that even the man who reads while he runs is halted in his tracks," according to the art director Elwood Whitney. While Whitney perfunctorily acknowledged the primacy of the copy, he credited the picture with attention-grabbing persuasiveness: "How is the poison going to do its work if no one swallows it? The illustration must lead the reader to the poison [the copy] and *make* him drink it."[80]

The rhetorical emphasis on copy at the expense of the formal aesthetics of the advertisement reflected the advertising agencies' histories and personnel. Typically, copywriters and account representatives rose to executive positions in agencies or left to start their own. Because the position of full-time art director was not firmly

established until after World War I, few visually oriented people in advertising agencies rose to management positions between the wars. Company leaders, rooted in literary traditions, continued to emphasize copywriting and believed that advertising pictures should simply illustrate the copy.[81] Over time their viewpoints and rhetoric changed. Empirical evidence provided by psychologists and market consultants led executives by the late 1920s to expand their art departments and hire expensive freelance photographers to provide their clients with strong, effective images.

Steichen had returned to New York in the early 1920s to find a great commercial demand for photography. Business needed and commissioned more images than ever before and cast itself in the new role of patron of the arts. Empirical studies demonstrated that photography would sell goods effectively, and many minor technological advances converged to make available better quality, less expensive photographic reproduction. But most important, the ideological implications of photography for business were clarified, and photographs were employed to describe modern American life: the freshness and enthusiasm of a corporate age just emerging after the war and the concomitant benefits of consumerism. Business, moreover, recognized its power to evoke and manipulate the desire for goods. Steichen worked with his art directors in the newly professionalized advertising industry to express these corporate goals and needs. He called on his military experience and fine art photography, and by the end of the 1920s he had evolved an emotive style suited to the task. The chapters that follow look inside the advertising agency at Steichen's interactions with staff members, his solutions to specific campaign demands, the social and cultural contexts of his images, and the effectiveness of his photographs and their impact upon the audience.

From "Reality" to "Fantasy" in Early Photographic Advertising

Steichen took his first photographs for the J. Walter Thompson Company in the fall of 1923, beginning a professional relationship that would continue for two decades. Stanley Resor, the company president, and his wife, Helen Lansdowne Resor, a successful copywriter and then a director of the agency, urged him to come work for them. Stanley Resor, a 1901 Yale graduate who had advanced from the Cincinnati office of JWT to become owner and head of the New York–based agency, admired Steichen's "uncanny ability to understand the human animal" and believed there wasn't "anyone within gunshot of him in his field."[1] Helen Resor, who ardently promoted the use of photography in advertising, was a patron of modern art and later served as a trustee of the Museum of Modern Art. She advanced Steichen's work and reputation in the agency, finding assignments for him during the difficult depression years.[2]

THE PHOTOGRAPHER AND THE AD AGENCY

The Resors and the Thompson agency art directors so highly regarded Steichen's ability that, fearing other agencies might lure him away, they offered him renewable

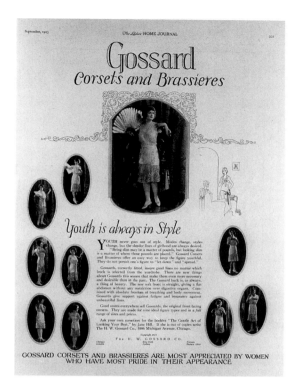

3.1 Advertisement for Gossard corsets and brassieres, *Ladies' Home Journal*, September 1923, p. 201. Photographer probably Edward Steichen.

contracts each year from December 1, 1924, through November 30, 1931. The initial contract guaranteed Steichen a minimum salary of $15,000, whether or not enough billable work developed from clients. The contract specified a fee of $500 for a single black-and-white image and $600 for two or more photographs taken at the same sitting and used in the same ad.[3] The contracts through 1927 were exclusive ones: except for his work on the Gossard corset account, which he had begun prior to his initial contract, Steichen could take photographs only for Thompson clients (Fig. 3.1). The net result was that in the mid-1920s Steichen handled "practically all the photographic work" for the agency.[4] Beginning in 1928, the agency continued to guarantee Steichen a minimum amount of work each year but allowed him to take on additional outside work up to a fixed dollar amount per year, provided the agency staff saw no conflict with his work for their own clients. After his last contract lapsed, the photographer continued to work for Thompson and other agencies on a freelance basis.[5]

Even by today's standards, Steichen's early exclusive contracts were unusual. A former staff member recalled that Thompson generally tried "to avoid committing clients or the agency to contracts of any kind or using a particular artist."[6] Steichen's

contracts, an exception to this practice, can be attributed to the solid support of the Resors.

Besides the Resors, Steichen's greatest supporter at the Thompson agency was the art director Gordon Aymar. The 1914 Yale graduate had studied painting at the School of the Museum of Fine Arts, Boston. Following naval service in World War I and brief stays as art editor of *Vanity Fair* and then *Harper's Weekly,* Aymar came to the company around 1920. After a year at the London office, often a proving ground for Thompson employees on the way up, Aymar was appointed head of the newly created Art Department in 1929. As an art director at Thompson, Aymar maintained his avid interest in modern painting, although some thought his taste conservative.[7] He served as president of the New York Art Directors' Club and wrote a 1929 graphic design textbook, *An Introduction to Advertising Illustration,* which was partly illustrated with Steichen photographs.

Aymar was a fervent believer in both advertising photography and Steichen's abilities as an artist. He characterized Steichen as

> a man who is willing to accept his artistic sensibility as that of the greatest significance. Starting with the premise that artists are primarily concerned with the revelation of beauty, he has availed himself of the most modern, most direct, most uncompromising means of doing this. Steichen was a painter. He became converted to the opportunities for expression which are offered in photography and he has contributed widely to establishing it as an art as distinct from a mechanical process.[8]

Thus Aymar made no distinction between Steichen's fine art and his commercial art. Steichen, moreover, had a "way of seeing things around us that is entirely fresh. Each genuine movement of art has had this as its most noticeable characteristic— someone has received new impressions from nature and by selection, elimination, accent, has been able to convey those new impressions to us. In Steichen we have someone who has proved concretely that he can lay claim to the title he abjures— that of an artist."[9]

The agency itself promoted Steichen as an exemplary commercial artist. After the company moved into offices in the brand-new art deco Graybar Building, which coincidentally housed the offices of Condé Nast Publications, Steichen was offered a permanent exhibition space there that he would control, choosing "examples of his work which he considers representative and appropriate."[10] Through these exhibitions the agency familiarized its employees with modernist trends in photography and demonstrated its use of the highest-quality photographs in its advertising, thus building up pride and company morale. The agency might also have hoped to head off the inevitable grumbling about the high prices it paid Steichen.

Steichen's prices, perhaps the highest in the industry, were a constant subject of discussion at the agency. Although clients always wanted costs held down, Stanley Resor and Gordon Aymar often persuaded them that an expensive photograph was a good investment. Resor justified the cost in terms of talent and inspiration.[11] And

while Aymar knew that "to the average businessman high-priced photographers are racketeers," he believed the rent, time, materials, assistants' salaries, and model fees the photographers must bear, combined with the top photographers' "inventive genius and craftsmanship," warranted high prices.[12] Steichen justified the fees for his work by its high quality and its low cost in relation to the funds spent on advertising space. In a 1928 presentation, he told the agency staff that if a client "pays $5,000 or $10,000 for space, this $500 expenditure for something that will attract attention, tell the story, and sell his product, is not expensive." Ever the booster where commercial photography was the issue, he emphasized that "there ought not to be any question in your mind as to the photograph's worth of $500." And he urged them: "Now you have to go out and sell it."[13]

Steichen believed that his work was superior to that of other commercial photographers. He challenged the agency's representatives: "If you could get for $1,000 a photograph 10% better than mine, I would say it was cheap, only—get it."[14] He asserted publicly that the agency "would pay me five times as much if my work were proportionately better. If men are paying $100,000 for advertising, what is $1,000? They'd pay $5,000 a picture and they will." He contended that the high prices he charged increased respect for all commercial art, thus professionalizing it. Boasting to an interviewer in 1932 that he had raised the prices of photographs to new levels, Steichen claimed: "That's the greatest thing I've done for photography."[15]

THE JERGENS LOTION ACCOUNT, 1923–25

Jergens lotion was Steichen's first campaign for the J. Walter Thompson Company, and his success with it earned him his exclusive contracts with the agency.[16] Steichen took all the advertising photographs for the lotion company from 1923 until the agency resigned the account in 1936, producing a new photograph for the major women's magazines almost every month. Thus, the campaign presents a rare opportunity to follow the artist through conceptual, iconographic, and stylistic changes in the promotion of a single product.

Steichen, in his advertising photographs for Jergens over the years, developed visual conventions that defined changing ideals of social class and women's roles. His images increasingly glamorized upper-class life at the expense of middle- and working-class concerns (compare Fig. 3.2 with Fig. 6.1), and the female lead in the advertisement shifted from homemaker to alluring companion—a role of greater social status that still fell within the traditional bounds. Steichen's photographic style also evolved, from consciously documentary early in the 1920s to more dramatic and "emotional" in the 1930s. Even as Steichen's images depicted more fantasy, his medium of photography made it easier for consumers to believe that the product could transform ordinary housewives into ladies of leisure.

The Jergens lotion account came to the J. Walter Thompson Company through

3.2 Advertisement for Jergens lotion, *Ladies' Home Journal*, January 1925, p. 73. Edward Steichen, photographer; Gordon Aymar, art director (J. Walter Thompson).

its Cincinnati office in the fall of 1922. The path of the lotion company, guided by its advertising agency, exemplifies that of many small family-owned businesses in the early years of the twentieth century. Beginning as a local brand mixed by the pharmacist Andrew Jergens, it grew into a nationally marketed product.

The Jergens Company knew the value of advertising. The company promoted its Woodbury's soap through Thompson for twelve years and saw sales multiply eighteenfold. Despite these favorable results, Jergens had relied on available retail shelf space and low price to market its lotion, known by the unwieldy name of Jergens Benzoin and Almond Lotion. Total lotion sales in 1921 were under $100,000.

Stanley Resor, noted for coining trade names and developing product images, had urged the Jergens Company in 1919 to revamp the product completely by changing its scent and consistency, redesigning the bottle and label, renaming it Acta Sentalis, and marketing it through the Thompson agency. The Jergens Company, which agency staff considered an "old conservative house," decided against the reformulation and the new name but allowed the Thompson agency to shorten the name and replace "ugly" packaging with a modern bottle and label designed by the art director Gordon Aymar. To fit the new upscale image, the price was raised from twenty-five to fifty cents.

The earliest advertisements for Jergens lotion, like those for almost all lotions at the time, claimed that it healed irritations, clarified complexions, and protected skin from winter chapping and summer sunburn. In 1923, however, the Thompson agency discovered that 95 percent of lotion used was for the hands, only 5 percent of consumers used Jergens, and the Jergens image was indistinguishable from that of its competitors.[17] The agency decided to try an innovative strategy. Stanley and Helen Resor, along with the copywriter Edith Lewis, developed a campaign that promoted the product solely as a hand lotion. And they convinced Steichen to begin his advertising career. The photographer had just resettled in New York to take fashion and portrait photographs for Condé Nast Publications.

Steichen's first assignment for the ad agency was to construct photographs that would make "women conscious . . . of the enormous wear and tear on their hands caused by housework."[18] These photographs would give the product its visual identity and build its national reputation. The use of Steichen's photographs indicates the significance of the campaign for the Thompson agency and its executives' desire to advance the most modern image for the product.

Steichen was to develop the campaign theme "in a new and forceful way, by using photographic closeups of hands in action—kneading dough, dusting, washing dishes, peeling potatoes, gardening, ironing, mending."[19] His photographs of working hands present these simple domestic chores prosaically, in the direct style of straight photography, rather than the soft-focus dreaminess of the pictorialist style (Figs. 3.2–3.4). Steichen's camera angles are frontal and direct, the effect documentary. The photographs focus on the woman's activity and the agents that dry her

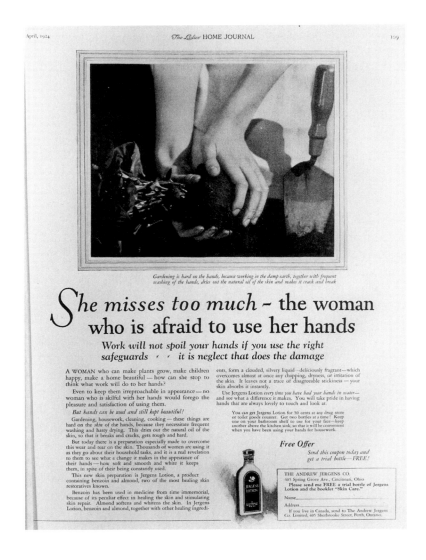

Gardening is hard on the hands, because working in the damp earth, together with frequent washing of the hands, dries out the natural oil of the skin and makes it crack and break

She misses too much ~ the woman who is afraid to use her hands

Work will not spoil your hands if you use the right safeguards ~ ~ it is neglect that does the damage

A WOMAN who can make plants grow, make children happy, make a home beautiful — how can she stop to think what work will do to her hands?

Even to keep them irreproachable in appearance — no woman who is skilful with her hands would forego the pleasure and satisfaction of using them.

But hands can be used and still kept beautiful!

Gardening, housework, cleaning, cooking — these things are hard on the *skin* of the hands, because they necessitate frequent washing and hasty drying. This dries out the natural oil of the skin, so that it breaks and cracks, gets rough and hard.

But today there is a preparation especially made to overcome this wear and tear on the skin. Thousands of women are using it as they go about their household tasks, and it is a real revelation to them to see what a change it makes in the appearance of their hands — how soft and smooth and white it keeps them, in spite of their being constantly used.

This new skin preparation is Jergens Lotion, a product containing benzoin and almond, two of the most healing skin restoratives known.

Benzoin has been used in medicine from time immemorial, because of its peculiar effect in healing the skin and stimulating skin repair. Almond softens and whitens the skin. In Jergens Lotion, benzoin and almond, together with other healing ingredients, form a clouded, silvery liquid — deliciously fragrant — which overcomes almost at once any chapping, dryness, or irritation of the skin. It leaves not a trace of disagreeable stickiness — your skin absorbs it instantly.

Use Jergens Lotion *every time you have had your hands in water* — and see what a difference it makes. You will take pride in having hands that are always lovely to touch and look at.

You can get Jergens Lotion for 50 cents at any drug store or toilet goods counter. Get two bottles at a time! Keep one on your bathroom shelf to use for your face — keep another above the kitchen sink, so that it will be convenient when you have been using your hands for housework.

Free Offer

Send this coupon today and get a trial bottle — FREE!

THE ANDREW JERGENS CO.
405 Spring Grove Ave., Cincinnati, Ohio
Please send me FREE a trial bottle of Jergens Lotion and the booklet "Skin Care."

Name _____

Address _____

If you live in Canada, send to The Andrew Jergens Co. Limited, 405 Sherbrooke Street, Perth, Ontario.

3.3 Advertisement for Jergens lotion, *Ladies' Home Journal,* April 1924, p. 109. Edward Steichen, photographer; Gordon Aymar, art director (J. Walter Thompson).

hands: flour, soil, and water. The working hands fill the frame; the background elements become simply abstract compositional forms. In the days before smaller, faster cameras could give the results he desired, Steichen used his cumbersome 8 × 10 view camera, posing the hands with their props rather than stopping their action. The effect is genteel, and the agency was pleased with the way Steichen tackled his

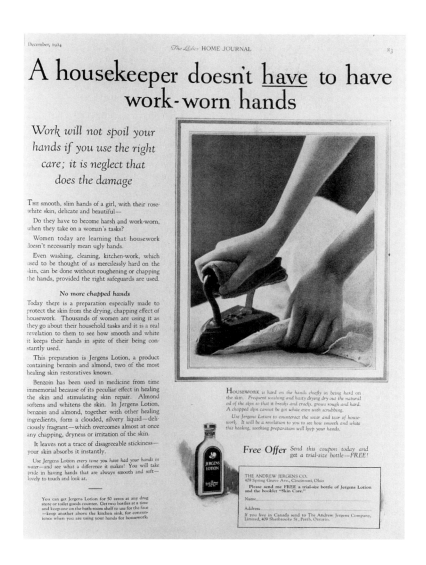

3.4 Advertisement for Jergens lotion, *Ladies' Home Journal*, December 1924, p. 83. Edward Steichen, photographer; Gordon Aymar, art director (J. Walter Thompson).

"extremely difficult problem" of making "photographs of housework sincere and realistic, and at the same time beautiful and distinctive."[20]

Steichen's photographs were but one element in the advertisement's overall message, which the advertising professionals intended be read as a narrative. Large headlines in the ads were followed by copy that filled the rest of the space. A picture of

the new, modernized bottle and a coupon for a free sample were strategically placed in a lower corner. The ads reassured women that they could work with their hands yet keep them attractive. A trade journal at the time noted how successfully the Jergens advertisements fused image and text into a single narrative: the problem in the photograph (dry hands) and the answer in the text (Jergens).[21]

Steichen's mid-1920s Jergens photographs emphasized the ordinary tasks that occupied most women most of the time. Although Thompson's 1923 market research study had determined that 73 percent of upper-middle-class women used hand lotion, this study was cited as the reason the agency decided to aim the campaign at "the class of women who use their hands most; that is, women of the great middle class who do their own housework."[22] The emphasis on the hands of typical mass magazine readers—middle-class women—was a logical but surprising move since no market research had identified this group as the primary consumers of the product. The decision to appeal to them with descriptions of their daily life was equally unusual. These photographs of working hands constructed and reinforced a feminine identity tied to domestic tasks.

THE DEMOGRAPHICS OF READERSHIP

The agency staff were so willing to work on instinct in part because they recognized the impreciseness of their own demographic studies. The science of audience surveys in the 1920s and 1930s was imperfect, and random sampling was still in the future. Pollsters relied on door-to-door neighborhood surveys, interviews with customers at Macy's cosmetics counter, counting coupon returns, or crude compilations of statistics on population, income, and distribution networks.[23] The readership of women's magazines grew steadily from a circulation of over thirteen million per month in 1914 to a peak in 1928–30 of over nineteen million.[24] The agencies' efforts to categorize the social class of these readers were rudimentary. Although they developed an analysis of social status based on income and consumption patterns, they usually divided their targeted audience into simply "class" and "mass" consumers. Mass consumers were situated between the "class" consumers (the top 5 to 6 percent of the urban population, who enjoyed a high business or professional income) and the lowest-income Americans, somewhere between 30 and 65 percent of the population, depending on the study.[25] Members of this class, which included blacks, immigrants, and many working-class whites, were not even considered potential consumers. A staff analyst of Thompson's *Population and Its Distribution* estimated that once all "illiterates, ⅔ of the foreign-born white literates, 9/10 of the Negro literates, all Indians, Chinese, etc." are eliminated, "approximately 70%, or 21 million families, have at least one member capable of reading a magazine."[26] According to less generous figures compiled by the Curtis Publishing Company only 40 percent, or twelve million American families, had at least one member "above 14 years in

intelligence." Thus, "mass" consumers were defined by their higher-than-average incomes and educational levels.

The Curtis Publishing Company, in advertising its access to this middle- and upper-class readership, was particularly adamant about the futility of trying to reach less educated consumers with lower incomes. Their 1925–26 demographic profile of magazine readers in two midwestern cities showed that the higher the income, the more likely the family was to subscribe to magazines. Of the families with no magazine subscriptions, 43 percent "appeared to be foreign" and 79 percent "had never sent anyone to high school." The publishing company suggested that potential advertisers exploit the easy access its magazines provided to the more affluent, because even if the manufacturers could directly reach the vast lower class, it was hardly worth the effort:

> Any educator who works with grade-school pupils and visits their homes is familiar with the type of mind that lacks the ability or the ambition to enter high school. It is the type of mind resistant to educating influences. It seems unable of its own accord to get a worthwhile message through visual impression. . . . If able to buy, these people are likely to buy by imitation or by asking a more intelligent neighbor. The process of reaching this group through advertising is primarily the problem of reaching the more intelligent persons in their communities, whose buying preferences they will follow.[27]

Other magazines also proudly claimed to deliver easy and immediate access to more affluent purchasers. *Redbook* ran a series of ads in the trade papers under the headline "Deliberately We Aim at an Educated Audience with Money to Spend."[28] The *Women's Home Companion* pitched its advertising space by pointing out that its readers had leisure time, discretionary income, and a wide range of interests; they had "ambition to become broader individuals and more valuable members of their community, as well as efficient homemakers."[29] Even newspapers claimed educated and affluent women among their readers. The *Chicago American* promoted its advertising services by claiming to provide "450,000 active young families" with "Buying Ideas." The profile of this "typical [white] American family" (mom, dad, girl, and boy) described how "the kids will get a college education. There's a car, of course—in good condition. They go to the theatre, movies; give parties."[30] In other words, they have money to spend.

Thus the magazines and advertising agencies claimed access to an affluent market while they designed advertising campaigns to appeal to "average" Americans. This strategy may simply have been realpolitik. The agencies may have assumed that the magazines had inflated the educational and financial profile of their readers to increase the value of their advertising pages, just as the agencies exaggerated their access to markets in selling their services.[31]

The Jergens campaign, then, in which Steichen's photographs appealed to working- and middle-class women, seemed refreshing because it cut through the

pretense of agencies and publishers. The trade paper *Advertising and Selling Fort-nightly* editorialized: "They might have shown hands, unsoiled in immaculate sur-roundings. Instead the makers of Jergens Lotion wisely chose hands that iron, pot plants, wash dishes, bake and perform innumerable household tasks to illustrate their current advertising. Thus they widen their market to include the woman who works—as well as the woman who is waited upon." [32] *Advertising World,* a British trade journal, praised the departure "from the beaten path to strike a true, yet new, appeal for this class of product," noting that "the woman who constantly uses her hands . . . sees an understanding appeal to her needs in this." [33] Steichen's photo-graphs crystallized the theme of the campaign.

The agency placed the ads to reach the largest number of women who did their own housework. Jergens lotion ads appeared almost every month in the *Ladies' Home Journal, Women's Home Companion, Good Housekeeping,* and the *Pictorial Review* and only rarely in the fashion magazines, like *Vogue,* with a more affluent and/or sophisticated readership. The advertisements also appeared in newspapers across the country, but when they did, for clarity Steichen's photographs were re-placed with line drawings based on them. [34]

The contradiction between the middle- to upper-class economic status of custom-ers targeted in the ads and the choice of middle- to working-class imagery and maga-zines for the ads may be explained not only by the agency's lack of faith in its demo-graphic analyses but also by larger social changes in women's roles and aspirations. Women's class status did not define their activities as rigidly after World War I as be-fore. Because of the "labor-saving" devices introduced into the home and the post-war scarcity of domestic workers, many middle-class women began doing chores their mothers would have assigned to household help. On both the editorial and advertising pages of women's magazines such as the *Ladies' Home Journal,* these routine domestic tasks were recast as labors of love provided by the homemaker for her family. Ruth Schwartz Cowan has argued that in the 1920s nonfiction features in women's magazines reflected the social pressure that "trapped educated American women in their kitchens, babbling at babies and worrying about color combinations for the bathroom." The magazines promoted a new appreciation for women's do-mestic roles and promised fulfillment through home management:

> Laundering had once just been laundering; now it was an expression of love. . . . Feeding the family had once just been feeding the family; now it was a way to communicate deep seated emotions. . . . Clearly tasks of this emotional magnitude could not be relegated to servants. . . . The servantless housewife was no longer portrayed as "unfortunate"; she was happy, revelling in her modern home and in the opportunities for creative expression that it provided. [35]

Images such as Steichen's photograph of a woman ironing presented the home-maker's most humble tasks as worthy of attention (Fig. 3.4). The position of the

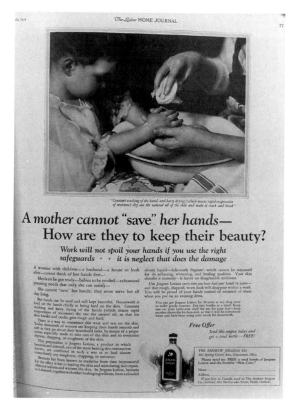

3.5 Advertisement for Jergens lotion,
Ladies' Home Journal, March
1924, p. 77. Edward Steichen,
photographer; Gordon Aymar, art
director (J. Walter Thompson).

hands in the act of ironing also recalls the posing and empathy in fine art treatments of the same themes by artists like Degas and Picasso. As in the paintings, there is no hint of fantasy or escapism in Steichen's image. Rather the photograph reinforces and supports the value of women's work.

The photograph of a mother tenderly washing her child's hands conveys the fulfillment derived from the responsibilities of mother and housekeeper (Fig. 3.5). The linked hands, soft skin, and pastel colors tinted over Steichen's black-and-white photograph signal an emotional bond. Meanwhile, the text assures readers that such self-sacrificing tasks need not take a physical toll. Thus Steichen's working hands for Jergens give visual form to the shifting identities of middle-class femininity after the war. Domesticity now meant more labor for the middle-class housewife—a narrowly defined labor centering around home and children.

At first the agency had "some doubt" about the effectiveness of these "sincere but homely" photographs of women's hands. The agency decided to test the sales strength of the new photographic images by running split editions, half using a photograph and half using a drawing, but all with the same copy. The coupons were

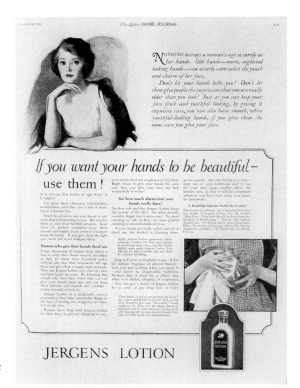

3.6 Advertisement for Jergens lotion,
Ladies' Home Journal, November
1923, p. 101. Edward Steichen,
photographer; Gordon Aymar, art
director (J. Walter Thompson).

keyed and counted. When the test "threw no particular light" on the choice of media "except to prove that the photographs of hands engaged in homely tasks were quite as popular as the illustrations showing beautiful women," agency staff decided that since there was "no risk" in doing so, they would exclusively use photographic images, which were "much more original and sincere . . . [with] a fresher note than the other."[36]

The experiment demonstrates that the agency incorporated photography into advertisements tentatively and somewhat intuitively. One of the earliest advertisements in the campaign combined a Steichen photograph with an illustration by another artist (Fig. 3.6), with the photograph smaller and less conspicuously placed than the drawing of a woman. The woman is young and attractive, comfortable but not overly aristocratic. The differing media construct the narrative. The photograph, with its implied documentary quality, reinforces the real, everyday qualities of the woman's work; the drawing signifies her leisure and entry into a higher socioeconomic class. Later the agency decided that a montage of photographs could present a more credible narrative, and they abandoned the last remnants of the illustration tradition. Sales figures in the 1920s supported this decision.[37]

The early Jergens lotion campaign was perhaps the only one on which Steichen worked where the realism of the advertising images recalled the Realism of nineteenth-century painters. This use of the word corresponds to its historical sense as Linda Nochlin has defined it, in which Realism sought "to give a truthful, objective, and impartial representation of the real world, based on meticulous observation of contemporary life." [38] Similarly, Raymond Williams noted "the historical significance of Realism was to make social and physical reality (in a generally materialist sense) the basis of literature, art, and thought." [39]

The usual subject matter of advertising, however, differed radically from the traditional subject matter of art-historical Realism. The nineteenth-century Realists were against idealization and therefore chose working-class subjects. As Nochlin noted, the Realists depicted "the low, the humble, and the commonplace, the socially dispossessed or marginal as well as the more prosperous sectors of contemporary life." [40] Typically advertising idealized the more satisfying and prosperous life promised by the product. Steichen's images of working hands ran counter to this trend in 1920s advertising.

In addition to its meaning as an experiential basis for the artist's subject matter, the term "realism" is used to describe stylistic conventions, which have varied widely throughout the history of Western art. In this book I have emphasized realism as a possibility of style as well as content. Realism in advertising, as in fine art, had a wide variety of stylistic markers, but the diversity was often unrecognized. [41] In terms of Steichen's images, some advertising photographs, such as these early works for Jergens, self-consciously evoked a documentary style, while later works depicted melodramatic tableaux. But as we shall see in the next chapter, admen indiscriminately labeled all photographic images realist. They equated "realism" with photography's mimetic properties—its naturalistic depiction of detail. They rarely demonstrated an awareness of photographic styles and conventions, unless it was to comment on the soft focus in the occasional advertisement with a pictorialist photograph.

In his autobiography Steichen indicated that the agency's desire for realism was one of the reasons he became interested in the Jergens commission. He sympathized with the aims of the campaign—to present women's work naturally and believably. Reminiscing about *Peeling Potatoes,* his first assignment for the Thompson agency and a subject suggested to him by agency personnel (Figs. 3.7, 3.8), Steichen recalled that "the idea was to photograph the hands of a woman who did her own housework. . . . Mrs. Stanley Resor, wife of the president of J. Walter Thompson, posed for the hands, and I could tell by the way she cut the potatoes that this wasn't the first time she had done it." [42] In *Peeling Potatoes,* the woman's activity and dress clearly signify her class status, that of an average mass-magazine reader. But Steichen completely missed the irony of casting a professional woman and executive's wife in the role of an average housewife.

Steichen manipulated the formal elements of the photograph to transmit the major themes of the campaign. He strongly lit the woman's hands and the peeled potato,

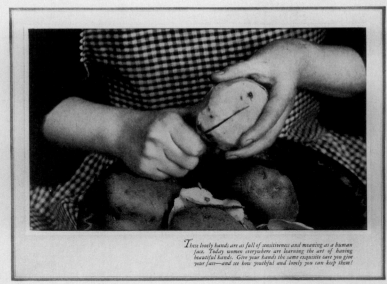

*These lovely hands are as full of sensitiveness and meaning as a human
face. Today women everywhere are learning the art of having
beautiful hands. Give your hands the same exquisite care you give
your face—and see how youthful and lovely you can keep them!*

Housework never yet spoiled the beauty of a woman's hands

*It is neglect that does the damage; cared for properly, the most beautiful
hands in the world are the hands of women who work*

Neglect—lack of care—may spoil your hands; housework never will, if you use the right safeguards.

The most beautiful hands in the world are the courageous, expressive, sensitive hands of women who work—

Hands that sweep, dust, mend, cook, dress children, perform all the thousand intricate tasks of a home.

They have the same disciplined beauty as an artist's hands. Often they express a woman more truly than her face.

Don't let superficial marks of neglect—roughness, redness, coarseness of the skin—spoil the underlying beauty of your hands! Keep the skin smooth and white and youthful looking—and then see what distinction they really have.

For women who give their hands hard use

Thousands of women today have found a way to keep their hands smooth and white as they go about their household tasks, without any fear that housework will age their hands and give them a rough neglected look.

They are doing this by means of Jergens Lotion, a product in which benzoin and almond, two of the most healing skin restoratives known, are combined in such a way as to heal almost immediately any roughness, chapping, or irritation.

Benzoin has been known to medicine from time immemorial for the peculiar effect it has in healing the skin and stimulating skin repair. Almond softens and whitens the skin. In Jergens Lotion, benzoin and almond, together with other healing ingredients, form a clouded silvery liquid—deliciously fragrant—which the skin absorbs instantly, leaving no disagreeable stickiness. This preparation cannot be surpassed for its softening, whitening, and healing qualities.

Use Jergens Lotion *every time you have had your hands in water*—and you will find that you can give them hard use and yet keep them delicate and smooth and youthful—lovely to touch or to look at.

You can get Jergens Lotion for 50 cents at any drug store or toilet goods counter.

FREE OFFER

*Send this coupon today and get a
large size trial bottle—free!*

The Andrew Jergens Co.,
 195 Spring Grove Ave., Cincinnati, Ohio.
Please send me free a large size trial bottle of Jergens Lotion, and the Booklet "Skin Care."

Name

Address

If you live in Canada, send to The Andrew Jergens Co., Limited, 195 Sherbrooke St., Perth, Ontario.

3.7 Advertisement for Jergens lotion, *Vogue*, November 1, 1923, p. 121. Edward Steichen, photographer; Gordon Aymar, art director (J. Walter Thompson).

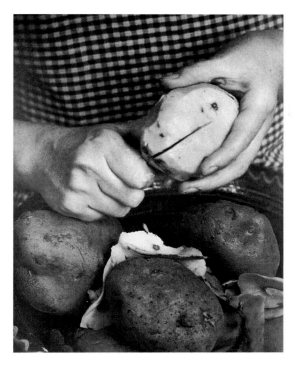

3.8 Edward Steichen, *Peeling Potatoes,* Detail of Figure 3.7.

captured the woman's tight grip on the knife, and riveted attention on the gash in the potato. The depth of field is shallow, and the contrast between the three planes of focus visually expresses the message of the text. The near potatoes and the curling, discarded skins are sharply drawn, the earthy texture of the unpeeled potatoes precisely mapped. The hands are softly modeled, although the lines and skin texture can be discerned. Behind the central action, the gingham apron is rendered in even softer focus; some of the checks barely keep their geometric form and read simply as circles of light. Central placement and light value draw attention to the velvety hands, which contrast with the potato skins, signifying the effects of the lotion.

With the close-up composition and textural veracity of the unpeeled potatoes Steichen introduced elements of a modernist vocabulary to a wide public through commercial photography in this early advertising photograph. But his modernist vision was diluted by the art director's cropping and layout. Figure 3.7 reproduces the advertisement as it was originally conceived and published by the agency; Figure 3.8 shows the photograph as Steichen cropped it for inclusion in his own 1963 autobiography. Steichen envisioned the image as more tightly centered on the action. His cropping strengthens both the formal composition and its social content, while the agency's presentation dilutes the effect of the action for a more generalized representation of women's work.

THE CARE OF THE CUTICLE IS THE BASIS OF WELL GROOMED HANDS

The way Beauty Experts keep the cuticle smooth and Lovely

3.9 Advertisement for Cutex nail polish, *Ladies' Home Journal,* February 1924, p. 41. Horace Scandlin, photographer (J. Walter Thompson).

Steichen's photographs of hands, while still softly modulated, are unusual for their time because they suggest actual labor. The Cutex nail polish campaign of 1923 and 1924 exemplifies the more common representation of hands in commercial photography at the time (Figs. 3.9–3.11). As the complex geometric format of multiple photographs and illustrations suggests, this campaign was also created by the Thompson agency. Although the agency claimed that in this campaign "photographs were used in order to give a sense of reality impossible with drawings," the "sense of reality" differs markedly from that of Steichen's work.[43] Horace Scandlin's dreamy model limply poses her beautiful hands in front of the camera; her gentle reverie indicates that Scandlin has not strayed from his pictorialist training. In Ira L. Hill's and Nikolas Muray's photographs hands are posed as if in motion, but the gentility of their actions—selecting fruit and opening perfume—evokes an atmosphere of leisure and ideal beauty also often associated with pictorialism. The agency discovered that the goals of such imagery could be represented with ease in either photography or drawing. The next year the Cutex campaign used elongated, elegant art deco drawings of hands to suggest leisure and beauty (Fig. 3.12). As in the photographs by Scandlin, Hill, and Muray, the model's hands in the drawing are ornaments rather than tools for labor. By contrast, Steichen's imagery for the Jergens lotion campaign looked vigorous and refreshing to the agency.

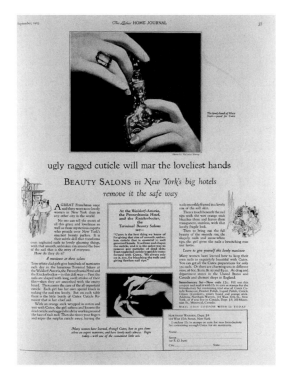

3.10 Advertisement for Cutex nail polish, *Ladies' Home Journal*, October 1923, p. 41. Ira L. Hill, photographer (J. Walter Thompson).

3.11 Advertisement for Cutex nail polish, *Ladies' Home Journal*, September 1923, p. 37. Nikolas Muray, photographer (J. Walter Thompson).

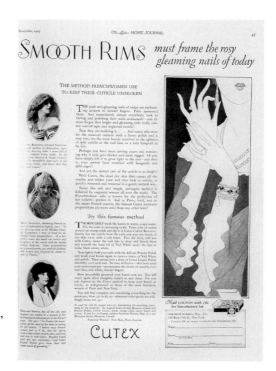

The Ladies' HOME JOURNAL

SMOOTH RIMS *must frame the rosy gleaming nails of today*

CUTEX

3.12 Advertisement for Cutex nail polish,
Ladies' Home Journal, November
1925, p. 45. Illustrator unknown
(J. Walter Thompson).

ADVERTISING STRATEGIES:
"REASON-WHY" AND "ATMOSPHERE"

Although photographs in advertising were still novel in the early 1920s, the strategy employed in the Jergens campaign dated back to the late nineteenth century. Called informational or reason-why advertising, it presented a logical, often lengthy discussion of a product's merits to convince consumers to buy. In reason-why ads, the facts spoke for themselves. Art directors first linked this older strategy with the new medium of photography, probably because they believed that straight photographs were objective and value-free, and thus suited to an ad that encouraged the consumer to make a rational decision. The art directors had not yet assimilated the complex workings of photographs.

By the 1920s "atmosphere" advertising was more common, usually accompanied by a drawing or painting. (If a photograph was used, it was in the soft-focus pictorialist style like the examples by Scandlin, Hill, and Muray [see Figs. 3.9–3.11].) A 1924 drawing for Jergens lotion by the successful painter John Carroll, the artist who had illustrated the Jergens account before Steichen was hired, typifies this approach (Fig. 3.13).[44] Atmosphere advertising sought to persuade consumers by associating products with a certain status and self-image.[45] Carroll's illustrated adver-

tisements for Jergens featured "portraits of beautiful and aristocratic young women in evening dress," intended to "surround the product with an atmosphere of class" and appeal to "women of fashion and social distinction, although [the advertisement] was intended to reach, indirectly, all classes of women."[46]

In 1925 and 1926 Steichen's second series of images for Jergens lotion adopted the atmosphere strategy. The agency's account representatives had "decided to introduce a sentimental situation in the copy and the illustration, while still keeping to our main platform."[47] Although Steichen continued to use straight photography—that is, sharp focus and naturalistic detail—in these images he developed a strong undercurrent of fantasy. The agency paired them with his earlier images of household tasks. The additional photographs, and their differing sizes, necessitated a more complex layout. The largest photographs in the new series featured elegant, manicured women's hands posed in romantic situations: a man kisses a woman's hand, a woman serves tea with elegant china, a man places a bracelet on a woman's hand (Figs. 3.14–3.16). Small versions of Steichen's 1923 and 1924 photographs of working hands were shown, with the lotion providing a conceptual bridge to the elegant hands. Photographs now presented both sides of the narrative: the solu-

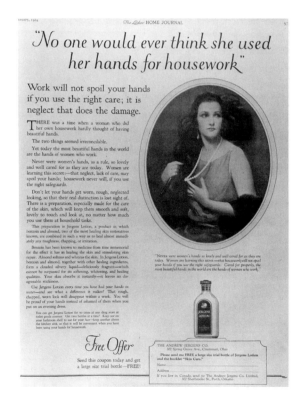

3.13 Advertisement for Jergens lotion, *Ladies' Home Journal,* January 1924, p. 97. John Carroll, illustrator (J. Walter Thompson).

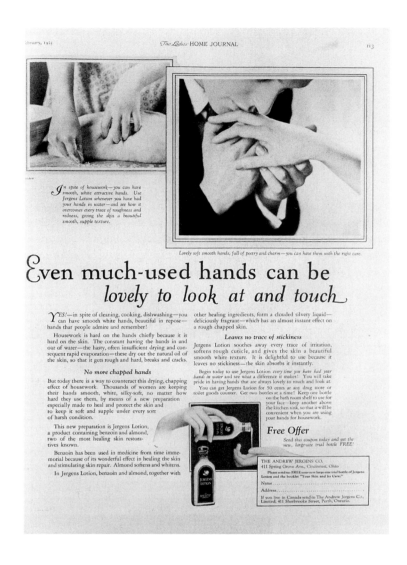

3.14 Advertisement for Jergens lotion, *Ladies' Home Journal*, February 1925, p. 113. Edward Steichen, photographer; Gordon Aymar, art director (J. Walter Thompson).

tion, as well as the problem. But in case the consumer missed the visual message, copywriters enumerated the product's benefits. This format continued throughout 1925 and 1926: the large photograph introduced the new sales strategy, while the older photographs reminded consumers of the product image Jergens had already established.

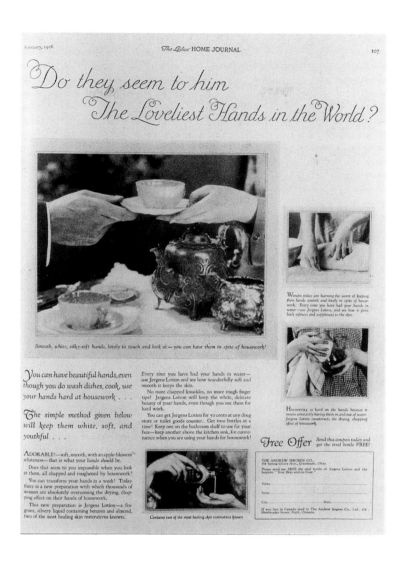

3.15 Advertisement for Jergens lotion, *Ladies' Home Journal*, February 1926,
 p. 107. Edward Steichen, photographer; Gordon Aymar, art director
 (J. Walter Thompson).

The balanced layout signaled balance in a woman's life. The small images reminded her of the reality of work in her daily life, while the large images encouraged her in flights of fancy. The headlines made it clear that both sets of photographed hands belonged to the same woman—"Wonderful *at their* Work · · *and* Lovely *at* Play · ·" (Fig. 3.17). Although the diamond rings, pearl bracelets, silver tea sets, and

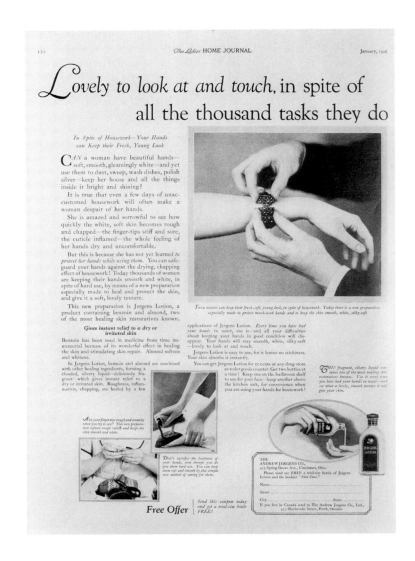

3.16 Advertisement for Jergens lotion, *Ladies' Home Journal*, January 1926, p. 120. Edward Steichen, photographer; Gordon Aymar, art director (J. Walter Thompson).

china were beyond the reach of many *Ladies' Home Journal* readers, the images suggested that each woman could internalize varying, and sometimes competing, identities of femininity and class. In doing so these images may have eased the contemporary instability of women's roles.

The ads appealed to both material and emotional desires. The kiss, the silver tea

set, and the pearl bracelet graphically depict the woman's material rewards for competent homemaking. And the white cuffed suit of her companion (her assumed husband, since the small images indicate she is a housewife) emblematizes her romantic reward. It signifies his white-collar occupation and thus her middle- or upper-middle-class status. Although her work is depicted as in the earlier campaign, the montage indicates that she can hold his romantic interest—with both her admirable domestic qualities and her attention to her physical appearance. In a darker reading, these are the price she pays for his economic support. Thus the woman fantasizing about upward mobility and romantic leisure time is reminded that she must conform to the traditional domestic female role and maintain her good looks to earn love and material goods.

As in atmosphere advertising in general the contradictions of class in the Jergens ads were neatly resolved for the consumer. The props in the photographs created the impression that, by its softening effect, Jergens lotion could raise the economic and social status of the woman who used it. This promise of social mobility both diffused dissatisfaction among the working and middle classes and encouraged consumption to fuel the economy. Moreover, by using Steichen's photographs for both parts of the narrative, the ad agencies indicated a new sophistication, a nascent un-

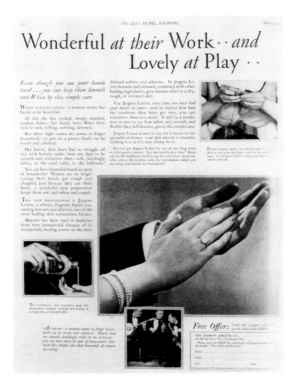

3.17 Advertisement for Jergens lotion, *Ladies' Home Journal*, March 1926, p. 126. Edward Steichen, photographer; Gordon Aymar, art director (J. Walter Thompson).

derstanding that photography was not just a mechanical recording but also an interpretive medium.

THE INDUSTRY DEBATE:
PHOTOGRAPHY VERSUS DRAWING

Although in hindsight the discovery of photography's ability to influence consumers through the atmospheric strategy and its eventual domination of advertising art looks like a smooth evolution, debates about the medium in the agencies indicate that the transition was not obvious or inevitable. During the 1920s campaigns frequently switched between photography and drawing as, for instance, when the Jergens company employed both Carroll and Steichen in 1924. Although the language differentiating the uses and impact of drawing and photography remained relatively clear and simple, the trial-and-error process the agencies followed reveals doubts and underscores their exploratory and sometimes contradictory thinking.

In the 1920s art directors typically expressed two overgeneralized positions: that drawing encouraged imagination and identification, and that photography excelled

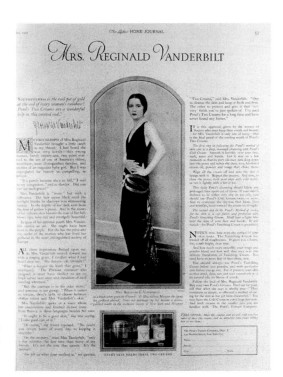

3.18 Advertisement for Pond's cold cream (Mrs. Reginald Vanderbilt), *Ladies' Home Journal*, May 1925, p. 53. Edward Steichen, photographer (J. Walter Thompson).

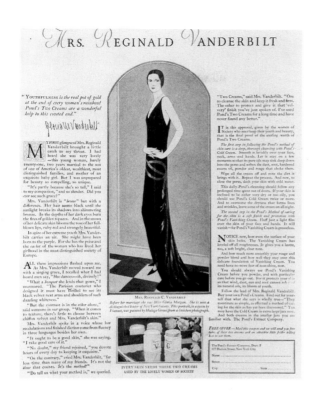

3.19 Advertisement for Pond's cold cream, ca. 1925, unidentified tear sheet, J. Walter Thompson Company Archives. Malaga Grenet, illustrator.

in naturalistic depiction (with the exception of pictorialist soft focus). A Thompson art director, Adrian Head, summarized the first viewpoint when he proposed that a drawing should be employed to sell "an idea" while photographs are most useful to sell "merchandise." Paul Cherington, an economist and an influential JWT business executive, considered the naturalism of photography to be its chief failing, its "vulgar, half-witted literalness."[48] The art director Lou Ingwersen, stationed in JWT's San Francisco office, criticized photography for its "great detail," resulting in a "labored impression" without persuasive emotional content. He argued that the client wants more in the advertisement than "just the product": "He wishes flavor, zest, appetite appeal—yes, feeling—beyond the limits of a camera lens. The artist can catch it and interpret it to a lay reader; the camera cannot."[49]

In search of more interpretive representation, art directors even commissioned drawings of photographs. Malaga Grenet's drawing of Steichen's 1925 portrait of Mrs. Reginald Vanderbilt for Pond's cold cream not only added color to the image but also reshaped Vanderbilt's body (Figs. 3.18, 3.19). Steichen tried to elongate Vanderbilt's body through pose and vantage point. Grenet abstracted and stylized her even further: she is taller, thinner, and more angular in the drawing than in Steichen's photograph—and thus idealized, removed from the realm of common

people. Yet the drawing's origin in photographic reality must have been significant to both the agency and the client, for the caption says it was made "from a Steichen photograph." Although an ideal woman, Vanderbilt must be real to be an effective role model.

LUX SOAP, 1926–28: A CASE STUDY IN ALTERNATING MEDIA

The art directors' search to define the impact of differing media is perhaps most clearly seen in the Lux soap campaign, which alternated between drawing and photography during the late 1920s. The first photographs were commissioned for Lux in 1927. That year Lejaren à Hiller photographed models using the bar soap, and Steichen photographed the box and soap for Lux flakes. Hiller was assigned to interpret the product image previously established for the soap by the illustrator Helen Dryden (Fig. 3.20). The agency staff had decided Dryden's sinuous, elegant art deco ladies were too "highbrow" for the average consumer of Lux soap, and they asked Hiller to create an image the average reader would respond to more readily.

The agency chose Hiller for the task because of his motion picture experience;

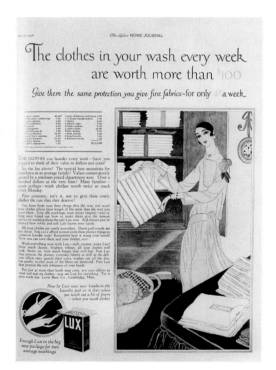

3.20 Advertisement for Lux flakes, *Ladies' Home Journal,* March 1926, p. 101. Helen Dryden, illustrator (J. Walter Thompson).

William Esty, the account representative, and Gordon Aymar, the art director, urged Hiller to feature some filmic lighting techniques in his ads.[50] Hiller used light to soften the model and her environment, recalling the effects of pictorialism, and he called upon his moviemaking experience to stage clever vignettes. The *JWT News Letter* reported that in one instance "the photographer faked a luxurious Helen Dryden bath tub by draping an old-fashioned porcelain tub in black cloth upon which a design was made by pasting silver ribbon and silver stars. The background was drawn on a blackboard in white chalk with silver stars" (Fig. 3.21).[51]

The agency personnel contended that Hiller's women offset the "highbrow" effect of Helen Dryden, but, in fact, his photographs reflected the beauty and glamour of her illustrations and even copied her settings. Hiller depicted women of the same social class engaging in the same activities of personal cleanliness that Dryden pictured. Although it was never stated at the time, or perhaps even realized, Hiller replaced Dryden solely because he was a photographer. Since Alfred Cheney Johnston's photographs taken for the same campaign were rejected because his models were too "common-place," Hiller's photographs were certainly not chosen to offset Dryden's upper-crust figures.[52]

Steichen's contribution to the Lux campaign of 1927 was a close-up photograph of Lux flakes, a soap for dishes and clothes. Using a more obviously straight pho-

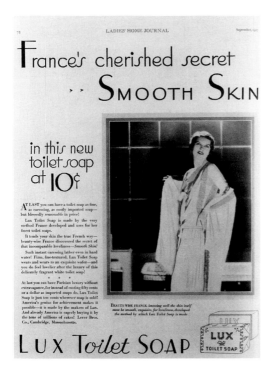

3.21 Advertisement for Lux toilet soap, *Ladies' Home Journal,* September 1927, p. 72. Lejaren à Hiller, photographer (J. Walter Thompson).

3.22 Advertisement for Lux flakes, *Vogue*,
March 15, 1927, p. 131. Edward
Steichen, photographer (J. Walter
Thompson).

tographic style than Hiller's, Steichen pictured the open box with gleaming flakes
scattered around its base (Fig. 3.22). The edges of the soap flakes are sharp, and
each square glitters. Although Steichen's photograph looks like any business-as-
usual commercial photograph today, its oblique vantage point, sharper focus, in-
creased contrast, and greater tonal range seemed distinctively modern at the time.
The clear description of details also recalls the tradition of documentary photogra-
phy dating back to the nineteenth century.

The Hiller and Steichen photographs illustrate the art directors' evolving formula:
emphasize the interpretive when promoting an idea or lifestyle and emphasize the
documentary when picturing a product. Hiller's photograph concentrates on the
user of the soap; his pictorialism, like drawing, was thought to evoke viewer empa-
thy. Steichen's work describes the soap, enlivening the product, emphasizing its ef-
fectiveness. Although we now see Steichen's photograph as highly interpretive, it
was intended to be objective. In the magazine advertisements, the words "actual
photograph" replaced the artist's signature in small letters under the image. This
caption, reminding the reader that the photograph was "taken from life," was cal-
culated to reinforce the advertisement's credibility.

Despite self-assured reports at staff meetings and in trade journals that linked

photographs with documentation and drawings with interpretation, in using the two media art directors inadvertently tested their theoretical assumptions. For example, in 1928 the account representative William Esty reported that in an earlier year the drawings for the Lux toilet soap campaign were commissioned to be "as realistic as we could make them. We tried to get a photographic technique." Then, realizing that "the very best in drawing falls short of reality," the agency switched to photography because "we thought we could get not only better results but far more of an air of conviction if we used actual photographs instead of drawings."[53] Esty, naturally enough, decided that the realism desired for the campaign could be achieved more directly with photographs yet he simultaneously employed Hiller's pictorialism for atmosphere. The question is not why Lux switched to photography, but why it persisted in using drawings when the medium was inappropriate to the campaign goals. Not until well into the 1930s did the agencies resolve the contradictions between rhetoric and image and recognize the complexities of photographic styles.

Subtle Manipulations:
The Persuasion of Realism

By the mid-1920s Steichen employed a number of photographic styles concurrently in his advertising photography, choosing his approach to complement the sales strategy for the product. Although the J. Walter Thompson Company had hired him to bring realism to Jergens lotion advertising, within two years he was making more sentimental vignettes for Jergens and constructing fanciful images for Pebeco toothpaste. In the Pebeco ads active, youthful, obviously upper-class couples have fun at the wheel of a yacht, on horseback, or at the golf course, opera house, or bridge party (Figs. 4.1, 4.2). These images, in the atmospheric strategy, interweave pictorialist softness with more modern close-up and composition. Although artistically posed, executed, and peopled with actors obviously playing parts, to the agency's mind such ads did not challenge the notion of the photograph as descriptive reporter.

The style called realism was hotly debated by advertising professionals. Although images of a fantasy world populated solely by the fun-loving young and wealthy predominated in Steichen's work by the mid-1920s, art directors saw in them no challenge to their belief that the photograph was simply a document. Slowly, advertising executives and art directors realized that the public perception of photographic accuracy enabled them to use photographs to manipulate consumers. They came to

understand the dual nature of photographic realism, which comprised both the descriptive element that gave it journalistic credibility (deserved or not) and an emotional, evocative element that made it persuasive.

Steichen's work for the Welch's grape juice campaign from 1924 to 1928 exemplifies this more complex understanding of photography. Steichen employed a straight photographic style whose sharp focus and meticulous detail urged acceptance of the image as an objective report on the product and its uses and at the same time played to consumers' desires and aspirations. The photographer's vivid renderings of sparkling crystal, luscious fruit, blooming flowers, and fine china promised elegance to everyone able to afford the small cost of grape juice (Figs. 4.3–4.5). The client and ad agency chose the style of the photograph—its precise description—to convey the fiction that consumers could achieve a higher socioeconomic status simply by exercising good taste in buying juice. This very detail, however, masked the actual paths and difficulties of social mobility. In minimizing the hindrances, the ads, by extension, minimized class distinctions by portraying consumerism as an attainable goal for all classes of people.

This dual reading of photographic imagery that worked to obscure class differences was a visual analogue to larger economic trends in which class distinctions were blurred in an effort to promote consumerism. Stuart Ewen has argued that soon after World War I business managers began to focus on "neutralizing social unrest" and "the need to produce pacific social relations."[1] The worker was now viewed as the consumer of mass-produced items as well as their producer; the classic example is Henry Ford's belief that workers needed to be paid a living wage so that they could afford to buy the cars they produced. According to Christine Frederick in her 1929 primer *Selling Mrs. Consumer,* this new "consumptionism is . . . the greatest idea that America has given to the world; the idea that workingmen and masses be looked upon not simply as workers and producers, but as *consumers.* . . . Pay them more, sell them more, prosper more is the equation."[2]

A TOUCH OF CLASS: THE WELCH'S GRAPE JUICE
ACCOUNT, 1924–28

By the time the Welch's grape juice account came to the J. Walter Thompson Company in 1924, the product was sold nationally and was considered the leading brand of grape juice. The company, founded by the Welch family in 1869, had first sold Mrs. Welch's homemade grape juice to physicians and churches. In his memoirs, Earnest Elmo Calkins claimed that the ads for Welch's by his agency, Calkins and Holden, had transformed the image of grape juice, making it a popular beverage around the turn of the century.[3]

Although the Welch Company had marketed its juice to soda fountains and had

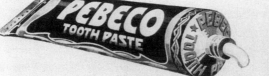

4.1 Advertisement for Pebeco toothpaste, *Ladies' Home Journal*, September 1924, p. 173. Edward Steichen, photographer (J. Walter Thompson).

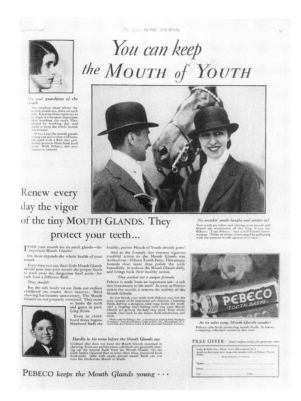

The figure contains the following advertisement text:

*You can keep
the MOUTH of YOUTH*

Renew every
day the vigor
of the tiny MOUTH GLANDS. They
protect your teeth...

PEBECO keeps the Mouth Glands young · · ·

4.2 Advertisement for Pebeco
toothpaste, *Ladies' Home Journal*,
September 1926, p. 95. Edward
Steichen, photographer (J. Walter
Thompson).

sold it as a home party drink, competition from bottled sodas and packaged fresh citrus juices forced the Thompson agency to develop a new sales strategy when it acquired the account. The concept it developed through market research was typical of food advertising in the mid-1920s: the text of the ad emphasized nutritional value; Steichen's photographs evoked the less tangible "appetite appeal."[4]

The Welch's grape juice ad in *Vogue* for June 1, 1925, exemplifies Steichen's contribution to the campaign (Fig. 4.3). In the image, grape juice fills a fine stemmed glass placed near the center of the composition; a highlight on the glass draws attention immediately to the product. The centering of the product is a metaphor for what the advertiser hopes will become its place in the American breakfast. The props—a silver spoon, a simple but beautiful china tea cup and saucer, a linen placemat, perfect strawberries in a ceramic bowl, and richly textured pansies—transmit the message: grape juice belongs on the most elegant breakfast table. The straight photographic style intensifies the sensuous textures of the props, encouraging viewers to consider the palpable qualities of grape juice: its rich color, its viscosity and body, its fragrance, and its taste.

Color was by far the most controversial element in developing food advertising. Many in the advertising agencies argued that it was needed to replicate

COLORFUL, FRAGRANT, LUSCIOUS . . . PURE JUICE OF THE CONCORD GRAPE . . . THE DULLEST APPETITE WAKES TO ITS APPEAL

"*More than* Passing Pleasure"—

find our Great Dietitians, in the Taste, Color, Fragrance we delight in

SATISFACTION from your meals, you know so well, depends on more than food.

Bright flowers, sparkling glass, gleaming china and silver—the best-cooked meal seems incomplete without them.

And today our greatest dietitians say:

Much more than passing pleasure is the service that they give us—this color and fragrance, and the rare flavor we delight in.

They are vitally important in every meal we eat.

For they awaken appetite, say our greatest food authorities. And appetite controls the whole system in the body that digests our food. Unless we eat with appetite we fail to take full benefit from our best planned meals.

And so, apart from its value as fruit, dietitians find in this juice of fresh ripe grapes significance for health. For Welch's has incomparably, they find, the color and fragrance, the exquisite flavor to which appetite responds.

PURE juice of the finest Concord grapes in all the world—only in Welch's can you enjoy that perfect flavor.

Such choice grapes ripen in just two little spots in the whole United States, near the Great Lakes, where sun and soil are perfect for the Concord.

When the great purple clusters are ripest Welch cuts the luscious fruit and presses out the juice— a few hours after the grapes leave the vines.

¶ They stress the lasting value in our diet of fruit in this delicious form

All the delicacy, all the health-giving qualities of the fresh fruit are in each glass of fragrant juice.

Mineral salts that children need particularly to build up their bodies, vitamines, nourishing fruit sugar, and laxative properties that modern diets need. Natural fruit elements, too, that turn to alkalies in your body and help your body to overcome the acidity so common today.

But aside from these values of Welch's as fruit, it is the importance for health of its flavor that

"*All the health-giving qualities of the fresh, ripe fruit,*" food experts say, "*are in each glass of luscious fruit.*"

experts stress today, its color and fragrance that awaken instant response from appetite.

AT BREAKFAST—Half-fill a small glass with cracked ice; then fill with Welch's— fresh-pressed juice of the Concord grape, fragrant, luscious.

FOR LUNCHEON—Make 3 cups of tea and allow to cool. Add 1 pint of Welch's, juice of 2 lemons and 4 tablespoons sugar. Serve in tall glasses very cold.

FOR DINNER—or for after-theater supper—Take from the ice-chest 1 pint of Welch's and two 12-ounce bottles of dry ginger ale. Partly fill glasses with Welch's—then fill with ginger ale.

Get Welch's today from your grocer, druggist or confectioner, in quarts, pints, or four ounces. Try it at the fountain for luncheon or for refreshment between meals.

Let us send you, free, our booklet *The Vital Place of Appetite in Diet*. It tells new delicious ways to serve this juice of fresh, ripe grapes. The Welch Grape Juice Co., Westfield, N. Y.

THE WELCH GRAPE JUICE CO., Dept. V-3
Westfield, N. Y.

Please send me—free—your booklet *The Vital Place of Appetite in Diet.*

Name

Address

City State........

4.3 Advertisement for Welch's grape juice, *Vogue,* June 1, 1925, p. 101. Edward Steichen, photographer (J. Walter Thompson).

So healthful · · so delicious

Famous Resort Hotels serve Welch's regularly for Breakfast

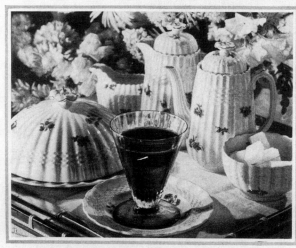

For the Breakfast Fruit Juice—half fill a small glass with ice— then fill with Welch's. *It is pure fruit juice.*

Among the resort hotels that serve Welch's for breakfast are:

Royal Daneli Hotel	*Palm Beach*
The Maryland Hotel	*Pasadena*
Hotel Plaza	*Havana*
The Ambassador	*Atlantic City*
The Breakers	*Atlantic City*
The Shelburne	*Atlantic City*
The Greenbrier	*White Sulphur Sprs.*
Flamingo Hotel	*Miami Beach*
The Roney-Plaza Hotel	*Miami Beach*
Hollywood Hotel	*Hollywood, Fla.*
Hotel Washington	*Cristobal*
Los Angeles Biltmore	*Los Angeles*
Samarkand Hotel	*Santa Barbara*
The Catherine Hotel	*Avalon*
Alexander Young Hotel	*Honolulu*
The Grand Hotel	*Mackinac Island*
The Mount Royal	*Montreal*

Fruit Drinks that are Social Favorites

Palm Beach . . Pasadena . . Atlantic City . . Havana—luxurious play-time places idling in the sun; their magnificent hotels plan every detail for the health and pleasure of their patrons.

Regularly the very finest of these hotels serve Welch's Grape Juice for the breakfast fruit juice.

It is so delightful for breakfast—so invigorating; and it offers most welcome variety.

For Welch's is the pure juice of choicest fresh grapes. Nothing is added to "preserve" or "prepare" this natural fruit juice; it is just pasteurized as fresh milk is to keep it from spoiling.

All the refreshing health-giving qualities of the ripe fresh grapes are captured in Welch's. And all their delightful qualities, too.

Read what great Food Experts say:

America's leading specialists on foods are impressed with the service that Welch's can do for your health, if you will make it a part of your regular diet. Its mineral salts, they tell you,

will help to build strong bones and teeth, especially important for children.

It gives you vitamins you must have; and mild laxative properties that keep you in health; natural fruit sugar that is nourishing and easily digestible; and fruit elements that are necessary to balance your heavier foods and prevent the acidity so prevalent today.

And its glowing purple color, rich fragrance and tempting flavor of luscious Concords rouse your appetite, they say, and thereby start proper digestion.

Doctors and hospital dietitians prove their faith in Welch's; they prescribe it for their patients. Mothers welcome it for their children.

Both men and women order Welch's at the soda fountain,—straight or as a Welch "ade,"—the pure juice with syrup and carbonated water.

Order Welch's today from your grocer, druggist or confectioner in quarts, pints and four ounces. Ask for it at the soda fountain for luncheon or refreshment.

Fruit drinks are the vogue at home and at the clubs, and the choicest of them is Welch's. The most popular recipes are printed on the label of each bottle of Welch's. Try one of these today, with a meal or between meals!

Welch's with Ginger Ale: Fill glasses one-third to one-half with Welch's, well chilled; then fill with ginger ale.

Welch's Sparkling: Half fill tall glasses with Welch's; add a spoon of cracked ice; and fill with sparkling water.

Welch Manhattan Cup: Blend 1 pint Welch's and 1 pint cider; chill; just before serving add 1 pint sparkling water.

Free Offer: More recipes are given in our booklet *The Vital Place of Appetite in Diet.* It is free. Write for it to The Welch Grape Juice Co., Dept. J-31, Westfield, N. Y. Makers of Grape Juice, Grapelade, Grape Jelly and other Preserve Products. Canadian plant—St. Catharines, Ontario.

WELCH'S · · PURE FRUIT JUICE *from* FRESH GRAPES

4.4 Advertisement for Welch's grape juice, *Ladies' Home Journal,* March 1927, p. 178. Edward Steichen, photographer (J. Walter Thompson).

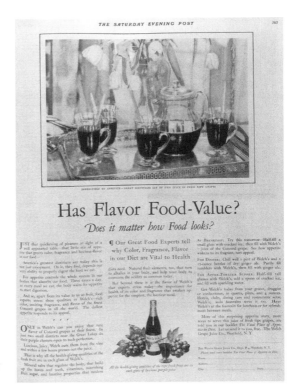

4.5 Advertisement for Welch's grape juice, *Saturday Evening Post,* May 3, 1925, p. 207. Edward Steichen, photographer (J. Walter Thompson).

nature and attract attention. Some of the agency's staff felt that adding color even to black-and-white photographs as tactile as Steichen's would make the advertisement more immediate. Although the original marketing research report for Welch's grape juice had recommended that the entire campaign be run in color, cost probably explains why this was not done. Thus Steichen's black-and-white photographs appeared in *Good Housekeeping, Vogue,* the *Saturday Evening Post,* and *Life;*[5] and watercolors painted from Steichen's photographs were published in full color in the *Ladies' Home Journal* (see Plate 1). When coupon returns demonstrated that the black-and-white photographs were as effective as the color illustrations, the color was discontinued.

Sales statistics further confirmed the effectiveness of Steichen's grape juice photographs. In June, July, and August 1925, sales improved 31, 62, and 51 percent over the figures for the same months the year before. Sales for September–December showed a 74 percent increase over the year before. And a study of the coupon returns in January 1926 demonstrated a 315 percent increase over January 1925 in requests for the grape juice company's booklet on its product.[6]

The advertising agency attributed this increase, not to the obvious new factor, the introduction of photography into the campaign, but to a shift in headline strategy.

They thought the huge increase in requests for the Welch's booklet meant "the wider acceptance of Grape Juice as a fruit juice drink" and "a more direct approach." The first year's headline had been "A New Standard of Values in Diet." The second year's was "So Appetizing, So Delicious, the Waldorf Serves It Regularly for Breakfast!"[7] The "more direct approach" here is based, paradoxically, on an atmosphere, not an informational, strategy.

Despite the agency's preoccupation with headline strategy, it is the large, clear photograph that dominates the ad and draws the viewer. The agency's goal for the ads, undoubtedly communicated to Steichen, was to promote the "best modern thought" about the product, and he translated it into comparatively simple, bold designs.[8] Yet the subject and composition of the images recalled the old-master tradition of still life painting, making their novel representation more approachable for the mass audience.

Steichen's transition into modernism becomes clear when his images are compared with drawn and painted Welch's advertisements, such as the one that appeared in the May 1925 issue of *Ladies' Home Journal* (Fig. 4.6), with its garish color—the result of crude color separation and printing processes—and baroque layout. Coupons, recipes, and subsidiary illustrations clutter the page. The primary illustration, with

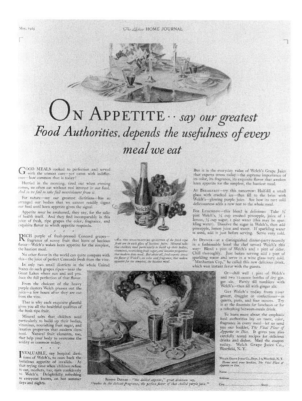

4.6 Advertisement for Welch's grape juice, *Ladies' Home Journal,* May 1925, p. 151. Illustrator unknown (J. Walter Thompson).

its serpentine outline of the fruit, ornate bowl, and brocade fabric background, continues an older style of imagery. Despite the illustrator's typically modernist viewpoint, a tilted perspective back and up from the subject, the resulting vignettes retain a traditional look.

Advertising personnel who favored a more contemporary look urged greater visual simplicity, even if it meant cutting out text.[9] For the grape juice campaign, the art director devised a layout to complement Steichen's crisp, clear illustrations (see Figs. 4.4, 4.5). Steichen's dramatic photograph, printed large, dominates, but the art director could not resist a small image of the bottled product or a coupon, although he situated them unobtrusively at the bottom of the layout. And the copywriter, still viewing the picture as only a hook, has retained the long text believed necessary to complete the sale.

Steichen's photographs were the first used in ads by the Welch's Grape Juice Company. A look at some of the still life photographs used by other corporations to promote their products establishes Steichen's contribution to the genre. In 1921 Baron Adolph de Meyer, Steichen's predecessor as chief photographer at Condé Nast Publications, had created a series of elegant still lifes for Oneida Community Plate silverware. One of these is echoed in the composition of a Steichen image (Figs. 4.5, 4.7). De Meyer used a classic pictorialist technique, with soft focus, blurred background, and generally foggy atmosphere. Steichen employed somewhat sharper focus and photographed from a closer, slightly diagonal vantage point. By 1925, when Steichen's grape juice images appeared, de Meyer's work looked decidedly old-fashioned.

THE STYLE OF "STYLELESSNESS"

In the late nineteenth century, trade cards, posters, and other advertising sometimes employed documentary-style photographs along with the more common drawings. Pictorialism was the next photographic style incorporated frequently in mass media advertising. As we have seen, by the early 1920s a number of advertising photographers, including Lejaren à Hiller (the chief photographer for Underwood and Underwood), Alfred Cheney Johnston, Horace Scandlin, William Shewell Ellis, Grancel Fitz, Ira Hill, Nikolas Muray, and the firm of Winemiller and Miller, as well as de Meyer, built their reputations on pictorialist representation (see Figs. 3.9–3.11). Most of these photographers had fine arts training and participated in fine arts exhibitions. Hiller and de Meyer, for example, had exhibited photographs in pictorialist art exhibitions and journals.

In the mid-1920s the dominant style in advertising photography shifted away from pictorialist to straight representation, especially in campaigns that included still life rather than figural subject matter. Although Steichen suggested in his autobiography that he was responsible for this shift, the signals of a major stylistic change were evi-

4.7 Advertisement for Oneida Community Plate, *Annual of Advertising Art*, 1922, p. 99.
 Adolph de Meyer, photographer (Patterson Andress Co.).

dent in the advertising industry by the time Steichen came to Thompson. It is more likely that he was recruited to work for Thompson because his fine art style was compatible with the direction in which the agency wished to develop.[10]

Stylistically, advertising photography in the middle and late 1920s varied more than the category of straight photography might imply. For example, Lewis Hine won the 1924 Art Directors' Club medal for his documentary photographs of railroad workers, images he had taken originally for a photo essay in the *Survey Graphic* that were recycled into advertisements for the Pennsylvania Railroad account (Fig. 4.8).[11] The 1924 *Annual of Advertising Art* prominently featured Hine's railroad photographs as well as his work for the American Brass Company, Aldus Printers, and the Vacuum Oil Company; the next year the annual featured his work for the Prest-o-lite Company, the Incandescent Lamp Company, and the Vacuum Oil Company.

Other advertising photographs of the mid-1920s blended stylistic features. The 1924 Art Directors' annual also displayed Ralph Steiner's photograph for Fioret perfume and Paul Outerbridge's photograph for Pyrex glassware in simplified, mod-

4.8 Advertisement for the Pennsylvania Railroad, *Annual of Advertising Art,* 1924,
p. 117. Lewis Hine, photographer (Ivy Lee).

ernist compositions, if somewhat softened focus. Grancel Fitz took photographs
for the Fostoria Glass Company that exhibit the close-up bird's-eye perspective
and the simple, clean arrangement of form associated with modernist composition
(Fig. 4.9).[12] While these designs may have been more composition advanced than Stei-
chen's, their softened silhouettes subtly recalled his pictorialist roots. A Carnation
milk advertisement (photographer unknown) combined modernist clarity, oblique
vantage point, and dramatic composition with the immediacy effected by careful
descriptions of detail (Fig. 4.10).

 The diversity of components of such advertising photographs met the demands of
the advertising industry: sharpened focus gave the impression of "realism," while
pictorialist remnants signified an elegant, upper-class "artistic" atmosphere. And
modernism, introduced into American advertising by the end of the decade, gave an
impression of novelty and modernity.

 Gordon Aymar, who had begun his career as an art director early enough to have
experience with pictorialist advertising, avidly promoted the shift from pictorialism
to straight photography. He had come to believe that when photography is "forced

4.9 Advertisement for Fostoria glass, *Annual of Advertising Art,* 1927, p. 15. Grancel Fitz, photographer (N. W. Ayer and Son).

beyond the limits of its own inherent characteristics, it becomes false and loses that sense of reality which is its chief asset."[13] Aymar's criterion of truth to the artistic medium, expressed by his prescient phrase "inherent characteristics," reflects the philosophy of the modernist photographers who had all but displaced the pictorialists in fine art circles and seems to presage later formalist criteria. Surprisingly, Aymar was one of the few who recognized the transition to straight photography. Trade papers and staff meetings of the day rarely discussed it, perhaps because it appeared so gradually as to be almost unnoticeable to the new art directors who joined the profession.

By the late 1920s straight photography had become so prevalent in advertising that it had ceased to be recognized as a style: it was simply photography. For example, when a trade paper advertisement in 1932 promoted the versatility of N. W. Ayer and Son, it represented three styles of drawn illustration recently used by the company but included only one photograph.[14] Charles T. Coiner, an abstract, modernist painter who wrote astutely on modern graphic design (he was Steichen's art director at Ayer in the mid-1930s), also distinguished photography from drawing:

4.10 Advertisement for Carnation milk
products, *Ladies' Home Journal,*
April 1928, p. 160. Photographer
unknown.

Before photography became so dominant, a different art approach could be used for each
product. Take automobiles. We used a different style with a different artist on each series.
You could have Ford, Lincoln, Zephyr, Lincoln and Mercury, and they all look entirely
different in character. Well, nowadays, with photography, you can't do that because pho-
tography is photography period. And one photograph is just like another except for what
they're photographing. Well that isn't enough to build character around a product. That's
why much of our automobile advertising looks alike.[15]

Although agency staff did not acknowledge straight photography as an indepen-
dent or personal style, when they defined *effective* photography, its characteristics
were precisely those of artistic straight photography. *Camera,* a 1929 booklet pro-
duced to bring new business to N. W. Ayer, enumerated the "attributes of good
photography" as "clearness of detail, purity and delicacy in tone values, transpar-
ency in light and shadow, and imaginative composition."[16]

The inability of admen to recognize photographic style may have been reinforced
by cultural factors. Their primary visual tradition prized mimesis, "an unproblem-
atic window on reality," as Jackson Lears has defined it, which provided "the same
sort of clear and unadorned perception embodied in the positivist ideal of scientific

observation." Such a worldview, which Lears sees as rooted in the class needs of the bourgeoisie and the established Protestant tradition of plain speech, led to an insistent literalness in mid- and late-nineteenth-century art, theater, and literature—one can think of Ruskin's dictum that paintings have "truth to nature" or the daguerreotypists' desire to provide a "correct likeness." Admen raised in such a visual culture of literal-mindedness may have taken comfort in the descriptive qualities of straight photography. Straight photography also dovetailed neatly with the rational, scientific, and managerial aspirations of many early-twentieth-century advertising practitioners who, as Lears analyzed it, hoped to contain the embarrassing carnivalesque roots of advertising with scientific process and restrained style.[17]

STEICHEN'S VIEWS ON STRAIGHT PHOTOGRAPHY

Steichen's discussions with art directors and his writings in graphic design journals frequently allied straight photography with objectivity and pictorialism with emotion. He saw straight photography as the more modern, dismissing the "petty trickery" of old-fashioned pictorialism that imitated other arts. He praised "the meticulous detail, the biting precision," and the "conviction of truth and reality" that he thought made straight photography the most potent advertising style.[18] Consistent with the tenets of straight photography, Steichen argued for emphasizing the specifically photographic qualities of the image: "You cannot make the steamboat do what the railroad train will do." Steichen insisted that blatantly manipulating advertising photographs, by collaging or heavily retouching them, was an affront to the photograph. "Some things are made with photographs pasted together. I dare say that the elevator man doesn't know it, but it gives me the creeps." He blamed such overt manipulations on "the habits of thinking in terms of drawing transferred to photographs. When you make those lines in pencil in the layout, they are all right, but the moment you paste them together, it no longer works. It gets flat."[19] Since Steichen respected the photographic qualities of the image, he fought against airbrushing his photographs: "In the very beginning, when I got paid $500 for a photograph and another man was paid $10 to brush it out again, I went up in the air and went loud enough, so that's over."[20]

Steichen's interest in maintaining the photographic qualities of the print extended to its reproduction in the mass media. He told the agency personnel that when he made an advertising photograph, he thought in terms of the printed reproduction rather than the photograph for its own sake: "I never think when I am making photographs for reproduction, in any term except the printed page." He believed that determining the best-quality print for reproduction was "part of my job." He explained that "a great many of the negatives making the best printed page, make poor photographic prints. . . . Prints that looked perfectly marvelous as prints, when

reproduced, look dead and lifeless."[21] Steichen told the agency staff he would assume responsibility for judging prints before reproduction.

THE RHETORIC OF REALISM

While advertising discourse continued to equate the perceived stylelessness of straight photography with absolute realism throughout the 1920s, cracks appeared in the facade, as one can see from the subtle persuasion in Steichen's Welch's grape juice photographs.

Agency men in the 1920s knew instinctively what Roland Barthes theorized forty years later when he distinguished the three "messages" sent by every photographic advertisement: a linguistic message in the text that "anchors" any ambiguity in the imagery to the maker's intentions, and dual messages in the photograph, one "denoted," or literal, and the other "connoted," or symbolic. Like the early admen, Barthes did not recognize the codes, or artistic style, of the photograph.[22] Even when straight photography came to prevail in advertising, advertising professionals never discussed how a photographic representation channels messages, although in practice they presented information with an overlay of suggestion. Because straight photography seemed styleless, realism was discussed narrowly as naturalistic depiction. Advertising professionals argued that the mechanical origins of both the original photographic print and its reproduction in an ad made them free of manipulation. They failed to acknowledge the inherent stylistic characteristics, or "syntax," that transmitted the false impressions of objectivity and truthfulness.[23]

Theorists now ascribe the wide historical acceptance of photography as a neutral and accurate recorder not only to its technological beginnings but also to its alliances with the values of a capitalist society. Commercial photography affirms bourgeois values; it does not challenge them and thus does not call attention to its own constructions or encourage the audience to question them. This alliance was largely unrecognized, so the imagery in the ads just seemed "natural" to the audience.[24]

ALTHOUGH the technical qualities of photography greatly impressed advertising professionals, the medium was adopted slowly because the agencies doubted its ability to trigger the imagination; photographs were considered too real. The exception, of course, was the obviously artistic pictorialism, which could be substituted for drawing at will. A 1917 article on commercial photography laid out the assumptions that continued throughout the 1920s; it concluded that photography's "ultimate object is to produce what is more or less a diagram, which will give the fullest possible information."[25] Another recurrent theme was photography's authority. A 1917 trade booklet prepared for salesmen of Conaphore headlights, thought to be the first instance in which the Thompson agency employed photography for a cli-

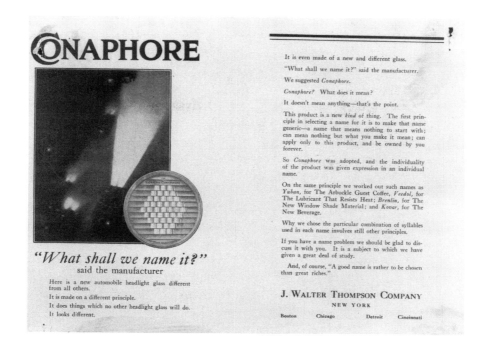

4.11 Advertisement for J. Walter Thompson Company that includes its work for Conaphore
headlights, tear sheet, 1917, JWT Archives. Lejaren à Hiller, photographer.

ent, was celebrated for its "wonderful amount of realism" (Fig. 4.11). Although by
today's standards the grainy soft-focus photograph of the headlight beam scarcely
suggests realism, agency staff were assured that the "Conaphore salesmen are very
convincing when they tell customers that these illustrations are not imaginary prints
but real photographs."[26]

Soon advertising agents were selling the veracity of the photograph wholeheart-
edly. A pamphlet produced to attract new business to the Ayer agency suggested
using photography "wherever it is necessary to show a product exactly as
it is, with fidelity and detail." The psychological effect of photography on consum-
ers was not to be underestimated either; "the air of authenticity which it conveys"
gave it great value. By 1925 the J. Walter Thompson Company, with Steichen as its
star photographer, described its policy as "presenting facts, not opinions." The
agency relied on photographs whenever possible to make "all its evidence as con-
crete as possible."[27]

The acceptance of the realism of advertising photography developed from popu-
lar notions about the accuracy and objectivity of news photography. Readers, con-

4.12 Advertisement for Fleischmann's yeast, *Annual of Advertising Art,* 1928, p. 78.
Edward Steichen, photographer (J. Walter Thompson).

ditioned to believe in news photography as a "faithful witness" to events, scarcely noticed its manipulation of values and viewpoints. Advertising staff in turn realized they could exploit this credibility, for example, in an advertising layout with photographs mimicking the editorial pages of the magazine.[28]

Even obviously staged photographs qualified as realistic. Although Steichen's photograph of happy picnickers eating cakes made with Fleischmann's yeast seems theatrical today, Gordon Aymar labeled it as a "thoroughly honest use of photography" in his textbook of graphic design: "Here are all the inherent virtues of the camera—a scene recorded instantaneously, completely, without effort and without retouching. A remarkable piece of stage direction in which four separate individuals have been simultaneously infected with the spirit of the occasion" (Fig. 4.12).[29] "Stage direction" did not undercut the "honest use of photography," and obvious artifice never negated the photograph's "realism."

Steichen's theatrical vignettes for Fleischmann's yeast ranged from a pleasant scene of a trio picnicking beside a pond to studies in upper-class pretension (Figs. 4.13, 4.14). His rendering of human interaction and emotion drew on picto-

4.13 Advertisement for Fleischmann's yeast, *Ladies' Home Journal*, June 1927, p. 91. Edward Steichen, photographer (J. Walter Thompson).

4.14 Advertisement for Fleischmann's yeast, *Ladies' Home Journal*, January 1928, pp. 110–111. Edward Steichen, photographer (J. Walter Thompson).

rialist conventions. In this regard his work followed industry expectations rather than challenging them. There are few differences between Steichen's improvisational dramas for Fleischmann's yeast and those, for example, of Lejaren à Hiller for Listerine antiseptic (Fig. 4.15).[30] Hiller's advertisement enacted the tension between the couple caused by their ignorance of the advertised product. Both Hiller and Steichen overdramatized such simple moments with gestures like those in silent films. Both constructed more complex staging and included more props than necessary. To our eyes, these studies seem less naturalistic, less modern, and less effective than sparer product studies Steichen did for Welch's grape juice. Yet because they were photographed, they were included under the realist rubric.

Across the industry, art directors were encouraged in their naive analysis of realism by the photographers themselves. As late as 1930 the Photographers' Association of America reiterated stereotypical notions in trade press ads that sold photography to the sellers of goods.[31] Each advertisement featured a photograph by one of the organization's members exemplifying straight photography: sharp focus, crisp textures, wide tonal range, slightly oblique vantage point. By so consistently employing and promoting one style, these photographs reinforced the notion that photography was a styleless medium that accurately illustrated the product.

This advertising campaign stressed the credibility of photographs with the public and their effective representation of detail (Figs. 4.16, 4.17). Each advertisement prominently featured the campaign slogan "Photographs Tell the Truth" and, near the main photographic illustration, the caption, which read: "'This is an actual photograph.' Those five words under an illustration inspire more confidence than five volumes of adjectives. Use this phrase in all your advertising—it pays!" The photographers sold photographs on what they saw as the medium's most effective selling point: the public's belief in them.

STEICHEN could play both sides against the middle, and he made frequent public statements somewhat disingenuously bolstering these ideas about the objectivity of the photograph. The New York Times, reporting on the first interview he gave after his return from Europe in 1923, quoted his statement that "no progress has been made in photography since the daguerreotype . . . a photographer is supposed to take things as they are, without interjecting his personality into the picture."[32] This statement, understandable, perhaps, in light of his recent military experience with aerial photography, expresses one of Steichen's contradictory viewpoints. For he alternately championed the photograph as a completely objective reporter and as a representation constructed by the artist. In 1928 he emphasized the unique naturalism of the photograph to the Thompson agency, its "meticulous detail."[33] And in 1932, debating the relative merits of photography and drawing with the illustrator Roy Spreter, he credited the success of advertising photography to its "convincing and truthful . . . delineation of objects."[34] Steichen chose his vocabulary carefully,

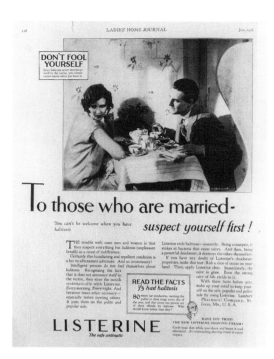

4.15 Advertisement for Listerine antiseptic, *Ladies' Home Journal,* July 1928, p. 118. Lejaren à Hiller, photographer (for Underwood and Underwood) (J. Walter Thompson).

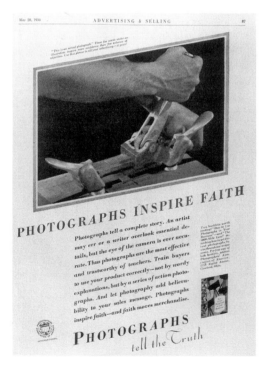

4.16 Advertisement for the Photographers' Association of America, *Advertising and Selling,* May 28, 1930, p. 87. Photographer unknown.

4.17 Advertisement for the Photographers' Association of America, *Advertising and Selling*, August 6, 1930, p. 10. Photographer unknown.

shying away from overstated, categorical claims for the photograph's realism. His choice of terms like "objectivity," "truth," "natural," and "detail" indicated a sophistication about realism and the artist's ability to control and manipulate the medium without directly challenging the basic assumptions of the agency art directors.

From the earliest days of his career Steichen was well aware of the artist's intervention in image making. In a 1903 defense of pictorialist photography he argued that this intervention begins when the image is conceived and continues as "the operator controls and regulates his time of exposure, when in the darkroom the developer is mixed for detail, breadth, flatness or contrast." "In fact," he insisted, "every photograph is a fake from start to finish, a purely impersonal, unmanipulated photograph being practically impossible."[35]

If he believed that "the value of the camera is its objectivity," Steichen could also take the other side: "But you can have objectivity in many ways. *I believe it is impossible to get to the whole truth and nothing but the truth in any photograph.*" He recounted to the staff of the J. Walter Thompson Company an anecdote of how a reporter secretly photographed the execution of the convicted murderer Ruth Snyder. The purloined image demonstrated both levels of photographic reading: it re-

corded the details accurately but also so emotionally that it "was the one thing sure to make the State ashamed of itself" for capital punishment. Steichen reminded his audience that the photographer was an artist and interpreter as well as a recorder and that several levels of meaning could reside in a photograph: "People want to interject their personalities into [their work]. The photographer cannot resist the temptation."[36] Yet four years later, writing for a different audience with different expectations, Steichen characterized the same photographs of Snyder's execution as "totally devoid of anything but bitter fact."[37] If such consistent inconsistency indicates Steichen's willingness to shape his presentations to the beliefs and goals of his audience, it also suggests that he was searching for language to articulate the complexity of what photographers and some art directors knew instinctively.

Despite the widespread rhetoric of realism and the insistence on the objectivity of straight photography, advertising agencies came to recognize that photographs implicitly transmit values. Thus straight photography became the style of choice for illustrating the atmosphere strategy of advertising.

THE PSYCHOLOGY OF PERSUASION

Steichen's work, both informative and suggestive, exemplified the ad agencies' concept of realism in the mid-1920s: exacting detail overlay luxury, sophistication, and wealth, providing a persuasive subliminal sales pitch. This stylistic choice received a boost from the first advertising psychologists, who confirmed that the consumer was *suggestible* and thus susceptible to the atmosphere strategy. Thus by the mid-1920s two significant trends shaped the direction of advertising photography: the reassurances of the advertising psychologists that consumers could be influenced by visual means, and the art directors' new understanding of the paradoxical nature of photography's so-called realism.

Advertisers had been intrigued since the late nineteenth century by the potential of psychology to strengthen the effectiveness of their appeals.[38] Their rising sales curves should have been enough to convince more of them to try the atmosphere strategy, but they turned instead to business psychologists to gain greater marketing certainty from empirical consumer testing.

The earliest advertising psychologists, such as Harlow S. Gale, Walter Dill Scott, and Daniel Starch, based their inquiries and methodologies on the discipline of experimental psychology that arose in the late nineteenth century. Gale and Scott, like most prominent early-twentieth-century American psychologists, had studied in Germany with the medically trained Wilhelm Wundt. In Wundt's research laboratory at Leipzig University, the first of its kind in the world, he combined quantifiable empirical studies with introspection (human subjects' analyses of their mental processes as reported to investigators).[39] Typical problems investigated there included

how to attract and hold involuntary attention and what caused impulsive action. Such investigations were solely theoretical; Wundt prescribed no social applications for his or his students' discoveries.

Wundt's structuralism—his study of mental processes and the structure of consciousness—combined with the strong American traditions of practical psychology and problem solving to become the basis for advertising psychology. Wundt's students Gale, Scott, and Edward W. Scripture, who taught at prominent American universities, explored structuralist concepts in the earliest psychological studies of advertising.[40] Their work, which fulfilled the desire of American businessmen to make advertising a science, not an art, formed the intellectual basis and rationale for twentieth-century advertising practice.

Harlow S. Gale used advertisements to study mental processes as early as 1896. He had no links with the advertising or business communities but utilized ads solely to give his students at the University of Minnesota practical laboratory experience in experimental psychology. The questions he asked reflected the structuralist search for the general laws of mental process (How can ads gain one's involuntary attention? Are readers open to suggestion?) and the functionalist concern with individual difference (Does suggestibility vary by gender or other factors?). Most important, he investigated both conscious and subliminal preferences for products among his students that resulted from their memory of arguments they had read in ads. Gale concluded that consumers did not necessarily buy specific brands because of rational arguments; much of their buying was the product of unconscious decision making. Thus Gale's studies were the earliest empirical support for the change in advertising strategy from reason-why to atmosphere.[41]

In the first decade of this century, Walter Dill Scott strengthened the notion, already gaining currency among admen, that the consumer was suggestible and nonrational. From the beginning of his career Scott clearly saw his function as an advertising psychologist as serving the interests of the corporate world. He dedicated his 1908 book to "that increasing number of AMERICAN BUSINESS MEN who successfully apply Science where their predecessors were confined to Custom." He assured businessmen that psychology could provide a "scientific basis" for their singular goal, "the influencing of human minds."[42] Scott's first advertising studies were commissioned by Chicago businessmen to address specific issues. He continued a long, active career developing psychology for business as director of the Bureau of Salesmanship Research at the Carnegie Institute for Technology, for the military as director of the U.S. Army's Committee on Classification of Personnel (CCPA) during World War I, and in academia as a professor, then eventually president, at Northwestern University.[43]

Immediately after World War I the entrepreneurial Scott went on to market psychological services through the Scott Company, whose members included a number of his former army CCPA associates, some of whom were among the elite of academic psychology: John B. Watson, Robert M. Yerkes, James R. Angell, and

Edward L. Thorndike, of Johns Hopkins, Harvard, the University of Chicago, and Columbia, respectively. The corporation applied the personnel studies developed for the military to corporate concerns, formulating tests to aid in such decisions as who would make the best foreman and assisting management in attempts to resist labor union organizing.[44]

The centerpiece of Scott's theory was his analysis of suggestion. Although other psychologists had studied the concept in the 1890s, Scott was the first to apply it to advertising practice.[45] This theory revolved around the law of ideo-motor action, a belief shared by both the Leipzig school and William James, the acknowledged leader of American functionalism.[46] According to this precept, a thinker was compelled to act on a thought unless impeded by a conflicting idea. Both Gale and Scott invoked it to explain their conclusion that ads influence people to buy products: once the idea was placed in the consumer's mind, in the absence of a conflict, he or she was powerless to resist buying the product. Thus advertisers, in conveying an idea to consumers, must present it without conflict, so that the consumer acts reflexively. Scott advised advertisers to use both headlines that issued direct commands ("Let the Gold Dust twins do your work") and coupons that required specific, direct, and easy action.[47]

Scott believed ads worked: in the marketplace the consumer remembered the product—it was already a personal acquaintance or an old friend—and bought it. Those who claimed immunity to advertising's influence were deluded, for although they did not consciously remember the image, they knew the product. The most emotional ads were the most effective: "The attention value of an object depends on the intensity of feeling aroused."[48] Ads must appeal to the senses, excite mental imagery, and perhaps trigger instinctive responses, those "hidden springs of action."[49] Thus Scott advocated the suggestive, or atmosphere, strategy over reason-why ads in most cases, thus legitimating advertising trends.

Scott relied on his own observations to a degree surprising for an empiricist. From his personal reaction to specific magazine ads, he determined that ads encouraging identification with a higher socioeconomic class were especially effective and that those painting a rosy picture of the world attract the most attention. When he did conduct experiments, his empiricism was rudimentary. He gathered data by unobtrusively observing and timing a hundred magazine readers on each of six trips to the Chicago Public Library, where he calculated the percentage of men reading advertising and editorial pages on his first glance. He sent a questionnaire to newspaper readers in an effort to correlate social class with reading habits. And he tested his college students' memories of sample ads (like Gale, whose work he knew) to devise "laws" governing the attention value of specific ads.[50]

As early as the first decade of this century Scott prescribed how advertising should look, insisting that high-quality aesthetics increased sales and that even the "uninitiated . . . [are] able to appreciate the work of the artist." In his 1908 book *The Psychology of Advertising* he presented a long list of "laws" for all advertisers to

make ads visually attractive and thus effective. Scott's list organized the obvious. The most successful ads, he said, were large, brightly colored, and designed with "pleasing" symmetry and proportions. Beauty drew attention to the ad, but the artist's hand should not assert itself. In "the best works of art," said Scott, "attention is drawn wholly to what is represented and not to the manner of representation." The consumer should appreciate the imagery, but not "be aware it is the beauty that attracts us."[51]

The decision of advertisers to use photography for persuasive advertising may have been bolstered by Scott's insistence on the effectiveness of styleless illustrations. Although they considered drawing better for fantasy, they also saw it as the display of an artist's personal style. Steichen's straight photography in his second series for Jergens lotion (see Figs. 3.14–3.17) and his work for the Welch's grape juice campaign (see Figs. 4.3–4.6) exemplified Scott's dictum that advertising required aesthetics, elegance, and imagination for success. These photographs, unlike soft-focus pictorialism, avoided revealing the medium's obvious manipulative qualities while suggesting romance and material comfort. Scott's theories, which paralleled intuitively derived contemporary business practices, were widely read within the advertising industry. One of the first advertising histories, Frank Presbrey's 1929 *History and Development of Advertising*, noted that Scott continued to influence the industry a quarter of a century later, attributing to Scott's work "the real beginning of the study of appeal as a science."[52]

Daniel Starch, like Scott a structuralist psychologist, studied involuntary attention and the law of ideo-motor action. But he was more rigorously empirical than Scott and considered the psychology of the individual consumer to a greater extent. For Starch, the ad's ability to generate interest was the key to its effectiveness.[53] In his influential 1914 book *Advertising,* he assured advertising professionals that effective advertising was not luck: he described its "scientific foundation" and "underlying principles." An advertisement had three functions: "to attract attention, to stimulate interest, and to secure a response." Arresting visuals stopped the reader, whose interest could then be piqued with headlines, text, and arguments that were "terse, pointed, and full of news." The successful advertiser followed a long list of "laws" guaranteed to attract the consumer's attention: use large, easily readable type, bright color, and good contrast; employ unusual borders; develop harmonious and well-balanced layouts; leave some white space on the page; and run the largest illustration possible.[54] Starch's most important contribution was to catalogue current wisdom and give it a scientific veneer by formalizing and systematizing it into law.

His study of sales figures firmly convinced him that images boosted sales, whether the atmosphere or the reason-why strategy was employed. Arguing that people had a "natural interest in pictures," Starch explained that they "speak a universal language. . . . An illustration can represent at a glance what it would take paragraphs to describe. It . . . imprint[s] the message more easily, more quickly, and more completely." The best ads "really illustrate" and "really exhibit the goods." Starch's no-

tion of realism, however, like that of other advertising professionals in the early twentieth century, was multilayered and contradictory. He implied that all images, no matter the style, were real: "A suit of clothes might be exhibited on a hanger, but [an illustration] of a young man wearing the suit adds a strong touch of realism." The most effective images were those that provided "a clear distinct idea of what the article is like." Nonetheless, he did not endorse only reason-why advertising: "Human nature is influenced . . . at least as much by suggestion and imitation as by reason and deliberation."[55] Eventually Starch went into business for himself, founding a very successful subscriber-funded service that quantified and reported on the effectiveness of individual ads for the advertising agencies.

Other early advertising psychologists centered their research on human instincts, needs, and wants, advancing Starch's investigations of individual consumers. The advertising psychologists Harry L. Hollingworth and Edward K. Strong, Jr., studied the motivations for human behavior. Influenced by Sigmund Freud's ideas on instinct and drive, they subscribed to a psychodynamic explanation of human thoughts and actions that allowed for either conscious or unconscious persuasion and decision making. They also incorporated some aspects of early behavioral ideas into their theory of advertising, including a stimulus-response model that allowed for mental events intervening between stimulus and response.[56] They challenged the convention of advertising as a means to attract attention and spark ideas that inevitably led to consumer action.

Hollingworth inventoried consumers' needs and then demonstrated how the product might satisfy them. Once the association between need and commodity was established, he argued, the consumer was compelled to buy the product. Following a common early-twentieth-century custom among psychologists, Hollingworth developed a list of twenty-four human instincts, which could be exploited by advertising.[57] Strong agreed that advertising must "create a desire for the advertised commodity" and incorporated this idea into his theory of "want-solution," which held that the desire for goods already existed in the consumer.[58] Both Hollingworth and Strong gave early scientific support to what has become the classic formula in advertising: present a need and fill it. This premise was the psychological underpinning of the early Jergens lotion advertisements that had presented the chapped hands resulting from housework, then told women how to attain beautiful hands with the product.

Gale, Scott, Starch, Hollingworth, Strong, and other early advertising psychologists provided support for the atmosphere advertising strategy by demonstrating that consumers were open to suggestion.[59] But the fantasy must not be too apparent. The advertising men, who had intuited in the mid-1920s that photography powerfully influenced consumers, came to realize that the photographic style best suited to desire and motivate consumers was not the most overtly manipulative style. Pictorialism was too obvious in its fantasy and artistic syntax; a more naturalistic depiction made the product and the lifestyle associated with it seem more attainable.

By the 1930s Steichen had developed a new stylistic treatment, an updated application of straight photography. Although he used both the terms "realism" and "naturalism" in his autobiography to describe this more obviously value-laden imagery, which seamlessly blended information with sentimental appeal, I will use the term "naturalism" to distinguish it from the seemingly detached documentary style of his earlier advertising photography, such as his Jergens ads from 1923 and 1924. "Naturalism" was emotive; "realism" appeared more emotionally neutral.

The headlines of the Kodak advertisements make clear that the ad agency perceived the complexity of this naturalism (Figs. 4.18, 4.19; see Plate 2). Even when the content is sentiment, as "the sweetness of the world's most precious baby" in Plate 2, the rhetoric underscores ideas of the "truth" of photography: the "record" of their child's progress "can be a truer one than ever now." Figures 4.18 and 4.19 take for granted the factual nature of photography and concentrate on its sentimental value. In Figure 4.18 the "magic" of photography has created a snapshot that the young man will carry "with him, and always feel that she's near." In Figure 4.19 the man tells his grandchild, "You don't know, darling, what this snapshot means to me." In each case, the text implies that the snapshot is treasured because it is "true to life." It was easy for the agency staff to collapse realism and naturalism since both were defined against the fantasies and melodramas Steichen had begun to elaborate for beauty and hygiene products (see Chapters 6, 9).

Steichen was pleased with his new style, demonstrated most visibly in the Kodak film campaign photos, one of only two campaigns he featured in his autobiography. Steichen wrote that the Kodak project, like his working hands for Jergens lotion, intrigued him initially "because of the realism involved."[60] In the Kodak campaign, Steichen's images seem less posed, more naturally lighted, and generally more relaxed than in many of his other assignments or in advertising images by his contemporaries. The frozen poses, overly gestural expressions, and dramatic spotlighting prominent in Hiller's carefully staged vignettes for Listerine and Steichen's own photographs for Fleischmann's yeast have disappeared (see Figs. 4.15, 4.12).

Steichen's images for Kodak celebrate a sanitized and homogenized view of family life. While they do not suggest a fantasy life like that of Steichen's photographs for beauty products, the idealized roles, affluence, and warm interactions among the models set standards few could hope to reach, especially during the depression.

Kodak had a long history of advertising to the general public and to amateur and professional photographers. Its original 1888 slogan, "You push the button, we do the rest," reportedly was devised during a discussion between George Eastman and the original J. Walter Thompson.[61] Thompson eventually lost the account, but after a thirty-year affiliation with the Frank Seaman Company, Kodak came back to the company in 1930.[62]

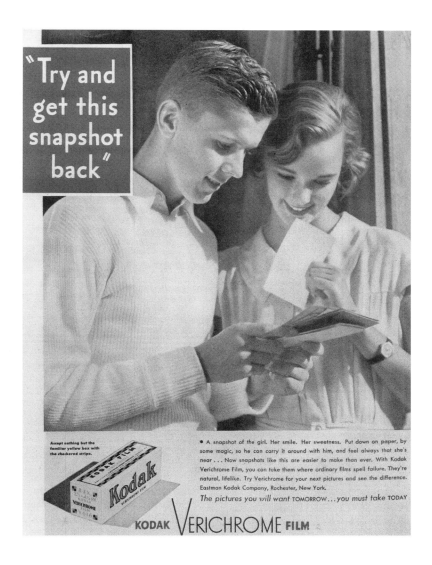

4.18 Advertisement for Kodak Verichrome film, *Saturday Evening Post,* June 30, 1934. Edward Steichen, photographer; John Scott, art director (J. Walter Thompson).

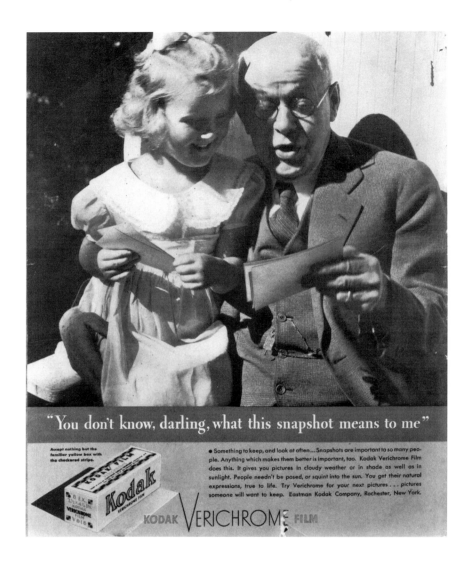

4.19　Advertisement for Kodak Verichrome film, unidentified tear sheet, 1934, J. Walter Thompson Archives. Edward Steichen, photographer; William Strosahl, art director (J. Walter Thompson).

George Eastman was admired in the advertising industry for his business acumen, although he was also accused of blocking unionization and of employing ruthless business practices against his competitors.[63] His company was frequently cited as an example of success attributable to advertising. "Eastman created a new product, for which there was no demand at all. Through aggressive marketing motives, Eastman put a pure luxury product, the Kodak, into widespread use."[64] Kodak, and Eastman in particular, had tremendous faith in the power of advertising. The company successfully fought the recession of 1921 with a 50-percent increase in spending for advertising.[65] Eastman, who never admitted the seriousness of the depression, decided, as in other difficult years, to "spend a little more money and do a lot more hard work."[66] That "hard work" during the depression consisted of a series of camera giveaways, amateur photo contests, and commissions for Steichen to photograph the campaign for Verichrome film, a particularly forgiving black-and-white film for amateurs introduced in 1931.[67] Kodak undoubtedly chose Steichen because he was a well-known art photographer as well as a famous commercial photographer.[68]

The Kodak campaign in the mass magazines focused on selling film to the general public; the central message of the images was the contribution of Kodak products to American family life, a theme that had recurred in Kodak advertising since the late nineteenth century. Although the Thompson agency would have preferred a more tightly targeted and hard-hitting campaign, they continued to deliver the more general "humanness" that the company demanded.[69]

Conventional wisdom at the Thompson agency favored real locations for photographing typical American life. Consequently, in 1933 the agency sent Steichen to Saint Petersburg, Florida, to seek "warm and happy" people for Kodak.[70] Dissatisfied with the local models, he found nonprofessionals more to his liking. On another assignment for the campaign Steichen photographed people from the New York area. He detailed the lengths he went to for a spirit of naturalism:

> I decided not to use professional models. The agency was to find everyday people in the suburbs and various towns around New York. The result was that one of the staff did a piece of casting the like of which Hollywood has never been able to achieve. To make each picture as real as possible, I worked out a specific procedure. First, I set up the composition in a general way, with the people looking at some nondescript snapshots. But I had in reserve a selection from the Eastman Kodak files of lively snapshots of subjects that would particularly interest the people I was photographing. Just as I got ready to make the exposure, I handed this set of snapshots to them. In every case they were greatly interested and their expressions were spontaneous and real.[71]

At the suggestion of agency personnel, Steichen kept palm trees and any other identifying features out of his Florida pictures. Even though the agency specifically sent him on location, it wanted a universal and "timeless" image.[72]

The Kodak campaign photographs seem to solve what Steichen considered one of the greatest difficulties in advertising photography, "how to capture a moment of reality just as you release the shutter. By reality I mean provoking an emotional reaction in your subject, making him spark into life."[73] The people are modeled in strong sunlight. For an informal effect Steichen abandoned his characteristic studio lights and extremes of light and shadow. His outdoor lighting also demonstrates Verichrome film's performance under the conditions most frequently encountered by amateurs. The ads persuade viewers that they can photograph as well as Steichen, thus reinforcing the goal of the campaign—to stimulate the general public to take snapshots.[74]

In the trio of images from the 1933 series two figures look at snapshots that engage them, entertain them, and act as an agent to strengthen the bond between them (see Figs. 4.18, 4.19; see Plate 2). The figures in the photographs represent stereotypes of the stages of life: the child, the young lovers, the new family, the grandfather. All are white, middle-class, and blond.

This homogeneity reflects the ethnicity, class, education, and lifestyle of those who created the advertisements. Roland Marchand's study of advertising industry practitioners between the world wars found them overwhelmingly male and white. There were only a handful of Jewish advertising professionals before World War II and virtually none of Italian, Polish, or African descent. Advertising staff were further removed from the "average Americans" they profiled: they had much-higher-than-average salaries, were generally college graduates, and lived in eastern cities, particularly New York.[75] Steichen's figures represent the new consumers, better-off than most whom advertisers had targeted.

These characters translate into visual form the 1930s paradigms for an ideal American family. They are an early media-created stereotype of family life. But Steichen, I suspect, saw these works as human interest photographs, which highlighted the American esteem for the nuclear family. In this regard they portend his fascination with the subject, which culminated in his *Family of Man* exhibition at the Museum of Modern Art in the 1950s.

STEICHEN'S WORK for Kodak was but a small portion of the company's overall advertising. The Thompson agency ran five separate Kodak product campaigns simultaneously.[76] The sentimentality of Steichen's Kodak advertisements comes into sharp relief when this work is compared with the advertising for technical products that Kodak and the Thompson agency placed in the trade press. To sell its industrial line, Kodak relied on a sales pitch and photographic style that echoed 1920s realism, but without any pretensions to high-art status. The photographs in these ads have none of the warmth of Steichen's.

The advertisement for the Eastman clinical camera outfit placed in *Hospital Progress* graphically illustrates the medical uses of photography (Fig. 4.20). The pictures

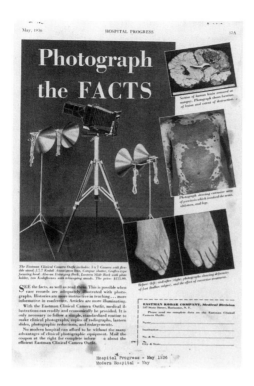

4.20 Advertisement for Eastman clinical
camera outfit, *Hospital Progress,* May
1936, p. 37A. Photographer unknown
(J. Walter Thompson).

carry out the command of the headline by carefully describing a deformed foot, extensive psoriasis, and a dissected brain. These informational photographs have been taken with the camera equipment advertised. The text details the advantages of the visual over the verbal for accurately conveying medical information.

In an advertisement from the *American Bankers Association Journal,* a woman repetitiously operates the Recordak, a primitive microfilming machine developed by Kodak in the late 1920s (Fig. 4.21), while her two male supervisors look on. The copy claims the accuracy of film saves the bank from error and unnecessary expense. Unlike Steichen's American family snapshots or other images in the mass media, the trade press Recordak photograph does not ask viewers to identify with the three figures, who pose stiffly and conventionally around the center of attention, the machine.

Kodak's clinical camera outfit and the Recordak promised the solution to medical and corporate needs for accurate recording; Verichrome film provided sentimental memories as well as accuracy. These divergent goals are manifested in the photographic style of the ads as well as in their sales strategy; the trade magazines, which use an older documentary style, make the subjectivity of Steichen's naturalism clear.

Although Steichen was pleased with the "naturalism" of his work for Kodak, in the industry these advertisements were not considered exceptionally effective, and

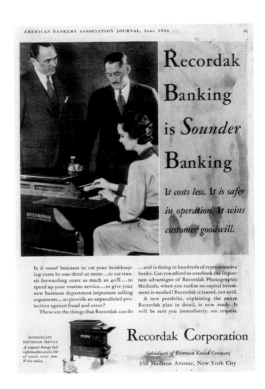

4.21 Advertisement for Recordak Corporation, subsidiary of Eastman Kodak, *American Bankers Association Journal*, June 1933, p. 31. Photographer unknown (J. Walter Thompson).

the images neither developed the expected popular appeal nor influenced other advertising images of the period.[77] Nor did the style come to dominate Steichen's own work; images that called attention to their construction of fantasy were in far greater demand in the 1930s. And Steichen was a leader in translating this new strategy into visual form, making more explicit and even celebrating the emotive and manipulative qualities of the image.

Before examining Steichen's photographic fantasies and melodramas, we look in the chapter that follows at other elements that Steichen added to his vocabulary in the late 1920s and early 1930s with his still life advertising photography and his experiments in modernist product design. Steichen soon left behind his subtle old-master still lifes like the Welch's grape juice compositions, which had employed just a few modernist references, and he pushed his straight photography toward more severe, abstract modernist composition and clarity, which clients came to see as signifying sophistication and "class."

Plates

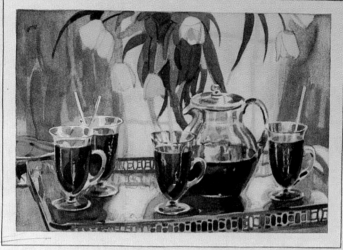

Plate 1 Advertisement for Welch's grape juice, *Ladies' Home Journal,* June 1926, p. 176. With painting of Steichen photograph, illustrator unknown (J. Walter Thompson).

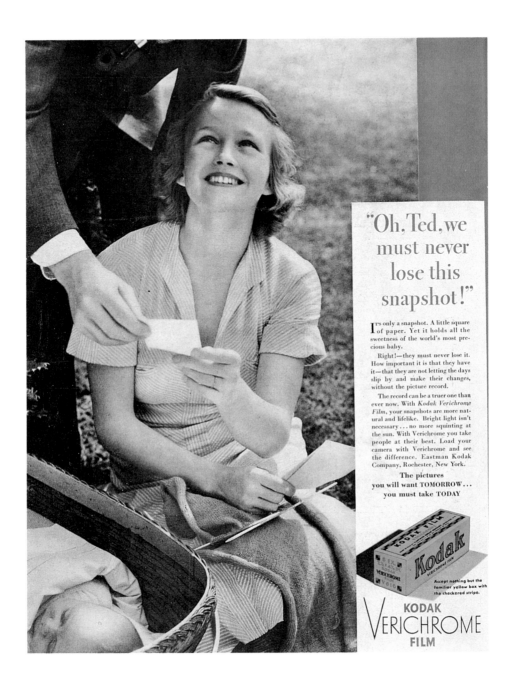

Plate 2 Advertisement for Kodak Verichrome film, *Ladies' Home Journal*, June 1934, p. 136. Edward Steichen, photographer; John Scott, art director (J. Walter Thompson).

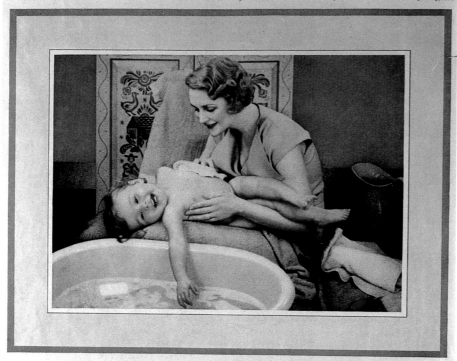

Take it from JANE!

your soap isn't beauty soap unless it's pure enough for a baby's skin . . .

This water-baby is Jane! She's apt to giggle when she's asked how she grew that beautiful skin. But you'll notice that the giddy girl is reaching for IVORY, so her heart's really in the right place.

Jane's soft pink skin has always been mighty fortunate because her doctor recommended Ivory. But is your complexion as lucky? Do you actually realize the slow damage an impure soap can do?

Day after day, an impure soap slowly coarsens your naturally smooth, fresh skin . . .

And you can't tell whether a soap is pure just by its looks, you know. A "pretty" cake of soap may be just the one that contains drying free alkali or irritating free fatty acids.

How can you be sure? Take it from Jane that Ivory can help you win a clear smooth freshness, because Ivory is *pure*. And yourself can prove it—

Lift up your hands and check off these points on your fingers. *No* free alkali in gentle Ivory. *No* free fatty acids in soothing Ivory. *No* color (dye). *No* bleach in Ivory's natural creaminess. *No* clinging perfume in Ivory—nothing that is coarsening or drying!

When you tuck Guest Ivory near your washbowl, and station the bigger Ivory by your bath tub, you're all set for a safer, surer beauty course. And Ivory's purity costs so little!

Keep a baby-clear complexion with the baby's beauty treatment · 99 $^{44}/_{100}$% pure IVORY SOAP

Plate 3 Advertisement for Ivory soap, *Ladies' Home Journal*, January 1934, inside cover. Edward Steichen, photographer.

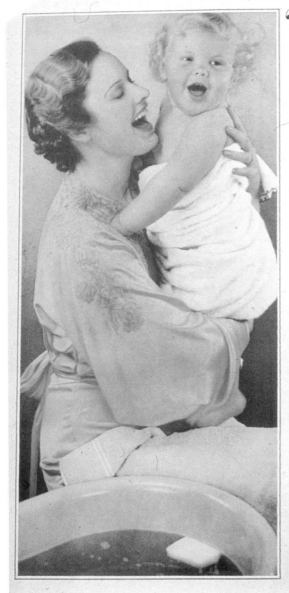

Plate 4 Advertisement for Ivory soap, *Ladies' Home Journal*, March 1934, inside cover. Edward Steichen, photographer.

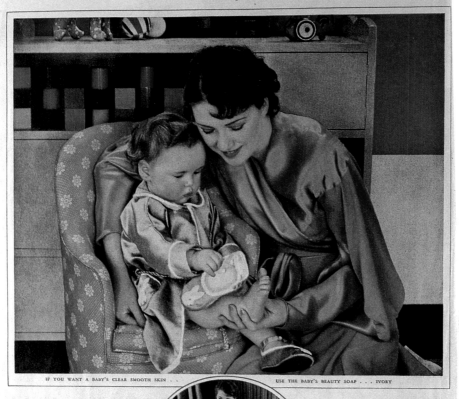

IF YOU WANT A BABY'S CLEAR SMOOTH SKIN . . USE THE BABY'S BEAUTY SOAP . . . IVORY

Beauty Story..
for little girls
..and Big Girls

Supposing we start with Jean's beauty story. She's the little girl in green with the kiss-me-please skin. She is so young that we'll speak her piece for her—*every bit of Jean gets an Ivory bath every day.*

And the same beauty story belongs to big girls, too. The more grown-up, the better! Just stop your ears when anyone tells you that beauty care stops at the chin. Your complexion and your skin should be all of one beautiful piece, and both need the same gentle care!

So take care of both your face and body—every day—in your Ivory bath. Work Ivory's gentle foam into every pore of your face. Then continue your Ivory-Soaping until all your skin is refreshed and glowing. This arouses the circulation, while pure Ivory purifies the pores—and sweetens the skin!

And why is Ivory the finest soap that can float in your bath and touch your face? Oh,

shame on you for not knowing! Ivory is the pure *white* soap that doctors advise for a baby's sensitive skin. It contains no "fixings"— no color, no clinging perfume. So it doesn't dry out the youthful oils that keep the skin fresh and smooth. Ivory will guard your charm as gently as if you were a baby!

99 44/100 % PURE · · IT FLOATS

Ivory Soap

Plate 5 Advertisement for Ivory soap, *Ladies' Home Journal*, September 1933, inside cover. Edward Steichen, photographer.

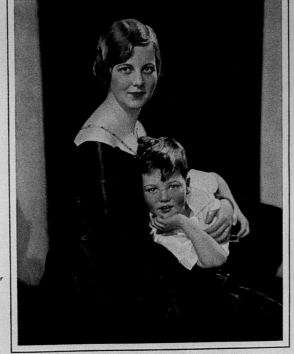

Plate 6 Advertisement for Woodbury's facial soap (Mrs. Richard O'Connor), *Ladies' Home Journal*, July 1929, p. 29. Edward Steichen, photographer (J. Walter Thompson).

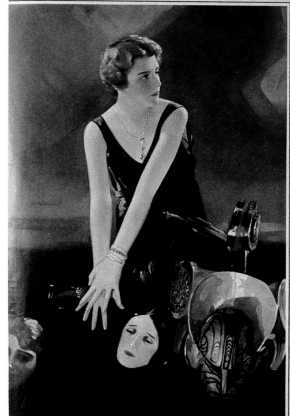

VOTED THE MOST BEAUTIFUL WOMAN IN THE ARTS

by John Barrymore
Cornelius Vanderbilt, Jr.
F. Scott Fitzgerald

"BEWILDERING"—the judges found their task when it came to choosing the most beautiful woman in the arts among users of Woodbury's Facial Soap.

Every type, every locality, seemed to be represented. There was a slim little golden-haired dancer from California. There was a grave-faced young violinist from Pennsylvania, with a head that might have been engraved on a Greek coin. There was a curly-haired art student from Kansas City—a tall young sculptress from Connecticut—and out of San Antonio, Texas, came the lovely laughing face of a singer of Spanish folk songs.

From hundreds of entrants the judges chose Miss Julia Evans, a young dramatic student of St. Louis.

<p style="text-align:center">★</p>

Her beauty is very distinguished, very individual, with something rich and golden about it that somehow suggests the rippling play of light on Western wheat-fields. Long lovely lines that give her most unconscious attitudes a wonderful plastic grace—a slightly husky contralto voice full of haunting undertones and overtones—a face as beautifully modeled as a statue's, but warm with color and life.

She is a member of "The Players" of St. Louis and has played in various amateur productions. She is "serious" about the stage—hopes to act professionally some day—and is all on the side of the revolutionists in drama.

When asked about her lovely skin—fair, warm in color, as if the sun had given it just a hint of the gold that is in her hair and in her voice—Miss Evans said that she had used Woodbury's for years, and that she found it matchless for keeping her skin in good condition.

"I know Woodbury's must be absolutely pure, for while other soaps have a tendency to irritate my skin, Woodbury's has just the opposite effect. It gives it an almost velvety softness. I love the feeling of my skin right after I have used Woodbury's—refreshed, invigorated—deliciously smooth."

FROM all over the country their letters come to us—letters from the beautiful girls and women of every community—telling how Woodbury's Facial Soap has benefited their skin. Only a few of their photographs can be printed in this series—only an indication of the thousands of women throughout America whom Woodbury's has helped to gain and keep a fresh, clear, flawless complexion. Get a cake of this wonderful soap today and see how much it will do for *your* skin. *You, too, can have the charm of "A Skin You Love to Touch!"*

WE SHALL BE HAPPY to send you a delightful Woodbury set, containing a trial cake of Woodbury's Facial Soap, Facial Cream and Powder, Cold Cream, treatment booklet, and directions for the new complete Woodbury Facial, for 10 cents and your name and address. The Andrew Jergens Co., 1817 Alfred St., Cincinnati, Ohio. For Canada, The Andrew Jergens Co., Ltd., 1817 Sherbrooke St., Perth, Ont.
© 1929, The A. J. Co.

MISS JULIA EVANS, *of St. Louis, Missouri, chosen from among Woodbury beauties of forty-eight States as the most beautiful woman in the arts. She is photographed here with the famous Benda masks.*

JOHN BARRYMORE CORNELIUS VANDERBILT, JR. F. SCOTT FITZGERALD

Plate 7 Advertisement for Woodbury's facial soap (Miss Julia Evans), *Ladies' Home Journal,* September 1929, p. 41. Edward Steichen, photographer (J. Walter Thompson).

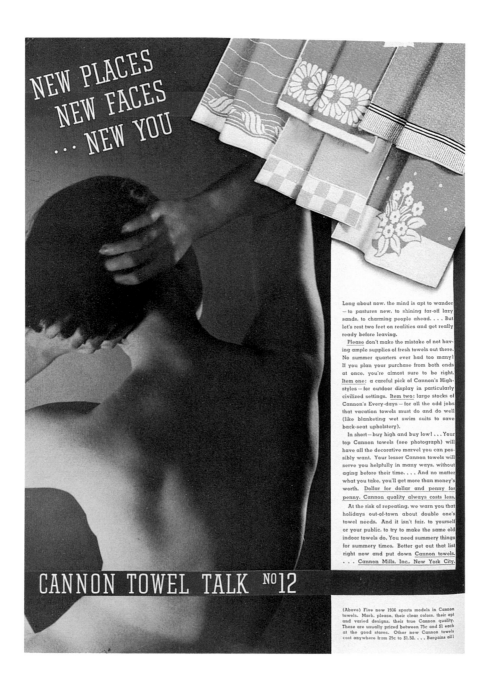

Plate 8 Advertisement for Cannon towels, *Vogue*, June 15, 1936, inside cover. Edward Steichen, photographer; Charles T. Coiner and Paul Darrow, art directors (N. W. Ayer and Son).

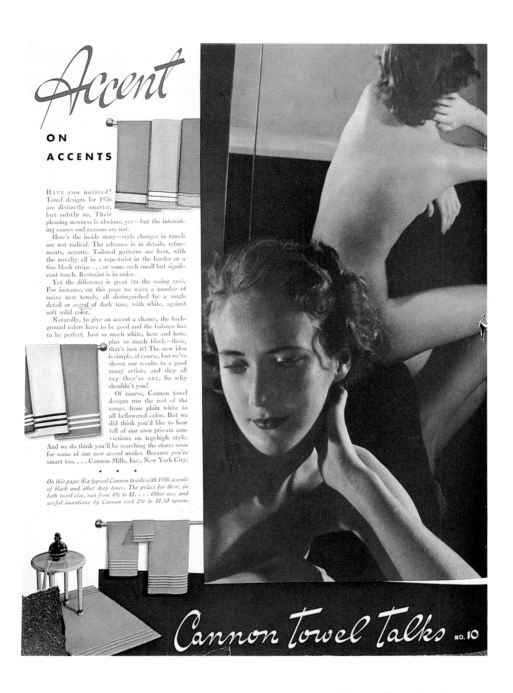

Accent

ON ACCENTS

HAVE you noticed? Towel designs for 1936 are distinctly smarter, but subtly so. Their pleasing newness is obvious, yes—but the interesting causes and reasons are not.

Here's the inside story—style changes in towels are not radical. The advance is in details, refinements, accents. Tailored patterns are best, with the novelty all in a rope-twist in the border or a fine black stripe . . . or some such small but significant touch. Restraint is in order.

Yet the difference is great (to the seeing eye). For instance, on this page we wave a number of suave new towels, all distinguished by a single detail or *accent* of dark tone, with white, against soft solid color.

Naturally, to give an accent a chance, the background colors have to be good and the balance has to be perfect. Just so much white, here and here, plus so much black—there, that's just it! The new idea is simple, of course, but we've shown our results to a good many artists, and they all say they're ART. So why shouldn't you!

Of course, Cannon towel designs run the rest of the range, from plain white to all beflowered color. But we did think you'd like to hear tell of our own private convictions on top-high style.

And we do think you'll be searching the stores soon for some of our new *accent* modes. Because you're smart too. . . . Cannon Mills, Inc., New York City.

• • •

On this page: Six typical Cannon towels with 1936 accents of black and other deep tones. The prices for these, in bath towel size, run from 49c to $1. . . . Other new and useful inventions by Cannon cost 29c to $1.50 apiece.

Cannon Towel Talks NO. 10

Plate 9 Advertisement for Cannon towels, *Vogue*, March 1, 1936, inside cover. Edward Steichen, photographer; Charles T. Coiner and Paul Darrow, art directors (N. W. Ayer and Son).

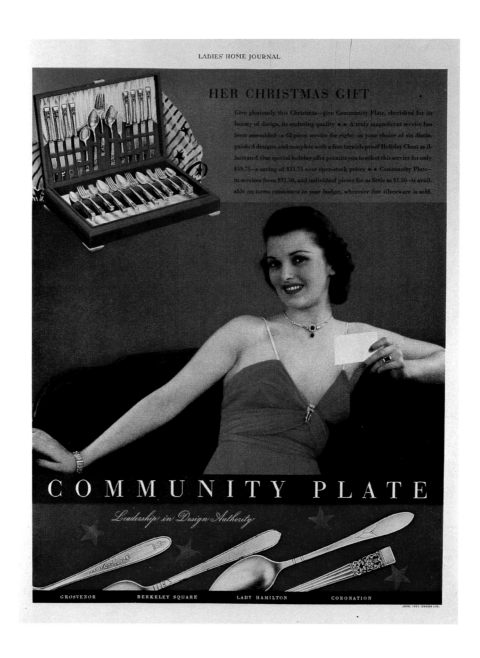

Plate 10 Advertisement for Oneida Community Plate, *Ladies' Home Journal*, January 1938, p. 45. Edward Steichen, photographer.

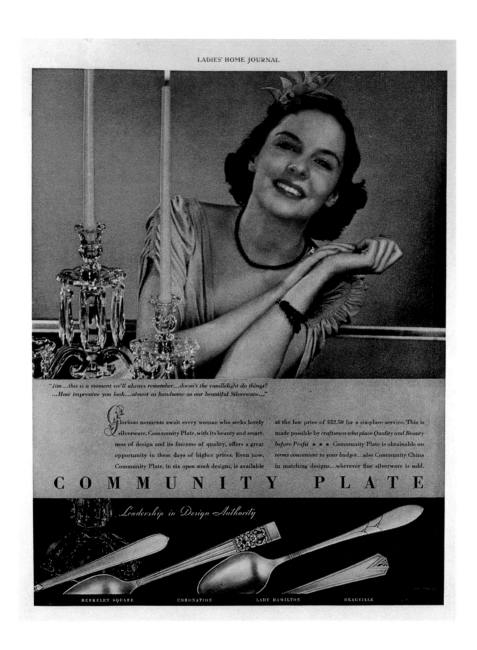

Plate 11 Advertisement for Oneida Community Plate, *Ladies' Home Journal,* December 1937, p. 83. Edward Steichen, photographer.

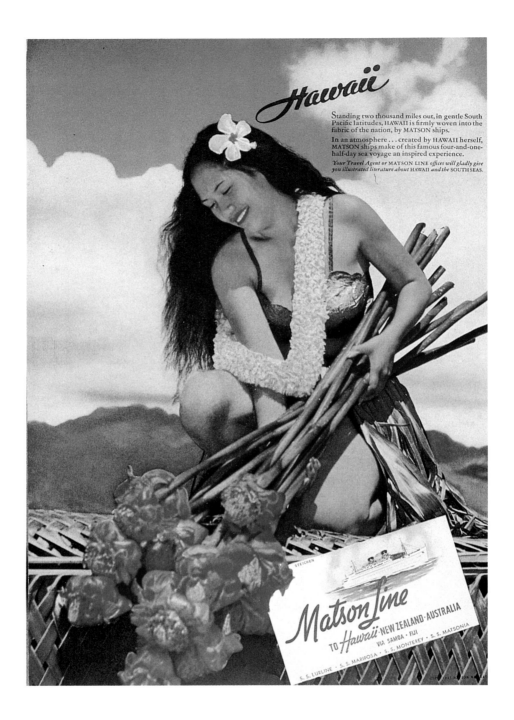

Plate 12 Advertisement for Matson Line cruises, *Vogue,* November 1, 1941, inside cover. Edward
Steichen, photographer; Lloyd B. Meyers, art director (Bowman Deute Cummings).

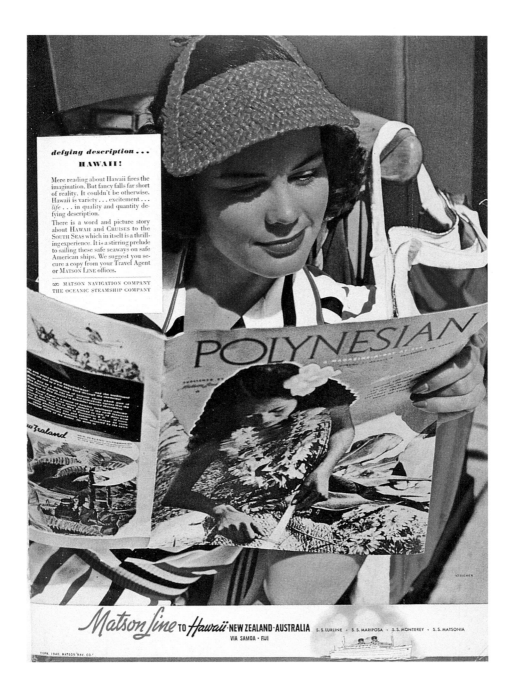

Plate 13 Advertisement for Matson Line cruises, *Harper's Bazaar*, March 1940, inside back cover.
Edward Steichen, photographer; Lloyd B. Meyers, art director (Bowman Deute Cummings).

The Modern Look in Advertising Photography and Product Design

The world of American consumerism portrayed in the media during the 1920s and 1930s was a fast-paced, self-consciously "modern" world. New technologies, new consumer goods, and new attitudes created this "complete change in tempo."[1] The public was treated to such new developments as "buses, tabloids, air mail, refrigeration, pale ginger ale, traffic lights, public discussion of 'personal hygiene,' four-wheel brakes, skyscrapers, cooperative apartments, vending machines, wirephotos, [and] oil heaters."[2]

Modernity quickly infiltrated both the fine art and commercial spheres. Painters such as Stuart Davis and Gerald Murphy developed a clean precisionist style with iconography drawn from the newly available products, and commercial illustrators absorbed the simplified shapes and designs of the new abstract painting to push their drawings further toward abstraction. The interaction was quick and intense; Steichen's art director Gordon Aymar commented in 1929 that "a startling exhibition of contemporary art" will show up in the magazines "the following month or two."[3] This may be the moment in American design history—when art directors so strongly asserted a modernist vocabulary in the late 1920s and early 1930s—that the fine and commercial arts were closest together, the borders most blurred, and the exchanges most entangled.

The new visual language expressing modernity in the fine arts had been solidly established before World War I. European and American artists had devised a variety of formally inventive modernist painting styles—expressionism, cubism, abstraction, and others—to depict culture in the twentieth century. Concurrent with these developments in painting, modernism also appeared in photography. As we have seen, the fine art style of straight photography, particularly the simplified and direct forms of Paul Strand promoted by Alfred Stieglitz, transformed into art the unmanipulated photography of nineteenth-century documentation and commerce that pictorialism had rejected.

Commercial photography developed its own variants of modernism. It was worked out first in still life compositions (advertisements that featured an image of the product itself), then translated into figural work. As the graphic designer Frank Young observed, by 1930 "realistic pictures" were forced out, abstract forms brought in. Emphasis on "the significance of the picture" replaced "unnecessary details."[4] And the simplification of the image extended to the entire design. The geometry of precisionism, cubism, and art deco that was nascent in the magazines of the 1920s dominated layouts and typography by the end of the decade. Modernist industrial design developed simultaneously. This flowering of modernist vocabularies in imagery, graphic design, and industrial design demonstrates the accessibility of the style for popular audiences. It issues a direct challenge to the predominant linear histories of photography: commercial photography may be seen as an alternative pathway to modernism in American visual culture.[5]

"The majority of advertisers are demanding the newer technique," Frank Young declared.[6] The trade press, which drove the swift stylistic revolution, attributed modernism's success as a sales tool to its newness. Earnest Elmo Calkins, the advertising agency president and prolific chronicler of advertising history, saw the origins of modernism in advertising in an "effort to be different, to find a new pattern to attract the eye and intrigue the mind of the indifferent advertisement scanner . . . rather than a deeper and more philosophical motive."[7] And the adman W. H. Beatty noted that modernism would succeed by virtue of its "sheer novelty."[8] But novelty alone cannot explain why the modernist style quickly crowded out pictorialism and "realism." Cultural factors were also at work.

Because Americans accepted modernism as a natural expression of their times, the style became an effective selling tool. Frank Young argued that advertising had to use "the most advanced technique in art" to impress "modern minds."[9] Calkins observed that "modern art, when it is really modern and really art, is admirably adapted to expressing modern goods, and influencing the minds of people to possess them."[10] Modernism gained currency in the commercial world because contemporary society was widely and self-consciously perceived as modern.

The workings of modernism in advertising were double-edged. Modernist advertising presented stylish, expensive goods with panache. The impression of exclusivity, however, was precisely what appealed to great masses of consumers. Just as

wealthy socialites' testimonials made dime store cosmetics into symbols of prestige for status-seeking consumers, the severe and polished style of modernism, which implied selectivity, in fact created great popular appeal. Some of the exclusivity of the new modernism can be attributed to simple economics. The capital-intensive nature of manufacturing—the great investment required in tool and die and other heavy equipment—led industries to try out their new styling ideas on more expensive consumer goods. Thus, at first, only the wealthy had the opportunity to acquire the new modernist-design products. Once the style's popularity and desirability were established, manufacturers implemented less expensive and much larger runs of products. Presumably these mass-produced items resonated with some of the cachet of their prototypes.[11]

The direction of influence worked in the reverse as well. As Thomas Crow has argued, modernism in the visual arts often borrowed from and then transformed popular culture. The recognition of these elements, and their repackaging, made the modernist advertisement attractive to a large public.[12]

By the 1930s manufacturers had no fear that the look and language of modernist advertising would pass over the heads of consumers. "Department stores are the museums of today," claimed one executive.[13] It was now impossible to be too high-style for consumers. In 1932 the designers and industry analysts Roy Sheldon and Egmont Arens announced that "styling down to the masses is a thing of the past." Modernism itself was an expression of democracy: the artist once "had to please a single cultivated patron. . . . Now he must sell the American housewife."[14] And housewives seemed ready for modernism. The home economist Christine Frederick told advertisers in 1929 that "millions of women" now "thrill over the new modernistic art," primarily because it expressed "the American idea and spirit."[15]

Although many American designers, and observers such as Frederick, laid nationalistic claim to modernist design, the commercial variants of modernism had roots on both sides of the Atlantic. The Paris Exposition of Modern Decorative and Industrial Arts in 1925 emphasized contemporary designs. The United States refused the invitation to participate because the manufacturers polled by then Secretary of Commerce Herbert Hoover told him there were not enough unique or well-designed American consumer goods produced to constitute a national style of industrial design. The United States did send a special commission made up of trade association members, architects, and designers to view the exhibition. Because many other designers visited it independently and it received wide press coverage, the exhibition spurred modernist design in the United States. Magazines covered the new "modernism" in European consumer goods and furniture design. The 1927 Machine Age Exposition in Steinway Hall drew large crowds to view photographs, drawings, architectural models, and industrial designs created in the new style. Major department stores held shows of available goods styled in the new design, and by 1928 the modernist movement was in full swing in the expensive New York retail world.[16]

In their transatlantic journey, the cultural meanings embedded in modernism

proved malleable. Any radical social or personal artistic message inherent in the archetypal fine art style could easily be reshaped or stripped away. Brilliant formal innovation could stand on its own. European fine art modernism was too theoretical, too elusive, too abstract, and its form too tenuously tied to its philosophy to retain its original meanings when it entered the American corporate world. Now, as in the 1920s, one wonders how relevant Mondrian's neoplasticism and theosophy are to adaptations of his signature, primary-colored geometric compositions to kitchen cabinets, tee shirts, or commodity packaging.[17]

With its importation into the United States, modernism in both fine and applied arts gained new forms and meanings expressive of contemporary American culture. Growing out of European fine arts precedents, modernist fine art in the United States was often colored by indigenous visual culture influences. For example, Charles Sheeler included quilts and Shaker and colonial furniture in his precisionist studies of room interiors; Marsden Hartley made geometric abstractions that derive their distinctive character through their marriage of cubism with Native American art and design. These formal influences had an impact in commercial art as well.[18]

Steichen quickly assimilated the modernist vocabulary to adopt a highly effective commercial expression. His modernist still life studies of the 1920s and 1930s for Douglass lighters, Gorham silver, and Steinway pianos build on the modernist experiments of other contemporary commercial photographers such as Steiner and Outerbridge. In the 1930s he applied the modernist language to the human form to produce his most celebrated commercial images. His interest in the product itself as a work of art intensified in the late 1920s, and he tried his hand at industrial design, attracted, perhaps, by the emerging importance of professional designers in manufacturing and advertising. This work gave him an opportunity to examine issues of art and design in a context where the needs and desires of a mass audience had to be met. Industrial design and product imagery in advertising photography became additional ways for Steichen to bring a modernist vocabulary to the general public.

THE PRODUCT AS MONUMENTAL OBJECT
AT THE WHITE SCHOOL

Among the precedents Steichen drew on for a modernist representation of the product as a monumental object was the work of other commercial photographers who had been students at the Clarence H. White School of Photography. They had developed abstract pictorial strategies for depicting objects in a "cubist-derived, art deco style of photography especially suited to the demands of advertising."[19] This style, practiced most successfully in the early 1920s by Paul Outerbridge and Ralph Steiner, grew out of the White School's rigorous curriculum, which stressed compositional exercises and (as Steiner complained in later years) "design, design, de-

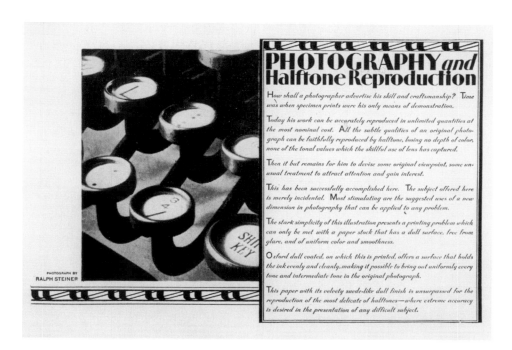

5.1 Advertisement for the Oxford Paper Company, *Annual of Advertising Art*, 1929, p. 132. Ralph
 Steiner, photographer.

sign."[20] One of the major significances of the work produced at the White School
was that it had both commercial and fine art roots.

Steiner remembered taking his most frequently reproduced picture, *Typewriter,*
in 1922 as a compositional assignment at White's school with a pictorialist lens
stopped down to make the print as sharp as possible. Seven years later, the photo-
graph won an Art Directors' Club medal when it was used in an advertisement for
the Oxford Paper Company (Fig. 5.1). Steiner's oblique close-up derives from the
emphasis on Japanese composition transmitted through Arthur Wesley Dow and his
mentor, Ernest Fenollosa, to Clarence White, then to his students.[21] But that ele-
ment, along with the strong emphasis on the geometric construction of the keys,
also signals a clear understanding of the principles of modernist straight photogra-
phy. The graphic designer Frank Young praised the "modernistic effect" of this im-
age in his 1930 textbook. Although "only a small portion of the machine is shown,
everything in the photograph has significance and more was not needed to say 'type-
writer.'" Young was impressed not only with its concentration of meaning but also
with the "decorative qualities" of the shape of the keys.[22]

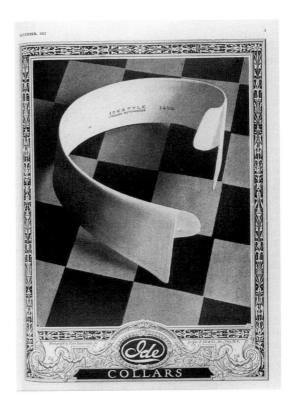

5.2 Advertisement for Ide collars,
Vanity Fair, November 1922, p. 5.
Paul Outerbridge, Jr.,
photographer.

Paul Outerbridge also took his well-known *Ide Shirt Collar* during his years as a
student at White's school (Fig. 5.2). The image, commissioned by the client, was
not a class project, but *Ide Shirt Collar* nonetheless exemplifies the principles of
design and composition taught in classes at White's school that established Outer-
bridge as a successful commercial photographer: close-up examination of the prod-
uct, simplified abstracted form, geometrically constructed compositional design,
and oblique perspective. The strong design in this work results from Outerbridge's
high vantage point and the dramatic contrast between the organic shape of the collar
and the rigid geometric checkerboard. Although abstract, the photograph evokes
empathy. Bonnie Yochelson has traced this emotional reaction to Outerbridge's for-
mal choices: "The elegant curve and subtle modeling of the collar suggest the ele-
gance of the wearer. The sharp focus permits the legibility of the trade name inside
the collar as well as the neck size, 14¾, of the slim imaginary owner. In an instant
the necessary information and the temptation to buy are conveyed." [23] Ironically, the
modernity of the image was not carried through the entire ad: in it the photograph
was surrounded with an outdated logo and a stylized Arts and Crafts border.

In *Bracelets,* photographed for newspaper ads for the R. H. Macy department

store but frequently reproduced as an art photograph, Outerbridge used a spotlight and constructed the composition from the resultant strong shadows to give the jewelry an aura of preciousness (Fig. 5.3).[24] This was a signature Steichen technique, visible in his Douglass lighters advertisements as well as in a number of *Vanity Fair* celebrity portraits from the 1920s. It demonstrates the cross-influences among individual photographers and between the fine and applied arts during this decade of modernist experimentation.

Despite their concentration on formal structure, Outerbridge's advertisements sold the product's modernity, persuading the consumer with an implicit "story" of elegance and social activity. Studies of Outerbridge's work discuss both *Ide Shirt Collar* and *Bracelets* as simply advanced formal constructions and correctly insist that Outerbridge's advertising photographs are art. That these studies pass swiftly over Outerbridge's advertising career to emphasize his later surrealistic nude studies and ignore the integral cross-influences between the fine art and the commercial worlds, however, reveals a recurrent modernist theme, in which commercial photography is thought to be art corrupted by the marketplace, more artistically conser-

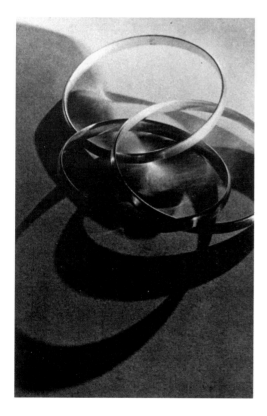

5.3 *Bracelets,* advertisement for R. H. Macy, *Pictorial Photography in America,* 1926, n.p. Paul Outerbridge, Jr., photographer.

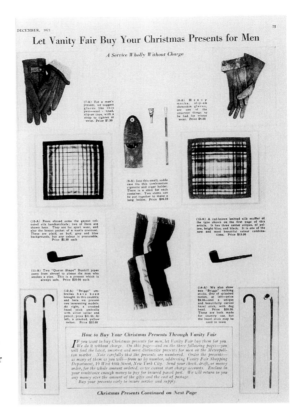

5.4 Editorial page, "Let Vanity Fair Buy Your Christmas Presents for Men," *Vanity Fair,* December 1921, p. 75. Photographer unknown.

vative than fine art photography, a constraint on the artist's creativity, and a drag on the artist's reputation. Howe and Markham, for instance, argue that Outerbridge "kept his photographs uncompromised by the commercial illustrative and advertising market to which most of his work was sold."[25] But if the modernism of Outerbridge's work had disturbed the commercial market, that work would not have been in such demand; instead, advertising agencies, clients, and magazine editors recognized modernism as an effective selling tool.

In addition to their roots in the abstract design exercises practiced at White's school, the modernist advertising photographs of Outerbridge and Steiner may also have grown out of the documentary tradition of photography. The work of Lewis Hine, for example, stood in sharp relief against the pictorialists' soft, artistic compositions (cf. Figs. 4.8, 3.9). Early in the century, this documentary style had worked its way to the editorial and advertising pages of magazines where goods were described without hard-sell pressure. In such features as *Vanity Fair*'s December 1921 "Let Vanity Fair Buy Your Christmas Presents for Men" the descriptions are clinical, like those of a Sears catalogue (Fig. 5.4). Although such an article intends to create

a desire for quality material goods, it has none of the showy, soft focus of "atmosphere" advertising. Photographs like these, with their detached description, were certainly familiar to White's students; along with the emerging artistic straight photography of the period, they may have worked to move commercial photographers away from pictorialism.

STEICHEN'S MODERNIST STILL LIFES

Steichen's photographs for the Douglass lighter, Gorham silver, and Steinway piano campaigns draw on a combination of applied and fine art strategies to elevate the products to modernist icons. Echoing a common modernist practice, he isolates the product and works a transformation to encourage its reading as abstract form. At times he adopted the cubist-inspired fracturing of form and space associated with the stylized elegance of commercial art deco style. Alternately, he employed the monumental scale, close-up view, and striking vantage points that also characterize some modernist art photography.

In the Douglass lighter series, Steichen consolidated his modernist vocabulary (Figs. 5.5, 5.6). He capitalized on the angularity and simplicity of the product, no doubt in part at the agency's urging to emulate the art deco look of earlier drawn illustrations of the lighters that had already solidified a modern image for the product in the media (Fig. 5.7). As previewed here, light becomes a primary instrument of abstraction as well as expression for Steichen. To make the images he positioned the lighters against a white paper backdrop and used spotlights to construct a background pattern of light and shadow.[26] The resulting layered, fractured pattern recalls the dissection and reassembly of analytical cubism, a painting style for which Steichen had no fondness, though he employed its angularity and spatial flattening frequently in his fashion work of the late 1920s.[27] In his studio he had at least thirty different lighting appliances; they were, according to a visitor, "affixed to derricks and flash down from aloft, they peek out from every corner, they can be arranged so that they actually paint the subject of the photograph." Steichen explained: "We use light to dramatize, to build up. We use it to transform. We use it to express an idea."[28] Although no figure is present in the Douglass lighter photographs, the form suggests that the probable consumer is thin and graceful, much like the lighter itself: a well-manicured, stylish smoker, the male half of the "smart set" who read Condé Nast's magazines.

For the lighter series, Steichen intensified modernist elements he had explored more hesitantly in his photographs for Welch's grape juice: wide-ranging tones, clarity of form, sharp focus, and oblique perspective. In the Welch's grape juice images Steichen had favored a more subtle angle of vision reminiscent of late-nineteenth-century impressionism and retained an emphasis on textural detail that

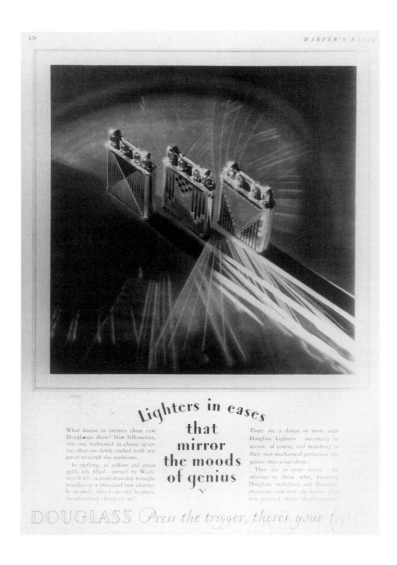

Lighters in cases
that
mirror
the moods
of genius

What finesse in artistry these new
Douglass show! Slim Silhouettes,
this one fashioned in chaste sever-
ity, that one deftly etched with tra-
ceries to catch the sunbeams.

In sterling, in yellow and green
gold, 14k filled—turned by Wads-
worth whose craftsmanship brought
watchcases a thousand new charms.
In enamels, inlaid, in odd leathers,
breathtaking things to see!

There are a dozen or more such
Douglass Lighters automatic in
action, of course, and matching in
their new mechanical perfection the
genius their cases show.

They are in your stores. An
offering to those who, knowing
Douglass usefulness and Douglass
precision, seek now the beauty that
fine personal things should possess.

DOUGLASS *Press the trigger, there's your light*

5.5 Advertisement for Douglass lighters, *Harper's Bazaar,* November 1928,
 p. 128. Edward Steichen, photographer (J. Walter Thompson).

encouraged art directors and the public to read them as realistic. By contrast, the
Douglass images rival the daring simplicity of the Outerbridge and Steiner advertis-
ing photographs and approach the radical vantage points explored in the fine arts
by other twentieth-century photographers such as Alvin Langdon Coburn, László
Moholy-Nagy, and Alexander Rodchenko. The bird's-eye view of the Steichen pho-

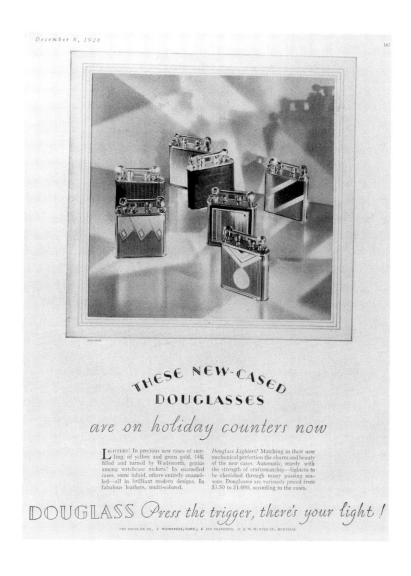

5.6 Advertisement for Douglass lighters, *Vogue*, December 8, 1928, p. 167.
Edward Steichen, photographer (J. Walter Thompson).

tographs also conforms to "modernistic" compositional preferences discussed later
in this chapter.

Steichen considered his photographic interpretation of the Douglass lighters one
of his more successful advertising commissions. It was included in Sandburg's
monograph *Steichen the Photographer,* and Steichen later gave a print from the

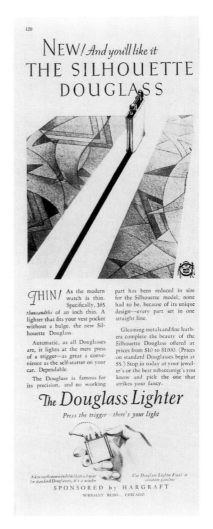

5.7 Advertisement for Douglass lighters, *Vanity Fair*, September 1927, p. 120. Illustrator unknown (J. Walter Thompson).

campaign to the Museum of Modern Art. This campaign is one of the few in which Steichen's work evidences the direct influence of a modern painting style; however, the photographer's response to cubism goes beyond a formalist exercise of style.[29] The simplified, angular, constructed images linked the product to wealth, sophistication, and refined taste. As such, these images function as indicators of media taste and transmit this new visual vocabulary to the public.

The 1930 Gorham silver campaign gave Steichen another opportunity to employ a modernist vocabulary. In each of the four published photographs the silverware is made monumental through artful arrangement combined with a direct approach to the object. In Figure 5.8 he monumentalizes the silverware through its isolation on

All the natural pride of owning Gorham sterling is yours for a modest expenditure

**A COMPLETE SERVICE FOR EIGHT
MAY BE HAD AS LOW AS $218**

THERE is both pride and pleasure in owning Gorham sterling table silver. You weave a spell of beauty, well-being—even luxury about your table. For a very modest sum it is entirely possible to own this lovely and distinguished Gorham sterling which has been the choice of the most discerning families for generations.

A complete service for eight, 76 pieces, can be had for less than $218. The beautiful Etruscan pattern illustrated below actually costs $234.

The established jeweler in your city will be glad to show you a wide variety of exquisite Gorham patterns in table silver, as well as many beautiful hollow-ware pieces in harmonizing designs. A new book, charmingly illustrated, written by Lilian M. Gunn, well-known authority on the etiquette of entertainment, is now ready. Fill out and mail the coupon below.

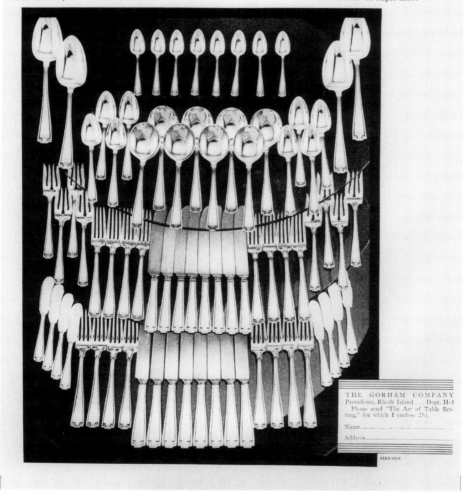

THE GORHAM COMPANY
Providence, Rhode Island . . . Dept. H-3
Please send "The Art of Table Setting," for which I enclose 25¢.

Name

Address

STEICHEN

5.8 Advertisement for the Gorham Company, *Vanity Fair*, June 1930, p. 89. Edward Steichen, photographer (J. Walter Thompson).

a simplified background, its crisply focused account, and rhythmic, totemic massing of like elements. At first glance the flatware looks as if it has been arranged against a wall and photographed straight on. There is some overlapping, but each individual fork, knife, and spoon retains its integrity. Closer inspection, however, reveals that the silverware has been arranged on glass shelves and photographed from above. The distance between the shelves disappears, leaving spatial ambiguity and the impression of a montage. A cardinal feature of analytical cubism, this intentional confusion of spatial relationships was a frequent device in advertisements around 1930.[30]

In another image from the Gorham Company series, Steichen continues the modernist preference for austere composition in once again reducing the image to rows of carefully arranged silver (Fig. 5.9). Overtones of drama and dynamism arise from the oblique camera angle, floating planes that slice through space like the nearly contemporaneous streamlined forms of the Douglas DC-2 aircraft.[31] In both Gorham photographs Steichen, while displaying a keen sensitivity to the design of the product, creates his own design.

Steichen continued to abstract the form of a product in his 1936 Steinway piano advertisements. These photographs eschewed the minute differences in texture and value that had characterized his Welch's grape juice images in favor of a more theatrical impact. Spotlighting, in tandem with a low eye level, conveys the grandeur and elegance of the instrument (Fig. 5.10), making an artistic photograph of a work of art. The art director Paul Darrow, who was present when Steichen took the Steinway photographs, remembered how Steichen, "already a photographic saint" when the N. W. Ayer and Son agency hired him to work on the Steinway account, photographed the instrument from all angles and was "enthusiastic about the Steinway piano as art."[32]

These three campaigns echo the preoccupation in contemporaneous American culture with the single object as a marker of the modernist style. Paul Strand wrote that a photographer should be informed first of all by "a real respect for the thing in front of him," and Strand's work of the 1920s typically studied the shapes and textures of nature at close range.[33] Edward Weston by 1927 had developed his matchless vegetable abstractions, with their anthropomorphic suggestions. The fascination with the thing itself was not limited to fine art photography. Modernist painters such as Georgia O'Keeffe found in the object its abstract essence. Imagist poets sought concrete images; modernist filmmakers pioneered the montage. As Jackson Lears has observed, by the 1920s modernist fascination with the object replaced Victorian sentiment: "What they did with those things varied: cubists fragmented and reassembled the object; imagists and surrealists juxtaposed radically dissimilar images in illogical structures. Rejecting a literalist referentiality, they nevertheless sought a new precision of form."[34]

Steichen's modernist product studies worked effectively for their clients, both because they delivered the au courant formal language that manufacturers saw as an

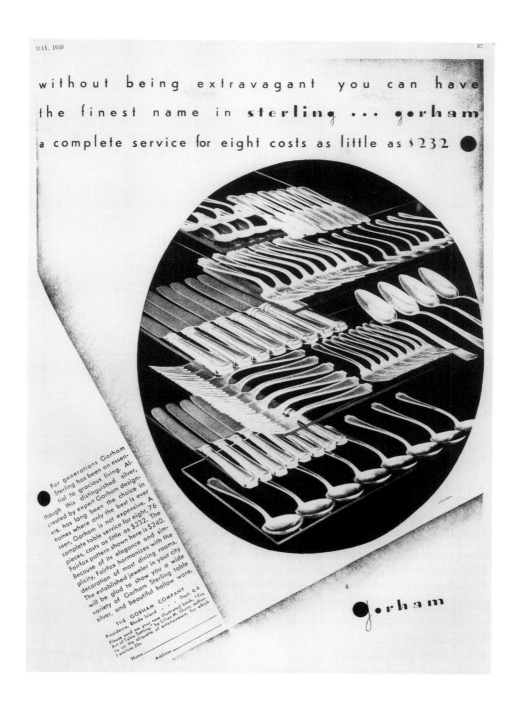

5.9 Advertisement for the Gorham Company, *Vanity Fair*, May 1930, p. 87. Edward Steichen, photographer (J. Walter Thompson).

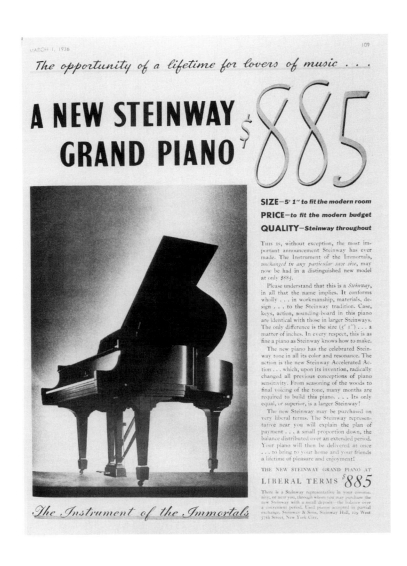

5.10 Advertisement for Steinway grand piano, *Vogue*, March 1, 1936, p. 109.
Edward Steichen, photographer; Charles T. Coiner, art director (N. W.
Ayer and Son).

analogue to the product and because his interpretation of the object alone evoked
images of a stylish and comfortable life. Represented in the new language, the prod-
uct itself was captivating enough to trigger fantasy, desire, and subsequent purchase.
Thus these product studies clearly worked on both the denotative and connotative
levels.

Modernistic photography is easily recognized by its
subject matter: Eggs (any style). Twenty shoes, stand-
ing in a row. A skyscraper, taken from a modernistic
angle.* Ten tea cups standing in a row. A factory chim-
ney seen through the ironwork of a railroad bridge
(modernistic angle). The eye of a fly enlarged 2000
times. The eye of an elephant (same size). The interior
of a watch. Three different heads of one lady superim-
posed. The interior of a garbage can. More eggs (mod-
ernistic age).

*If no skyscraper is available, try the Eiffel Tower.

 M. F. AGHA, "A Word on European Photography," 1929

In the span of a few years, in the late 1920s, the commercial photography sphere
developed a distinct application of modernist tenets that came to be identified as
modernistic. In its day, the term was in frequent use among art directors and trade
journal writers to identify the visual revolution taking place in the print media, and
art directors usually used the terms "modern" and "modernistic" interchangeably.
Because of its alternate lineage and its commercial service, "modernistic" photog-
raphy has received far less thoughtful analysis than its art photography counterpart.
Typically scholars have dismissed this art deco–influenced commercial manifesta-
tion of modernism as populist and derivative. Devaluing it on the grounds of formal
innovation, however, ignores its significance as a critical barometer of modernism's
inroads into popular visual culture. The lively industry debate that accompanied
the development of modernistic photography serves as a vehicle for tracking the
advertising industry's assimilation of modernist vocabularies as an expression of a
modern American cultural identity. While drawn to modernist photography for its
visual intrigue and affirmation of American technological advancement and eco-
nomic prosperity, advertising professionals struggled with its radical, abstract means
of visualizing these messages.

By 1929 "modernistic photography" was so established that Mehemed Fehmy
Agha, the former editor of Berlin *Vogue,* who had newly arrived in New York to
take the helm of Condé Nast's flagship, could gently tease its practitioners. Agha
had a strong modernist sensibility but found modernism's many imitators tiresome.
He worried that its "academic monotony" might "endanger the future of this type
of photography." [35] In a 1931 article, Agha, who was Steichen's art director for his
work at Condé Nast, identified the key features of modern photography as "signifi-
cant form" and "sublime detachment from 'story telling.'" [36] The term "significant
form," which acknowledges Clive Bell's original conceptualization of abstraction,
appeared frequently in the literature of commercial art in the late 1920s. [37] It indi-

cates that art directors accepted modernism for its expressive power as well as its novel attention-getting formal design.

The commercial idiom of modern photography favored an urban, technological context of imagery—skyscrapers, factories, the internal workings of mechanisms, serial repetitions of products—to convey the abundance and sophistication of modern American life. Its abstraction derived from dramatic scale enlargements, eccentric vantage points, and extreme simplification of form. Spatial ambiguity was favored, achieved either through montage overlays of images or the gravity-defying suspension of objects on plain grounds. Type designer Carl Greer's vigorous objections to the new "unconventionality" nonetheless offer a succinct graphic delineation of modernistic style: "The distortion of perspective and alteration of angle are two of its chief devices. Balance and proportion are thrown overboard; while simplicity, stark and asymmetrical, is an ideal."[38] Frank Young described these modernistic formal elements as "original effects which are obtained through peculiar lighting of the object, its greater creative ingenuity in combinations of exposures, and by the strange and interesting new perspectives used."[39] "Look-down views" were recommended because they showed more sides of an object than traditional straight-on perspectives.[40] Advertisers believed these visual idiosyncracies of modernistic photography grabbed the attention of would-be consumers of their products. The commercial Hollywood photographer Preston Duncan prized eccentric camera angles for their upsetting of "visual equilibrium": "Well done, 'freak' angles have great eye appeal and retention value because they first cause an impression of surprise in the observer, and then of discovery."[41]

Industry discussions about the relative merits of realism and modernism delineate the modernistic approach to subject matter and reveal the compelling commercial motivations for adopting modernistic photography. Oversimplifying the differences in their eagerness to make modernism saleable, proponents characterized realism as detailed and modernism as more abstracted. They allied realism with reportage and modernism with interpretation.[42] Content in modernistic photography shifted from a narrative to an evocative account that was the product of this abstract approach to form and composition combined with just enough information about the product for "getting over the story," as Steichen explained.[43] Addressing the New York convention of the Photographers' Association of America in 1927, Lejaren à Hiller criticized the narrow literalness of realism and praised the suggestive, imaginative quality of content in modernistic photography: "A few years ago advertisements were purely literal photographs of objects themselves. Today we photograph in order to get into these things a little more of what is known as atmosphere."[44] W. M. Westervelt's photographs of hats for Dobbs and Company were praised in the trade press for just that evocative quality: "He gave each hat a personality, an atmosphere. Almost one might say that he invested each hat with a royal lineage of its own."[45]

As these commentaries also demonstrate, the advertising industry appreciated the

commercial viability of modernistic photography. The open-ended suggestibility of content meshed with their progressive sales tactics of persuasion. By bringing action and atmosphere to representations of inanimate objects, such photographs could trigger viewer fantasies about the fruits of ownership. As Steichen's modernist still lifes tacitly acknowledged, such representations build desire for the product by imputing membership to the purchaser in the group that would consume it.

While Agha worried about the possible loss of its radicality, other advertising professionals had reservations about its extremity in terms of its commercial viability and aesthetic quality. Whatever attention modernism secured, Carl Greer doubted that "type which cannot be read, or pictures which cannot be understood, are destined to survive. . . . [I]t does seem to me that once realism surrenders, the justification of art ceases to exist."[46] Other writers vacillated. Christine Frederick appreciated "the charm of pure line and high color" of "modernistic art" and thought that "a straight-down perspective" was "smart and modern" and "excellent for sophisticated foods and certain hospitality service." But raising the old issues of class versus mass consumers, she believed "the great majority of women are not yet ready for this too bizarre and revolutionary art form." She regretted that many designers had gone too far: "Nothing sold today is immune, and weird attempts many of these are! . . . No crime that could possibly be committed in the name of the new touchstone of *art moderne* has been left uncommitted."[47] Despite such reservations, because they were recognized as interpretive as well as formally innovative, modernistic photographs joined the growing cultural compendium of modernist architecture, industrial design, and even urban planning.

COMMERCIAL PHOTOGRAPHY AND INDUSTRIAL DESIGN

Steichen had his earliest freedom to use a spare modernism in his studies of products, both because others had paved the way and because advertisers recognized the need for a more contemporary look to complement goods that had been shaped by the new attention to industrial styling. Frequently, the fashionable form of the product suggested and reinforced the photographer's modernist treatment. Steichen's choice of a cubist-derived photographic style for the Douglass lighters, for example, was compatible with the art deco chevrons, diagonal bands, and rectangles ornamenting the product.

In their printed form Steichen's advertisements are in many ways as much artifacts of the Machine Age as their subjects. As we have seen, their visual strategies fit the modernist spirit of the new professionally designed industrial products. Further, the printed commercial photograph itself passed through mechanical processes reminiscent of those needed to bring an industrial designer's concept to material form. The reproduction process affected the photograph's tonal gradations, value contrasts,

and focus, like technology influenced industrial designs. Just as the industrial designer functioned as part of a team to bring the product into being, the commercial photographer worked with the advertising agency staff to create the printed page.

Steichen showed great concern for the presentation of his image on the page. He supported the simplified, dramatic layouts that M. F. Agha instituted at *Vogue* in 1929: bolder use of white space, asymmetrical placement of the photograph, and sans-serif type.[48] Often Steichen personally approved the *Vanity Fair* layouts that included his photographs. Most of the time he made images compatible with the art director's concept, but sometimes he influenced the art director's graphic decisions. On the Simmons mattress account, for example, he persuaded the art director to adopt a modernist sans-serif lowercase headline style for a more up-to-date look.[49]

In view of Steichen's keen interest in design, it is not surprising that he welcomed opportunities to design fabrics for the Stehli Silk Company, pianos for Hardman, Peck and Company, and glass for the Steuben Company. Industrial design was emerging as a profession in the late 1920s and early 1930s. Steichen was undoubtedly drawn to the field because it offered a high-profile outlet for his considerable administrative and aesthetic skills. The new designers garnered much media attention, and some became celebrities. The new emphasis on product and package design, which incorporated modernism into the styling of even the most common mass-produced consumer items, was compatible with Steichen's advertising art style and his democratic views. Advertising photography and industrial design, more than the fine arts, brought modernism to the general public.

THE DESIGNER Lucian Bernhard poetically described the new industrial designers, who combined "the eyes of a painter, the sensitiveness for shape of a sculptor, the love for materials of a craftsman, the feeling for construction of an engineer, together with a knowledge of the aesthetic possibilities of new materials." The designer, Bernhard thought, was an idealist who combined "efficiency" with "love and care."[50]

As the historian Jeffrey Meikle has noted, the first industrial designers "hoped to create a coherent environment for what they self-consciously referred to as 'the Machine Age.'" From the beginning there were close ties between the advertising industry and the new industrial design industry. "Industrial design was born of a lucky conjunction of a saturated market, which forced manufacturers to distinguish their products from others, and a new machine style, which provided motifs easily applied by designers and recognized by a sensitized public as 'modern.'" In the depths of the depression, moreover, new industrial design reflected a hope that technological progress would solve economic problems and reinforced a sense of optimism.[51]

The designers saw their charge as developing what the industrial designer Walter Dorwin Teague called a style "true to our time."[52] They turned to modernism as the

natural stylistic expression for their new endeavors and found inspiration for efficient, inexpensive, streamlined product design in new materials and production technologies. By the mid-1930s, with the new plastics and metal alloys, industrial designers and their clients discovered that ornamentation could be eliminated and products in the latest airflow silhouettes could be inexpensively manufactured.[53]

Many of the designers had begun their careers as advertising art directors, occasionally designing labels and packages for their clients. Although they acknowledged the need to generate sales, their professional literature stressed their desire to improve the public's aesthetic sense.[54] In insisting on the link between education and good design, the trade press echoed the rhetoric of advertising agencies in the 1920s. Industry insiders generally deplored the present level of public taste but agreed that better-quality commercial design was improving it. The art director Vaughn Flannery noted that anyone examining "the American scene with an eye to determining the taste of the public is letting himself in for a shock. Even those who have studied it first hand cannot believe how bad it is. . . . [But that] does not mean that it is not receptive to improvement, or that it is not improving. It is. What the public craves is guidance . . . from sources it respects, or is learning to respect."[55] The industrial designer Joseph Sinel echoed Flannery's view: "I think the mass responds readily to gaudy, tricky things. The mass is Coney-Island minded, at least in a great many things." But it does respond to "good design in clothes, in automobiles, in airplanes, in steamships, in banks, in public buildings, and in many articles for the home." Thus "the mass can be educated; indeed, is being educated—to a point where the merchant will have a difficult time disposing of goods that lack rudimentary taste. It is because I firmly believe the great consuming public is willing and often anxious to accept better design in the articles of necessity that I engage in the business of industrial design."[56]

The quest for modernist industrial design was closely related to a new business concept: "progressive obsolescence." The new styling would make what people owned seem old-fashioned and undesirable, no matter how serviceable. Obsolescence could spur sales of consumer goods regardless of economic conditions. In the relative boom year of 1929 Christine Frederick enthusiastically welcomed the concept "that goods should not be consumed up to their last ounce of usability." She believed that "Mrs. Consumer is happiest" if her consumption of goods keeps up with "improvements that science and art and machinery can make possible." A woman now expected only one season's wear from a garment and did "not want her clothes to last."[57] Style, Frederick thought, was more important to consumers than value.

The concept of obsolescence worked even in a depressed economy; many hoped that consumer demand for new design would keep the factories busy. But because consumers resistant to continually upgrading their belongings needed to be convinced to buy, advertisers made psychological appeals. Not only were the new styles

irresistible, but buying things was itself a patriotic act. The process envisioned was cyclical; once factories hummed again, the newly employed could afford new purchases. No sacrifice of resources was too great: "We still have tree-covered slopes to deforest and subterranean lakes of oil to tap."[58] It seemed that the American economy would be energized by a combination of creative waste and modernist style.

Like advertising, industrial design strove to make the client's product more appealing. Steichen's interest in industrial design seems a natural outgrowth of his work in commercial photography; in both areas he sought to develop new, exciting designs for a corporate client seeking a mass audience.

STEICHEN'S EXPERIMENTS IN INDUSTRIAL DESIGN: STEHLI SILKS AND HARDMAN, PECK PIANOS

Steichen was one of almost one hundred artists invited to design for the Americana Print series, which the Stehli Silk Company, a Swiss firm, intended for the American market.[59] The work of these artists ranged from regionalism to abstraction. Stehli's art director Kneeland (Ruzzie) Green met Steichen traveling to Europe on the *Isle de France* in 1926 and asked him to contribute the only photographic designs to the current Americana III series. Steichen was quick to accept and later thanked Green "for opening up this beautiful opportunity into a new field of photography."[60] In 1926 and 1927 Steichen prepared at least ten designs, which the company printed on fabric for women's dresses.[61]

Green explained the genesis of the print series: in the 1920s the public's taste became more sophisticated, and women grew tired of "conventional florals and polka-dots," while artists became interested in industrial design. Green noticed that some "American artists became aware that there was a good deal of drama in the American scene which could be given a wider expression than merely in formal canvases for the formal few." With the convergence of public demand for better design and artists willing to provide it, Green observed, "all that was needed was a manufacturer to come along, be broad-minded and courageous enough to say: 'Let's go!'" Green claimed that the Stehli Silk Company ensured the success of the project by giving each artist full rein to develop the most modern designs: "They merely told the artist to go ahead and break out with all the notions he had in his head about the story that contemporary American art should be telling the American people. . . . Here were designs for modern American women by modern American artists reflecting the modern American scene and temper just as vitally as Oberkampf's Toiles de Jouy told the story of eighteenth-century France, and as every true art has reflected its own age." Green encouraged the artists to explore modernism in their textile designs, arguing the public would accept contemporary, nonacademic

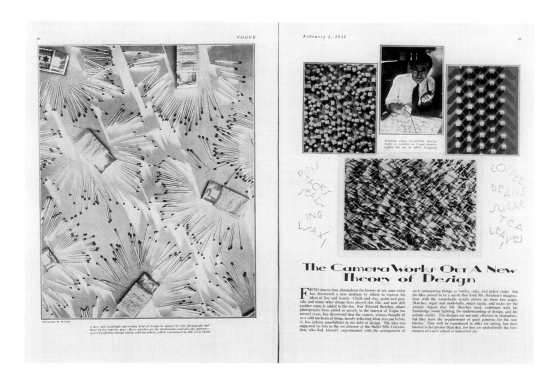

5.11 Double-page spread from *Vogue*, "The Camera Works Out a New Theory of Design,"
 February 1, 1927, pp. 60–61. Edward Steichen, photographer.

design because "art must be ever changing with the constant changing of people if
it is to be alive." [62]

Steichen's contribution to the series followed up on Green's own previous experi-
ments, made by arranging ordinary objects such as bottles, cans, and poker chips.
A double-page spread in *Vogue* featured four of Steichen's designs. In *Matches and
Match Boxes* (Fig. 5.11, left) Steichen arranged partly open match boxes, then
fanned single matches around them. The bursts of matches play off typical commer-
cial fabric patterns such as palm fronds. But Steichen's pattern has some contempo-
rary twists. The boxes are placed at regular intervals, while the matches around
them are arranged irregularly. Much like the play in cubist still lifes, Steichen broke
the rhythm by flipping over one of the boxes (top left corner), introducing typogra-
phy into the pattern and showing the viewer the origin of the abstract design.
Matches and Match Boxes also displays Steichen's characteristic bravura with light-
ing. By lowering the spotlights almost to the table surface, he made even the thin

match cast a shadow. As in his Douglass lighter advertisements, the contrast between light and shadow in the silk pattern constructs the abstract armature of the design.

While Steichen retained the integrity of the industrial object in *Matches and Match Boxes,* in a design created from tacks he moved the image another step from its ostensible subject toward a purely abstract design (right page, bottom). The tacks, which form the basis of the pattern, are barely identifiable in the photograph; strongly lit from two directions, they cast shadows that form a vibrant abstract pattern. Only with difficulty can one distinguish the strong, flat shadows from the frail three-dimensional objects. The other two silk designs featured in the article combine rhythmic arrangements of mothballs and sugar cubes, dramatically spotlighted to achieve sophisticated abstract motifs.

Steichen's silk experiments were widely praised in the media, perhaps because they were the only photographic designs in the series, but more probably because of Steichen's connections with editors and art directors. Frank Young included them in his design textbook *Modern Advertising Art.*[63] The article for *Vogue* credited Green's work as the "spark that fired Mr. Steichen's imagination" but attributed the "remarkable results" to the photographer's abilities: "Matches, sugar and mothballs, sugar again, and tacks are the prosaic objects that Mr. Steichen used, combined with his knowledge about lighting, his understanding of design, and his artistic ability." The *Vogue* article declared that Steichen's designs were "not only effective in themselves" but also "undoubtedly the forerunners of a new school of industrial art."[64]

A *Vanity Fair* article about Steichen's silk designs commended the company's choice of artist and praised Steichen's designs: "Observe how simple is this design, yet how satisfying and effective. When our readers behold this fabric of gold brocade in the shops of New York we implore them to purchase it, if only to see that good art, when entrusted to the right man, is often inspired by the simplest and most everyday subjects."[65]

Steichen promoted these works, no doubt seeing them as fulfilling the same "democratic" desire for a wide audience he had often cited to defend his entry into advertising photography. Just as advertising suited this commercial age, he saw photographically generated fabric designs as suited to the industrial age. In using semiabstract designs for mass-produced objects, he confirmed the prevailing sentiment that modernism could have great popular appeal. But he paid little attention to the cost of silk and failed to note that his designs received their greatest acclaim in the so-called class magazines. Although the fabric the Stehli Silk Company produced quickly sold out, it is doubtful the material reached the wider public Steichen claimed he designed it for.

Steichen cultivated a "democratic" image both in the 1920s and later. When he was interviewed by Marguerite Tazelaar in 1927, she was impressed that "big, rug-

ged and bony in build, dressed in a rough tweed suit and a soft blue shirt, he some-how symbolized the simplicity and democracy that is so much a part of him."[66] Tazelaar reported that Steichen had stopped painting to become "an artist in what he believes to be a much broader sense, in that his work can reach out to so many more people, and can be, generally speaking, of so much greater use than a canvas in a parlor." Steichen linked his populism to his career, telling the interviewer that commercial photographers had as much "creative impulse . . . as did any of the painters and sculptors of the past, with their paints and clay." His commercial art was more relevant to modern life because of its wide impact and its close relation-ship to industrial design. "We are living in an age in which all things have to stand the test of usefulness."[67] Both mass production of the fabric and his own abstract design were means to improve the aesthetics of the age. Steichen agreed with Sand-burg, his biographer, who asserted of the silks: "They are justifications of the Ma-chine Age."[68]

STEICHEN'S next industrial design work was two pianos for Hardman, Peck and Company, part of their Modernique series, which expressed "in the outward ap-pearance of a piano a decorative significance which derives from the modernist ten-dencies in music."[69] The Modernique series consisted of six designs by four artists, selected because they were "widely known for their contributions to the new art of decoration."[70] The other designers commissioned were Helen Dryden, the well-known advertising illustrator; Lee Simonson, chief stage designer and one of the founders of the Theatre Guild; and the architect Eugene Schoen. Undoubtedly, Stei-chen was chosen because of his commercial rather than his fine art work and be-cause by the late 1920s he had become something of a spokesman for the modern industrial movement.[71]

The piano company gave its designers few instructions. "They were not restricted in any degree as to the style of piano they should create other than it be soundly artistic, that it should not effect [sic] the musical excellence of the Hardman, and that it be able to take its place harmoniously in the modern American home."[72] Both of Steichen's contributions to the series, *Vers Libre* and *Lunar Moth,* applied deco-ration to the surface of the traditional piano form. *Vers Libre* was a grand piano, to which the artist applied lines and geometric shapes in black, green, red, and gold leaf. Steichen featured it as a backdrop in a 1928 photograph for *Vogue* with the model Marion Morehouse. A reporter for the *Music Trade Review* recognized in Steichen's design "remote abstractions of the forms of musical instruments."[73] *Lu-nar Moth* was a small silver piano described as "a delicate, diminutive affair . . . with a keyboard of only four feet six inches, said to be the smallest true grand piano yet produced." Steichen inlaid the legs and the underside of the keyboard cover with mirrors and applied strips of mirrors elsewhere to decorate the surfaces.[74]

Neither of Steichen's designs radically restructured the instrument, and the tradi-

tional form stubbornly asserts itself, outweighing any impact it might have had as a modernist object. This approach, however, reflects a common design practice of the time. While some industrial designers, such as Raymond Lowey, Norman Bel Geddes, and Walter Dorwin Teague, reengineered products to streamline function as well as form, others—notably those coming out of a decorative arts tradition—redesigned only the surface.[75] The pianos in the Modernique series received mixed reviews. A contemporary commentator, noting their "inferior workmanship" and "essentially superficial" decoration, nonetheless considered Steichen's designs the most "reserved and effective."[76]

The piano company, however, considered the introduction of the Modernique group a success, and the *Music Trade Review* reported "thousands of interested patrons . . . on the opening day of the exhibit," many showing a high "pitch of interest."[77] Although the most likely consumers for such a product were affluent urbanites, the company decided to seek national exposure. They sent a selection of the pianos on tour to dealers in Binghamton, Buffalo, and Albany, New York; Cleveland and Columbus, Ohio; Pittsburgh and Philadelphia, Pennsylvania; and Washington, D.C., and they planned additional tours. The tour drew crowds and news coverage in each city but sold few Modernique pianos. Sales of standard pianos, however, increased. A company representative explained that although people were interested in modern design, they "evidently decid[ed] that in the ordinary home the conventional models would 'wear' better."[78] Few Modernique pianos were produced, and they sold at prices considerably higher than those for standard pianos.

Despite the egalitarian rhetoric of many industrial designers of the 1920s, their products, until the 1930s, were sold only in the more expensive department stores. By 1927, department stores like Lord and Taylor and Macy's carried expensive products in the new modernist style, but the Montgomery Ward catalogue introduced the first inexpensive modernist goods only in 1934. Observers saw the contradiction between "a faith in the social benefit of design for mass production and the reality of custom-made luxury goods,"[79] but mass production had to catch up with modern design before it could become truly democratic.

While Steichen's industrial designs were not manufactured on a large scale and did not reach the large audience he envisioned, eventually their modernist language filtered into the visual landscape of average Americans. The initial high prices and elitism associated with modernism may have spurred its acceptance, but the dramatic decrease in the cost of producing modernist designs in the 1930s largely accounts for their wide distribution.[80]

Because modernism grew out of social and economic changes, Steichen's advertising photography and industrial designs are important, not for their advanced formal vocabulary, but for their interpretation of modern life, particularly the pervasive culture of business. And even though this vocabulary of modernism gave the sense of high style and social exclusivity, in fact it was a formal language readily accessible

to and widely accepted by a broad consumer audience, who saw it as an analogue to science, technology, industry, and the growing power of America in the global marketplace. Steichen developed a visual language of America as a modern consumer culture; his work expressed his era's major social, cultural, and economic trends. The chapters that follow explore specifically how Steichen's advertising photographs reflect and may have even shaped social relations through their representation of gender roles and class status and their wide distribution in the popular press.

The Collaborative Image

The Jergens lotion campaign of 1929 featured the hands of elegant, aristocratic women adorned with diamond bracelets and posed with the material symbols of their wealth and leisure: crystal perfume atomizers, ostrich-feather boas, tennis rackets, and opera glasses. Their only activity was to apply hand lotion. In a typical image from this series, the February 1929 advertisement in *Ladies' Home Journal,* the diamond ring and bracelet, the fan, opera glasses, and sheet music clearly identify a woman of wealth and culture (Fig. 6.1). The documentary-style imagery of Steichen's earlier Jergens advertisements has been replaced with a diffuse and dream-like softness (see Figs. 3.2–3.5). The sharpest focus in the photograph, perhaps signifying reality within the daydream, centers attention on the stream of lotion the woman pours into her palm. What can account for this surprising return to an earlier, and by then outdated, pictorialist style of representation? What has happened to the push toward modernism of the still life photographs? And why have photographs of working women's hands been replaced by those of a woman who so clearly belongs to an economic class well above that of her audience?

Traditionally, when art directors chose the atmosphere strategy, they looked to their illustrators to spark fantasies of class mobility that would encourage readers to wish for material goods. John Carroll's "beautiful and aristocratic young

women" for Jergens and Helen Dryden's "highbrow" art deco ladies for Lux were typical (see Figs. 3.13, 3.20). But as the 1920s came to a close, advertising personnel understood more clearly the emotional and persuasive potential of photography, which became the main criterion for choosing photographs. The persuasiveness was increased by the medium's long tradition of "truthful" description. Nonetheless, the audience, accustomed as they were to theatrical dramas, dime novels, con artists, patent medicine exaggerations, political hyperbole, escapist movies, and other social and cultural forms that made inflated, overstated, or twisted assertions, saw the manipulation behind the advertisements. The ads worked because the consumers were *willing* to be sold on the desirability of the products. The key to success was to find just the right promises and tone to lead them to action.

Steichen's depression-era photographs were thought particularly effective for products pitched exclusively to women, such as Pond's cleansing cream, Woodbury's facial soap, and Jergens lotion. But his empathetic approach was also believed to work when the *user* of a product could be either male or female, but the *purchaser* was assumed to be female—as for Oneida silverware and Simmons mattresses. Although Steichen and the admen continued to make public statements about the naturalism and objectivity of the photograph, by the 1930s Steichen's photographs were commissioned when art directors sought to evoke the glamour, romance, and prestige of the product.

The more obviously evocative images of the late 1920s and early 1930s reflected developments in both the fine arts and society. Subjective and fantastic movements in the fine arts like surrealism, which called into question the nature of the rational and the objective through evocation of the unconscious, strongly affected artists and art directors. Moreover, stylistic developments in both photojournalism and documentary photography deepened the contrast between what seemed their objectivity and the fantasy of advertising photography. Once the novelty of photography in advertising had worn off, its subjectivities stood exposed.

Reasons to use more overtly persuasive imagery in advertising photography came, however, not from fine arts theory, but from business practice and economic conditions. Empirical studies of the market and academic psychology, which earlier had validated the effectiveness of photography, now suggested manipulative sales strategies that were enthusiastically adopted by the advertising agencies. Behavioral psychology, in particular, with its analysis of well-defined patterns of consumer behavior that could be influenced by advertising, became important in the agencies. Rapidly declining sales figures in the early 1930s led the agencies to pitch a harder sell and promoted a stylistic change in advertising photography that paralleled newly codified theories of persuasion.

It brings *Youth* and *Beauty* to your hands

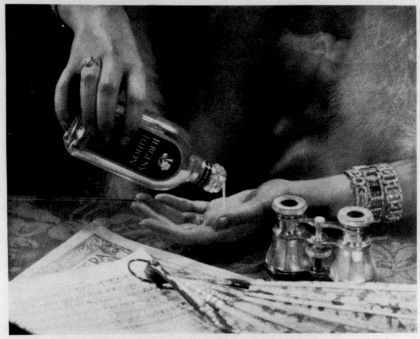

WHEN a woman is getting ready for the opera—for a dance—a formal dinner party—how she rejoices if her hands and arms are beautiful! For never are they seen to such advantage as then; their whiteness enhanced by jewels, their lovely living texture outshining the satin and silk of her costume. Keep your hands exquisite for these occasions with Jergens Lotion! Use Jergens Lotion every time you have had your hands in water, rubbing it gently and deeply into your skin, giving especial attention to wrists, knuckles, and finger-tips. It is wonderful for overcoming the roughness and harshness caused by winter weather. It keeps your skin soft, milk-white—lovely with freshness and youth.

This fragrant healing preparation has

instant power to soften your skin

It has a wonderful effect on a skin that is the least bit harsh or rough or dry.

First, an instant feeling of coolness and comfort. The parched tissues relax, your skin becomes smooth and supple, pleasant to the touch. Gradually, as you accustom yourself to the regular use of Jergens Lotion, you notice a great improvement in the whole texture of your skin. It grows constantly finer and whiter.

You may have despaired of ever having smooth, white hands; now you wonder that you ever allowed yourself to neglect your hands—for they are beautiful!

Two powerful skin restoratives, used in medicine for generations, blended with other healing ingredients in Jergens Lotion, give it this special quality of softening and whitening the skin. Women everywhere are saying that no matter how hard they use their hands, they are able to keep them in exquisite condition with Jergens Lotion.

Get a bottle of this wonderful preparation today! Sold at any drug store or toilet goods counter.

FREE

A new trial bottle · A beautiful booklet!

The Andrew Jergens Co., 1003 Alfred St., Cincinnati, Ohio.

Please send me—free—the new large-size trial bottle of Jergens Lotion, and the booklet, "Eight Occasions When Your Skin Needs Special Protection."

Name _____

Street _____

City _____ State _____

In Canada, The Andrew Jergens Co., Ltd., 2003 Sherbrooke St., Perth, Ont.

JERGENS LOTION

Made by the makers of
Woodbury's Facial Soap

6.1 Advertisement for Jergens lotion, *Ladies' Home Journal*, February 1929, p. 111. Edward Steichen, photographer (J. Walter Thompson).

The Jergens lotion advertisements increasingly promised leisure and beauty. In 1927 each monthly advertisement prominently featured a new Steichen photograph of flawless hands along with images repeated from the working hands campaign of 1923-24 (Figs. 6.2, 6.3; see Figs. 3.2-3.7). A new streamlined layout, with abbreviated copy, replaced the more complex montages of the previous two years (see Figs. 3.14-3.17). As the campaign developed and Steichen's new images of women at leisure grew larger on the page, the older images became commensurately smaller. With product recognition built up from earlier campaigns, the agency could be assured that the one large photograph would deliver the message quickly and accurately. In 1928 the Jergens Company completely dropped the small icons of working hands and evolved a simpler layout with larger photographs and less copy (Fig. 6.4).

Although the Jergens lotion user represented in the ads had been transformed from a middle- or working-class housewife and mother to an upper-class woman of leisure, the targeted audience had not changed. Jergens continued to place ads in *Ladies' Home Journal, Pictorial Review, Women's Home Companion, Good*

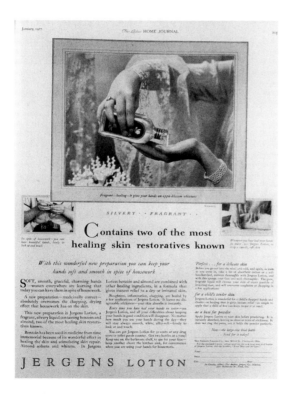

6.2 Advertisement for Jergens lotion, *Ladies' Home Journal*, January 1927, p. 115. Edward Steichen, photographer (J. Walter Thompson).

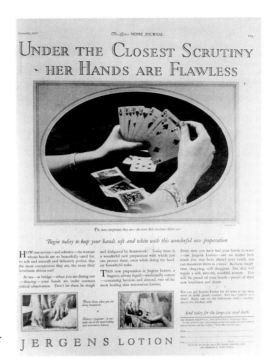

6.3 Advertisement for Jergens lotion, *Ladies' Home Journal*, February 1927, p. 129. Edward Steichen, photographer (J. Walter Thompson).

Housekeeping, and *McCall's.*[1] The Jergens photographs continued to address "ordinary housewives" but reflected less and less of their lives.

Advertising industry strategists made a conscious decision to represent the Jergens customer as upper-class. Executives who demanded accurate representations of class were in the minority. For example, Helen Resor, who had posed for Steichen's *Peeling Potatoes,* complained to the agency's art directors and account representatives that in some of the photographs "the laboring classes look like capitalists." Several people in the audience quickly responded, "They want to look like capitalists."[2] Admen expected immediate sales benefits from flattering potential consumers. Moreover, by identifying mass magazine readers with the wealthy, the ads implied that the consumers' needs were the same as those of the businessmen who produced the goods—and that the average consumer was next in line to share the riches.[3]

Steichen revived his pictorialist vocabulary to represent these upper-class women. Although by 1923 he had publicly and vociferously renounced pictorialism,[4] much of his figural advertising work of the late 1920s employed soft focus to effect an emotional appeal. In Figure 6.2, for example, shimmering highlights in the image are a metaphor for the "silvery liquid" described in the text and pictured in the photograph. Soft areas of white highlights draw attention to the sleeves of the woman's sheer dressing gown, and circles of light coalesce into the apple blossoms in the

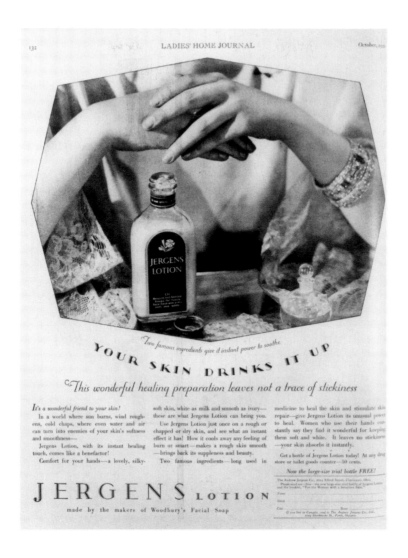

6.4 Advertisement for Jergens lotion, *Ladies' Home Journal*, October 1928,
p. 132. Edward Steichen, photographer (J. Walter Thompson).

foreground and define the space of the background. The model's hands are the visual demonstration of the promise to the consumer made in the text: her hands will always be "smooth, white, silky-soft—lovely to look at and touch." The text makes this promise, while the pictorialist image intimates a further promise—of youth, beauty, elegance, wealth, and leisure.

In Figure 6.5 the model rests her buttery hands on her dressing table. Again a few

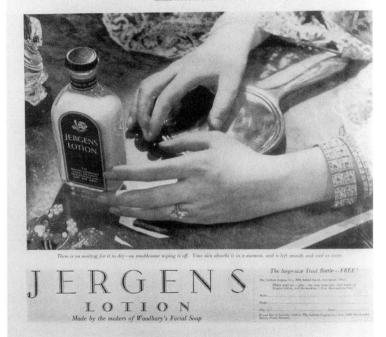

6.5 Advertisement for Jergens lotion, *Ladies' Home Journal,* January 1928, p. 94. Edward Steichen, photographer (J. Walter Thompson).

props suggest her class status, occupation, and interests: the marquise-cut diamond ring, the elaborately jeweled bracelets, the lacy trim of her dressing gown. Other props—the mirror, crystal figurine, and flowers—belong to a still life that frames the other star of the picture—a bottle of Jergens lotion. In this image Steichen searches for a suitable stylistic vocabulary for figural advertising in the late 1920s. Similar softened hands could have appeared in the same magazine five years earlier,

and perhaps twenty years earlier in art photography; compare, for instance, Horace Scandlin's 1924 hands for Cutex (see Fig. 3.9). What is stylistically more current in Steichen's work is the vantage point. Steichen takes a bird's-eye view of the hands and the bottle (its label photographed to emphasize the contrasting, crisply readable type). The vantage point echoes the conscious modernism of still life product ads in the 1920s that was rarely seen in figural work.

Steichen was not alone in using a pictorialist approach for some advertising clients in the late 1920s. Baron Adolph de Meyer, who had begun his commercial career making fashion photographs after 1910, was in great demand for advertising photographs in the 1920s. In 1929 he was still turning out soft, elegant, wistful pictorialist ladies (Figs. 6.6, 6.7). In one of his lingerie ads for Carter's, for example, he retained the dramatic poses of fashion models and silent movie stars, photographing the stylishly clothed model in an expressive profile stance that he echoed in the smaller inset photograph in which she wears only the product. In an advertisement for Woodbury's soap he also posed the model in an artificial stance, emphasizing the theatrical expressiveness of her hands resting on her chin and hip. In both ads de Meyer retains his earlier conventions of pose and focus; it was probably the only way he knew to achieve the elegant effect for which he was so well known. Other photographers, including Grancel Fitz, who had investigated modernist com-

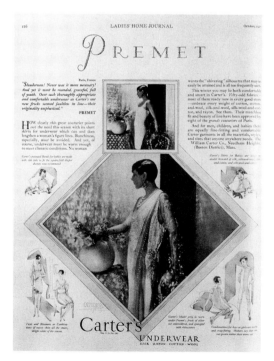

6.6 Advertisement for Carter's underwear, *Ladies' Home Journal*, October 1927, p. 126. Adolph de Meyer, photographer (J. Walter Thompson).

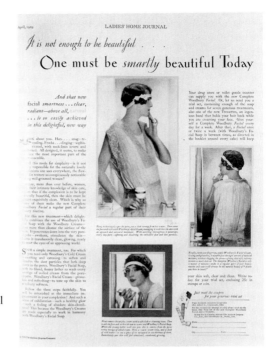

6.7 Advertisement for Woodbury's facial cream, *Ladies' Home Journal*, April 1929, p. 39. Adolph de Meyer, photographer.

position and oblique perspective in his still life arrangements for Fostoria glass, frequently retained some soft-focus elements in their figural compositions late into the 1920s, but rarely to the affected degree of Steichen's Jergens or de Meyer's Carter's advertisements.

The newer focus and framing of modernist photography made few inroads into dramatic vignettes. Most commercial photographs simply fell back on the old formula: use the sharp-focus straight photography to convey information and the dreamy soft-focus pictorialism to suggest atmosphere. In the late 1920s the integration of modernism into figural advertising photographs was tentative and delayed.

Jergens lotion sales climbed during the 1920s; by 1929 the product had captured 18 percent of the market share, up from 5 percent in 1923. But by the end of September 1930, economic conditions had taken their toll and sales were off 10 percent from the year before.[5] This sales slump, along with newer hard-selling advertising strategies and reduced consumer spending, caused the Thompson agency to reevaluate the Jergens campaign. Gordon Aymar, who had been the art director for the campaign since its inception, left Thompson for the Blackman Company. The two art directors who replaced him on the account, Elwood Whitney and especially James Yates, were enthusiastic advocates of emotion and drama in advertising photography. Though they briefly flirted with a scientific appeal, consulting dermatolo-

gists and chemists about the effect of the lotion's ingredients on skin and commissioning microphotographs of treated skin pores,[6] they decided to stick with what had worked in the past—drama, fantasy, and romance.

Steichen strongly packaged the new romance. His photographs no longer featured hands but included the woman's face and shoulders as she watched an opera, pampered herself at her dressing table, or tanned herself in the sun. Steichen used what had become his standard props: ornate bracelets, gold necklaces, fans, and opera glasses. In both Figure 6.8 and Figure 6.9, the women are clothed in formal but revealing dresses; Steichen emphasizes their exposed shoulders, arms, and backs. The ads display their bodies as objects of beauty, commodifying them so that they become as much a product as the lotion itself—the women's looks result from time-consuming, careful attention to grooming that only wealthy women can afford. Yet this grooming was so easy with only that bottle! Instead of seeing the product as the palliative for their everyday housework-chapped hands, the audience was invited to fantasize that Jergens lotion could bring soft skin and a leisured life. Steichen's stylistic treatment of figural advertising was slowly changing: he began to abandon the soft focus of pictorialism for fantasies that superficially seemed more naturalistic but

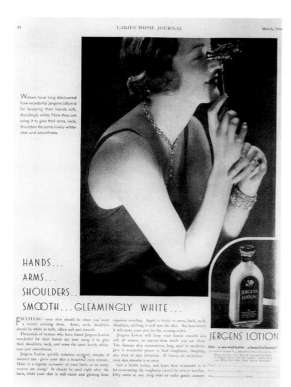

6.8 Advertisement for Jergens lotion, *Ladies' Home Journal,* March 1930, p. 84. Edward Steichen, photographer; James Yates, art director (J. Walter Thompson).

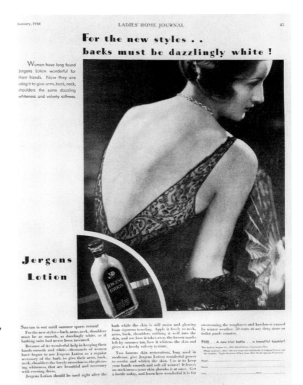

January, 1930 LADIES' HOME JOURNAL 85

For the new styles . .
backs must be dazzlingly white !

Women have long found
Jergens Lotion wonderful for
their hands. Now they are
using it to give arms, back, neck,
shoulders the same dazzling
whiteness and velvety softness.

Jergens
Lotion

6.9 Advertisement for Jergens lotion,
 Ladies' Home Journal, January
 1930, p. 85. Edward Steichen,
 photographer; James Yates, art
 director (J. Walter Thompson).

offered greater emotional engagement. When a male partner entered the image, the stylistic treatment became even more direct and the romantic content more explicit (Fig. 6.10).

Advertising executives recognized the subjectivity and emotional charge of such images. For example, Lloyd W. Baillie, a vice president at the Thompson agency, described how the 1932 advertising strategies for Pond's, Lux, Jergens, Cutex, and Simmons—all accounts Steichen had worked for, some of which still actively employed him—were all "examples of the creation of illusion." Each "stimulates in the mind of the woman reader the illusion that she can be more beautiful than heredity and environment made her or that she can take her place among the sophisticated women of the world."[7]

Despite this practical acknowledgment that advertising photography had moved beyond a realistic description of the product and its world, theoretical assessments of photography were slow to change. In 1931, for example, Baillie had made the old equation of drawing with fantasy and photography with realism. Because "people do not want to see themselves in terms of reality," many believed that "art work ordinarily drawn by pencil or brush was more effective in selling than a

Beguiling! soft girlish hands

. . . but hands grow old so quickly! Cruel little lines and persistent roughness destroy their thrilling charm . . . sometimes even at 20, often before 30

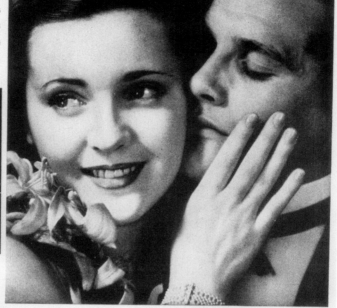

Its two famous ingredients keep hands serenely white and smooth

Gift Box for Men

For every man on your Christmas list this gift package of shaving luxuries! It contains Woodbury's Shaving Cream, Talc, Soap (guest size) and Jergens Lotion or Woodbury's After-Shaving Lotion —whichever you choose—as sure protection against chapping. Father, brother, husband, son—one or all will be touched by your benign thoughtfulness in bestowing so practical and humanitarian a gift! Found at all drug stores and toilet goods counters, $1.

You can keep your hands enchantingly young and soft and white with the simplest, easiest care

YOUR HANDS can keep that smooth bewitching whiteness of youth. No need now for them to grow withered and old, long before their time.

Skin specialists know two famous restoratives—one for whitening, the other for softening the skin. Both are blended with other healing elements into a fragrant silvery liquid—Jergens Lotion—which has a most marvelous effect on the skin.

If your hands have a tendency toward redness, if they often feel dry and harsh, begin using Jergens Lotion at once—always after washing your hands and when you come in from the cold. With the very first application you'll notice a distinct improvement.

Within an amazingly short time you'll find that this gentle care makes your hands softly smooth and white—charmingly young—no matter how hard you use them at household tasks or active sports.

You can use Jergens Lotion any time—your skin absorbs it so readily that it leaves no stickiness. Instantly your hands are smoother, softer, whiter. For these reasons many women delightedly use it for a powder base, too.

Start using Jergens Lotion today and give your hands the beguiling flower-like softness of youth. Get a bottle at your druggist's or any toilet goods counter. 50¢ and in an economical $1 size.

FREE! *New Trial Bottle of this wonderful lotion.* A generous-sized sample of Jergens Lotion will be sent you free—just write to The Andrew Jergens Company, 4023 Alfred Street, Cincinnati, Ohio. (In Canada, 4023 Sherbrooke St., Perth, Ont.)

Name

Address

Jergens Lotion
its 2 famous ingredients make hands smooth . . . white

6.10 Advertisement for Jergens lotion, *Ladies' Home Journal,* December 1931, p. 48. Edward Steichen, photographer; James Yates, art director (J. Walter Thompson).

photograph." For him the almost total adoption of photography for mass media advertising meant that "the spirit of the times and of people has so changed that today they are willing to face realities and see things in terms of how they actually look." [8] He argued that consumers, ready and able to deal with the economic hardships of the depression, demanded photography and its "realism."

The contradiction in Baillie's two statements can be explained by the differences he perceived between male and female consumers. Although Baillie did not articulate it, in practice, the advertising industry had constructed an image of the female as emotional and susceptible to fantasy and the male as more rational. Thus fantasy and emotional appeal characterized pitches for products marketed exclusively to women. Still, Baillie's uncritical restatement of the older convention indicates that it shaped discussions of photography long after actual practice had discredited it. In discussions of specific campaigns Baillie revealed his more current thinking (and mirrored the implicit acknowledgment of photography's subjectivity across the industry), which he had not yet integrated into his broader understanding of the medium.

"THE CONSENSUS" IMAGE

The shift to more explicitly romantic images was a collective decision. At the Thompson agency, teamwork was the corporate policy; multiple opinions were believed necessary to judge mass appeal. According to agency lore, "Mr. Resor distrusts the Individual Opinion. He believes in getting The Consensus." At Thompson, the idea came first; then a planning board analyzed and refined it before they wrote the copy and commissioned the art. A Thompson spokesman kidded: "We think *endlessly* about the total problems of our clients. . . . We think so damn long and so damn hard that the final business of writing the copy and making the layout becomes, in one sense, almost subsidiary." [9] After market research and group analysis had produced a concept, account representatives, copywriters, art directors, and artists worked closely on it together. The copywriter, working with the art director, negotiated a path between direction and freedom. If the copywriter, according to Gordon Aymar, "comes with too much information and too definite an idea, he is depriving himself of the creative possibilities in the Art Director. If he comes with too little, he will not be getting what he wants in the end." [10]

The art director and the artist also had to work in harmony. The copywriter

cannot come in and ask for a campaign as he would order a dozen eggs, any more than an Art Director can buy a picture from an artist by writing out an order. An Art Director regards an artist as the potential source of his picture. Just as nature is a creator, so is the artist. But his ground must be planted and harrowed by stimulating his interest. It must be fertilized with enthusiasm. The best seed must be sown by presenting the essence of the problem. This must be watered with constructive and creative suggestion, and, if pruning is finally necessary to insure the best fruit, it must be done with the utmost intelligence and understanding of the way in which the plant is grown. [11]

Clearly, art directors thought of themselves as the artists' full partners in developing the visual elements of the advertisement. This alliance motivated the Art Directors' Club, for example, to include both the artists' advertising images and the full layout in their annual exhibitions.[12]

Aymar's 1929 graphic design text outlined the typical working relationship between the art director and the artist. "Generally the whole plan of action has been decided before the artist is called in"; then the artist must "interpret in pictures the ideas he is given."[13] But plainly this interpretation grew through consultations between the two. While sensitive to the artist's need for room to create, Aymar believed that "it is only under certain conditions that an artist can have complete freedom and that freedom is only relative."[14]

When Aymar worked with Steichen in the 1920s, he discussed the aims and problems of the campaign with him and showed him rough sketches and sample layouts. A 1926 article in the *JWT News Letter* described their teamwork on the Pebeco toothpaste campaign of that year:

> After the general copy plan had been evolved and approved, the writer on this account suggested a number of "situations" for illustrating photographically the several advertisements. The Art Director made thumb-nail sketches of these, from which two were selected to be worked up into the first pencil layouts.
>
> Both layouts were shown to Steichen, the Vogue photographer, with whom an appointment had been made a week ahead to do the work. . . . Mr. Steichen made one or two suggestions as to the most practical way of getting the effects desired.[15]

With economy moves in the company in the mid-1920s art directors reduced the level of finish in their layout proposals. By 1927, when the client allowed it, the agency provided simple thumbnail-sketch layouts, "but very good looking."[16] This practice, intended to allow art directors more time to prepare variations for clients, also minimized the direction given to artists. The photographer worked independently to produce the most skillful, attractive, and contemporary interpretation of the agency's concept.

This balance between teamwork and individual interpretation led to an unstated corporate belief in collective authorship. Steichen's request that his signature appear with his photographs thus caused debate. The company objected because its policy was *not* to put an artist's name on any advertisement but granted Steichen's request simply because it would "mean a great deal to the artist," and other agencies had established a precedent.[17] Although Steichen's contract allowed the agency to use his signature, it rarely exercised this right. The Pebeco toothpaste and Jergens lotion ads, for example, had included his signature sporadically. The agency's inconsistency suggests that even if Steichen lent the agency prestige among clients and industry insiders, his signature was not necessarily a selling point to the general public. Steichen's request to use his name in the magazine implies his pride in these images and his desire for public recognition for them.

By the 1930s the industry was often providing specific direction to artists. When Steichen worked with the art director James Yates, who replaced Aymar on the Jergens lotion account in 1930, the art director suggested details as specific as the models' poses, expressions, and props. Yates even went so far as to take test shots of the models and potential poses at the Watts Studio, the agency's in-house photographic lab, that he passed on to the artist.[18]

The value of the Watts Studio experiments for the "Jergens Romance campaign," which cost only about twelve dollars per picture, was explained at a weekly staff meeting: "They try out new models as well as girls we have used, and they try them out in new situations. You need a new situation on the old story of romance. The cost of the test pictures was saved on Steichen's time. We probably got twice as many pictures in half as many sittings. We have such good pictures they win prizes."[19]

Yates believed that his active intervention produced the most effective finished picture:

> It is not enough to just procure the best photographers available, and leave it up to them. We must be sure . . . in presenting our problems to them that we get over to them first a vivid impression of the emotion or illusion we are after. It is not enough to give them just bare facts, just the list of ingredients that must go into the picture. We may have to do more than simply check up on whether the girl model's hair is combed prettily or whether the knives and forks are laid on the table correctly. We must develop picture sense in ourselves, dramatic feeling, or actor sense, so that before we begin littering the photographer's mind with details, we can first supply inspiration.[20]

Yates believed that art directors must determine both overall effect and details. The differences between Aymar's and Yates's work patterns reflected a difference in personality and working style but also testified to a trend in the industry toward more control by the art director. This closer supervision of the artist answered to Stanley Resor's desire for consensus in every campaign. There had always been an ironic contradiction between Resor's search for luminaries for the agency, such as the renowned psychologist John B. Watson and the star photographer Edward Steichen, and his corporate goals of joint decision making and mass appeal. By the 1930s, with tighter supervision by his art directors, Steichen's work more closely reflected the agency's consensus.

The freedom of the 1920s, however, can be overidealized. Despite Gordon Aymar's loose direction in the 1920s and Steichen's own strong statements about creative interpretation, Gordon Aymar reported in 1928 that Steichen and some other freelance illustrators had the "feeling of being held down." Steichen himself made it clear that the only direction he wanted was the discussion of the marketing concept. He felt the message of the campaign, rather than a preconceived style of graphics, evoked his best work. He asked the staff not to "think in terms of picture. Think in terms of putting people or objects right into things. The moment you think of pictures, you think of the clap-trap that makes the magazines the mess they are today. . . . [T]he best way is to think in terms of reality, and put it up to me."[21]

Although Steichen accepted agency constraints on the content of the photograph, any suggestions about the interpretation or composition were interference:

> Unless the layout is to be followed definitely for some reason or another, or unless it calls for an outline, I don't see any reason for indicating the space. We found that out in the very beginning I believe, on some of the toothpaste ads. We had layouts and whenever we tried to follow the layout—first, I tried it their way and when I got that off my mind, I swung around and did it myself. I think the photographer should have all the freedom he can have, except as regards the idea of it, that has to be kept closed in.[22]

Whatever creative freedom he claimed, Steichen knew the agencies' expectations of commercial photographers. According to Lillian Sabine, who interviewed him in 1932, he "made it clear that the successful commercial photographer does what is demanded—not what he wishes to photograph."[23] In the 1920s and early 1930s Steichen accepted and even thrived in this situation. But years later he recalled that twenty years of constant pressure, "when you have to be inspired at half-past two on Thursday afternoon to photograph Greta Garbo, or at half-past eleven to photograph a can of beans," made his work mechanical and formulaic and forced his retirement from commercial work.[24]

CINEMATIC NARRATIVE

The agency staff frequently picked up ideas from other popular media. For example, in the "Jergens Romance campaign" in the early 1930s, James Yates urged Steichen to approximate the narrative techniques of motion pictures (see Figs. 6.10, 6.15, 6.16). The close-up images, with impressionistic lighting and staged gestures, included just enough detail to suggest a story.[25] In Figure 6.10, for example, the woman smiles contentedly in the embrace of her tuxedoed companion. She wears a lei. Are they on an expensive vacation? Her eyes twinkle as she glances at the product that made it all possible.

Advertising also borrowed from popular cinema the use of sequential stills to suggest closely spaced moments in time. Their widespread use in both advertising and editorial material dates from the silent picture era. In the early 1920s the *Ladies' Home Journal* ran a series of "movies" giving women household tips, one of which showed how to clean a home thoroughly and efficiently (Fig. 6.11); others provided directions for tasks like bathing or dressing the baby or carving a turkey.[26] These "movies," which gave motion picture stature to the most minor chores, were part of the movement to systematize and scientifically manage women's work.

Sequential images quickly made their way into advertising. In Steichen's Pebeco toothpaste advertisement of 1924, for example, three small photographs reinforce the idea that people with good, healthy teeth (thanks to Pebeco) have lots of fun (see Fig. 4.1). They replicate the filmstrip to convince the viewer that the product can transform an everyday life into one worthy of the movies.

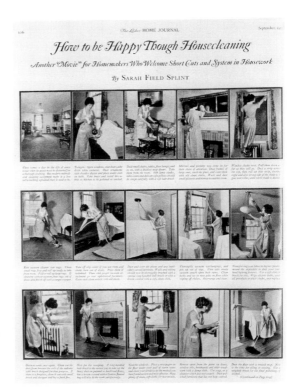

6.11 Editorial page, "How to Be Happy through Housecleaning," *Ladies' Home Journal,* September 1923, p. 106. Photographer unknown.

Steichen followed the movies closely. His colleague, commercial photographer Nicholas Haz, wrote that Steichen considered them "the most vivid art-form in the world today."[27] His early documentary advertisements for Jergens lotion reflect the influence of films like *Battleship Potemkin,* one of his favorites, which he recommended to admen for its realism and documentary qualities.[28] The later Jergens ads emulate the opposite end of the film tradition, the B-movie romances of the 1930s.

Steichen had used narrative techniques in his earliest advertising photographs of working hands for Jergens, suggesting the passage of time by showing hands, past and present, and developing character by isolating an action to show how the product solved that particular problem. This method of "getting over the story," as Steichen put it, required spare simplicity and only the essential accessories. "The more tricks you pull, the more you get away from what you originally intended to show . . . [E]verything else should be sacrificed to [the story]. When you try to tie in with other things, you wash out the first idea."[29] This approach to narrative typified advertising practice in the 1920s. The textbook author Leonard A. Williams explained that advertising persuaded through its narrative structure; instead of just

recording, advertising photographers must "possess the story telling sense."[30] Photographs that create a vivid, participatory narrative can "transform advertising from a series of static one-way messages into a dynamic interactive process."[31]

In the period between the wars, advertising executives insisted that audiences liked stories. William Esty of the Thompson agency linked the popularity of depression-era radio dramas to the public's preference for step-by-step narratives. Esty felt that ads should follow the model of Hollywood movies and lay out the whole story because "the public doesn't go one step beyond what's in the ad."[32] This viewpoint influenced both campaign strategy and layout design at Thompson. In a Jergens lotion ad from 1936, three Steichen photographs illustrate the problem, solution, and result (Fig. 6.12). The theatrical photographs were augmented with

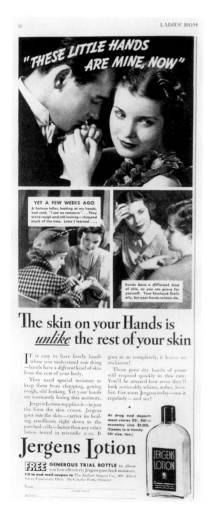

6.12 Advertisement for Jergens lotion, *Ladies' Home Journal*, February 1936, p. 58. Edward Steichen, photographer (J. Walter Thompson).

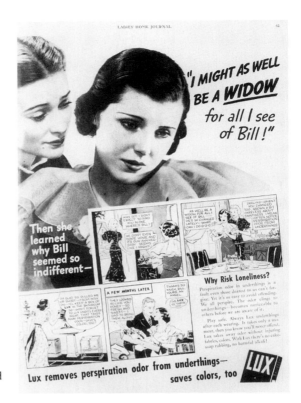

6.13 Advertisement for Lux flakes,
 Ladies' Home Journal, May
 1936, p. 61. Photographer and
 illustrator unknown.

text insets or overlaid with headlines to reiterate the story. Yet each element is kept discrete and readable. Esty's influence meant that ideas formerly implied in one image now required three.

The trend toward narrative completeness in advertising culminated in the use of comic strips and speech balloons with photographs.[33] In Figure 6.13 the over-dramatic photograph and blaring headlines define the problem, and the comic strip develops the melodrama, demonstrating how the product brought about a happy ending. The photograph dramatized the moment of crisis, while the cartoons developed the episodes to explain the problem and show the solution. There is no attempt to integrate photograph, comic strip, and headline. The differences between the three elements might entice readers to examine each separately, so that the advertiser has three chances to interest the consumer in the story. In Figure 6.14 a Steichen photograph for Kodak is overlaid with speech balloons and a headline, devices that make the ad more shrill. The complexity of such an ad—other ads were complex almost to the point of incomprehensibility and/or offensiveness—was thought to increase the reader's participation in the narrative and assure the delivery of the message.

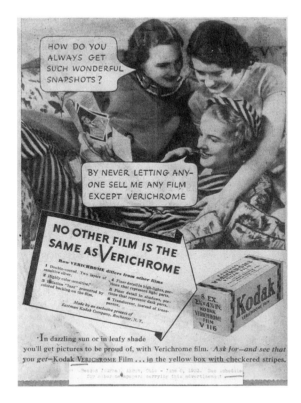

6.14 Advertisement for Kodak
Verichrome film, *Beacon Journal*
(Akron, Ohio), June 8, 1933.
Edward Steichen, photographer;
John Scott, art director
(J. Walter Thompson).

THE CONSUMER'S IDENTITY: SINGULAR OR COLLECTIVE

Steichen's photographs of the early 1930s inventoried the benefits of Jergens lotion to the woman who used it: beauty, jewels, a man, and fulfillment (see Fig. 6.10; Figs. 6.15, 6.16). His photographs illustrated the strategy, which the agency characterized as "more emotional, in line with the current trend in movies, newspapers, and magazines."[34] Despite the prominence of Steichen's photographs in this "romance campaign," for the agency staff the contribution of the copywriter, Mrs. Devree, equaled or surpassed that of the photographer in defining the strategy and setting the tone of the campaign. The account executive Ruth Waldo contended that headlines like "He loves your petal soft, girlish hands" gave "the story an unusually human and moving quality." Whereas the older Jergens headlines dealt "with the abstract subject of hands," the "hands of a crowd, of a nation, of a town," the use of the word "your" in the 1930s headlines made a more direct appeal.[35] This new language, advertising executives believed, engaged women in a romantic drama that would sell more lotion.

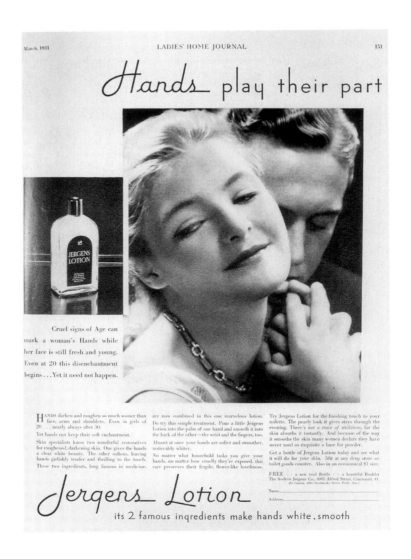

6.15 Advertisement for Jergens lotion, *Ladies' Home Journal,* March 1931,
p. 151. Edward Steichen, photographer (J. Walter Thompson).

Allan Sekula has observed of the fine arts that images offering "a wholly imaginary transcendence, a false harmony, to docile and isolated spectators"—as these advertisements do—support the existing social order. They construct a "cult of private experience," temporarily separating viewers from the routine of their lives and their "knowledge of the self as a commodity."[36] The use of the personal pronoun

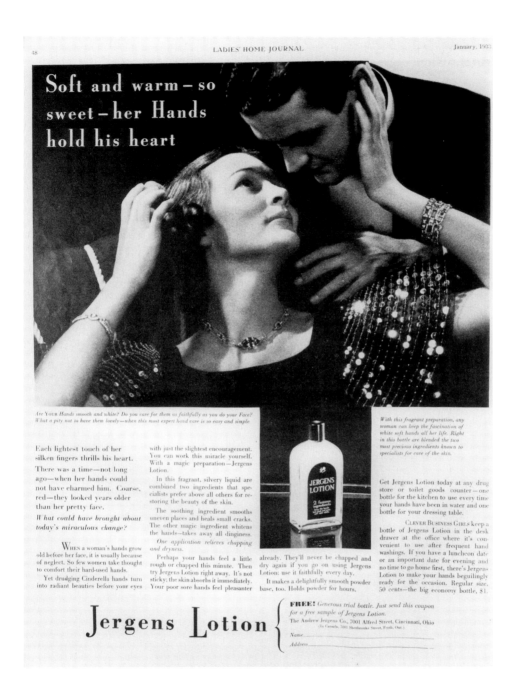

6.16 Advertisement for Jergens lotion, *Ladies' Home Journal*, January 1933, p. 48. Edward Steichen, photographer (J. Walter Thompson).

and identification with Steichen's photographs in the 1930s Jergens ads shifted the identity of the audience from a collective entity (working mothers) to atomized singular identities (potentially romantic, attractive individuals); it also shifted the cause of any unhappiness from the society to the individual.

The fine arts in the 1930s were also exploring personal and private experiences. As abstraction began to supplant social realism, modernist art privileged individual creativity and individual response. The change—in both commercial and fine art—may have been a response to the depression or a visual expression of the political rhetoric of the 1930s in which the American individual represented democracy and freedom, whereas anonymous, collective hands represented the foreign fascist threat.

Working-class hands—"the hands of a crowd"—now looked anonymous to advertising executives, while affluent hands belonged to individuals. Since it was assumed that women preferred to identify with the hands of upper-class individuals, the working-class hands that had ironed clothes and washed dishes disappeared from the pages of the women's magazines.

VISUALIZING PSYCHOLOGY FOR THE MASS MEDIA

Steichen's 1930s romance images for Jergens lotion incorporated prevailing scientific and business theories on strategy and imagery. The obvious strike at the consumer's heart, which replaced subtler hints about increased attractiveness, can be attributed to the growing influence of behavioral psychology. Behavioral theory was one of several psychological theories advertisers drew on in the late 1920s (others were suggestibility, discussed in Chapter 4, and Freudian psychodynamics). Each had its partisans. The advertising consultant Christine Frederick, for example, advised clients to base strategies on theories about instinct developed by "Freud, Jung, Adler, and even Watson" because "women are more definitely ruled" by instinct. "Mrs. Consumer's mind is an especially unconscious mind" because of social factors: "Early in a girl's life her mother, teachers, church, society outfit her with suppressions and inhibitions one after another." She is rarely able to shake them, Frederick argued, and so such repressions become "part of feminine psychology."[37] As Frederick demonstrated by collapsing psychodynamic and behavioral ideas, most advertisers, in practice, showed little allegiance to the nuances of any school of psychology; they left nuance to the theorists in the agency.

The psychologists invoked to justify the change to atmosphere advertising had argued only that consumers were open to suggestion. Perhaps more as a result of wishful thinking than empirical evidence, adherents of behavioral psychology contended that advertising could both influence consumers' choices and control their decisions. Because behavioral psychology was the dominant theory at the J. Walter Thompson Company, the agency with which Steichen was closely associated in the 1920s and early 1930s, it is the psychology most relevant to Steichen's work.

In 1920 the J. Walter Thompson Company had hired John B. Watson, a former Johns Hopkins professor who was the chief exponent of behavioral psychology, to direct its research department. Watson had served on the army's Committee for the Classification of Personnel during World War I, and, like Steichen, he left the military with an enhanced reputation as a patriot and a professional. After the war he did work for corporate clients along with his academic research. By 1924 Watson was a vice president of the agency. He actively promoted his theories by writing in the popular press and became a familiar radio talk show guest, so that by the 1930s Watson's behaviorism was well known among the general public and accepted by the advertising industry.

Watson had trained in psychology at the University of Chicago, a functionalist stronghold. In his dissertation, Watson examined the correlation between brain development and learning ability in rats. He observed how the animals learned to negotiate a complex labyrinth to secure food, a problem-solving project in line with functionalist concerns. Because he did not study human subjects, Watson circumvented the most common psychological methodology, introspection, which required subjects to describe their conscious perceptions and experiences.[38]

At Johns Hopkins, Watson continued his animal research. He outlined his radical theory of behaviorism in his controversial 1913 manifesto "Psychology As the Behaviorist Views It," published in the *Psychological Review*. Watson saw the discipline as "a purely objective experimental branch of natural science," one that allowed no room for the subjectivity of introspection that characterized the structuralism most American advertising psychologists subscribed to at the time. It also allowed no room for the influence of other levels of consciousness on behavior that characterized Freudian psychodynamics. Watson argued that the psychologist must make "*behavior,* not *consciousness,* the point of our attack." He contended that the methods of animal studies should be applied to human behavior; the behaviorist, he asserted, in his efforts to get a unitary scheme of animal response, recognizes no dividing line between man and brute."[39]

HISTORIANS have examined behaviorism as a cultural expression of early-twentieth-century America. Rapid urbanization and industrialization had created conditions of great geographic mobility and social uncertainty: workers migrated from small town to city, exchanging the agricultural life for the factory or office. Large numbers of immigrants entered the country, triggering in some quarters nationalistic values that desired to homogenize and neutralize the new arrivals. Efficiency became the primary goal of corporate and governmental planners, especially in business, where formerly complex jobs were atomized into simple units of work to order and systematize production, thereby lowering both the level of skill and integrated knowledge of the process among workers.[40]

Watson's theories were counterparts to these developments. As David Bakan has noted, the early-twentieth-century growth of urban-industrial life was accompanied

by opposing directions in psychology: the "vaulting urge to rescue the individual from the impersonality and the alienation which is associated with living in a complex society," the task of psychoanalysis, and the "vaulting urge towards the mastery of other human beings," exemplified by behaviorism.[41] Watson saw the usefulness of behaviorism in achieving "the prediction and control of behavior." The behaviorists' discoveries could provide the information and methods needed to engineer a stable social and economic structure.[42] Behaviorism's emphasis on control echoed the central theme of other empirically oriented social sciences of the 1920s. And those ideas of the day were particularly attractive to Watson, who grew up as a religious fundamentalist. As historian Dorothy Ross has observed, while "behaviorism represented his revolt against orthodox religion" it was also his "unconscious reproduction of its norms."[43]

To Watson, the ability to predict and control behavior had a positive, utopian character. Watson argued that behavioral engineering held the key to improved family relationships, competent child rearing, quality education, racial harmony, workplace efficiency, crime-free neighborhoods, and a prosperous commodity-filled economy. Watson's behaviorism was a radical environmentalism. In his view, people were shaped by their society, culture, and experience; neither ethnicity, race, intelligence, nor any inherited characteristic was significant or formative. Behaviorism thus appealed to some social reformers, for it minimized racial differences and challenged assumptions of racial superiority.[44]

But Watson's utopia had dark, oppressive undertones. People would be trained from their earliest years to conform to social roles and attain "behavioristic happiness" by helping to maintain society. They would be passive and docile, identifying their needs with the goals of the state. Such a society would be so strong that no government would be necessary. Social engineers and professional managers, the new elite, would replace "that abstract entity we call the State."[45]

Watson saw himself as part of this elite. Despite his concerns for the needs of society as a whole, he was no social progressive. Like many other admen, Watson opposed New Deal reforms and social welfare legislation and admired self-made men.[46]

Thompson executives, including Stanley Resor, received the psychologist's ideas enthusiastically. Like other psychologists, Watson was confident that advertisers could use psychology to develop effective appeals, targeting consumers' needs and desires precisely: "The consumer is to the manufacturer, the department stores, and the advertising agencies, what the green frog is to the physiologist."[47] The belief in the ability of psychology to influence and control people was growing. Harvard psychologist, and Watson confidant, Robert Yerkes claimed in 1919 that "two years ago mental engineering was the dream of a few visionaries." "Today," he wrote, "it is a branch of technology . . . perpetuated and fostered by education and industry."[48] Watson assured advertisers that with science, "when you go out on

the firing line with your printed message you can aim accurately and with deadly execution."[49]

Watson drew on the stimulus-response model in advertising psychology. He theorized that because three innate emotions—fear, rage, and love—drove all behavior, ad agencies could set up conditioned reflexes, constructing images to stimulate the consumer's desire and trigger a buying response. Because Watson was a respected and influential vice president, his psychological principles were disseminated throughout the agency to copywriters, art directors, and freelance artists. Steichen knew of Watson's ideas by 1928; he complained that although art directors continually quoted "Mr. Watson" to him, he and Watson had no direct contact.[50]

At Johns Hopkins Watson had explored the conditioned reflex in his "Little Albert" study, which has since become a textbook classic despite its questionable methodology. In a replication of Pavlov's famous experiment with dogs, the infant Albert was subjected to a loud and distressing noise at the same time that he was shown a white rat. Although Albert had had no fear of white laboratory rats before, his repeated simultaneous exposure to the noise and the rat induced one. Watson found, indeed, that little Albert had transferred his fears to other furry creatures, including a bunny rabbit, a dog, a fur coat, and even a Santa Claus mask.[51]

Account executives, copywriters, and art directors at the advertising agency applied Watson's academic research to consumer behavior, even if inexpertly or intuitively. The 1930s Jergens lotion campaign focused on one of Watson's three innate emotions, love, to construct a conditioned response. According to Watson's formula, Steichen's photograph of a glamorous, romantic life was the *unconditioned stimulus* (see Figs. 6.10, 6.15, 6.16), which set off the *unconditioned response,* thoughts of love. The *conditioned stimulus* (analogous to the rabbit or the fur coat in the "Little Albert" study) was the image of the product. The desired *conditioned response,* to buy the product, was described in the text. So the bottle of lotion a woman encountered at her local drugstore was supposed to make her fantasize about romance and, substituting the conditioned for the unconditioned response, purchase the product. Advertising had been doing this all along, but by employing a famous psychologist, the agency impressed its clients with the professional and scientific veneer of its ad campaigns.

The stimulus-response model of consumer decisions correlated with the prevalent belief that consumers were emotional and thus susceptible to the atmosphere strategy. According to behaviorist theory, because consumers were impulsive, agencies should develop an emotional appeal (stimulus) to trigger spontaneous buying (response). This image of the consumer seemed reasonable to the admen since their research had determined that most purchasers of goods were female.

Watson's behavioral perspective perfectly suited the needs of the corporate era. Earlier in the twentieth century, production and distribution had been analyzed and regulated. Markets were the only variable left in business practice. As the historian

Kerry Buckley has noted, "The product that advertisers hoped to sell [to their clients] was a controlled and predictable body of consumers."[52] They turned to science for help in delivering this product.

This deep desire for order emerged out of and masked profound doubts about contemporary social stability. As Buckley has observed:

> The possibility of an objective science of behavior control appealed strongly to many whose progressive faith in science led them to believe that it was only a matter of time before factual and methodological problems would be solved. Yet the intensity of that faith and the suspension of disbelief in the face of such meager evidence belies a deep despair in the cohesion of the social order. . . . Behaviorism was unambiguous, straightforward, and seemed to offer a hope of certainty for those who so desperately sought it.[53]

Behaviorism, then, had enormous appeal for businessmen who desired a scientific method to control consumers and predict sales.

READING THE ADS

Women knew in the 1920s and 1930s, as they know now, that advertising is a fiction. As one cynic of the period observed, "To read the rear ninety per cent of the *Saturday Evening Post* is the next best thing to going to the movies." This skepticism had deep roots in American culture. Nineteenth-century audiences at medicine shows, for example, expected to be tricked. And later audiences were equally skeptical. A 1931 study by psychologist Henry Link showed the number of people who believed an advertisement's claims varied from 4 to 37 percent, depending on the product.[54] With very little effort consumers could learn of the overblown promises and ineffectual (or even dangerous) ingredients of their favorite products. In the late nineteenth and early twentieth centuries, scandals involving contaminated food and harmful drugs had led to the federal Pure Food and Drug Act, whose enforcement, however, seemed inadequate to consumer advocates. A stronger consumer movement took shape in the late 1920s, when books, some of them best-sellers, appeared, cataloguing the hidden dangers of nationally advertised consumer goods. Newspapers and magazines carried horror stories of consumers terribly deformed or poisoned by cosmetics or patent medicines easily available in their local drugstores: Koremlu depilatory, Radithor tonic, and even Pebeco toothpaste (each tube alleged to contain enough potassium chlorate to kill three people).[55]

The nascent consumer movement circulated stories of an ineffectual FDA that refused to put public health before the profit of unscrupulous companies and urged the public to develop a more cynical view of advertising. The consumer advocate Mary Phillips advised women in 1934: "Don't think for a moment that the manufacturers and writers really believe their stuff. That's just the way they make their money. The childlike faith of most feminine consumers in the efficacy of his product is not shared by the cosmetic manufacturer when he's talking off the record."[56]

Consumer advocates were aided in their efforts by some disaffected or just plain honest industry insiders who recognized their social role and began to write about their experiences. As the socialist-turned-adman-turned-critic James Rorty wrote in 1934, the abler people in advertising "don't believe in the racket themselves." [57] The specific warnings and widespread critiques of advertising's credibility in the media make it unlikely that most women took advertising's promises at face value. Because experiences of advertising were complicated by the circumstances of women's lives, the social constructions of femininity, and varied readers' responses to the representations in different advertising images, it is impossible either to accord the advertisements unlimited powers of persuasion or to dismiss their influence altogether. Complicated and dynamic interactions between the image and the viewer must be in play.

So why do ads work? The ads no doubt convey authority—that of print as well as that derived from impressive corporate wealth, "scientific" study, and patriarchal custom. Thus some theorists have claimed that consumers are manipulated into buying products to satisfy needs or desires that the ads create. This idea, which has its roots in the critiques of mass culture by the Frankfurt School, proceeds from the belief that the mass media serve only the interests of capitalism and that their power to influence people goes only one way. [58]

More recently, mass media theorists have suggested a complex and dynamic process of how women read the ads, internalize advertising messages, and act upon them. These images are effective, not because they promise material rewards, but because they arouse women's deep-seated apprehensions about their social positions and their definition of femininity. These advertising images raise social anxieties, but only to the degree they are able to satisfy them. As Fredric Jameson has noted, art can bring "repression and wish fulfillment together within the unity of a single mechanism, which gives and takes alike in a kind of psychic horse-trading." [59] The image then arouses fantasies but is careful to also contain them.

Thus consumers are not simply the unwilling victims of multinational corporations seeking to force unwanted goods upon them. Rather, despite their skeptical reading, women participate (and ads work) because anxieties already present in their lives are symbolically allayed in advertising. Thus ads hypothesize and promise utopia for women, even as they accurately describe their lives; and they alleviate women's self-doubt, even as they raise it.

SELLING WOMEN ON TRADITIONAL GENDER ROLES

The scope of women's roles that emerges from the pages of women's magazines between the world wars is narrow. The roles were chosen, and thus women's interests were *publicly* defined, by a male advertising elite, who, despite their fascination with surefire sales methods, including psychology, seem to have had little consciousness

of the larger implications of their actions. Thousands of pages of corporate internal memos and minutes of staff meetings over two decades reveal no self-conscious decisions to limit women and no "conspiracy plot." They only wanted to sell soap or lotion or whatever—and please their clients, and, presumably, maintain their home in the suburbs. The advertising elite (despite their experience with the occasional female—probably single—copywriter) were simply happy with things as they were (or, they thought, should be for the comfortable middle class), where men went to work and women took care of the home. If they were happy, they thought women were, or should be, too.[60]

However "natural" ads were made to seem, or however scientifically they were couched, the gender relations constructed in them were based on intuition and on historical and class-based ideas of what made women happy and what advertisers hoped would convince women to buy their product. The ads expressed an unquestioning view of how society was, or should be, structured. The ideologies that defined contemporary social roles and behavior for the admen were so pervasive that they were invisible to them.

Steichen's images, like most early-twentieth-century photographic advertising images, reinforced the female consumer's traditional roles of lover and mother. The 1931 photographs of couples for Jergens lotion graphically represented a potent fantasy that recurs frequently in popular literature for women (Fig. 6.15).[61] The man is totally absorbed in the woman. He closes his eyes and concentrates on the flood of his emotions. With her half smile and half-closed eyes, the woman slips into dreamy reverie. A few props identify her social station. Her dress is informal, but the gold links around her neck indicate some level of economic security. And her impeccable makeup and carefully coiffured blonde hair testify that she has leisure time in her life. The chain around her neck (an unintentional metaphor?), its links symbolically repeated in the clasp of hands, suggests a strong union, implicitly initiated and solidified by the beautifying effects of the product. Thus the woman's dutiful attention to her appearance is rewarded with love, money, and happiness. Even an advertisement picturing only the woman enjoying her leisure and wealth implied ability to attract a mate. Surely the beautifully manicured hands in Figure 6.17 have not come to the tennis court alone!

In Figure 6.16 the woman's sparkling jewels and dazzling sequined dress again indicate class status and activities as well as suggesting a specific night on the town. The partners' gaze, the focal point of the photograph, suggests their strong attraction. The theatrical lighting, the strongly modeled profiles and hands, and the costuming make the image seem as much like a B-movie still as a lotion advertisement, so that the reader's identification with the model is effortless.

These Jergens advertisements of the early 1930s looked "modern" to Steichen's art directors because their comparatively sharp, close-up, and cropped figures contrasted with the softer focus used only a few years before. By combining elements of modernist art photography with the formal and narrative techniques of motion pic-

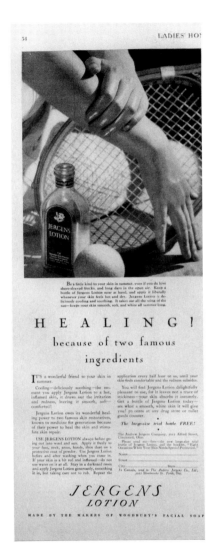

6.17 Advertisement for Jergens lotion, *Ladies' Home Journal*, June 1929, p. 54. Edward Steichen, photographer (J. Walter Thompson).

tures, Steichen was able to infuse emotion into a figurative composition. The content consciously elicits empathy, and the story line seems sentimental even though Steichen publicly stated that he detested sentiment in advertising.[62] His technique, with its modernist veneer, perfectly suited the Thompson agency's dramatic requirements for beauty product advertising in the 1930s. The same strategy was used in other Thompson campaigns, for Cutex nail polish, Pond's cold cream, and Lux soap—all of which used Steichen's photographs at some point.

In the romantic images for beauty products, women gained happiness by making men happy, by contributing to a solid relationship. In others women attained hap-

piness by caring for their children. In a series of color images Steichen photographed for Ivory soap, a mother gains great satisfaction bathing and dressing her toddler. In Plate 3 bathtime has just ended and the mother is tenderly drying her child, who seems not quite ready to end the bath. Both are smiling, the child more expressively than the serene mother. Bath accessories surround them, and the child points down to the water where the bar of soap is conspicuously floating. In the completed advertisement, Steichen's photograph was framed by borders that suggest a matted and framed artwork, implying that Steichen's photograph was more than just an advertisement—it was a keepsake image, an example of fine art that refers back to and updates the Renaissance Madonnas.

In Plate 4 the child, still wrapped in his bath towel, is more playful. The mother, dressed in a salmon-colored satin robe with lace appliqué, is as lively as her child. The slogan subliminally connects the quality of the soap—"99 44/100% pure"— with mother love. The text assures women that the soap is just as good for them as it is for their children, thus doubling the potential market.

The models in Plate 5 represent another satisfied, serene subunit of a traditional family. The mother gently and lovingly guides the child's foot as the little girl learns to put on her slippers. The mother's expression radiates a quiet joy. Manicured, coiffured, made-up, and dressed in a satin and silk kimono, she helps her child in a room furnished with blocks and other educational toys. This is the image of a competent, well-informed, financially comfortable, and blissful mother. As in the Kodak advertisements Steichen photographed at nearly the same time, the accessible, "naturalistic" style of the Ivory soap ads encouraged an easy identification with the model (see Figs. 4.18, 4.19; see Plate 2), one that the soft yet full colors produced by the new color film technology further enhanced.

The effect of stereotyping the gender roles in these images is to assuage any dissatisfaction women felt from constricted horizons. Women's attitudes and emotions toward their real roles in life were manipulated to replicate the narrative pattern established by the ads: just as the advertisement described cosmetic, hygienic, or other needs to explain how the product solved them, any tensions and anxieties women felt over their circumscribed lives were raised enough to acknowledge them, and then were neutralized. None of this ambivalence is represented on the surface of the ads. Not only were traditional gender roles unquestioned, but they were presented as immutable facts discovered through the force of science and considered necessary to maintain the family's standard of living and social status.

THE PSYCHOLOGY OF GENDER ROLES

The earliest advertising psychologists, without any statistical evidence, argued for the status quo. Walter Dill Scott, providing no empirical studies, contended that women read ads more thoroughly than men and were more easily convinced to pur-

chase products because "women are, in general, more susceptible to suggestion." He advocated the atmosphere strategy, which would "awaken" women's "emotional nature" enough to make the sale.[63] Daniel Starch agreed that women were more suggestible than men and more readily influenced by "indirect," or "irrelevant" emotional appeals. The most successful ads would reference "the greater domestic interest of women, that is, the more intense interest in and the larger amount of time devoted to the home and the family. This difference, of course, is very deep-seated, and is a part of the very make up of men and women."[64]

Among psychologists woman's "emotional nature" was an article of faith. But despite widespread interest in "Selling Mrs. Consumer" in the early twentieth century, few scientific studies provided empirical guidelines for developing strategies or evaluating success. In one of the few studies of effective appeals, Harlow Gale discovered that males preferred the colors green and black, females, red and green.[65] And in one of the few surveys of buying habits, Harry Hollingworth confirmed that women bought most of the common products consumed by twenty-five New York families.[66]

Behaviorism, which sold itself as an empirical science, perpetuated the stereotypes, relying on similar unconvincing and unscientific evidence. Watson himself categorically opposed all challenges to women's traditional roles and rejected women's need for intellectual stimulation. He warned that a business career caused "callousness and self-sufficiency" that made women unfit for marriage. In his popular writings he argued that "a girl is foolish to spend her best years in the office . . . sharpening her brains when these things are of little importance to her in her emotional life as a woman."[67] Watson believed in the doctrine of "separate spheres," with men working outside the home and women confined within it. Historians today trace the division of labor by gender during the nineteenth and early twentieth centuries to industrialization, which forced men into the wage-earning economy.[68] Despite Watson's belief in the shaping influence of environment and his rejection of the significance of most inherited traits, he seemed to see the sexual division of labor as natural.

Instead of a career, Watson argued, in a utopian society women need attend only to "keeping themselves young and beautiful" and to "learning about home science." But he insisted that "their life is just as serious and rich in achievement and endeavor as the men's." In Watson's utopia, while the older teenage boys explored science, medicine, manufacturing, architecture, mining, and agriculture, girls would learn "how to run a home," an activity that would keep them "busy and happy from morning till night." Besides cooking, child care, and interior decoration, Watson thought young women ought to know "the use of cosmetics, . . . how to stay thin, . . . how to be successful hostesses and to put on the intellectual attainments that go into the making of a beautiful, graceful, wise woman."[69] Any challenge to traditional roles was a sure sign of maladjustment. Watson argued with the full authority of behavioral psychology: "When a woman is a militant suffragist the

chances are, shall we say, a hundred to one that her sex life is not well adjusted? . . . [Among well-adjusted women] I find no militant women, I find no women shouting about their rights to some fanciful career that men—the brutes—have robbed her of." [70]

Watson's acrimony reflects a wider apprehensiveness about changes in women's roles in the early twentieth century. The "new woman," who worked between the completion of her education and the time of her marriage and rejected the extremes of Victorian morality and manners, had emerged soon after the turn of the century. After World War I the revolution that had begun among middle- and upper-class women spread to more middle- and working-class women. By the 1920s feminist ideas were widely accepted by the public because of the suffragettes' recent success. [71] The popular magazines were full of the changes in family life—divorced women, working mothers, independent career women, and so on. Even *Vogue*, the elitist, conservative bastion of proper behavior, announced in a headline of 1925: "Gone Is the Prim, Put-upon Female, the Old Maid of Bygone Days, and in Her Place Is an Independent Person Who Glories in the Fact that She Doesn't Have to Marry unless She Wants To." [72]

The "new woman," with newfound rights and freedoms celebrated in the press and in feminist anthems during the flapper years, was largely illusory. A backlash against women's widely acknowledged achievements began almost immediately after World War I. Conservative Republicans held the White House from 1921 until Franklin Delano Roosevelt's election in 1932. In Congress, the progressive element weakened after 1924, another indication of the change of mood in the country. More important for the women's movement, almost immediately after women gained the vote, organized feminism split along ideological lines. One group sought a federal equal rights amendment to guarantee women legal equality in matters of property, divorce, and child custody; the other sought protective legislation for women, arguing that youth, inexperience, and job instability necessitated special programs such as widows' pensions and welfare. [73] The supporters of protective legislation, who dominated feminist ideology until the late 1960s, urged even self-proclaimed feminists to return to more traditional roles.

Women's hard-won rights and freedoms faced further retrenchment in the depressionary 1930s. At a time when "marriage bars" (state and federal laws) allowed employers to fire married women, the editorial pages of popular magazines urged women to accept their traditional roles and avoid competing with (and possibly embarrassing) their husbands by earning money. *Vogue* admonished readers to cut expenses rather than work, because "in these trying times, the breadwinner, in daily fear of being unable to supply the needed funds, wants his wife at home, attending to her responsibilities and obligations." [74] The home magazines, read by middle- and working-class women, also urged them to return home. Women were encouraged to accept—and even favor—the limited options of earlier times. Thus the text and images on both editorial and advertising pages defined femininity in domestic terms.

The pictures do the cultural work of making women content with the status quo. Women's own ambivalence about their role, function, and place in the modern order complicated their response to the ads. If they decided to participate in the fantasy, they accepted the weight of social norms and opinion in its seemingly palatable guise.

The imagery that conjured up an atmosphere of glamour, beauty, and social success became the hallmark of Steichen's 1930s advertising style. But that style must be seen as collective and collaborative rather than individual, for Steichen worked closely with others in the agencies. Schooled in the new theories of behavioral psychology by his art directors, Steichen amplified the persuasive elements implicit in his earlier photographs to create more "emotional" imagery.

Collaborative image making affected content as well as style. Images were constructed to reinforce stereotypical gender roles that reflected a partial truth about many women's lives, depicting their attainment of romance and their competence as homemakers. Their anxieties about their choices or their unhappiness at the lack of other possibilities was never directly represented in the image itself, which only suggested how the given product might soothe these anxieties without radical social change. The drama-infused naturalism of the photographic medium reinforced the spectators' participation in the images, encouraging greater identification with the model, and in the process selling both the product and a self-image as a consumer.

Testaments to Class Mobility

Steichen's society portraits taken for testimonial advertisements epitomized the representations of glamour, wealth, and elite social position that were the photographer's stock-in-trade by the late 1920s. While the later Jergens images invited readers to identify with unnamed ladies of leisure and fantasize about the details of life as one of the rich and famous, Steichen's photographs for Pond's cold cream and vanishing cream provided elaborate descriptions and illustrations of the whirlwind activities of the women admen deemed the most beautiful and admired in America. Countesses and queens joined socialites from industrial families like Vanderbilt, Morgan, and Du Pont in endorsing beauty products and household items on the pages of the women's magazines. The ads gave middle- and working-class American women a glimpse of the glittering elites of New York, Washington, Palm Beach, and Newport.

Advertising agents insisted that such a personalized "class" appeal worked. Why did they feel that housewives looked to society women as role models in the choice of beauty preparations? What did these moneyed, leisured women signify for the readers of the women's magazines? And how did Steichen's portraits work with the copy to construct an image of the sitters as members of an exclusive club, which the ordinary woman could peek inside, if not enter, by using the endorsed product?

The testimonial was a particularly potent advertising strategy because it spoke to contradictory values, embodying both democratic and elitist impulses. The inexpensive, mass-produced product indicated equal access to goods, but the endorsement by wealthy and beautiful socialites conferred a touch of "class" on the product. Even as they reinforced class hierarchies, testimonial advertisements made social mobility seem easy by implying that using the advertised product would make a woman equal to the endorser. These contradictions extended to gender relations. The women celebrated for their good taste, wealth, and fame always derived their status from their family and social circle rather than from personal achievements, thus reassuring the viewer of the worth of traditional, home-centered activities.

The testimonial promised the individual consumer "personal" advice that, paradoxically, supported collective, dominant standards of beauty. The endorser's picture was complemented by copy written in a confidential tone. In an increasingly urbanized and industrialized society, these testimonial advertisements gave the consumer an intimate knowledge of the product, helping her to navigate among an array of new commodities and brand names.

Steichen's portraits echoed these paradoxes. In an age when documentary photographs were popularly accepted as purveyors of truthful representation, the artistic constructions of social and gender relations imaged in Steichen's photographic advertisements were made to seem "natural." The precise description inherent in photography itself made these constructions of class and gender particularly forceful. The testimonial strategy reinforced the implied honesty of the photographic medium (and vice versa). All claims were backed up by a real person, a figure of some social standing, whose words attested to the truthfulness of the manufacturer's assertions.

Steichen in the 1920s and 1930s was perhaps best known for his commercial portraits of celebrities published monthly in *Vanity Fair*; the magazine never tired of reminding its readers of his skill as a photographer. He was even sent on special assignment to Hollywood in 1929 to photograph stars for Condé Nast and J. Walter Thompson.[1] Steichen's own celebrity, grounded in the prestige and international reputation of a successful art photographer, and his use of sophisticated new photographic vocabularies gave his commercial images published in popular magazines a greater status and credibility than run-of-the-mill advertising photography.

THE ALLURE OF WEALTH AND BEAUTY:
THE POND'S CAMPAIGN

During the 1920s the testimonial technique reached a new height of popularity, and the advertising agency persuaded the Pond's company to try it. The Thompson agency had almost single-handedly rejuvenated this nineteenth-century advertising technique. First developed for patent medicines, testimonials in advertising had

fallen into disfavor as a result of ads featuring doctors of questionable competence recommending elixirs of dubious value. The popular 1933 exposé *One Hundred Million Guinea Pigs* warned consumers that "practically all quacks" used "testimonials exclusively."[2] The strategy was championed in the Thompson agency by Stanley and Helen Resor themselves, however, as well as by their star psychologist, John B. Watson. The agency made a reputation in the industry by designing a new upscale version of the testimonial. The agency supplied the magazines with images of Hollywood starlets telling readers how Lux soap improved their complexions and boosted their careers. And European doctors, free of the watchful eye of the American Medical Association, explained how eating Fleischmann's yeast promoted good health and cured "intestinal fatigue."[3]

When Steichen was commissioned to take many of the testimonial portraits for Pond's, the cream manufacturer was already a venerable client and an important account for the J. Walter Thompson Company—the oldest of all the agency's accounts, acquired in 1886, when the company made only Pond's extract, a refined witch hazel. As overall use of the extract declined and the company competed for the diminished market with druggists who produced their own brands of witch hazel, Pond's augmented its product line with a vanishing cream, then a cold cream. Like Jergens, Pond's flourished under the guidance of the Thompson agency, and the manufacturer rewarded the agency with more business: by 1924 Jergens lotion and Pond's cold cream were Thompson's fifth and sixth largest accounts.[4]

The industry celebrated the Pond's campaign, with each ad featuring "the testimony of a woman of accepted beauty and arresting social position" who was considered "so socially famous as to command instantaneous attention and unquestioning credence."[5] Steichen was just one of a number of well-known commercial illustrators and photographers, including Alfred Cheney Johnston, Adolph de Meyer, and Charlotte Fairchild, who made portraits of the "smart set" for the campaign. Their work appeared in a wide variety of women's home and fashion magazines, including *Vogue, Ladies' Home Journal, Good Housekeeping, Women's Home Companion, Butterick, McCall's, Liberty, Pictorial Review,* and *Farmer's Wife.* In trade journal companion ads designed to win more shelf space, the manufacturer reminded retailers that "the most distinguished women in the world are talking to your customers about Pond's two cold creams."[6]

Testimonials for consumer products by prominent members of "high society" had begun in earnest in the mid-1920s. Mrs. O. H. P. Belmont, a prominent New York society matron, lent her name to Pond's in 1924 in exchange for a donation to charity. The ad included images of her home and an interview, but not Mrs. Belmont's picture.[7] Soon wealthy debutantes, socialites, and titled women posed monthly for Pond's, sharing their most affordable beauty secret with the rest of America for a healthy fee.

In one of the first advertisements in the Pond's series, dated January 15, 1925,

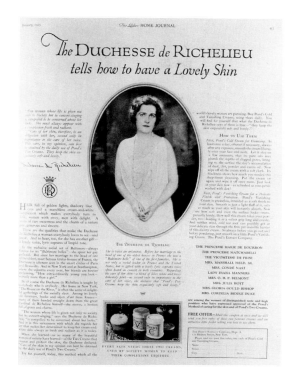

7.1 Advertisement for Pond's cold cream (Duchesse de Richelieu), *Ladies' Home Journal*, January 1925, p. 43. Edward Steichen, photographer (J. Walter Thompson).

Steichen's image of the Duchesse de Richelieu appeared with text describing her background, talents, and beauty secrets (Fig. 7.1). Raised in the "exclusive social set of Baltimore," she was married to "the head of one of the oldest, most famous titular houses of France," which gave her entrée to the "smart circles of Paris and Deauville." Thus she was the perfect Pond's advocate: she joined American money and social standing with a European title. Perhaps sensitive to possible resentment on the part of less fortunate readers, in caption and copy the ad described her talented voice, a "lyric soprano of limpid tone," and mentioned her "concert-singing."

Steichen's image provided the air of elegance the agency sought. The duchess is represented as a typical pictorialist beauty. She looks like a star of silent films, with her etched features playing against the softer contours of her hair and the fabric of her dress. The dress's flowing folds and scooped neckline echo in the loops of her long beads and the gentle curve of her arms. The repetition of oval elements and the softness of her overall appearance become metaphors for her soft skin—courtesy of Pond's. A decorative background, perhaps a Japanese screen inherited (like many of her household furnishings) from the Cardinal de Richelieu himself, frames her, and its high-art status signals her exquisite taste. The duchess gazes out from a distant world, a beautiful and dignified creature, represented to be admired.

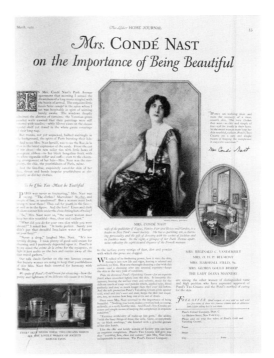

7.2 Advertisement for Pond's cold cream (Mrs. Condé Nast), *Ladies' Home Journal*, March 1925, p. 53. Alfred Cheney Johnston, photographer (J. Walter Thompson).

For the duchess's portrait Steichen used the soft focus typical of testimonial advertisements throughout the 1920s. Alfred Cheney Johnston used a similar style in photographing Mrs. Condé Nast for Pond's (Fig. 7.2).[8] Despite the up-to-the-minute styling of Mrs. Nast's bobbed hair, she seems a distant, meditative creature, her pose stiff and self-conscious, her eyes turned away. The soft focus is the artist's signal that "art" is here substituted for "reality," as in the earliest Pond's testimonial advertisements, where drawn and painted portraits conveyed the atmosphere of "class" sought by the manufacturer. For example, the painter Wayman Adams, in the portrait of Alice Roosevelt Longworth (Fig. 7.3), the daughter of President Theodore Roosevelt, emphasized the sweep of her arms and the length of her fingers, much as Johnston did in the photograph of Mrs. Nast. Longworth gazes off into the distance, as if to escape the close scrutiny the illustration otherwise invites. The elongation of Longworth's body and the references to John Singer Sargent's portrait style make the Longworth portrait seem more elegant to us than Johnston's photograph, but at the time, Johnston's photography was considered a suitable photographic transcription of the style. Steichen's portraits would soon come closer to matching the elegance of the painted portraits, and he was selected more and more frequently to produce the portraits for the campaign.

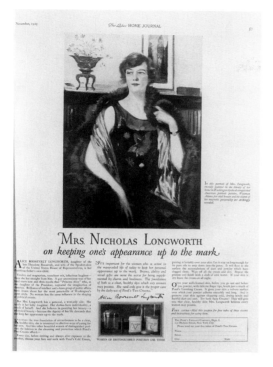

7.3 Advertisement for Pond's cold cream (Mrs. Nicholas Longworth), *Ladies' Home Journal*, November 1925, p. 57. Wayman Adams, illustrator (J. Walter Thompson).

The Pond's strategy combined reason-why and atmosphere approaches, providing both an explanation of the product's benefits and an invitation to fantasize about the changes it will bring about. In analyzing the effectiveness of the campaign, Carroll Rheinstrom noted how the ad, both emotional and rational, "breathes of sophisticated personal journalism."[9] Carl Naether described the campaign as a rational argument offering convincing "proof" of the product's value.[10] Typically the professional debate centered on strategy and copy and ignored the role of Steichen's photographs in creating the desired atmosphere.

ELITISM AS EQUALITY

The Duchesse de Richelieu's endorsement was considered a triumph, bringing in 19,126 requests for samples with its first appearance in the *Ladies' Home Journal*, almost twice as many as Mrs. Vanderbilt's (see Fig. 3.18).[11] Following closely in generating requests for samples were portraits of the actress Lady Diana Manners and Marie, the queen of Romania, a granddaughter of Queen Victoria.[12] The number of requests confirmed the admen's suspicion that any European title edged out

American high society in persuading women to mail in coupons for free samples. The results sent Pond's advertising representatives scurrying about Europe to sign up, among others, Eulalia, the infanta of Spain and aunt of the then reigning king; the Princess Murat of Paris; the Duchesse de Gramont of Paris; and Queen Victoria Eugenia of Spain.[13] Given the limited supply of European titles, the agency also used photographs of European-born women who had married into the American elite: the Italian-born Mrs. John Davis Lodge, the Parisian Mrs. Gifford Pinchot II, the Spanish Mrs. Potter D'Orsay Palmer, and the prerevolutionary princess of Soviet Georgia Mrs. Norman Ogden Whitehouse all sat for Steichen in the late 1920s. Their wealth and new family connections gave them a prestige most immigrants could not enjoy.

Money may have induced some titled women to pose for ads. Others may have been motivated by the opportunity to affirm their status and gain more prestige through media exposure. Wide distribution made their opinions, and them, important. In America the fascination with royalty was fueled by its absence. Americans imported old stock from across the sea and, in recontextualizing them, infused royal images with new meanings constructed by corporate advertising or other concerns.

As Judith Williamson has pointed out, the beguiling quality of royalty is its members' very ordinariness. Their status is conferred by birth. Royals do not necessarily possess greater intelligence, talent, athletic prowess, or business acumen than others, and thus in a way they represent the masses of people who are not special. Yet because they claim an elite position in a fixed hierarchy, they reinforce class structure.[14] Thus the American middle- and working-class fascination with royalty signifies contradictory currents in Americans' conceptions of their own society: royals represent an elite yet are ordinary enough to stand in for the consumer. The privileges of life at the top and the myth of a society of equals are reinforced simultaneously.

As for wealthy American women, modern celebrityhood—being famous for being themselves—must have motivated them. By endorsing products, moneyed Americans accepted the role of tastemaker and perhaps asserted their equality with European royalty. That admen believed wealthy women inspired envy among the masses is a comment on the 1920s obsession with the acquisition and possession of money and the ad industry's own Republican Party sympathies. There was no stigma of commercialization among the new upper-class models; if anything, their actions were consistent with their family's capitalist ideology.

Roland Marchand has argued that testimonials by the elite proved so enduring in advertising because they demonstrated equal access to the many new inexpensive items being mass-produced in America.[15] They assured consumers that everyone, regardless of class, used the goods advertised. One adman of the time explained: "If we can't get an invitation for tea for our millions of customers, we can at least pre-

sent the fellowship of using the same brand of merchandise."[16] Pond's cold and vanishing creams equalized the beauty routines of rich and poor, uniting women in their feminine rituals. At the same time, this strategy minimized the consequences of a class society. As Marchand observed, the "social message" was clear: if "antagonistic envy of the rich was unseemly, programs to redistribute wealth were unnecessary." Equality was easily achieved through trivial acts of consumption.[17]

Yet the ads that constructed a democratic vision based on goods paradoxically reinforced class distinctions, to which Americans became more attuned in the decades after World War I. Advertising contributed to this awareness with its representations of "high society"—wealthy, well-connected people who worked hard at entertaining, shopping, and attending parties and sporting events in New York, Palm Beach, Newport, and Paris. The ads presented social distinctions as natural and immutable so that advertisers had no fear that presenting the unproductive rich as role models would set off a backlash against the product (or class society, for that matter).[18]

Although ads effectively strengthened the class hierarchy, they did not describe the power relationships that maintained wealth. They depicted the rich, inexplicably born into a stress-free fairyland whose exchanges were social rather than economic. As Marchand has noted, the only power ascribed to them as a class was the ability to shape fashion and aesthetics;[19] thus women's power was confined to the realm of clothes and makeup. The ads did not acknowledge the relationship between the country's business elite (represented by the conspicuously consuming female members of the family) and real power to influence government policies and regulations for the industry or set wages for workers. The elite class was represented as admirable, benign, and open to new membership.

Another reason testimonials proved powerful was because they provided personal advice and a sense of empathy in a quickly changing society and reassured people of their worth as individuals. They may have had a "therapeutic" value, helping to develop a sense of self in the anonymous modern world. Mass-produced goods and images became signifiers of a new identity that filled the void left by the destruction of older identities based on family, religion, occupation, and geography.[20]

Advertisers inundated consumers with advice from both real and fictional characters. Steichen's society leaders found themselves in the company of fictional advisors, like Betty Crocker, who coached women on the use of modern products in magazine ads, answered letters to the manufacturer, and dispensed advice on the radio. Armed with individually provided knowledge, the consumer could navigate store shelves ever more crowded with brand names.[21]

Though the testimonials were seemingly sincere and authoritative, abuses of the strategy were widespread and extensively covered in the trade press by an industry that deeply feared a loss of their recently gained professionalism. Hoaxes, exaggerated claims, public repudiation of some endorsements, testimony by obvious non-

users, overexposure of some personalities who endorsed more products than they could possibly use, and rumors of high fees all contributed to keeping the shady history of the testimonial in the consumer's mind and undermining the strategy's credibility. As industry critics Stuart Chase and F. J. Schlink told consumers, "When you read a testimonial, laugh heartily." [22] The worst offenders were tobacco companies that paid singers and actors to explain how their brand of cigarette offered the most "throat protection" and beauty products that employed actresses who claimed the product made them look half their age. Reports of solely monetary motivation circulated in the press; Marie, the queen of Romania was said to have an agent who got her $2,000, two silver boxes, and a miniature painting of herself to use her name for one endorsement (in all likelihood for Pond's). Alice Roosevelt Longworth was said to hold out for $5,000, and when she got it, announced the deal through the Associated Press. [23] Such public controversies sent fear through the advertising industry that the public would think that "all testimonial copy is faked." [24] But the critical voices went largely unheard, until the FDA strengthened its regulation of misleading advertising in the mid-1930s. [25] Others were concerned that lightweight celebrities could not provide the needed honesty, sincerity, and assessment of the value of the products. Christine Frederick, for one, preferred "the prestige of great home economics authorities" (like herself) to the "snob's paradise" featuring "people whose position is merely social or on a notoriety basis." [26] But the publicity surrounding the testimonials, the appeal of the imagery, and the hyperbolic assurances of the copy made good reading. Advertising could be and was accepted by a public that was constantly aware of the fictive nature of its content and treated it only as an entertaining guide.

THE SOCIETY MATRON

"High society" women of all ages, from freshly minted debutantes to established matrons, lined up to endorse Pond's two creams. In 1927 Steichen photographed Mrs. W. K. Vanderbilt (Fig. 7.4) for a layout that includes five images: three portraits of Mrs. Vanderbilt, a photograph of the product on her dressing table, and a drawing of the outside of her Manhattan home. Apparently the art director felt that all the detail and a fussy layout, with its image borders and multiple typefaces, were necessary to construct the story of Vanderbilt's lifestyle and product choices. Steichen's photographs, moreover, brought no modernist simplification to Mrs. Vanderbilt's cluttered Victorian environment. They convey the textures of her precious possessions: the leather-bound books, the patterned drapery and upholstery, the mahogany mantelpiece, and the Chinese porcelains that graced her "spacious English living room" and her "little morning room." Her poses accentuate her impeccable manners and distance her from the viewer. But her aloofness in the portraits is

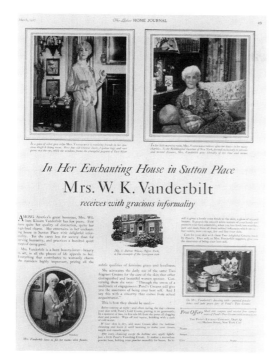

7.4 Advertisement for Pond's cold cream (Mrs. W. K. Vanderbilt), *Ladies' Home Journal,* March 1927, p. 49. Edward Steichen, photographer (J. Walter Thompson).

counteracted by the text, which humanizes her, referring to her hard work for "many charities." Pond's cast her as a role model for older women, thus opening up the market for the products and stamping them as practical and durable cosmetic necessities.

The distance between the model and the viewer in commercial representations of wealthy, older women is greater than that of social status alone. Like Steichen's portrait of Mrs. W. K. Vanderbilt, Adolph de Meyer's 1926 portrait of Miss Anne Morgan for Pond's conveys a sense of formal hospitality, grace, and social correctness (Fig. 7.5). Morgan, the daughter of the millionaire financier J. P. Morgan, is seated as if enthroned, peering cautiously out at her admiring audience. The floral backdrop shimmers under the studio lights, creating a haloed effect. Morgan seems reserved, yet authoritative.

This sense of authority typified testimonials by older women. Steichen's commanding full-length portrait of Mrs. J. Borden Harriman holds down a corner of a 1927 advertisement for the Simmons Company (Fig. 7.6), reversing the usual testimonial formula that equated a male voice with authority and a female voice with pleasure in the product. Too old, distinguished, and powerful for her image to work with conventions developed for glamorous debutantes, Mrs. Harriman stands

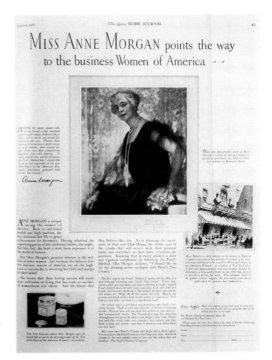

7.5 Advertisement for Pond's cold cream (Miss Anne Morgan), *Ladies' Home Journal,* February 1926, p. 49. Adolph de Meyer, photographer (J. Walter Thompson).

against a wall that accentuates her straight carriage and the tailored lines of her suit. The overcoat she carries is trimmed with leopard skin, signifying her wealth and power and adding visual variety. The caption stresses her political activities but implies that she uses her womanly gifts, entertaining in her Washington home and broadening the base of the Democratic Party by helping to establish the Woman's National Democratic Club.

Another ad from the series featured Mrs. Franklin D. Roosevelt (Fig. 7.7) in a small portrait that nonetheless conveys her authority as the woman of the house, who is also active politically. As in the Harriman ad, other photographs reinforce the themes of quality and wealth through information and atmosphere. Whereas the small inset image of the coils that go "right to the very edge" stresses quality of construction and durability, the large Steichen photograph of a maid in each advertisement invites fantasies about the benefits of wealth and social standing.

No doubt Steichen chose imagery in consultation with the other members of the agency team: the young white "French maid" was a visual cliché used to symbolize the homes of people of power. In these ads she is an index of the Harriman and Roosevelt families' social status. Like nine out of ten maids shown in women's magazines, she is a stereotype that does not represent American domestic workers

at the time, who were older and were likely either to be black or to have emigrated from southern or eastern Europe—not France.[27]

The role models in the Simmons ads were unusual for featuring prominent women, influential in their own right, who were mature and had access to real political power. Significantly, they endorsed household essentials rather than beauty

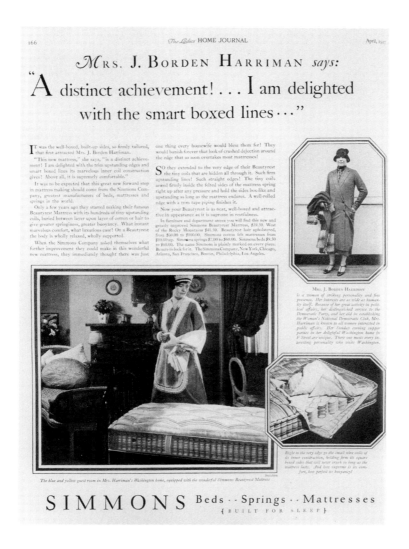

7.6 Advertisement for Simmons mattresses (Mrs. J. Borden Harriman), *Ladies' Home Journal*, April 1927, p. 166. Edward Steichen, photographer (J. Walter Thompson).

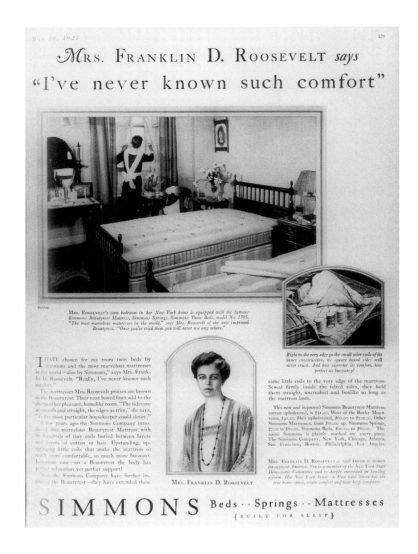

7.7 Advertisement for Simmons mattresses (Mrs. Franklin D. Roosevelt), *Vogue*, May 15, 1927, p. 129. Edward Steichen, photographer (J. Walter Thompson).

products. (Mrs. Harriman also endorsed Johnson's wax for floors and furniture.) The overt partisan affiliation of the two women was also rare. Few advertising industry executives shared the Democratic views of Roosevelt or Harriman. Party affiliation in these ads may have been an attempt at populist appeal or it may simply have reflected the preference of the Simmons executives.[28]

The women who endorsed beauty products were honored for their beauty, youth, and inherited money. For Pond's, in the staid pictorialist style, Steichen photographed Miss Camilla Livingston, whose credentials as a role model stemmed from her ancestry, dating back to "one of the distinguished old families which helped settle Manhattan three centuries ago" (Fig. 7.8). Although the ad describes her "gay and varied" summers spent "riding and swimming by day, dancing by the summer moon," she is placed statically in the center of the image, anchored by her book and ostrich-feather wrap. Steichen transforms this busy debutante, who shuttles between New York, Paris, Newport, Huntington, and the Lido, from a flesh-and-blood girl into an otherworldly creature. As in the other ads of this series, the tone of the copy is familiar, opening with her "own words" (filtered, of course, by a copywriter), shifting to an affected tone of feminine confidentiality, then offering instructions on using the product.

Steichen's conservative pictorialist formula in the early Pond's ads effectively un-

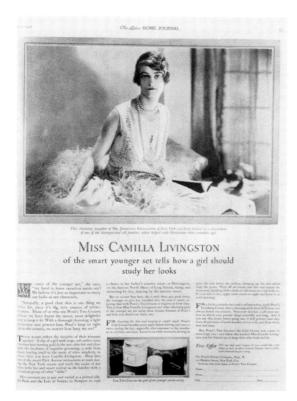

7.8 Advertisement for Pond's cold cream (Miss Camilla Livingston), *Ladies' Home Journal,* April 1926, p. 57. Edward Steichen, photographer (J. Walter Thompson).

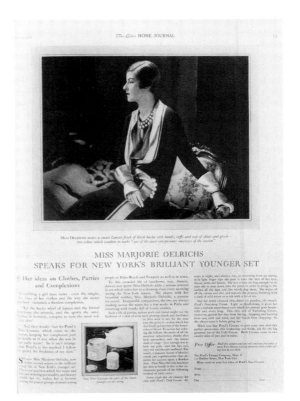

7.9 Advertisement for Pond's cold cream (Miss Marjorie Oelrichs), *Ladies' Home Journal*, March 1926, p. 53. Edward Steichen, photographer (J. Walter Thompson).

dermined the images of vivacity that emerged in the text. The visual vocabulary used to convey a timeless sense of beauty began to look outdated with the emergence of modernism. As in the Jergens ads, the transition to a modernist figural style in the Pond's ads was halting. Steichen introduced some of the austerity and dramatic tonal contrasts of straight photography into his 1926 portrait of Miss Marjorie Oelrichs for Pond's, published a month before the Livingston portrait (Fig. 7.9). Oelrichs's profile, highlighted against the dark background, conveys an elegant severity that is repeated in the contrast between the dark fabric of her dress and the silver bands and cuffs that trim it. Even though the copy tells us that Oelrichs was busy balancing the demands of "her second season in the brilliant social life of New York's younger set" with shopping in Paris and her "serious interest in art," Steichen's large studio camera required that she sit quietly for her portrait. Modernism is introduced through focus, contrast, and lighting, rather than activity. Thus the photograph conveys a dignified, though somewhat updated, beauty.

In 1927 Steichen depicted Mrs. Felix Doubleday modeling her Chanel wardrobe (Fig. 7.10). Mrs. Doubleday combined the exoticism of her Viennese birth with a family fortune acquired through her marriage to the publisher's son, again providing

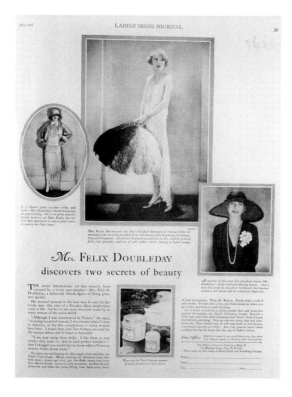

Mrs. FELIX DOUBLEDAY

discovers two secrets of beauty

7.10 Advertisement for Pond's cold
cream (Mrs. Felix Doubleday),
Ladies' Home Journal, July
1927, p. 39. Edward Steichen,
photographer (J. Walter
Thompson).

the client with that magical combination of European cachet and American money. Although the photographs exemplify artistic conventions—the folds of her dresses and lengths of her beads elongate her stature in the manner of Greek sculpture— Mrs. Doubleday herself, with her bobbed hair, short dresses, high heels, long neck- laces, and fashionable hats, is the most modern of women. Her demeanor is livelier than that of her predecessors in the campaign. Her daytime and evening dresses demonstrate that she is a woman on the go, and her ostrich-feather fan shows she can have a bit of fun with her accessories. Two of the three images of her are full- length portraits; and unlike the Duchesse de Richelieu and Miss Livingston, she seems ready to take a step.

THE EMERGENCE OF THE MODERNIST ADVERTISING PORTRAIT

Around 1929 Steichen began to incorporate the modernist elements of abstracted composition and greater clarity of form into his portrait advertising. Earlier, how-

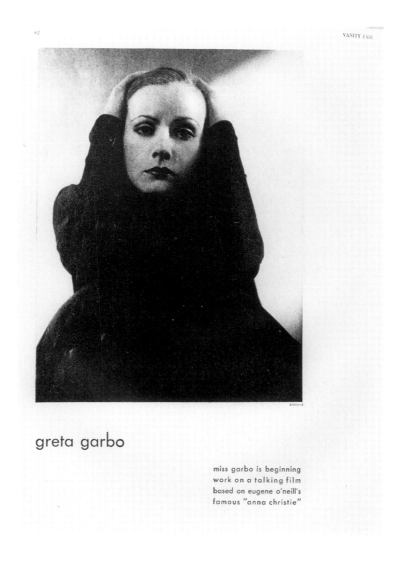

greta garbo

miss garbo is beginning
work on a talking film
based on eugene o'neill's
famous "anna christie"

7.11 Edward Steichen, "Greta Garbo," *Vanity Fair,* October 1929, p. 62.

ever, he had employed the austere, dramatic simplicity of modernism in some of the celebrity portraits that he made monthly for *Vanity Fair.* For example, in his portrait of Greta Garbo he eliminated all background detail and focused on Garbo's features, modeled by light falling naturally from the right (Fig. 7.11). She is represented as intense and intelligent, with great emotional strength. Such a stark portrait never made it into Steichen's advertising repertoire. The slow entry of the modernist vo-

cabulary into figural advertising in the late 1920s can be attributed to the admen's perceptions of what would play with the audience. They knew the self-proclaimed sophisticates who read *Vanity Fair* admired the strong, simplified vocabulary that had become Steichen's trademark style, but they doubted its appeal to the readers of the *Women's Home Companion* or *Farmer's Wife*.[29]

They pointed to statistics that reinforced their intuitions. Articles in the *JWT News Letter* tallied the number of coupon returns each testimonial ad generated and attempted to correlate the numbers to photographic style. They concluded that while the woman's name and place of birth were significant, photographic style also influenced sales. Steichen's soft-focus image of the Duchesse de Richelieu (see Fig. 7.1) "outpulled" his more austere portrait of Mrs. Reginald Vanderbilt (7.12; see Fig. 3.18). The most popular name image was Princesse Marie de Bourbon, photographed by Charlotte Fairchild (Fig. 7.13): "How much of her success is due to her name and how much to the illustration is hard to say. She is young and pretty and the photographs were romantic and sentimental with none of the severity of [Steichen's Mrs. Reginald] Vanderbilt . . . portrait." The success of the portrait of Mrs. William Borah, the Idaho senator's wife, was also a mystery to the agency (Fig. 7.14):

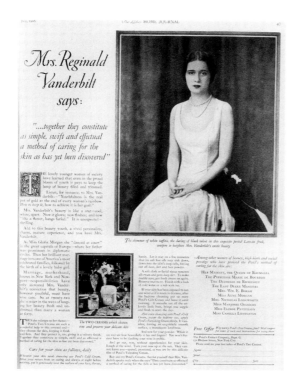

7.12 Advertisement for Pond's cold cream (Mrs. Reginald Vanderbilt), *Ladies' Home Journal,* July 1926, p. 47. Edward Steichen, photographer (J. Walter Thompson).

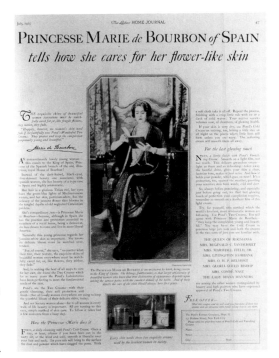

7.13 Advertisement for Pond's cold cream
 (Princesse Marie de Bourbon of
 Spain), *Ladies' Home Journal,* July
 1925, p. 47. Charlotte Fairchild,
 photographer (J. Walter Thompson).

BORAH the second name, also showed up well in all circulations. The photograph of Mrs. Borah was in no way striking, in fact almost commonplace, but there was a simple homelike atmosphere about it and, in the copy, a dramatic success story. That Borah out-pulled names such as Vanderbilt, Longworth, Manners and so on in Vogue and Cosmopolitan is hard to explain. . . . The ranking of Mrs. Vanderbilt and Mrs. Longworth, considered the two strongest American names, was disappointing. . . . It may be . . . the Vanderbilt [photograph is] too sophisticated.[30]

Although both Steichen and the agency considered the pictorialist style outdated, it lingered in the Pond's campaign because agency statistics suggested its effectiveness in drawing consumers' attention. This "empirical" evidence of success accounts for the soft-focus appearance of Mrs. W. K. Vanderbilt and Miss Anne Morgan so late in the decade.

 In 1929 elements of a more modernist style began to prevail in the Pond's advertisements. Two Steichen advertisements for Pond's that year featured Jane Kendall Mason, touted by the copywriter as "the prettiest girl that ever entered the White House" (Figs. 7.15, 7.16). Mason must have seemed an ideal photographic subject for Steichen's exploration of the modernist vocabulary in these ads. For one thing, her tightly pulled-back hair invited a spare interpretation. For another, simplifica-

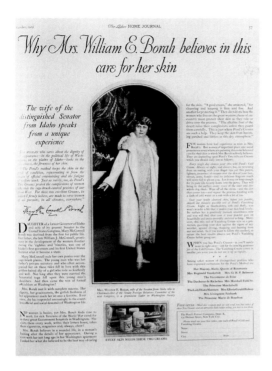

7.14 Advertisement for Pond's cold cream
(Mrs. William E. Borah), *Ladies'*
Home Journal, October 1925, p. 57.
Photographer unknown (J. Walter
Thompson).

tion enhanced her beauty and carriage. The more modernist approach of the figural
study found a sympathetic echo in the crisply and obliquely photographed products
in both Mason advertisements. The agency pointed proudly to the "modern touch"
the still lifes had given the whole campaign.[31]

In the advertisement that appeared in the January 1929 issue of *Vogue* and other
women's magazines. Steichen's portrait of Mason is the most prominent among the
photographs that tell her life story. The text and additional photographs were nec-
essary in this case because Mason was hardly a household name.[32] We are told that
she became famous for "her extraordinary beauty," and after her "dazzling debut"
she made a "brilliant marriage to a young New Yorker of distinguished family." Her
activities as a young wife are described in relation to the men in her life: "She flits
like a young butterfly" between her father's home in Washington and "the gay dip-
lomatic circles in Havana where her husband is an important figure." Her own at-
tributes are "talent, charm, grace, and a quick mind"—innocuous enough, and ap-
propriate for a diplomat's wife. According to the copywriter's purple prose, Mason's
"Botticelli beauty" is as "clear cut as a cameo"; her "delicate" and "flawless" skin
is compared to a wood anemone no less than three times!

The ad actively constructs an identity for Mason out of the linear and predictable

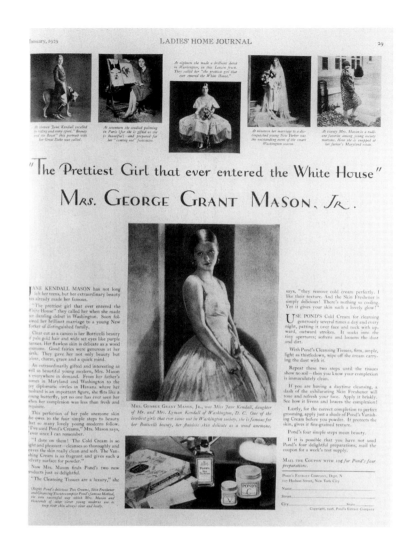

7.15 Advertisement for Pond's cold cream (Mrs. George Grant Mason, Jr.),
 Ladies' Home Journal, January 1929, p. 29. Edward Steichen,
 photographer (J. Walter Thompson).

story of her life that runs across the top of the advertisement (photographers un-
known). She has made the progression expected of a woman of her station: a teenage
interest in sports and art, followed by her debut into high society, then marriage to
a man who could support her well.

 Mason collaborated with Steichen to represent her current identity as a pretty,

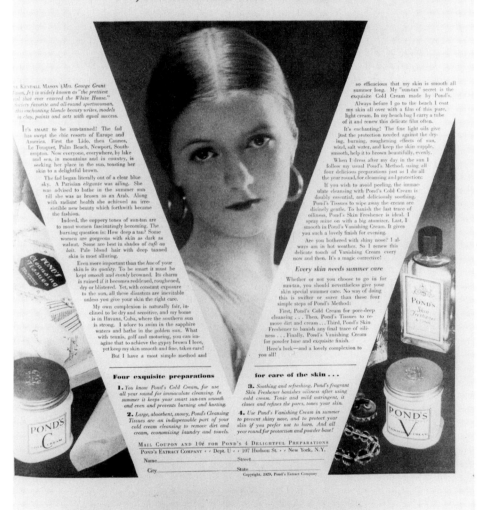

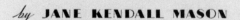

7.16 Advertisement for Pond's cold cream (Jane Kendall Mason), *Ladies' Home Journal,* July 1929,
 p. 31. Edward Steichen, photographer (J. Walter Thompson).

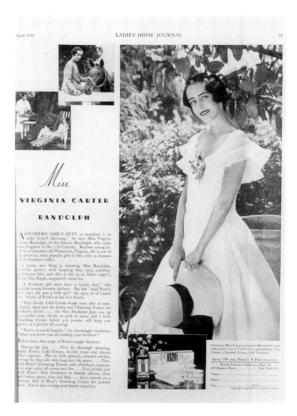

7.17 Advertisement for Pond's cold
 cream (Miss Virginia Carter
 Randolph), *Ladies' Home
 Journal,* April 1930, p. 43.
 Edward Steichen, photographer
 (J. Walter Thompson).

young socialite. Her dress and her sleek form play against the dark background. Steichen frequently photographed a well-lighted, elaborately dressed woman against a simplified geometric background to give his fashion photographs for *Vogue* contrast and compositional variety. Indeed, this device became almost a signature element of his fashion work. This is one of the few instances in which he brought that spare vocabulary into his advertising photography, where it may represent a struggle between the client's demands and the photographer's evolving style. Yet the photograph of Mason lacks the intensity and stark treatment Steichen reserved for subjects such as Greta Garbo (see Fig. 7.11).

In the second Mason advertisement, run six months after the first, the agency cropped the earlier photograph to show only a close-up of the socialite, with copy flanked by photographs of the four products she endorsed. The viewer is brought into the image by her gaze—one of the few in this type of ad that seems direct and engaging. Steichen's image combines the austerity that had been problematic in his portrait of Mrs. Reginald Vanderbilt with the softened facial features of pictorialist portraiture that the audience had come to expect in such testimonials. The close-up

both humanizes Mason and reinforces her status as a dream girl. The art director has experimented with a modern design, cropping the photograph into a triangle, with the V-shaped text echoing the large V of the Pond's vanishing cream logo. The geometric layout imparts an innovative, modern feeling that complements Steichen's nascent modernism.

As the agency staff correlated photographic style and the endorser's personal appeal, they drew "few conclusions." They did discover that "as a rule, the young outpull the old—even though the old are more socially exalted." And their studies demonstrated that "the more glamorous the photo—or rather the more sentimental—the better the returns." But the terms "glamour" and "sentiment" were used with no precision at all. An account executive explained, for example, that "pretty Betty Randolph in her ruffled organdie on the garden steps outpulled many better knowns" (a version of Fig. 7.17).[33] Although this Steichen photograph seems ordinary to later eyes, the agency was pleased with its effectiveness, and Steichen, surprisingly, chose the seated version as one of the ten advertising photographs to be included in the 1929 monograph on his work, *Steichen the Photographer*.

Like the first Mason ad, the Randolph ads embodied the agency's conviction that unknowns had to be surrounded by more visual narrative to give credence to their claims as role models. Randolph's formal portrait by Steichen is supplemented by additional images illustrating her life (photographer unknown), showing her offering a treat to her fine horse, then relaxing in the manner of Manet's Olympia as her black maid brings her iced tea on a tray. The ad thus establishes Randolph's identity as a pampered Southern belle, who believes her "duty to mankind is to make herself charming." Steichen's photograph, however, does little to distinguish her or bring her to life; nor does he cast her as a great beauty. His image of her seems flat, a stereotype.

FEMININE STEREOTYPES:
THE WOODBURY'S SOAP CAMPAIGN

Stereotyping in testimonial portraiture was the basis of the Woodbury's soap campaign for 1929. Woodbury's, one of the more expensive soaps on the market, needed to attract a loyal following because even with the price reduction in 1928 from 21 cents to 16 cents per bar, it could not compete with run-of-the-mill soap priced at 10 cents. Noting that their targeted consumers, "the real Woodbury beauties," were the young, active women who took great care with their appearance, the company announced that it "longed to meet them face to face."[34] It invited readers to enter a photographic beauty contest, which the publicity promised would be judged by F. Scott Fitzgerald, John Barrymore, and Cornelius Vanderbilt, Jr. Then for twelve months it ran photographs of "the loveliest of each type" of woman chosen.

7.18 Advertisement for Woodbury's facial
soap (Miss Helen and Miss Lois Dodd),
Ladies' Home Journal, June 1929, p. 71.
Edward Steichen, photographer
(J. Walter Thompson).

"The loveliest high school girl," "the most radiant out-of-doors girl," "the fairest
sub-deb," "the most beautiful mother," and "the most fascinating wife" made their
appearance in the women's magazines. Predictably, there was no "most intriguing
business executive."

Steichen was commissioned to photograph the twelve beauties. He was appar-
ently most pleased with his portrait of the Dodd twins from Chicago, "voted the
prettiest of coeds," because it was included in *Steichen the Photographer* (Fig. 7.18).
The text emphasizes the twins' fun in college rather than their studies. Miss Lilias
Moriarty, the "most fascinating young sportswoman," represented a more active
woman whose athletic interests included horseback riding and airplane flying, both
of which are visually referenced in the ad (Fig. 7.19). Steichen took the oval portrait
with a large-format camera that would not permit more active imaging of the sport;
Moriarty posed in her leather flying gear against enough airplane detail to suggest
her unusual (and expensive) pursuit. Although the text describes her interests as
sports, she is a less conventional role model than the "most beautiful young
mother," Mrs. Richard O'Connor (see Plate 6). Like some of the others in the series,
O'Connor is flanked by photographs of the judges, subtly reinforcing the cultural
notion that women will be judged by men. O'Connor and her young son look

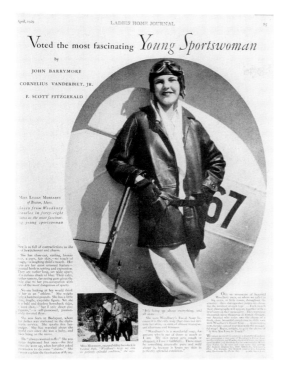

7.19 Advertisement for Woodbury's facial soap (Miss Lilias Moriarty), *Ladies' Home Journal*, April 1929, p. 85. Edward Steichen, photographer (J. Walter Thompson).

directly into the camera. In a pose and treatment reminiscent of John Singer Sargent's portraits of his upper-class patrons, their highlighted faces and hands emerge from a simplified, dark background, drawing attention to Mrs. O'Connor's features. The text addresses her joy in motherhood.

The only working woman in the Woodbury's group was Miss Julia Evans, "voted the most beautiful woman in the arts" (see Plate 7). An amateur dramatist from Saint Louis who hoped to "act professionally," Evans is surrounded by theatrical masks, as if to differentiate her "high art" pursuit from the movies. Like the other images in Woodbury's 1929 campaign, Steichen's photograph was hand colored by a collaborator in the Mechanical Department of the agency. But perhaps because Evans was in the arts, the photograph seems more like a painting than the others in the series; its photographic naturalism and accessibility are downplayed. The soft, melodic color and graceful contours cause the viewer to do a double take: Is the image a painting or a photograph? Evans's portrait evokes more associations with Sargent's portraits than with Steichen's own *Vanity Fair* portraits. The dramatic lighting, the crisp punctuation at the tips of her nose and fingers, her plunging neckline, and her elegant, elongated arms recall Sargent's sensational *Madame X*. The transformation of Steichen's photograph into a painting makes the woman seem remote and makes the reader more aware of the ad's fictive qualities.

The Woodbury's campaign stated flatly what other campaigns suggested: that testimonials by women with specialized interests or responsibilities in life effectively appealed to targeted consumers. The ads celebrated the traditional activities of homemaking and culture. By casting subjects with only a touch more glamour and excitement than the supposed Woodbury's consumers had in real life, the ads reinforced the satisfactions easily available to women. Stylistically, they were a bridge between the soft-focus glamour of pictorialism and the simplified elegance of modernism.

THE 1930S ADVERTISING PORTRAIT

By 1930 Steichen consistently brought the full bloom of modernism in photography to portrait testimonials. For Pond's, he pictured Mrs. John Davis Lodge, lively and lovely, sitting in a sleigh-back chair (Fig. 7.20). Like most of Steichen's *Vanity Fair* subjects, Lodge is a very beautiful woman. Her vivacious gaze demands the attention of the viewer and defines her as an outgoing personality. Steichen emphasizes the sweep of her arms and her expressive hands, again borrowing a convention from Sargent. The dark wall in the background, with its spare expanses alleviated only by variations in the tones of cast shadows, works with her dark dress to highlight her face. Despite the visual patterns of the gold chevrons on the dress, the curved chair back, and Lodge's active presence, the photograph conveys the relative spareness of modernism through its linearity, tonal contrast, and reduced accessories.

Did this new modernist vocabulary signify a different approach to representation? In its earliest manifestations in Steichen's portrait advertising—the Mason and Randolph ads—the photographer's modernism seems simply a new veneer applied to the old strategies of class appeal, conventional gender roles, personalized advice, and a narrative account of the rewards of consumption. It challenged no fundamental assumptions about social identity—perhaps because of the collaborative authorship of the advertisements. Although Steichen and his art directors were inclined toward the pictorially inventive, account representatives and clients, who did not wish to meddle with success, had to be convinced. Yet one by one they approved the purchase of space in popular magazines for modernist advertisements.

The Steichen image of Lodge and his portrait of Miss Elizabeth Altemus, later Mrs. John Hay Whitney, were the "best pullers" for Pond's in 1930 (Fig. 7.21).[35] Steichen placed Altemus against a mirrored wall, set at a forty-five-degree angle to the picture plane. The result is an ambiguous space that is Steichen's closest approximation of a cubist sense of geometry and space in his figural advertising. The dark edges of the mirror's tiles further fracture the space. Altemus is dramatically lit, and the contrast between the linearity of the figure and the dark ground further flattens the space and accentuates the cubist link. While the severe effect of her hairline,

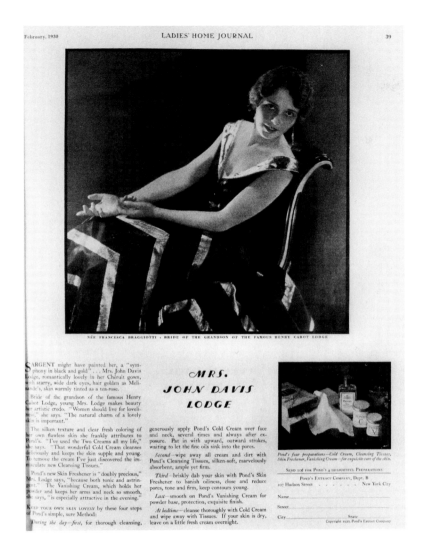

7.20 Advertisement for Pond's cold cream (Mrs. John Davis Lodge), *Ladies' Home Journal*, February 1930, p. 39. Edward Steichen, photographer (J. Walter Thompson).

echoed in the cut of the back of her dress, intensifies the modernist aura, the soft floral arrangement below diffuses it.

The next year Steichen photographed Mrs. Alexander Hamilton in profile from behind, again emphasizing the linear, distinctive contours of her features and the oval cut of her dress by contrasting them with the softened, irregular forms of the

Miss Elizabeth Altemus of Philadelphia

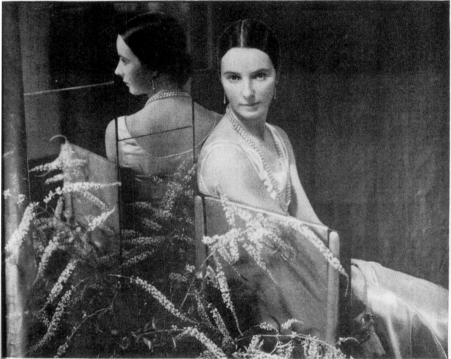

A BRILLIANT FAVORITE IN SOCIETY. SHE IS AN EXPERT HORSEWOMAN AND A DASHING GENTLEWOMAN JOCKEY

CLASSIC BEAUTY, reflected in a modern mirror . . . a flawless profile, the perfect oval of a face that Phidias might have chiseled in an Athenian frieze . . . the silky chestnut hair is parted in the Grecian manner, the firm young skin is fine and lustrous as Attic marble.

Yet this classic beauty is a debonair young modern . . . a brilliant favorite in smart society . . . Miss Elizabeth Altemus, of an old family prominent in Philadelphia since before the Revolution.

Spirited as the thoroughbreds she rides so fearlessly, Miss Altemus is widely known as an expert horsewoman . . . a dashing gentlewoman jockey who rides the colors of her stables, purple and fuchsia, in many a hard-won race.

To live so actively in the open, yet to keep one's skin so radiantly smooth and fine means taking pains! Like many other lovely society women, Miss Altemus has discovered the simplest, easiest, most satisfactory complexion care.

"I have found the perfect protection—Pond's," she says. "The Cold Cream cleanses perfectly.

I never use any other. And the Cleansing Tissues take off the cream easily and completely.

"The Skin Freshener is well named!" adds Miss Altemus. "The Vanishing Cream makes a wonderful powder base and is especially good for the evening."

KEEP YOUR OWN skin lovely with these four steps of Pond's swift, simple, sure Method:

During the day—first, for thorough cleansing,

POND'S FOUR DELIGHTFUL PREPARATIONS

generously apply Pond's Cold Cream over face and neck, several times and always after exposure. Pat in with upward, outward strokes, waiting to let the fine oils sink into the pores.

Second—wipe away all cream and dirt with Pond's Cleansing Tissues, silken-soft, absorbent.

Third—briskly dab your skin with Pond's Skin Freshener to banish oiliness, close and reduce pores, tone and firm, keep contours young.

Last—smooth on Pond's Vanishing Cream for powder base, protection, exquisite finish.

At bedtime—cleanse thoroughly with Cold Cream and wipe away with Tissues.

SEND 10¢ FOR POND'S 4 FAMOUS PREPARATIONS

POND'S EXTRACT COMPANY, Dept. G
107 Hudson Street New York City

Name

Street

City State

Copyright 1930, Pond's Extract Company

7.21 Advertisement for Pond's cold cream (Miss Elizabeth Altemus), *Ladies' Home Journal*, July 1930, p. 29. Edward Steichen, photographer (J. Walter Thompson).

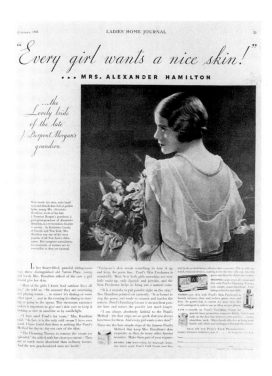

7.22 Advertisement for Pond's cold cream (Mrs. Alexander Hamilton), *Ladies' Home Journal*, February 1931, p. 33. Edward Steichen, photographer (J. Walter Thompson).

orchids and lilies she holds (Fig. 7.22). He used the lighting and dark background to construct the portrait design that by then had become a familiar pattern for him. Like the portraits of Lodge and Altemus, the photograph of Hamilton draws a parallel between the elegance and sophistication of the photographer's treatment and the woman's social and personal qualities. In comparison with the old pictorialist tradition, Steichen's later testimonial portraits seemed new, modern, and refreshing.

In his photographs of patrician beauties, Steichen established himself as the advertising industry's stylistic leader, developing a spare, linear, modernist advertising portrait, almost confrontational in its engagement with the viewer. These portraits elegantly describe the surface beauty of the subjects in the manner that made his *Vanity Fair* portraits so successful but without the simmering sensuality and exoticism of his portraits of such celebrities as Marlene Dietrich (Fig. 7.23). In both the Dietrich and the Altemus portraits the women are crisply outlined and balanced against floral arrangements. Dietrich's black dress, feathered hat, and shaded face, however, along with the lush carnations and Oriental motif, lend a mysterious, provocative quality to her portrait. But then Dietrich was an actress; the American women in the advertising portraits were not. Steichen's celebrity portraits imply no

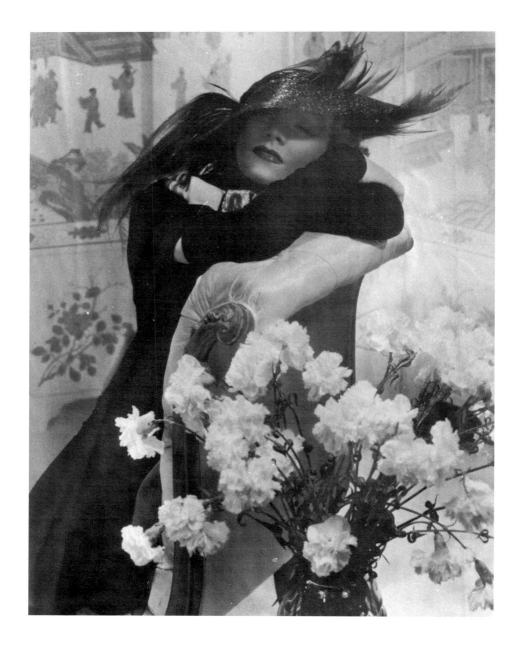

7.23 Edward Steichen, "Marlene Dietrich." Commissioned by Condé Nast Publications, outtake from a feature that appeared in *Vogue*, May 1935, pp. 54–55.

role model relationship; viewers have only to admire Dietrich or study her. But the testimonial advertisements encouraged the audience to identify with the Pond's models, to aspire to their grace and wealth.

Steichen's modernism in the portrait testimonials brought a new immediacy to advertising portraits, urging a closer identification with the model, despite the unchanged construction of class and gender relations. The photographic vocabulary of earlier pictorialist representations, such as Mrs. W. K. Vanderbilt or Miss Camilla Livingston (see Figs. 7.4, 7.8), with their obvious reference to art, distanced the viewer from the subject, accentuating the otherness of the models who invited viewers to use the products they used.

Steichen's modernist style became his signature style in the 1930s. His portrait of Mrs. Potter D'Orsay Palmer for Pond's demonstrates how formulaic much of his work became (Fig. 7.24). The portrait is unmistakably a Steichen—almost a caricature of his work. Palmer is shown in profile, emphasizing the linearity of her features. Like Ingres in portraits a century earlier, Steichen lights the figure to accentuate a linear design that moves throughout the image—the lines of light and shadow trace her arms, dress, dress folds, beads, hair, and facial features. And the background lighting is pure Steichen: a band of light divides a dark, flat ground into geometric units. The arrangement of daylilies provides a counterpoint to the severity and gives the image a "designed" look. Mrs. Palmer looks off into the distance.

By the early 1930s, Steichen's "masterly simplicity" was recognized as his trademark by publishers, advertisers, and other photographers. And a consciousness was dawning in some quarters of the commercial world about the workings of photography. *Vanity Fair* published George Hoyningen Huené's 1934 parody of commercial photography with its seven portraits of Mme Lucien Lelong in diverse photographic styles (Fig. 7.25). Huené was a well-known *Vogue* fashion photographer; his point was to demonstrate the creativity and stylistic variety possible within the constraints of commercial photography. The Steichen pastiche is in the center, and it is easy to see what made Steichen's imagery of the early 1930s so appealing to businessman and consumer alike: with its dramatic expression, theatrical lighting, linear design, and strong contrast, it seemed more immediate than the affectations of Adolph de Meyer or Cecil Beaton or the surrealistic otherworldliness of Man Ray or Lerski. Huené's own style was close to Steichen's, which may explain the eagerness with which the Condé Nast publications commissioned his work.[36]

The dramatic shift in representation from pictorialism to modernism in testimonial portrait photography paralleled dramatic social and cultural changes that even the most stubborn agency staff had to recognize. A pervasive perception of contemporary society as self-consciously modern developed. With the media filled with references to the "jazz age," advertising needed, as the graphic designer Frank Young put it, to appeal to "modern minds which think and feel in a tempo expressed by the airplane, radio and television, talking pictures and jazz orchestras."[37] Advertis-

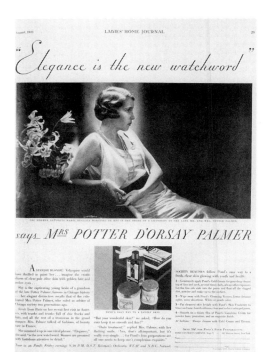

7.24 Advertisement for Pond's cold cream
(Mrs. Potter D'Orsay Palmer), *Ladies'
Home Journal*, August 1931, p. 29.
Edward Steichen, photographer
(J. Walter Thompson).

ing photography both reflected and constructed the changing fabric of modernity.
And magazine readers began to think of themselves as modern consumers.

STEICHEN AS A FINE ART PORTRAIT PHOTOGRAPHER

Portraiture is the only element of Steichen's commercial career that has been admitted into the pantheon of the fine arts without question: witness the numerous
exhibitions devoted to his portraits and the considerable number of his prints acquired by the nation's most prestigious photographic collections.[38] These events have
firmly fixed portraiture at the center of both Steichen's career and his contribution
to photographic history, though its use in advertisements in widely circulated magazines is usually ignored. Typically Steichen is credited with influencing portraiture's
evolution from a "descriptive document" to an "independent art form."[39] Beaumont
Newhall's *History of Photography*, a sure measure of canonization, praises Steichen's
"brilliant and forceful" celebrity portraits for the Condé Nast organization, treating
them as the equal of the photographer's early pictorialist landscapes.[40] Steichen's
advertising photographs are rarely included in this enthusiastic response to com

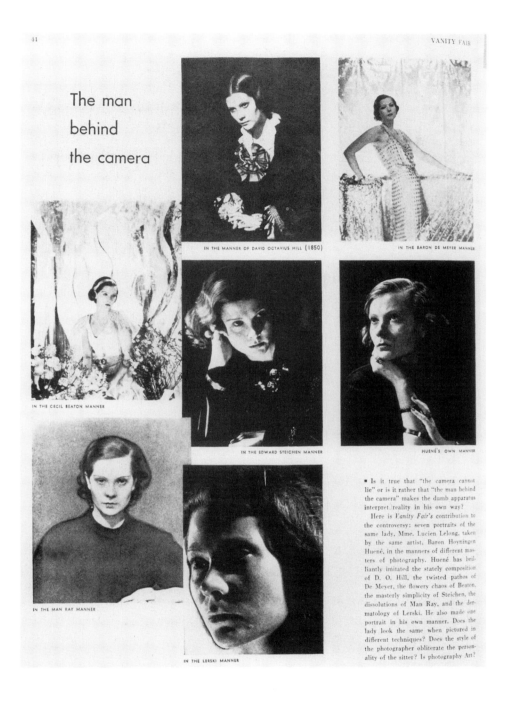

The man
behind
the camera

IN THE MANNER OF DAVID OCTAVIUS HILL (1850)

IN THE BARON DE MEYER MANNER

IN THE CECIL BEATON MANNER

IN THE EDWARD STEICHEN MANNER

HUENÉ'S OWN MANNER

IN THE MAN RAY MANNER

IN THE LERSKI MANNER

■ Is it true that "the camera cannot lie" or is it rather that "the man behind the camera" makes the dumb apparatus interpret reality in his own way?

Here is *Vanity Fair's* contribution to the controversy: seven portraits of the same lady, Mme. Lucien Lelong, taken by the same artist, Baron Hoyningen Huené, in the manners of different masters of photography. Huené has brilliantly imitated the stately composition of D. O. Hill, the twisted pathos of De Meyer, the flowery chaos of Beaton, the masterly simplicity of Steichen, the dissolutions of Man Ray, and the dermatology of Lerski. He also made one portrait in his own manner. Does the lady look the same when pictured in different techniques? Does the style of the photographer obliterate the personality of the sitter? Is photography Art?

7.25 George Hoyningen Huené, Editorial page, "The Man behind the Camera," *Vanity Fair,* April 1933, p. 44.

mercial portraiture, even though Steichen himself occasionally sent them to exhibitions, presented prints to museums, and included them in his publications.

Some of the neglect may be explained by the advertisements' frequent use of older styles of representation, but most of it derives from the strong modernist bias against commercial applications for art. But postmodern critics have called into question assumptions of modernism's "purity" and apolitical nature; they have sought to include in photographic history all camera-made expressions. In the process they have questioned the hierarchies of photographic practice. As John Tagg has established, the photograph's status as art, craft, or kitsch at any moment or place in history is produced institutionally and is not intrinsic to the photographic medium.[41] Steichen understood (unlike most of his critics) that there was no essential difference between his portraiture for advertising agencies, *Vanity Fair,* or private patrons. Yet he only rarely debated this point in the art world; instead he exploited the existing modernist hierarchies to garner the prestige of art for his commercial production.

Steichen made portraits from the earliest days of his career. In 1902, to make a living in New York, he had opened a private portrait studio at 291 Fifth Avenue (which became Alfred Stieglitz's Little Galleries of the Photo-Secession in 1905). He attracted some clients through his growing reputation, others from recommendations by such advocates as Stieglitz, and still others with a showcase window at the entrance to his building that he filled with his work. In France from 1906 to 1914, with occasional long voyages back home, he continued to support his family mainly through portraiture, both artistic and commercial. Many of these early portraits were reproduced on the pages of Stieglitz's journal *Camera Work,* where what they revealed of the sitter's psyche was discussed.[42] Steichen recognized the value of the camera as a device to "mechanically reproduce the physical likeness of the sitter" in his early portraits. But whatever its style, a good photograph used "its means to express the true spirit of the portrait, the vitality and life that underlie the interpretation of character and personality of the sitter."[43]

Steichen's early ideas on portraiture were consistent with portrait theory as it developed in the early twentieth century. To manipulate the camera to reveal personality was (and usually still is) considered an art.[44] According to a popular how-to magazine for photographers: "The individuality of character is shaped and molded by life and experience. It is expressed in the features and deportment," controlled "by the emotion, mood, or mental attitude of the moment." Photographers were urged to get beyond the self-consciousness and boredom that frequently struck models in front of the camera, to create a feeling of intimacy with the subject.[45]

While these ideas paralleled Steichen's goals in his early portraits, in the monthly commercial images he made for *Vanity Fair* and for the Pond's testimonials, Steichen developed a portrait style that concentrated on the sitter's looks rather than character. His images of celebrities are chiefly publicity photographs: they extract and polish the public persona much as his advertising photographs create an image for the product. Thus they shaped the sitter's public identity or synthesized an estab-

lished image. Audiences could feel that by reading a celebrity's image, they knew the person beneath the surface.[46] But actually they only knew the image. In the case of Steichen's publicity photos, the character analysis and intimacy were only skin-deep: the person in the image played a role, like any role on Broadway or in the movies.

Steichen often first met a sitter—for both the *Vanity Fair* portraits and the advertising testimonials—at the photographic session. The literature on him is filled with anecdotes about his putting the subject at ease, usually by flattery, sometimes with arrogance, but always by convincing the person that the photographer was an ally in constructing a public image. Near the end of his commercial career, he described his approach: "I have almost invariably found that the sitter acted as a mirror to my own point of view, so that the first step was to get up full steam on my own interest and working energy. . . . If everything moves swiftly and with enthusiasm, the model gains courage in the belief that he or she is doing well, and things begin to happen. The model and the photographer click together."[47] But this collaborative process did not mean that the photographer abdicated control. He told the advertising representatives at the Thompson agency that his job was to "get enthusiastic" and motivate his sitter. If he was to get a good portrait, he said, "the person's got to be lit up."[48] At the portrait sitting he constantly engaged the subject's interest to govern the mood and expression. "Never let the sitter get bored," he advised. "Never let on that you are at a loss, even if you are. Ideas will come up as you work. Never lose control of your sitter. Keep moving. Keep taking pictures. Many of them. Then when you know you have it, stop."[49]

Helen Lawrenson, the managing editor of *Vanity Fair* from 1932 until 1936, remembered Steichen as a good photographer with a "talent for self-aggrandizement." His attitude while working was arrogant, his manners, pretentious:

> Steichen was the top banana on our photographic staff. The *Vogue* ladies fawningly called him "Colonel Steichen," which I thought was ridiculous because World War I . . . had been over since 1918. He managed to give the impression that a photographic session in his Beaux Arts studio was the equivalent of an investiture at Buckingham Palace. Editors tiptoed reverently, speaking in whispers, if they dared speak at all, and I found this the-Master-is-creating atmosphere repellent. Besides, I didn't like the way he treated other photographers as if they were inferior serfs.[50]

As Lawrenson implies, Steichen turned his artistic skills into commercial currency. His reputation as a photographer hinged on his early record of international fine art exhibitions, his military service, and the monthly appearance of his signature in *Vogue* and *Vanity Fair*. His contributions to these magazines made him a hotter commodity in the advertising industry, and by 1930 he had created a public persona for himself as *the* photographic genius who could meld a sophisticated high-art sensibility with mass appeal. The Thompson agency cultivated this image, hyping Steichen's talents to clients and rivals and extending his public visibility by underwriting

the production expenses of the 1929 luxe monograph *Steichen the Photographer* for the Harcourt, Brace publishing firm. Thus Steichen became as much a celebrity as his sitters.

In their day, Steichen's celebrity portraits were considered exemplary in the art as well as the corporate world. According to the critic Samuel Kootz, "Steichen is at his best in his portraits of people." Kootz saw Steichen's talent for portraiture as an ability to carry on a dialog between the stereotypical and the personal. "Individuals fascinate him," Kootz contended, "as symbols of race, function, or purpose." He was able to make credible "what an inferior imagination would render circus-like and unbelievable." [51] Even fine art critics usually hostile to Steichen's commercialism did not condemn his portraits as a sellout. In the midst of an otherwise scathing review, Stieglitz ally Paul Rosenfeld acknowledged the "striking canniness" of Steichen's celebrity portraits. [52]

These artistic paeans were repeated in the commercial world. The trade journal *Advertising Arts,* for example, put Steichen on its honor roll for 1931, noting he was "without a peer" in photographing the "continual stream of the beautiful and renowned who come to sit for him." [53] Clare Boothe Brokaw (later Luce), then managing editor of *Vanity Fair,* wrote that Steichen's "divine" gift was his ability to absorb "the essence" of his sitters by becoming totally involved with drawing them out and collaborating with them to define their public image. She located Steichen's photographic flattery in this working process, where "he often appears to—and probably does—fall in love with his sitters, but the moment the last plate is exposed his ardour abruptly cools." But "if—which rarely happens—he doesn't like his sitters, he can take a revenge upon them which they do not suspect, but which everyone else instantly recognizes: he makes them look like what they are." [54]

But the critics warned that Steichen's portraiture could become too smooth. Steichen's "wonderful facility with suave lines and opulent textures, and a quick response to a certain type of feminine display," Rosenfeld warned, could quickly become "showy and inflated." [55] Kootz expressed similar reservations. He feared that Steichen's "flamboyant" advertising depended too frequently on a "bludgeon-like blow at the emotions for effect." [56]

In his advertising portraits Steichen transformed his sitters, the knowns as well as the unknowns, into celebrities, in much the same way that he glamorized the actresses he photographed for *Vanity Fair.* He developed an iconography for celebrityhood that traced surface beauty and created the *appearance* of character. Beauty is treated like any other fine possession; it is a material asset for display. Steichen's emphasis on looks and his simplification of the image made his subjects seem instantly familiar yet distanced them. But because every image is a construction—and images purported to be deeply revealing of the soul may be devised to give that impression—Steichen's portraits may be more honest. They do not promise more than loving description of the surface, and this can be recognized as a picture of the sitter's public image, not the sitter's inner life.

Advertisers continued to employ the testimonial strategy because sales figures indicated it worked.[57] It *was* successful. Despite the sharp downturn in the economy in the 1930s, Pond's continued its testimonial strategy and made even more money between 1929 and 1933 than in its three most prosperous years before the depression.[58] Steichen's photographs were important in establishing the glamour and wealth of the endorsers. Pond's considered the strategy so effective that its testimonial campaign extended into the 1950s with photographs by Cecil Beaton, Louise Dahl-Wolfe, Horst P. Horst, and George Hurrell.

Testimonials appealed to the readers' contradictory desire for the democratic distribution of goods *and* the material benefits of wealth and prestige. They offered individualized advice to women but also united them in their efforts to meet society's standards of feminine beauty. They assured each woman of her unique potential yet outlined the rewards for conforming to traditional gender roles. And as much as Steichen's photographic modernism represented a self-consciously modern society, it also demonstrated that the social and gender relations in that society remained essentially unchanged. While Steichen's testimonials encouraged readers to fantasize about the advantages of beauty, wealth, and social standing, the ads provided no real instruction manual for class mobility or personal development.

Viewing Fine and Applied Art:
The Female Spectator and Advertisements

At the end of 1931, probably because of deteriorating depression-era business conditions, Steichen and the J. Walter Thompson Company did not renew their contract. Steichen continued to work for Thompson occasionally, as in the Scott tissue campaign, but the agency no longer guaranteed him his generous minimum salary.[1] The agencies that employed Steichen as a freelance commercial photographer included N. W. Ayer and Son, Young and Rubicam, Bowman Deute Cummings, Lennen and Mitchell, and McCann-Erickson.[2]

FINE ART AND THE ADVERTISING INDUSTRY

One of the great mysteries and paradoxes of Steichen's career is his success in making his identity as a fine art photographer the primary defining element of his career while he actively pursued commercial work.[3] While such soap opera imagery as his Scott tissue ads (see Figs. 9.2, 9.3) was widely covered in the trade press and he unapologetically sent commissioned commercial works to art exhibitions, his public persona remained that of the stereotypical artist and genius. Charles Coiner, art director at N. W. Ayer, recalled that when he wanted a particularly artistic look for

the advertisements for the 1936 Cannon towel and Steinway piano accounts, he selected Steichen because of his solid reputation as an artist. Coiner must have known of Steichen's advertising work for the Thompson agency since examples of it were published almost annually in the Art Directors' Club yearbooks, yet Coiner claimed he wanted Steichen because he was "the best non-commercial photographer in the United States at the time."[4] Coiner insisted that he hired Steichen, not for his reputation in the ad industry, but rather for his artistic reputation, established through pictorialist exhibitions and work for *Vogue* and *Vanity Fair*, which, following standard divisions of the day, Coiner must have considered "editorial" rather than "commercial." For his part, Steichen must have welcomed the Cannon and Steinway accounts, because like his *Vanity Fair* portraits they occupied a critical space between his fine art photography and his applied art imagery.

For the Cannon Mills towel campaign Steichen made a series of nude studies (see Plates 8, 9). The polished fine art appeal of Steichen's Cannon work stands in marked opposition to both previous uses of the nude in advertising and Steichen's own previous advertising work, which had emphasized narrative and class. Steichen's graceful nude studies echo images more likely found in art museums and in Steichen's own early pictorialist photographs than images on the pages of mass magazines. And the placement of Steichen's Cannon advertisements in high-fashion magazines—*Vogue* and *Harper's Bazaar*—rather than in "home" magazines like *Good Housekeeping* and *Ladies' Home Journal* indicates that the manufacturer was targeting an audience that would be flattered by pictorial references to the long tradition of reclining Venuses, one sophisticated enough to accept a display of women's bodies more daring than that used previously in mass media advertising. The images were printed in sepia tones, which softened the more obviously "photographic" black-and-white, yielding a softer look that was simultaneously more "artistic" and more "naturalistic." The sepia tone reinforced the image of the woman's body as representation (that is, as "art") and lessened the contrast between the body and the accompanying small, brightly colored photographs and illustrations of towels in the advertisements. It also tacitly affirmed that Steichen's photographs were fine art, suppressing leftover doubts from the nineteenth-century debate on photography as art, or, in this case, commercial photography as art.

As a highly visible art director, Coiner had made Ayer the industry leader in incorporating fine art into advertising and had developed a reputation for introducing the style of more European modernist artists to the American public than any other art director in advertising. He had been trained as a commercial artist but maintained a solid second career as an exhibiting artist. He regularly showed his semi-abstract paintings at the Montross Gallery, and some were acquired by the Whitney Museum of American Art.[5] Because of executive support for his ideas at Ayer, Coiner was able to bring many of his fine art interests into advertising.[6] When appropriate, he advocated using fine art to develop interest in an advertisement,

solidify a corporate image, and add prestige to a product. For Dole pineapple juice in the 1930s he sent the artists Georgia O'Keeffe, Pierre Roy, Isamu Noguchi, and A. M. Cassandre to Hawaii for inspiration. One of his most notable later successes was the Container Corporation account, which in the 1940s and 1950s commissioned images by Rufino Tamayo, Henry Moore, Morris Graves, Ben Shahn, Herbert Bayer, Herbert Matter, Gyorgy Kepes, Fernand Léger, Willem de Kooning, and many others.[7] For other accounts he commissioned works from Pablo Picasso, Marie Laurencin, Raoul Dufy, Salvador Dalí, George Bellows, and many others.[8] His work with Steichen in the 1930s was among his earliest attempts to blur the distinctions between commercial and fine art production and reception and to define good commercial design as good art, a goal on which he built his reputation as a designer. The innovative art director Alexey Brodovitch in 1950 saluted "Coiner's force of personality, as well as his talent and discernment that ha[ve] enabled him to revolutionize advertising design in America, [and] to bridge the chasm that once separated modern 'pure' art from commercial art."[9] Arguing that good art attracted readers' attention, Coiner chose artists who worked in the most contemporary styles. With the diplomacy that art directors were noted for, Coiner reminded the agency of the artists' need for independence, and he urged that artists work in their own style rather than conforming their images to preconceptions about commercial art.[10] Thus Coiner's modernist notions about the artist and art fit seamlessly with the needs of his clients.

GENDERED VIEWING

Steichen's images for Cannon forge a model for the dynamics of spectatorship different from that of the photographer's earlier work. They also inscribe class signs and symbols in different ways. In Steichen's Cannon towel series the woman's body is presented as spectacle, complicating and obfuscating the usual relation between Steichen's constructed image and the intended spectator. In images such as those for the later Jergens lotion or Pond's campaigns, for example, the female reader could identify with the looks and desires of the model. The model's nudity objectified her in the Cannon ads, distancing the spectator and thus contravening advertising's goal of empathy with the model.

In "Cannon Towel Talk No. 12," the model is photographed modestly from the back (see Plate 8) as she sweeps back her hair with her well-manicured fingers, moving her arms so as to create compositional interest. The photographer's lights emphasize the contours of her body. In only a few areas, the inside of her arm and the very bottom of her hip, for instance, is the body allowed to blend into its surroundings. The colorful towels in the top right corner intrude into her private meditative space. The headlines at the top and bottom and the lengthy copy at the side bring

us back to the world of merchandising. Coiner's and Steichen's efforts to blend the fine and applied arts here seem forced.

Steichen used color film for the "Towel Talk" series of 1935–36. Although his photographs were reproduced through a four-color process, the overall effect is of sepia tone, not full color. The soft tones of the body contrast with the jarring colors of the towels. In each image, Paul Froelich, the layout designer, trimmed one of Anton Bruehl's full-color photographs of towels into a complementary shape and added it, along with the copy. Although the layout now looks distracting and poorly designed, Coiner believed Steichen's sepia and Bruehl's bright color worked well together.[11] Despite Coiner's claims of great sympathy for the modernist aesthetic, the art director has allowed a competing style to detract from the whole, much like the Victorian "spinach" that surrounded Outerbridge's Ide collar advertisement in its first appearance (see Fig. 5.2).

In some ways the Cannon advertisements represent a case of the advertising industry second-guessing itself: the agency hoped to appeal to sophisticated, affluent women with a "fine art" motif, but Anton Bruehl's bright, "realistic" representations of towels were there as a backup if that strategy did not work. It seems that the advertising agency wanted to credit the audience with refined taste but feared getting ahead of them.

The advertising trade press hailed the Cannon ads as a success. One columnist on copy trends who thought Steichen's photographs fit the category of a "*really* swell picture," good enough to "paralyze" copywriters, congratulated the agency for allowing equal contributions by the photographer, art director, and copywriter: "Paul Froelich of Ayer deserves a great deal of credit for giving Homer Smith room enough to write this long piece. Otherwise, the advertisement would have been chiefly an advertisement of Messrs. Steichen's and Bruehl's photographic skill and of the model's pulchritude. You could have even asked a distinguished lady about it, a few days later, and she wouldn't have known whether it advertised bathtubs or perfume."[12] The writer refused to attribute the effectiveness of the campaign to the image. Although we see that Steichen's commanding figure is the primary communication with the viewer, many in the industry in the 1930s still believed that the image was simply a hook for the real sell in the copy. The Cannon campaign demonstrates that the intuitive production of advertisements has no relationship to rhetoric, which lags far behind practice.

Trade magazine ads often used images of nude women because there advertisers could be reasonably certain the viewer would be male. Coiner's originality was his use of such an image in the popular magazines, which addressed women. The Cannon campaign explicitly cast the body, "dressed" in only its status as fine art representation, in the central role.

The image in "Cannon Towel Talks No. 10" is problematic, even jarring, for its content (see Plate 9). Although lesbian imagery has been common enough in por-

nography created for the male viewer, the image of two nudes, each absorbed in her own thoughts, must have seemed strange and intriguing, if not troubling, to the 1930s female viewer. Once the complicated viewpoints and ambiguous spatial relationships are untangled, however, it becomes clear that one woman is shown, reflected in a mirror. The stillness of the two figures is thus explained, but the spatial ambiguities are not resolved. Are we the mirror gazing back into the woman's face? Are we observing her from the typical spectator's distanced position outside the frame? Why has she turned her back to the mirror, visible behind her? Is there a second mirror that explains the direction of her gaze? Since this image is one of the few in the series that includes a woman's face, are we to identify with the woman more closely, or see her as a pictorial image? Steichen might explain such a perplexing arrangement of body and mirror as simply his own compositional originality, but social contexts beyond the frame of the advertisement are what make it compelling.

It is difficult to know how upper-class female viewers read and reacted to Steichen's images in the 1930s. Why did Coiner think the female nude would appeal to women and persuade them to purchase the advertised product? And why did he place the ads in a magazine like *Vogue,* which mainly advised women on spending money and catching and holding men through fashions and beauty? I believe that Coiner's and the Cannon executives' philosophy went no further than the belief that these more affluent audiences shared their ideals of beauty. Surely the admen hoped women would follow John Watson's simplistic behaviorist model, purchasing the product because the ad stimulated the desire for beauty. But the Cannon towel advertisements, with their novel yet modest display of women's bodies, their hidden or distanced gazes, and their fractured layout, complicated the easy identification with the model admen often hoped for.

The use of the body, even one clothed with the status of high art, was problematic for advertising. From Renaissance paintings to cheesecake ads for plumbing fixtures, images of women's bodies had been produced by male artists for the male gaze. Coiner recognized the risk in redesigning such an image for a different audience with different purposes: "Women generally do not like photographs of nude women like men do, and women buy the towels."[13] This position was the common wisdom. Although women appreciated female beauty, they were far sharper critics of the model than men. Christine Frederick wondered in her guide for advertisers why agencies did not try male beauty as an appeal to women.[14] Clearly there was little industry support or popular precedent for Coiner's commissioning of Steichen's nudes. Nonetheless, the trade magazines declared them a success, and they generated a long line of descendants, continuing in advertisements today. How does the female spectator see, identify with, or appreciate such images?

Since the 1970s, feminist film theorists have struggled with models of female spectatorship. Most early theorists concluded pessimistically that it was impossible for

women to have an unproblematic relation to such images as the Cannon towel ads. As Rosemary Betterton has noted, early feminists argued that "*all* representations of the female body draw upon the same visual codes, and reinstate the same relations of sexual power and subordination. No images can ever entirely escape the circle of voyeurism and exploitation which constitutes male power in representation." [15]

In early feminist theories, if women identified with the model, they were forced to either objectify themselves or admit to an unhealthy narcissism. Either way, they were relegated to a passive role. On the other hand, if the female viewer distanced herself from the model and identified with the active process of looking, she took on the masculine identity of the gaze, which had been embedded in viewing female nudes since the Renaissance. This choice was seen as equally damaging to the female viewer, who denied her own experience and lost her own sense of identity and gender in taking on the (male) role of voyeur. [16]

When feminist theorists recognized the trap such a binary theory of looking set up, they developed theories of the mobility of the gaze—which shifts between the positions of viewer and viewed—and the simultaneity of gazes. Yet these refinements still implied that the gaze reinstated the cultural conditions of oppression with every look, forcing the woman to constantly negotiate between uncomfortable viewpoints. These theories, moreover, with their reliance on Freudian or Lacanian constructions, often led to essentialist or ahistorical analyses. Feminists originally were drawn to psychoanalysis as a way to discover how ideology operates on an unconscious level, but it has not always worked in their favor. Although the early theorists recognized that Freudian theory developed at a particular historical and cultural moment, they seemed to accept its universalizing claims: the gaze is fetishistic and voyeuristic; thus no female spectatorship can exist in which the female gaze is equal to the male gaze. [17]

More recently, theorists have explored the possibility of women's active spectatorship to produce active cultural meanings rather than passive consumption of the image. And many theorists now argue that the female gaze is not natural or biological, but socially and culturally constructed. [18] I have argued in Chapter 6 for what may be termed "skeptical reading"; that is, an awareness on the part of the viewer that she is seeing a socially determined image, and yet she makes a decision to engage with the fiction as if reading a novel. I believe such an active, knowing reading is operative in these Cannon images.

Such ideas of the gaze must be historically rooted. What can these formulations of female viewing tell us about the reception of Steichen's Cannon towel images among 1930s magazine subscribers? No doubt the cultural strength (in fact, canonical unquestionability) of the fine arts led many women to view the images as Coiner proposed: as the latest in the display of women's bodies in the Western tradition, as examples of ideal beauty, as great appreciations of the female form, as evidence of the audience's sophistication as spectators. And I also suspect that in the

era before feminist film theory, because of the heavy weight of gendered ideologies, many women viewed the female form as Coiner did, with a male gaze or one that shifted positions, bringing both male and female values and judgments to the female form.[19] Thus the theories of the male-defined gaze seem at first to be borne out in the Cannon campaign.

But spectators may have done more than reinscribe their own limited gender roles each time they read the advertisement. The images may even have been liberating, and viewers may have taken an active, erotic pleasure in viewing other women's bodies, despite the agency's best efforts to derail that response with chatty copy and pedestrian drawings of towels. The copy, headlines, bright towels, and bars all combine to frame the figure, but that frame is patched, formed of disparate pieces that seem unable to lock the figure into the pictorial space and thus allow the standard dynamic between (male) viewer outside the frame and (female) subject inside it to operate.[20] The unstable frame presents a formal challenge to the long-standing assumption that men look and women are looked at.

CLASS VIEWING

Steichen's nude studies were only one element of Cannon's overall advertising strategy in the 1930s. The appearance of Steichen's nudes for Cannon towels in *Vogue* and *Harper's Bazaar* underscores the agency's belief that the images would appeal only to an upper-class, sophisticated audience. To target middle-class women, towel advertisements in the *Ladies' Home Journal* and other "home" magazines replaced Steichen's images with Anton Bruehl's more formulaic images of housewives using the product (Figs. 8.1, 8.2). In commissioning an entirely different campaign for this woman's magazine, the Cannon executives and the advertising agency revealed their ideas about each periodical's audience, its gendered viewpoint and class status. The two series of towel advertisements, each directed toward very different women, demonstrate how advertising accommodated viewers of differing classes while trying to raise the perceived status of its product overall.

The *Ladies' Home Journal* advertisements pictured attractive but fully clothed middle-class housewives. The model in one of Bruehl's photographs, for example, clearly enjoys displaying her band-new, brightly colored bath towels, like ornaments on her outstretched Christmas-tree arms (see Fig. 8.1). Her elaborate lace collar and neatly controlled hair convey middle-class standards of order and cleanliness. In another, woman's responsibilities and interests are portrayed in a humorless deadpan (see Fig. 8.2). The consumer, shown with her two children (a boy and girl, as was standard 1930s iconographic shorthand), works to bring them up to her own high standard of personal grooming.

Because Bruehl's models are clearly meant to be housewives, they lack the dis-

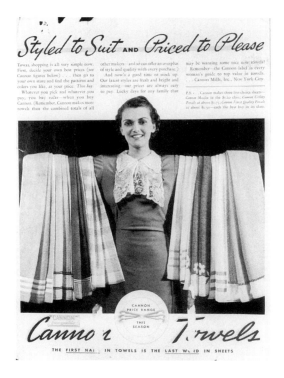

Styled to Suit AND *Priced to Please*

Towels shopping is all very simple now. First, decide your own best prices (see Cannon figures below) . . . then go to your own store and find the patterns and colors you like, at your price. *That key.* Whatever you pick and whatever you pay, you buy *safer*—when you buy Cannon. (Remember, Cannon makes more towels than the combined totals of all

other makers—and so can offer an overplus of style and quality with every purchase.) And now's a good time to stock up. Our latest styles are fresh and bright and interesting—our prices are always easy to pay. Lucky days for any family that

may be wanting some nice new towels! Remember—the Cannon label is every woman's guide to top value in towels. . . . Cannon Mills, Inc., New York City.

P.S. . . Cannon makes three first-choice sheets— Cannon Muslin in the $c.20 class; Cannon Utility Petals at about $1.75; Cannon First Quality Petals at about $2.50—each the *best buy in its class.*

Cannon Towels

THE FIRST NAME IN TOWELS IS THE LAST WORD IN SHEETS

8.1 Advertisement for Cannon towels, *Ladies' Home Journal,* June 1936, inside cover. Anton Bruehl, photographer; Charles T. Coiner and Paul Darrow, art directors (N. W. Ayer and Son).

tance and glamour of Steichen's models. And because they interact—with children or audience—they are less abstract and ultimately less "modernist" and less objectified than the women in Steichen's photographs. It was thought that readers would identify with these women much as advertisers believed they identified with Steichen's models for his Jergens and other campaigns. Thus the dynamics in Bruehl's advertisements, far more typical of mass media advertising across the board, place the unique components of Steichen's nude studies for Cannon in sharper relief.

Cannon Mills had put several years of effort into developing a fashionable image for this basic household product, to make it a sign of class in the home. An article in *Advertising Arts* reported that the Cannon company was almost single-handedly responsible for a new attitude toward towels on the part of female consumers: "Now, in 1932, the 'average woman' asks for woven-in, all-over designs. She buys matched bath sets wrapped in Cellophane. She looks for new colors, new weaves, new textures—she expects new ideas in towels every season just as in hats and shoes and handbags. She wants her towels to be unmistakably *smart*."[21] Though they believed that the "average woman" wanted the same style as an upper-class woman in her possessions, they marketed to different segments of the population with vastly different ads.

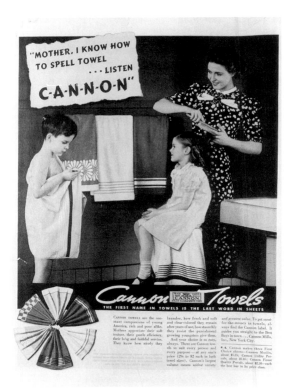

8.2 Advertisement for Cannon towels, *Ladies' Home Journal,* July 1937, inside cover. Anton Bruehl, photographer; Charles T. Coiner and Paul Darrow, art directors (N. W. Ayer and Son).

Clearly Coiner thought Steichen's photographs and Bruehl's belonged to different categories. Steichen was to develop a new kind of "classy" image—derived from the history of Western fine arts—while Bruehl's images were targeted at ordinary housewives. This essential difference of targeted class is seen most strikingly in the activities of the models: Bruehl's figures show the product in use; Steichen's images disregard this principle in favor of novelty and artistic composition. By removing the woman from basic involvement with the narrative of the advertisement, she and the towels are more easily reconfigured as "art."

Although Steichen's Cannon images are meant to represent the moments after the bath, the models never reach for the towels or evidence any need for, or interest in, the product. Coiner, however, insisted that the connection between the two was obvious and essential: "Cannon Towels . . . have a job to do. . . . The field of activity, for which its thirsty fibers are woven, is the human body." [22] Despite Coiner's insistence on the interaction between figure and product, the only connection between the nude and the towel is an implied bath. In each image of the series the models simply pose near the product rather than use it. The representation of

the woman as art transfers value to the product. Towels become art but cannot lose their identity as commodities. The danger for the agency is that the dynamic may work in reverse as well; association with the commodity may too obviously objectify the woman. Coiner's need to explain the visual association between the model and her product seems a stretch; it suggests that in fact the model's body is the product for sale.

To avoid such an unseemly conclusion, Coiner was careful to keep the images solidly within the allowable conventions of high-art representations of the nude. He praised Steichen's ability to construct a tasteful figural study, one that avoided the danger of degenerating to the level of pin-up kitsch found in most comparable photographs in the mass media. Falling back on the old defense of the "purity" of the fine arts, Coiner explained, the Cannon figures "might easily fall into the pretty girl classification were it not for the efforts of Edward Steichen. [He] posed [the model] as Renoir would enjoy posing a model." Coiner distinguished Steichen's advertising images from those in which "we see pretty girls posed on radios, draped on automobile fenders . . . to fill up the otherwise dull compositions."[23]

Steichen's models were inactive according to Coiner's guidelines: "It was the first nude series. We had to be careful. . . . They had to be classic *photographs,* not just nudes. They're nearly all back views, not really suggestive or anything like that."[24] Steichen's nudes were not in fact the first used in advertising. Glitzy photographs had long been used to sell goods, especially manufactured goods related to plumbing—like shower heads and bathtubs—that were advertised in trade journals.[25] Coiner's placement of the nude in magazines with more affluent readership revealed that the agencies saw class as the most defining category in their conception of spectatorship.

In the 1930s, although advertising agencies felt nude imagery could be used to market to the young upper-class women who read fashion magazines and to the working-class plumbers who read the trade magazines, they avoided using this sales pitch in ads directed at middle-class women. Advertisers, assuming that middle-class women wanted to identify with the model, presented them with attainable material goals. The higher their class level, the more women were assumed to share the normative male gaze and to observe with the distanced eye that characterized the reading of high art. Upper-class women were thus granted authority as admirers of art, even though that authority contradicted their usual passive relation to the high-art nude, which is constructed to be viewed by men. Remarkably enough, these women, who were the most active consumers, were also the most overtly objectified and commodified in advertising imagery. An attempt to ease any discomfort with this role may be reflected in such unusual elements of the Steichen Cannon advertisements as the instability of the frame in "Towel Talk No. 12" or the ambiguous vantage point for otherwise authoritative looking in "Towel Talks No. 10." The dominant codes of viewing are being stretched and strained to the limit to sell the

product. The advertisements attempt to position women as both authoritative for their class position and as women viewers within the traditionally masculine mode of viewing high art, creating an inherently unstable identity for the viewer. If viewers found the contradiction disconcerting, they could alleviate it by giving up the role of the viewer for that of purchaser—a purchaser of an inexpensive commodity that had taken on the status of high art.

WOODBURY'S SOAP

Using women's bodies to attract attention and market products in the respectable mass media must have been the hot new idea for 1936. The John H. Woodbury Company, a soap manufacturer and subsidiary of the Andrew Jergens Company, soon followed Cannon Mills with a series of nude studies, in which the model is discretely posed near a swimming pool. The use of sex appeal was not new to the client. In 1916 Woodbury had run an advertisement featuring Helen Lansdowne Resor's well-known caption: "A Skin You Love to Touch," although the suggestive line was paired with a conventional drawing of an upper-class couple in evening dress.[26] Through the Lennen and Mitchell advertising agency, Woodbury hired Steichen for the riskier 1930s campaign, ostensibly to give it the veneer of art.

In most of the images in this series, the swimming pool is obvious.[27] In Figure 8.3, however, no swimming pool is immediately evident, but the model is posed across several stairs very much like the pool steps in the other images. The narrative implied in this image is baffling. The models in "Cannon Towel Talks" were plausibly relaxing after the bath or attending to their personal grooming, and towels were shown in their usual setting. But soap in a swimming pool? Sunbathing in ankle strap sandals? Although the copy provided an explanation of how this soap packed "Filtered Sunshine" into every bar to give the consumer "all the benefits of a sun bath," the mise-en-scène seems far-fetched.[28]

Even if we discount the hokeyness of the setting, over which Steichen probably had little or no control, the handling of the figural study lacks the compelling quietude of the Cannon work. It is apparent that the woman's body is there only to attract attention. Without narrative or logic, the image looks cheaper, more stereotypically "commercial," an effect intensified by the woman's wearing only her shoes. Thus the image perpetuates the standard scopic relations of viewer and viewed.

The other images in the campaign were little better, though they were widely acclaimed in the trade press. In Figure 8.4 the model, partially obscured by a sundial on a columnar pedestal, reaches longingly for the sunshine. The "serious" classical column and astronomical instrument mark this advertisement as equivalent to old-master nude studies. But again the overdramatic gesturing, the model's makeup, and her awkward pose make the image improbable. In another image in the series a

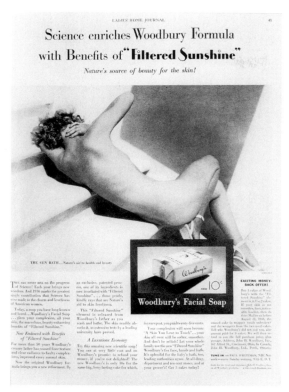

8.3 Advertisement for Woodbury's
facial soap, *Ladies' Home Journal*,
July 1936, p. 41. Edward Steichen,
photographer; Myron C. Perley,
art director (Lennen and Mitchell).

woman, shown from the back from the waist up, is draped over a large urn whose amphora shape continues the reference to classical art.[29] Where the Cannon towel ads echo fine art presentations of the woman's body in subject and composition, the Woodbury ads seem overworked and stale.

But Steichen must have been pleased with the images. He signed some of them in the print (see Fig. 8.4, lower left), much as he had inscribed his name into his pictorialist glass negatives. And the client must have been satisfied as well. The images attracted coverage in the trade papers and were featured in the 1937 *Art Directors' Annual*. The trade papers noted how uncontroversial the body had become as a sales tool. According to the journal *Tide*, Woodbury executives, when they "saw the proofs, started, hemmed & hawed, changed their minds three or four times, and, finally against their better judgment croaked a faint 'O.K.'" They expected a barrage of angry letters from the public, but weeks went by and only one came: "It was from a man who wanted to know where he could get a sun dial like that."[30]

The magazines where the ads were placed suggests that the nude female body no longer shocked and offended when it appeared in a highly public commercial con-

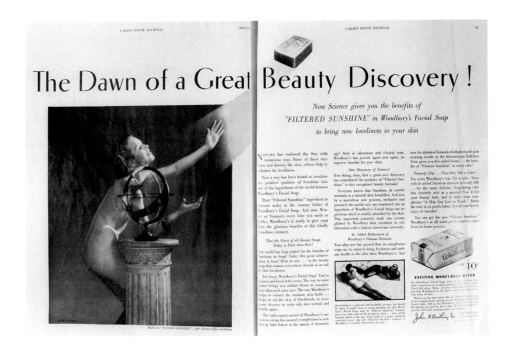

8.4 Advertisement for Woodbury's facial soap, *Ladies' Home Journal,* April 1936, pp. 62–63.
Edward Steichen, photographer; Myron C. Perley, art director (Lennen and Mitchell).

text. The campaign appeared in *Cosmopolitan, Good Housekeeping, Ladies' Home Journal, Pictorial Review,* and *True Story,* a list that reveals the company's target as a middle- and even working-class audience. Clearly the agency and the client felt that both proper housewives (*Ladies' Home Journal*) and shopgirls with a "tabloid mind" (*True Story*) would respond favorably.[31] Indeed, there must have been little resistance to the campaign, because Woodbury soon extended its magazine campaign to small spaces in three hundred newspapers.[32] *Advertising Age* observed that this campaign was a hit because "it is well understood by the masses that the best people do no wrong."[33]

THE DISCUSSION OF NUDES in advertising in 1935–36 sought to articulate the aesthetic differences between "art" in advertising and the sensational bid for attention. In trade magazines Steichen's Cannon nudes were firmly located in the "art" camp,[34] while others were deemed "as raw as a French post card."[35] Even the Woodbury ad, with its "money-back guarantee, sex, sunlight, and poetry," was considered an "attempt to raise the voice of Woodbury above the rival throng."[36]

By the mid-1930s the display of the body in the mass media caused only minor controversy in the mainstream press. *Vogue* planned a cover for its July 1, 1936, issue showing the back view of a woman, clad only in a straw hat and "Bruehl's best shadows." But after the editors talked to postal authorities, they pulled the cover and buried the photograph on page 55.[37] One could run nude studies inside a magazine if not on the cover. What seems new in the advertising agencies' strategies for Cannon and Woodbury was their commissioning a well-known photographer to design photographs of female nudes that clearly referred to the history of Western art and appealed to the upright middle-class consumer.

After his official retirement from advertising photography, Steichen was invited by Woodbury executives to return for another campaign. He photographed a series of sleeping women, whose romantic dreams were pictured in star-shaped insets. In Figure 8.5 Steichen set his camera to the side and slightly above the freshly made-up model, who is dressed in a lacy off-the-shoulder nightgown. Presumably she is in a private space, her bedroom, but there are no props to locate her or give clues to her identity and taste. Rather she is suspended in a featureless dreamscape, punctuated only by stars. These shopworn symbols of Hollywood aspirations inform us of her conventional fantasies: flowers from her handsome admirer, a night out on the town, and the thrill of her new engagement ring. In a subsequent advertisement in the series, the star insets have a picture of the couple at the altar and one in which they ride in a Venetian gondola.[38] The assertive star shape reinforces viewers' own romantic aspirations and foregrounds them as the most important part of life.

Since the woman has not yet married, she is, by the convention of the day, assumed to be alone, but the vantage point of the camera mimics that of someone observing her, perhaps someone sitting on the edge of the bed. Even alone, even asleep, her makeup and expression suggest she is aware of being the object of the male gaze, although this time she is set out on the pages of magazines for women to see.

Images such as this one illustrate John Berger's observation that men look at women and women watch themselves being watched, in the process turning themselves "into an object—and most particularly an object of vision: a sight."[39] Thus the image offers a contradictory visual experience to women: it suggests that they are free to engage in sexual fantasies, but it strongly reinforces traditional ideas that their pleasure and fulfillment in romance must inevitably end in marriage.[40] The images seem to confirm that many clichéd mass media images represent little more than a trap for women.

While the commercial world unproblematically accepted Steichen's advertising as "art," the art world did not. The art world defined commercial art as a cheaper product than their own, pitched to a mass audience, and constructed with more clichés. They did not distinguish between better and worse commercial art. Art directors, however, saw a continuum of visual expressions: all images are cultural

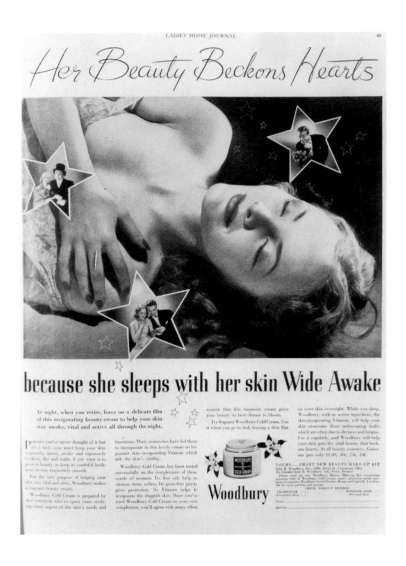

8.5 Advertisement for Woodbury's facial soap, *Ladies' Home Journal,* July
 1939, p. 49. Edward Steichen, photographer.

products; they vary in cost, audience, and goals, from cheaper "commercial" work
to artistic advertising to the fine arts. Although they never claimed full fine art status
for their products—probably because as veterans of art schools and gallery exhibi-
tions they were aware of the insular demands of that marketplace—they rated it
higher than run-of-the-mill commercial imagery, because they needed a middle

ground where they could professionalize their work. Those in the fine arts, in contrast, tried to hold on to a vision derived from the Renaissance and Enlightenment and solidified by modernism, in which fine art representation was more significant, more personal, and of a higher status than commercial art.

Those in the art world who had supported Steichen financially and emotionally early in his career frequently questioned his declared democratic motives. The critics and photographers who had remained loyal to Alfred Stieglitz's circle or had newly joined it criticized Steichen bitterly and publicly for his commercialism. But Steichen's friendship with Stieglitz had begun to pall long before Steichen signed contracts with Condé Nast Publications and the J. Walter Thompson Company. Steichen's diminishing involvement with Stieglitz's 291 Gallery, their conflicting allegiances over World War I, and friction between two strong egos had started the break. Steichen's success as a commercial photographer simply provided the rationale for the final rupture.[41]

The debates in the press over Carl Sandburg's book *Steichen the Photographer* outline the differences between Steichen and his former colleagues and give some insight into the definitions of "art" and "commercial" each camp held. *Steichen the Photographer* was warmly received in the graphic design community. The industrial designer Egmont Arens thought the book "worth the twenty-five dollars asked for it" because "every time you look through it you discover new subtleties. Advertising takes on a new dignity when it engages a man of Steichen's caliber."[42] But the book was far more harshly reviewed in fine arts circles. In the *New Republic* in 1930 the art critic Paul Rosenfeld called Sandburg's essay an "atrocity" and accused him of writing the introductory essay solely to deflect criticism of Steichen's commercialism. Citing Sandburg's reference to private and papal commissions granted to Michelangelo, Raphael, Titian, Botticelli, and Leonardo da Vinci, Rosenfeld claimed that Sandburg's "argument is tilted to deny spirit; to make it appear that the great artists did not work because of an impulse stronger than themselves which they dominated in their art, and which obtained them the support of Julius II, the Medici, the Chigi and other eminent patrons; but rather because of the irresponsibility and jobbery that generate the main enemy of art, modern mercantile advertisement."[43] While Steichen and Sandburg had argued that patronage prompted great art, Rosenfeld held that great art attracted patrons. Although he had kind words for Steichen's talent as a photographer, calling him "a picture-maker of the most superior sort," he was wary of Steichen's commercialism and placed it in contrast to the "purer" practice of Stieglitz and Strand.[44]

Paul Strand, in a letter to the editor of the *New Republic* responding to Rosenfeld,

thought the critic did not go far enough. Strand wrote that Rosenfeld should have more directly exposed the central thesis of *Steichen the Photographer*: the book "proclaims commercial art to be the great art of today, and all else, generously lumped under the category of 'art for art's sake' to be born dead." Strand criticized Steichen's work as a reflection of the "corporate age," one of the "intellectual and moral counterparts" of "big mergers in the industrial fabric."[45] Sandburg's and Steichen's uncritical admiration for commercial patronage and Rosenfeld's and Strand's insistence on the necessity for "pure" art set up an artificial polarity, leaving no room for crossing between them, or for developing yet another type of art that might combine a democratic or social approach with fine art aesthetics.

Sandburg's book had an impact even outside photography. Mike Gold, writing in the radical magazine *New Masses*, had a response to Sandburg's essay similar to that of Rosenfeld and Strand, but his analysis fell into more standard ideological categories: "Carl Sandburg advances the thesis that an artist has only two alternatives in America; he must be either a commercial or a revolutionary artist. We agree." In such a clear-cut environment, Gold thought the artist's choice was obvious: "We do not agree, however, with Sandburg when he chooses commercial art for himself; glorifies it, in this amazing and shameless essay, and advises the youth to sell their talents to Big Business. Sandburg is in his decadence. Once he believed in the Revolution, and it made him an inspired American poet; now he believes in Big Business."[46] The Stieglitz circle artists could certainly endorse Gold's analysis, but their own position was based on aesthetic rather than political categories. They seem to have had no reservations about making expensive, precious art commodities as long as the objects seemed to embody individual sensibilities and grapple with ideas. They saw corporate art as the antithesis of their own artistic struggles.

The photographer Walker Evans reviewed *Steichen the Photographer* for the literary journal *Hound and Horn*. For him Steichen's advertising images represented the "sad" and "trite" state of American photography:

Steichen is photography off its track in our own reiterated way of technical impressiveness and spiritual non-existence. In a paraphrase, his general note is money, understanding of advertising values, special feeling for parvenu elegance, slick technique, over all of which is thrown a hardness and superficiality of America's latter day, and has nothing to do with any person. The publication of this work carries an inverted interest as a reflection of the Chrysler period.[47]

Ralph Steiner recalled that Evans "belabored Steichen as despicable for making photographs for *Vanity Fair, Vogue,* and advertising agencies."[48] Although Evans harshly criticized Steichen for making commercial photographs, Evans himself later worked as a staff photographer for *Fortune*, although he claimed he had considerable latitude in choosing his picture stories.[49] Even Paul Strand had made commer-

cial photographs on occasion; for example, in 1919 his advertising clients had included Hess-Bright ball bearings and Eno's fruit salts.[50] And like Steichen, Strand had served in the military in World War I, taking X-ray photographs for the Medical Corps. The intensity of their positions derived from the decades-long battle of the pictorialists for the recognition of photography as a fine art. As the commercial photographer Margaret Watkins remembered in 1926, when she was the primary technical instructor at the White School, "No devout pictorialist would have deigned to descend to advertising. In their desire to establish photography as an art they became a bit precious; crudeness was distressing, materialism shunned."[51] Pictorialists, to gain the elite status as artists they desired, had to cling to romantic ideas about art. This view persisted, even as modernism replaced pictorialism.

In a 1934 interview with the *Commercial Photographer,* Strand further distinguished between art and design in photography: "Art . . . is always the product of the search for some truth. It is the result of a really religious activity—to find a wholeness, a holiness in life, and to bring one's self into relation with it." He complained that most modernist photography had become stale and academic, too engaged with technical formulas to be moving. "One sees, for example, in German magazines, a photograph of twenty or more barrel tops. In the first place, it's not new; in the second place, it doesn't seem to mean anything . . . the photographer has merely made a pleasant design of barrel tops and has really said nothing about anything except that a lot of barrel tops make a pleasing design."[52] Conversely, Strand believed that his own close-up art photographs of objects caught the spirit and essence of the subject.

The virulent reaction must have been prompted by Steichen's rhetoric on the populist elements of modernism and the potential of advertising for art education, which threatened the elite position for fine art photographers (despite the self-proclaimed socialism of some, like Stieglitz and Strand).[53] Stieglitz scorned the American public for failing to understand the modern art he showed in his gallery; stories abound of how he treated the unsophisticated visitor to 291. For these artists "commercial" was a disparaging code word for popular, accessible, and ultimately for both the working class, who responded to tabloid advertisements, and the bourgeois middle class, who were seen as crassly materialistic.

To Steichen, fifteen years younger than Stieglitz, such debates on photography as art were outdated, although his early start in the fine arts and his former close association with Stieglitz may have caused him occasional doubts about his new commercial direction. These two different experiences, first his immersion in art photography and later developing its possibilities as a popular art, fused into his own artistic sensibility.

The animosity reserved for Steichen was unique. Many other well-paid commercial photographers in New York, supported by the vigorous advertising and design industries, escaped such scathing criticism. Indeed, industrial designers were praised

for revolutionizing the form and function of consumer goods; architects, for considering livability and practicality; early American crafts and the popular art, for constituting a heritage. Steichen, it seems, was judged by his former fine art colleagues (and some later scholars) by different standards. Perhaps his critics were goaded by hagiographies in the popular press that still referred to Steichen as a fine artist; perhaps they were motivated by personal dislike, or bitterness over their own struggles. In any case, the hostility unleashed at Steichen had all the fury believers reserve for those who reject the true faith.

Melodrama in Black and White and Color

In the mid-1930s Steichen began to add to his repertoire sensationalist tableaux and bright images boldly designed to convey their messages instantaneously. As the American economy struggled out of what had finally been recognized as a depression, advertisers abandoned nuanced interpretations and gentle suggestions, commissioning hard-hitting black-and-white or harsh, gaudy color photographs to grab attention. Shrill and provocative advertising strategies became the norm, and Steichen evolved a suitable style. In his commercial works of the 1930s references to fine art aesthetics alternate with overt manipulative appeals. Melodrama became both his style and his content in these images.

Figure 9.1, promoting an upcoming issue of the *Ladies' Home Journal,* exemplifies Steichen's melodramatic mode. To attract buyers for the December 1937 issue, the magazine wanted a highly charged photographic teaser for its lead story, "Hasty Wedding." Steichen illustrated the story's most dramatic line, "'I know that you KILLED him'—her husband said." He emphasized the bridal details—veil, flowers, her ring—to situate the moment of the story. And he encouraged the models to express worry, anxiety, confusion, blame, and anger, the emotions the publishers believed would persuade women to buy the magazine faster than any advertisement for the issue's recipes or beauty tips. Clearly they believed that women wanted emotion and excitement from magazines and advertisements.

Historically, excess is the key to melodrama. Emotions run high; characters take strong, uncomplicated positions; and moral constructions, like innocence and evil, stand out in sharp polarized relief against one another. The message of melodrama is easily decoded by the audience.[1] By the 1930s, melodrama was a staple of popular films associated with both an appeal to mass culture and the "irrational and overly indulgent emotionalism" of women.[2] The popularity of such melodramatic films assured the birth of the form as an advertising strategy.

Although the advertising industry continued to link photography to "realism," admen intuitively changed their practice (without redefining their terms) to accommodate publishers' demands for melodramatic photographs with convincing representations of improbable events—representations so "real" in their fiction, so tricky in their "objectivity" that photographer, agency staff, and audience all could perceive them simultaneously as manipulative and credible.[3] The public read advertising photographs as it viewed the cinema: everyone knew that the movies were not "real," yet the art form swept the audience into involvement with the story.

The relationship between realism and melodrama in the movies is more problematic, however, than this brief account suggests. Although melodrama, by privileging women's emotions and interests, may disrupt the realist tradition that reinforces conventional social roles, hierarchies, and ideologies, it is itself linked to tradition because it offers the female audience no new positive roles or instructions for successfully resisting the social order—and because it is produced by the (largely male) Hollywood film industry.[4] Melodrama, in other words, is not opposed to realism but occupies a different position on the continuum of representation.

Because women were believed to identify more strongly with representations than men (men were thought to intellectualize the process of artistic creation and representation),[5] the advertisers thought photographic styles based on cinematic melodrama were sure to snare them. Steichen adapted readily to the melodramatic style. Some of his images, like the Scott tissue advertisements, had a clear narrative that worked on the emotions. Others used brilliant color and harsh linearity to replace the narrative, plot, or emotional turbulence to capture women's attention. Both approaches incorporated an intensified emotionalism that was one of his signature styles of the 1930s.

HIGH/LOW ANXIETY: SCIENCE AND THE CONSUMER

Melodramatic advertisements of the early and mid-1930s often used scare tactics to sell products. For the Scott Paper Company Steichen constructed overtheatrical vignettes to warn the public about the dire effects of using the wrong brand of toilet tissue. The photographer's work for this campaign may be considered the height (or depth) of his depression advertising photography.

Negative advertising appeals were not new. More and more frequently through

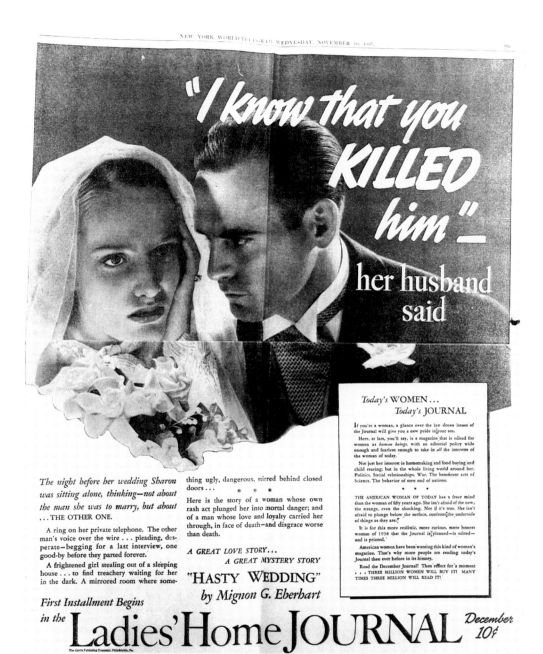

"I know that you KILLED him"

her husband said

Today's WOMEN . . .
Today's JOURNAL

If you're a woman, a glance over the last dozen issues of the Journal will give you a new pride in your sex.

Here, at last, you'll say, is a magazine that is edited for women as *human beings*, with an editorial policy wide enough and fearless enough to take in *all* the interests of the woman of today.

Not just her interest in homemaking and food buying and child rearing; but in the whole living world around her. Politics. Social relationships. War. The benedicent acts of Science. The behavior of men and of nations.

* * *

THE AMERICAN WOMAN OF TODAY has a freer mind than the woman of fifty years ago. She isn't afraid of the new, the strange, even the shocking. Not if it's true. She isn't afraid to plunge below the surface, confront the underside of things as they are.

It is for this more realistic, more curious, more honest woman of 1938 that the Journal is planned—is edited—and is printed.

American women have been wanting this kind of women's magazine. That's why more people are reading today's Journal than ever before in its history.

Read the December Journal! Then reflect for a moment . . . THREE MILLION WOMEN WILL BUY IT! MANY TIMES THREE MILLION WILL READ IT!

The night before her wedding Sharon was sitting alone, thinking—not about the man she was to marry, but about . . . THE OTHER ONE.

A ring on her private telephone. The other man's voice over the wire . . . pleading, desperate—begging for a last interview, one good-by before they parted forever.

A frightened girl stealing out of a sleeping house . . . to find treachery waiting for her in the dark. A mirrored room where some-thing ugly, dangerous, stirred behind closed doors . . .

* * *

Here is the story of a woman whose own rash act plunged her into mortal danger; and of a man whose love and loyalty carried her through, in face of death—and disgrace worse than death.

A GREAT LOVE STORY . . .
A GREAT MYSTERY STORY

"HASTY WEDDING"
by Mignon G. Eberhart

First Installment Begins
in the

Ladies' Home JOURNAL *December 10¢*

The Curtis Publishing Company, Philadelphia, Pa.

9.1 Advertisement for *Ladies' Home Journal*, *New York World-Telegram*, November 10, 1937, p. 39. Edward Steichen, photographer.

the 1920s and into the early 1930s, the message of advertisements was a (not-so-veiled) threat: consumers were warned to adopt the modern product to solve their common problems or to avoid a variety of devastating events—illness, unsatisfactory personal hygiene leading to both job loss and social ostracism, aging, and even death. Ads for Odorono in the 1920s warned consumers against the newly discovered disease B.O., the consequence of uncontrolled perspiration, and ads for Listerine cautioned against the perils of "halitosis."[6] Despite admonishments from advertising professionals concerned about eroding the credibility of their profession, such claims escalated. Readers were warned, for example, to avoid the disastrous fate of the dancer who bought the wrong soap, then collapsed and died onstage from "clogged pores."[7] Helen Woodward, one of the most successful female copywriters of the day, confirmed the industry belief in graphic representations of such fears. She reported that on her first assignment for the Frank Presbrey agency in 1909, one of her mentors advised her on writing copy for baby food: "For God's sake put some sob stuff into it. . . . Tears! Make 'em weep." She was told to discuss the infant mortality rate, but in a vivid, novelistic way: "If you just put a lot of figures in front of a woman she passes you by. If we only had the nerve to put a hearse in the ad, you couldn't keep the women away from the food."[8]

Though fear had a solid place in the advertising repertoire long before the depression, the hard sell became more widespread in the 1930s, when agencies terrorized the audience into buying products. Advertising became the victim of its own success. The growth of advertising had oversaturated the print media and radio, prompting advertisers to try more and more shocking and exotic gimmicks to get the attention of consumers.

The overstated claims and bad taste that had developed in the 1920s palled before the new appeals of the 1930s. Negative advertising campaigns reached a new low; the Scott tissue campaign was denounced by the American Medical Association. The Scott Paper Company had shifted from discussing the product's softness and purity in ads of the early 1920s to hints in the late 1920s of the unpleasant effects of competing brands.[9] In the 1930s the scare tactics intensified and images of the product were replaced by melodramatic scenarios. Consumers risked life-threatening diseases if they dared purchase an inferior brand. In one advertisement (Fig. 9.2) a concerned friend has come to visit the troubled victim as she recuperates in bed from one of the "at least 15 painful diseases" that a competitor's product has induced.

Steichen's photographs for the Scott tissue campaign of 1932 used these extreme scare tactics, which had particular appeal to the staff at the J. Walter Thompson agency. Even as studies of sales returns validated its effectiveness, the strategy derived intellectual justification from the theories of the psychologist John B. Watson, who considered fear, with its pendants love and rage, a powerful stimulus.[10]

One of Steichen's images from this campaign represents a hospital operation, which, the text implies, was necessitated, either directly or indirectly, by the com-

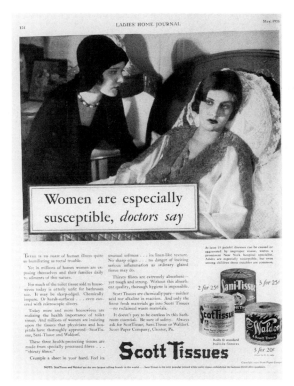

9.2 Advertisement for Scott tissues,
Ladies' Home Journal, May 1930,
p. 154. Photographer unknown.

petitor's product (Fig. 9.3). Steichen shows no medical details, but the situation is unmistakable. The models' concentrated gazes and their masked faces convey the gravity of the situation. The implied motion of the doctor's arm and the spotlighted, sharp contrast between the surgical gowns, background, and shadows further dramatize the operation. The close-up, suggesting the patient's perspective, conveys the threat to the magazine reader. The pathos of the image, like that of many melodramas, derives from the patient's passivity as the victim of unknown, uncontrollable forces. But as in films, because the audience sees and understands the cause of the sorrow, they are protected.[11]

Steichen was heavily coached by his art director, and the final image should be seen as a collaborative product. The *JWT News* reported that the Scott campaign's art director, James Yates, used the agency's new in-house photographic studio to solve the visual problem "of illustrating a surgical operation without being gruesome. Mr. Yates, through experimental work with lights and lenses, was able to produce photographs that had just the right dramatic effect."[12] He apparently handed Steichen his prints and requested the final published version.

In another of Steichen's images for the Scott campaign a sad little girl seeks help

from her mother that she cannot give her—unless she had been clever enough to read the ad and buy the product (Fig. 9.4). Steichen went for the most obvious expressions to increase the pathos of the dramatic moment. Backlighting the faces, thus silhouetting them against a dark ground, increased the voyeuristic, motion-picture sense. The faces, seen at close range, have a soft, grainy texture that diffuses the crisp effect the photographer adapted from straight photography. Steichen employed this stylistic tool frequently in the 1930s. The grain emphasizes the photographic qualities of the image and distances the viewer from the event. It makes the vignette seem less personally immediate and reinforces the viewer's sense of watching the enactment of a scene. Thus although the image forcefully reveals its function as drama, and the audience becomes involved in the story, the disclosure of the fiction (as in the movies) does not interfere with the photograph's credibility.

Characters in melodrama usually have uncomplicated social and emotional roles—the sacrificing mother, the innocent child, the uninvolved father—that are easily read by the audience. Like cinematic melodramas, advertising imagery presents figures unidimensionally. Most advertising photographs represented mothers as concerned, as in the Scott ad, or as blissfully happy or playfully relishing the role,

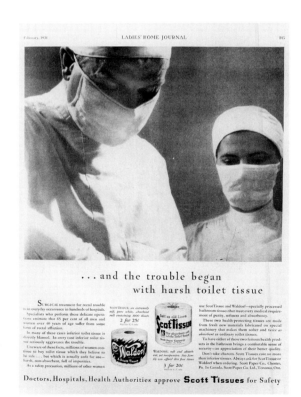

9.3 Advertisement for Scott tissues, *Ladies' Home Journal,* February 1931, p. 145. Edward Steichen, photographer; James Yates, art director (J. Walter Thompson).

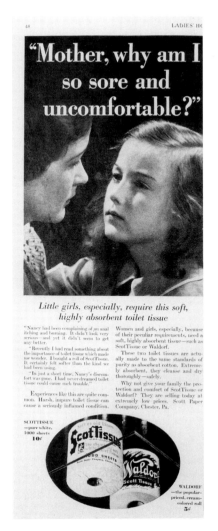

9.4 Advertisement for Scott tissues, *Ladies' Home Journal*, August 1933, p. 48. Edward Steichen, photographer; James Yates, art director (J. Walter Thompson).

as in the Ivory soap ads or Steichen's image of a nursing mother for Hexylresorcinol (Fig. 9.5; see Plates 3–5). The Hexylresorcinol ad is imbued with all the sentimentality new motherhood can evoke. The peaceful, dreamy woman gazes into the eyes of her newborn. The flowers, lacy nightgown, and wedding band are emblems of femininity fulfilled.

But this cardboard character is not the whole story. The ad in fact reveals the complexity of American society and its conflicts. Image and text together suggest the contradictions in ideals of American motherhood: although the photograph depicts a serenely happy mother, the text implies women's inadequacy for such grave

responsibilities. The Hexylresorcinol copy assured women that the product was used in hospitals and had the confidence of the male medical establishment. Even the chatty Ivory soap text had referred to how one mom learned about the product from her doctor.

The technique of inducing unsubstantiated fears and assuaging them with the proclamations of authorities prevailed at the J. Walter Thompson Company early in the 1920s, after John B. Watson's arrival. The strategy was used in ads for products like Alcorub, the breakfast cereal Grape-Nuts, and Johnson and Johnson baby powder (Figs. 9.6, 9.7), all of which used Steichen's photographs. Though the copy in the advertisements was similar to that of the 1930s, the earlier images were less melodramatic.

The photographs for the Johnson and Johnson baby powder campaign depict contented mothers cuddling their babies (Fig. 9.7). Their images seem to fit the demographic profile of the consumer that Watson, the account representative, said he hoped to reach: young, white, upwardly mobile middle-class women.[13] They lack the glamour of their beauty product cousins. The seeming ability of the women in these advertising photographs to care for and play with their children did not reflect

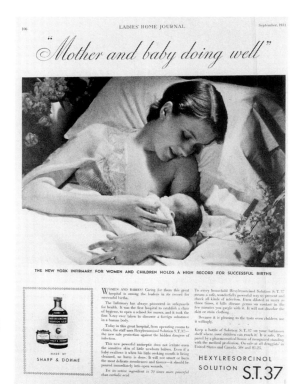

9.5 Advertisement for Hexylresorcinol solution, *Ladies' Home Journal*, September 1931, p. 106. Edward Steichen, photographer (J. Walter Thompson).

9.6 Advertisement for Grape-Nuts cereal, *Ladies' Home Journal*, April 1925, p. 145. Photographer probably Edward Steichen (J. Walter Thompson).

Watson's confidence in women as natural mothers. Although Watson vigorously argued that women were ill suited for the commercial world (see Chapter 6), he did not therefore think them innately fit for motherhood. As far as he was concerned, women, given an abundance of time by modern consumer culture, seemed to find no better use for it than "in destroying the happiness of their children."[14] Watson and his second wife, his former graduate student Rosalie Rayner Watson, co-authored a popular manual on child rearing, in which they announced that "no one today knows enough to raise a child."[15] Watson, moreover, appeared on radio talk shows to broadcast his advice, telling parents to dispense affection sparingly and without "sentimentality." They should treat children rationally and objectively to foster independence. Watson's insistence that parents needed outside professional advice on child rearing correlated with his promotion of expert testimony in the baby powder and other advertising campaigns.

Scare tactics and authoritative copy targeted women's deep anxieties in an age when traditional support from an extended family had lessened and women's roles in society were questioned in public debates: should women remain in the workforce they had entered during World War I or return to their "separate sphere"? The widespread professionalization of many occupations and the conduct of business itself also had an impact on women's confidence in their own knowledge and decisions.

"Experts" like the Watsons gave advice on child rearing, and trained home economists encouraged women to analyze and perform their duties with an eye toward the efficiency and scientific management that were transforming other sectors of society. In this context, women could no longer rely on the household values and techniques passed down from their mothers. Advertising, the self-declared authority on modernity and proper behavior, stepped in to guide women in scientific home management and child rearing. Steichen's photographs of the unhappy child for Scott and the new mother for Hexylresorcinol intimate that mothers can care for their children only if they receive expert advice and rely on the new technology

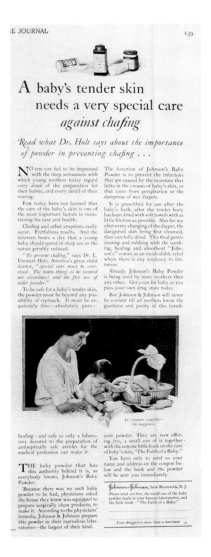

9.7 Advertisement for Johnson and Johnson baby powder, *Ladies' Home Journal*, March 1925, p. 139. Photographer probably Edward Steichen (J. Walter Thompson).

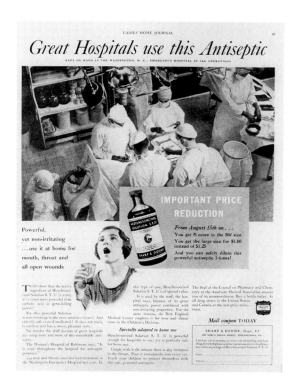

9.8 Advertisement for Hexylresorcinol solution, *Ladies' Home Journal*, September 1932, p. 99. Edward Steichen, photographer (J. Walter Thompson).

provided by industry and science. In melodramatic vignettes and highly charged copy the advertisements questioned women's competence to perform their domestic tasks and sentimentalized the innocence of children to insinuate parental guilt. The agency discovered that seemingly factual and scientifically authoritative copy was far less effective than emotional and melodramatic imagery.

Advertisements frequently paired gender expectations with assumptions about class status. The Johnson and Johnson, Scott, and Hexylresorcinol campaigns promise class stability or mobility to those who accept the advertisements' premises of acceptable hygiene, subservience to expert advice, and the benefits of consumerism. The agency designed some ads for Hexylresorcinol that feature an image of a clean and contented mother and others that vividly illustrate the use of the product in operating rooms (Fig. 9.8). While the doctor's performance of surgery is the central event in Steichen's photograph, the nurse's sterilization of medical implements (at the far right) is a significant addition to the narrative. The ad gives no sign of the controversy in the popular press over the product's effectiveness.[16]

The authority of the medical establishment and the promise of an improved standard of living for the middle class had long been invoked to promote hygiene. Beginning in the late nineteenth century, health reformers campaigned to raise standards

of cleanliness and to control disease through education and the arousal of the public's anxiety and guilt. Dirt became a moral problem, aligned with the forces of evil. Hygiene was a constant battle; the body was a fort under siege by enemy germs. Through cleanliness and order, moreover, the middle class could distinguish itself from the working class; these virtues expressed the middle-class desire for social stability at a time of social change. As Adrian Forty has observed, manufacturing, commerce, industrial design (and, we might add, advertising) were far more compelling than hygiene reformers in instilling a desire for cleanliness in the public.[17]

The public discussion of personal topics in advertising and the accompanying melodramatic imagery derived from an economically motivated hard sell rather than a desire to reflect social freedom. The persuasiveness of the strategy resulted from a lack of consensus on major social issues. Advertisers could play on deep cultural anxieties and the instability of basic social structures. Steichen's melodramatic imagery worked because it touched on points of social tension; the advertisements seemed to provide clear-cut solutions in a culture struggling with instability.

INDUSTRY PERCEPTIONS OF CONSUMER INTELLIGENCE

Watson's distrust of parents and the scare tactics of the 1930s advertisements mirrored a low opinion of consumers in the advertising industry. Trade journals debated whether the consumer (the upper two-thirds of the American population advertisers targeted) had a ten-, twelve-, or fourteen-year-old mentality.[18] The sensationalist strategies reveal that advertising executives continued to debate the intelligence of their supposedly middle-class audience. Roland Marchand has demonstrated that the admen had great difficulty "keeping the audience in focus," sometimes idealizing them, then, a moment later, disparaging them.[19] Thompson executive Paul Cherington summarized corporate wisdom: although there might be an occasional "advantage to pandering to low taste in pictures," he doubted "whether it is a safe principle to adopt this as common practice."[20] Despite some hesitation, and despite the admen's belief that they aimed to influence only the top two-thirds of the population, they used more fear advertising in the 1930s, even though insiders thought the strategy worked better with lower-income consumers than with their high-income targets.[21] This contradiction suggests that what the industry proclaimed was a "scientific" study of consumer demographics was simply intuition, common sense, and stereotyping. Even though some in the industry occasionally characterized consumers as astute and discriminating (in the best sense), advertisers' views of the public after 1910 became, as Marchand put it, "increasingly committed to a view of 'consumer citizens' as an emotional, feminized mass, characterized by mental lethargy, bad taste, and ignorance."[22] In other words, admen came to see their targets as "other."

This view of the consumer as "other" took hold as admen increasingly thought of their audiences as female. They exalted the knowledgeable and discerning consumer only to entice new clients to the agency with claims of their unparalleled access to key markets or to sell expensive items unlikely to be bought on impulse. Thus in her book *Selling Mrs. Consumer* Christine Frederick could portray the consumer as a housewife with a fourteen-year-old mentality, who looks elegant at the country club and has enough wealth to have purchased "several pianos of different shapes and woods in recent years."[23]

The strategy thought most effective in persuading women was emotion, which by 1930 had almost totally replaced the informative strategy.[24] "Emotion" as an appeal took many forms: the fear strategy of the Scott tissue campaign, the romance themes of Jergens lotion ads, and the sentimentality of those for Ivory soap. Advertisers heightened the emotion of their copy and imagery to involve women in the premises of their advertisements.

The executive William Esty, a dominating presence at the Thompson agency because of his success in leading the Lux toilet soap campaign, became an influential figure in this new reliance on strong emotion. Esty, who tested his theory during occasional stints as a barker for a sideshow at Coney Island, "the greatest laboratory in the world for a mass-mind scholar,"[25] argued, "It is futile to try to appeal to masses of people on an intellectual or logical basis."[26] Esty became noted for his study of "that baffling immensity—the mass mind," for which he had little respect. He stressed that advertising in the magazines had to aim low: "I think that today you have to read what the mob reads, understand what the mob likes; certainly go to the movies very frequently, and by that I don't mean go to the very fine movies like 'All Quiet on the Western Front' or 'Disraeli'—I mean the run of the mill movies. Because of this there is no doubt that the people in Hollywood have found the greatest common denominator of humanity."[27] Similarly, an article in *Advertising and Selling* admonished art directors to avoid the vocabulary of high art in their work; their "talents" were not "for the edification" of colleagues, but for the "client's business." The aspiring art director was advised that "a trip to the movies will teach him more than a trip to the Modern Museum."[28]

Many argued that the low common denominator in advertising gave the public what they wanted. According to the business historian Ralph Hower, "If the results seem obvious or vulgar at times, that is because they reflect the audience whose cultural standards are not very high."[29] Esty was even more blunt: "We say the Hollywood people are stupid, the pictures are stupid: What we are really saying is that the great bulk of people is stupid and personally I believe, if you are going out to trade with the natives you take along coral beads, or calico or whatever they like and not fight with bookshelves or anything else unless you are trying to improve them." The purpose of advertising was not to better the target audience: "Clients don't spend money trying to raise the level of intelligence of the country, even if it could be done."[30]

The emotional appeals were unusually successful. Despite terrible business conditions, total sales for the Scott campaign of 1930–32 exceeded those for 1927–29 by $5 million. And consumers read the ads. Daniel Starch's quantitative advertising service estimated that eight and one-half times as many people read the complete October 1932 *Ladies' Home Journal* Scott tissue ad from start to finish as read the average ad in that issue.[31]

This success gave support to the melodramatic mode. But the agency was clearly aware of engaging in a borderline practice. It weakly defended the situations represented in the Scott ads as promoting public health: "It's true, in the Scott tissue campaign, we show dramatic illustrations picturing people who are either suffering from rectal trouble or have just learned that an operation is necessary. The difference is that the average person has no idea that harsh toilet tissue can cause a condition of this kind. It takes a dramatic illustration to shock this fact into them." The average person, however, was not the only one who had not heard Scott's news. It surprised doctors as well. The advertising agency complained about a "very vicious attack" on the Scott Paper Company in the *American Medical Association Journal* but nonetheless relished the notoriety of the product, which had become a "national subject of conversation."[32]

But the advertising agency seems to have gone too far, for a consumer backlash began against this strategy. The nascent consumer movement challenged the scare tactics, asking the public whether they could believe ads on which "several million dollars are spent annually" to sell "sanitary salvations." Consumer advocates claimed the depression-era advertising industry had not moved much beyond the days of patent medicine: "Without [the product] you will soon find yourself hairless, toothless, afflicted with halitosis and B.O., and a little later you will die a horrible death from a combination of twenty or thirty dangerous diseases, the germs of which are lingering in your mouth or on door knobs, awaiting anxiously to pounce on your vital organs the first morning on which you forget to gargle with *Listerine* or *Pepsodent,* or wash your hands with *Lifebuoy.*"[33] The melodramatic images and overstated copy used in ads of the 1930s were re-creating the public perception of admen as charlatans and snake oil salesmen. Consumer advocates complained about advertising copywriters who felt competent to "diagnose and prescribe for all known diseases and conditions, without benefit of even ten minutes of medical education."[34] Reactions against negative advertising were building even in the advertising agencies. A 1936 Thompson agency internal report condemned the tactic, arguing that restraint was intriguing and would persuade women to read the advertisements.[35]

The term "realism" was used to justify the explicit copy and images like those of the Scott tissue campaign, although "stark realism" was sometimes preferred to differentiate between the simple presentation of facts (as in the 1920s Welch's grape juice ads) and a more melodramatic treatment.[36] The definition of realism in the 1930s was more ambiguous than it had been in the 1920s. The ads made conscious

attempts to strike terror in the hearts of consumers. They flagrantly abandoned "objective" analysis in favor of "pseudoscientific" evidence that was as valid as that written for the popular tabloids. But because the ads presented intimate issues in a style derived from straight photography, 1930s wisdom called it realism. It appears in retrospect, however, to be a heightened form of fantasy—melodrama rather than drama.

COLOR PHOTOGRAPHY IN STEICHEN'S STUDIO

In the mid-1930s, as improved technology became available, Steichen added state-of-the-art color photography to his studio services. The new technology was characterized by an unnatural garishness and a harsh linearity that worked hand in hand with the aggressive marketing of the 1930s. The new color processes perfectly expressed the melodramatic impulse in advertising. Although the advertisements in which color was used were typically less melodramatic in subject, Steichen discovered in the new color the visual analogue to melodramatic content.

Steichen continued to specialize in figural advertising addressed to female consumers, but now agencies chose him when they wanted a color image of a solitary woman, usually cast as an archetype of isolated upper-class privilege in the midst of the depression (in ads for Oneida silver and Holland furs). The general profile of Steichen's clients also changed somewhat. While he continued to work for manufacturers of inexpensive, mass-produced beauty products, he added more luxury goods to his client list (Matson Line, Steinway grand pianos). In these images the model's dress and demeanor were intended to convey elite, almost snobbish, attitudes. Their distant gazes and self-conscious aloofness were meant to stamp their superior class status upon the product. This strategy was essentially an update of the "atmosphere" strategy, in which the product itself had only a cameo role; the consumer was the star. These images also updated the vocabulary of advertising melodrama.

This newest stylistic twist on well-proved strategies was suited to the aesthetics of the moment: the blaring artificial flatness of the new color processes worked against any nuanced reading of an image. The resulting representation paralleled the aesthetics and plotlines of many 1930s film melodramas. The constraints of the color medium and Steichen's adoption of a more repetitive and formulaic approach make many of his later figures seem more stilted, more artificially posed, more harshly outlined, and more obviously maneuvered into fictional constructs representing consumers' aspirations to affluence than the figures in his earlier work. The casual informality of his "naturalism" for Kodak is gone. In the worst case, the images for the Oneida Company's Community Plate silverware, the stiff formality comes off almost as a parody of itself, in which overdiscriminating ladies defend their taste in silverware by assuming distanced and inaccessible personae (see Fig. 9.11; see Plates 10, 11).

The melodrama of color was paralleled by an equally dramatic shift in depression-era graphic design. Trade magazines recommended that harder-hitting ads replace softer, more aesthetic ones. Scare tactics abounded. Graphically, these strategies were expressed with multiple pictures, screaming headlines, and general clutter that demanded the consumer's attention (see Fig. 6.12).[37] Thus the tremendous demand generated for color advertising illustrations in the mid-1930s is no surprise.

By the 1930s Steichen had a staff of five to prepare his advertising photographs for reproduction. At the sitting, Steichen worked with his electrician, Henry J. McKeon, his sitting assistant, Henry Flannery, and sometimes his handyman, Harold Brown.[38] Flannery also acted as darkroom technician, printing black-and-white photographs. In the mid-1930s Noel H. Deeks replaced Norris Cummings as color technician, primarily making color transparencies from the negatives Steichen took with the one-shot color camera. Elizabeth Drown took care of the secretarial work. Deeks recalled that Steichen "had a fine, well trained team that worked easily together, knew what to do and got it done with as little fuss as possible. . . . Steichen set the example for us. He was always calm and smiling. He never lost his cool, as we say. He always knew what he wanted and how to accomplish it. . . . He could never have functioned with any prima donnas on his staff." Although his assistants did much of the actual printing, Steichen supervised the technical aspects of the photographs, demanding technical precision in the preparation of his advertising photographs. Deeks remembered Steichen as "a perfectionist. After I had hours, even days of intensive work put into making a color print, after I was certain I could do no better, he would study it and admit that now, at last, it might have possibilities. Then we would really get to work!"[39]

From the early days of his career Steichen had been fully engaged in the technical aspects of color photography.[40] His pictorialist landscapes had been crafted by color applied over color with the gum-bichromate process; he continued to pursue color experiments in his art photography into the 1920s. He saw the potential for commercial color photography very early, but technical problems delayed its use until the mid-1930s, when the availability of color film led to a rush of bright color photographs in the magazines.

Although color film became available only in 1935, technology had made some color possible in advertisements, usually in graphic elements like type or borders, since around 1900. And from this date magazines could make color separations and print color reproductions of drawings and paintings, although the process was expensive (for examples from the 1920s, see Figs. 3.19, 3.20). And color had an impact on consumer products as well as advertising; in the 1920s everything from bath towels to kitchen cabinets to plumbing fixtures had been jazzed up with color. But in its developmental stage, color photography was not practical for wide commercial application.

Steichen's photographs for the 1929 Woodbury's soap campaign, for example, were taken in black and white; some were then hand colored, separations were

made, and the image appeared in color in the *Ladies' Home Journal*. This process gave painterly surface qualities to such photographs as the portrait of Julia Evans (see Plate 7).[41] An agency staff member complained that an image treated in this manner lost its photographic credibility: it "has been so highly retouched or colored that it really in a way is a painting. . . . a good deal of the realism is gone." [42] In the photograph of Evans, Steichen blurred the line between painting and photography with theatrical spotlighting, and his collaborator who applied the color did the same with painterly strokes. In the 1930s, agencies rejected such painterly and atmospheric techniques in favor of the "realism" of the moment. Steichen, however, thought the realism of the new technologies "little better than hand-tinted prints." He intended, during his impending retirement, to "experiment with color photography—not colored photography—which is all we have at present." [43]

THE INDUSTRY DEBATE OVER COLOR

Some of Steichen's earliest color advertisements were taken for the ocean liners of the Matson Navigation Company, which specialized in cruises from the West Coast to Hawaii, the South Seas, and Australia. Steichen took his first trip on the Matson Line in 1934, and he made a series of photographs that glamorized the onboard luxury promised by such long-distance cruise ships. In Figure 9.9 the well-dressed traveler, in gloves and hat, has just entered her first-class stateroom, where fresh flowers, a telephone, and a vanity topped with personal grooming aids assure her of every comfort. This affluent woman seems to be traveling on her own; other images in the series suggest that such a traveler will have many opportunities to socialize.

In Figure 9.10, five women are seated around small tables topped with cocktails and hors d'oeuvres. A man stands looking on. Taking another cue from the cinema, the photographer has moved in so close to the models that the viewer feels like part of the party. The image has all the 1930s media codes for sophistication: cigarettes, martini glasses, evening wear, makeup, coiffed hair, and an elegant setting. In these images Steichen's style has moved far from the dreamy soft focus of his pictorialist fantasies of the 1920s. He has brought the implied narrative of movie stills and the inventive composition, dramatic tonal contrasts, and sharp focus of modernism into his style, which is essentially the same as that in his black-and-white vignettes of upper-class life. Color complements this style, but in this early color work, Steichen is not using it to radically restructure his imagery.

At the time Steichen got the Matson commission, color was becoming a more significant factor in magazine advertising. In 1907, just 5 percent of the ads in the *Saturday Evening Post* had some element in color (perhaps type or a border, or an illustration, but not a color photograph). By 1930 the *Saturday Evening Post* had color in some graphic element of 50 percent of its ads, and spending on color across the industry peaked at $84 million.[44] By 1931 *Ladies' Home Journal* was publishing

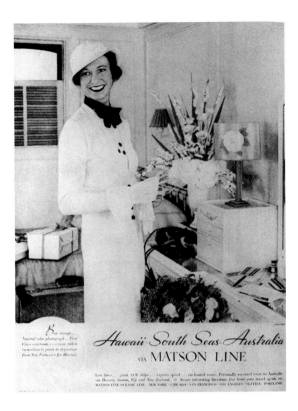

9.9 Advertisement for Matson Line cruises, *Vanity Fair*, May 1935, inside cover. Edward Steichen, photographer; G. Bristow Richardson, art director (Bowman Deute Cummings).

portraits for its feature articles in "natural color" by Nikolas Muray. By late 1934 color photographs of beautifully arranged food by Robert Bagby, Steiner-Fowler, and Margaret Bourke-White filled the editorial part of that magazine. In 1932 the *First National Exhibition of Photographs for Commerce, Industry, and Science* at the Art Center Galleries in New York included a gallery full of transparencies and color prints, including work by Steichen and Bruehl.[45]

The reasons for choosing color were the same as those for choosing any style, medium, or artist: admen believed color would sell more goods: color was more attractive, more accurate, and more attention getting and would bring in "a better class of replies."[46] Statistics seemed to back up the admen's intuition. Daniel Starch reported that color advertising brought 53 percent more replies per 100,000 circulation than a comparable black-and-white ad of similar size and character, although there was some variation by industry.[47] Mail-order houses, which tabulated the direct impact of color advertisements, reported that a black-and-white advertisement brought in 418 orders in a year, while a similar color advertisement brought in over 2,000 in a few months.[48] The Thompson art director James Yates saw no surprise in these developments: "Color has the most primitive appeal. It is a grand means of fascination."[49]

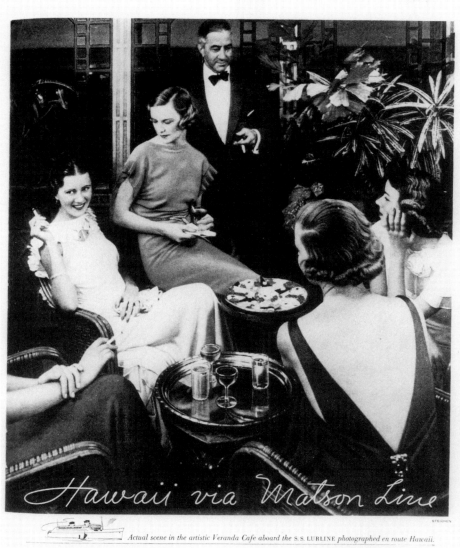

Hawaii via Matson Line

STEICHEN

Actual scene in the artistic Veranda Cafe aboard the S.S. LURLINE *photographed en route Hawaii.*

Following summer to Hawaii, in the luxury of the regal NEW Matson-Oceanic liners . . . equipped to anticipate the traveler's every desire. Establishing new standards in appointments, cuisine and service. Flawless living at sea, introducing flawless living ashore—in Hawaii. *Only a five day sail from California.*

Sailing every few days. LOW FARES will appeal.

☆

Only 10 days farther to New Zealand . . . 3 days more to Australia—fascinating lands of the Southern Cross. Samoa and Fiji along

the way. Low fares and all-inclusive-cost tours offer exceptional value. *Illustrated booklets, authoritative advice free at your Travel Agent's,* or MATSON LINE · OCEANIC LINE, New York, 535 Fifth Avenue · Chicago, 230 North Michigan Avenue · San Francisco, 215 Market Street Los Angeles, 723 W. 7th Street · Seattle, 814 Second Avenue · Portland, Ore., 327 Southwest Pine Street.

9.10 Advertisement for Matson Line cruises, *Vanity Fair,* April 1935, p. 4a. Edward Steichen, photographer; G. Bristow Richardson, art director (Bowman Deute Cummings).

Women, of course, were judged "more susceptible" to the color pitch.[50] Industrial designers noticed women had "a much subtler appreciation of tints and shades" than men because "from childhood on [they] are forever matching colors of fabrics, wall coverings, and utensils."[51] A 1931 Gallup survey determined that the extra cost for four-color advertising—on the average 52 percent more than for a black-and-white page—brought more attention to the product; it demonstrated that a color advertisement was 34 percent stronger with men and 79 percent stronger with women. The differences were especially noticeable in advertising for food and cars.[52] A Condé Nast in-house publication summarized the common wisdom: "Women are notorious for thinking in terms of color first, line next—and wearing quality a long way down."[53]

The feasibility and perceived effectiveness of color photography for advertising elicited the timeworn platitudes about "realism." The earliest advertising psychologists had urged advertisers to use any means available to make the product graphic. In 1904 Walter Dill Scott had advised admen to "describe the piano so vividly that the reader can hear it" and food so vividly that readers can taste it.[54] Color photography was now the best means to this end.

A 1935 deluxe Condé Nast publication set the standard for color advertising and solidified the industry desire for it. *Color Sells* featured the editorial and advertising work of the artist Anton Bruehl and the technician Fernand Bourges in a self-congratulatory promotional work for the Nast corporation: "Here at last was a perfected technique that made possible the faithful reproduction of merchandise to the minutest detail of color and texture; fabrics that could literally be felt—food that almost made one reach for a fork—human beings that were alive. . . . Here was the nearest thing to handing each magazine reader a sample of their product."[55] Bruehl and Bourges's photography was presented as the end of the unnaturalness of color photography before 1932.

Commercial photographers were quick to fill the demand and to promote their own products in the language of the trade. In a speech to the *New York Times*'s Advertising Club, Margaret Bourke-White urged photographers to learn the reproduction processes and work closely with engravers to make sure that the color photograph's "conviction of reality" carried through to the finished ad. She said she sometimes sent samples of cosmetics with her photographs to the engraver so that he could use them as guides.[56] As we have seen, Steichen worked hard to provide color services to his clients as soon as the technology allowed; his long-standing interest in color technology and well-funded business enabled him to keep up with improvements in the rapidly changing medium.

But some observers still held reservations about the imperfections of the infant technology. Bourke-White noted the difficulty of getting "true colors," and there was "always a great element of chance, as many unexpected and peculiar things can happen."[57] Insisting on naturalism, trade journals found black and white, though

less realistic, "preferable to lurid or unnatural color reproductions."[58] They hoped modern technology would bring a more lifelike representation that "looks more like nature and less like those picture postcards from Lake Wissiminestrone in which all the ladies have pink shirtwaists, and all canoes are green."[59]

POSTERIZING IMAGERY: THE ONEIDA CAMPAIGN

Steichen's work for the Oneida Company's Community Plate silverware seems a prime example of the "smack in the eye"—"crude splashes of color" that some art directors advocated and others found disconcerting.[60] At the Thompson agency this strategy was called "posterization," a use of brilliant color with the resultant flattening of pictorial space that the agency's executives thought would demand consumer notice.[61] In one of Steichen's compositions for Oneida the woman's sharply defined bright lipstick echoes the tailored lines and red glow of her dress (see Plate 10). Both match the vivid red of the wall behind the sofa and the starry foreground that serves as a display area for the product. Even allowing for the bright colors of the Christmas season as the impetus for the attention-getting red, the color in Plate 10 is so overpowering that it collapses spatial depth; the background and text panels imprison the model in a narrow space. The contrast between the flesh tones and their bright surroundings emphasizes the linearity of the figure, thus further abstracting her. The pose is affected; she pushes herself back into the sofa with one elongated arm, tilts her head, and smiles coyly at the viewer. Jewels are placed deliberately at the wrist, neck, finger, and cleavage. Her makeup, a common 1930s code for femininity, seems overstated, so that we see, not an easy, "natural" womanhood, but rather one whose staging must have been obvious to every viewer.

The ideal of womanhood in advertisements of the 1930s is exceptionally labor-intensive: a consumer, to compete with the model, must attend to her hair, nails, makeup, dress, and accessories. Although we cannot attribute such standards of artificiality to Steichen, he quickly adapted the vocabulary. As in his earlier pictures, he created a scenario of upper-class life in which the codes of femininity are also the markers of class security: jewels, dress, and time for personal grooming. And both are presented as compatible with ownership of Community Plate silverware.

Color became the prime element in developing drama in advertising. At the Thompson agency the art director Yates clearly agreed. He was after attention, not naturalism, he said. Too many recent ads, he thought, had used color "as an accessory to photography, not independently, in the broad striking way which is most quickly noticed and longest remembered. . . . something nearer the poster way . . . gives color its chance to really work for us in an advertisement."[62] The posterizing technique was new to Steichen. Most of his previous color work had sought the soft, blended mists of color that had fallen out of favor in the mid-1930s commercial

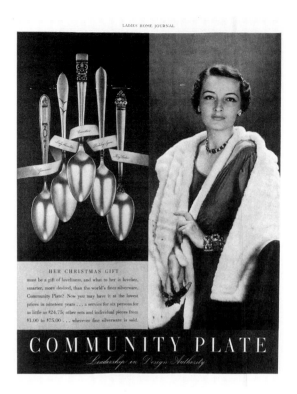

HER CHRISTMAS GIFT
must be a gift of loveliness, and what to her is lovelier,
smarter, more desired, than the world's finer silverware,
Community Plate? Now you may have it at the lowest
prices in nineteen years . . . a service for six persons for
as little as $24.75; other sets and individual pieces from
$1.00 to $75.00 . . . wherever fine silverware is sold.

COMMUNITY PLATE
Leadership in Design Authority

9.11 Advertisement for Oneida
 Community Plate, *Ladies' Home
 Journal,* December 1936, p. 93.
 Edward Steichen, photographer.

world. He now began, like other successful commercial photographers of the time, to compose with color. With his simplified color schemes, Steichen might have had Bourke-White's words in mind: "Photographers should not try to crowd in all colors of the rainbow, but build up simple and effective color schemes."[63] In the middle and late 1930s, Steichen's color advertising delivered what art director Yates termed photographs made in "the poster way."[64]

In Steichen's 1936 Christmas color photograph for Oneida (Fig. 9.11) the model is draped in white ermine, and her jewelry is more bulky and ostentatious than that of the 1938 ad. As in that photograph, overassertive background colors (here red and pink) are echoed in the model's dress and makeup. And the floating silverware, the object of desire and the reward for conforming to ideals of femininity, defies gravity and the logic of scale to claim priority in the picture. But the model's expression is disengaged, as if she is conscious of being herself the commodity or object of the gaze.

The viewer's identification with the model, which was the concept at the heart of so many of Steichen's advertisements (as for Jergens lotion), is absent here. The female readers view her, dissect her, scrutinize her mastery of the corporate dictates

of feminine grooming, and may see her appearance as a standard set for them; but they do not put themselves in her place. This female reader's gaze is neither passive and narcissistic nor active and voyeuristic but rather critical: it gives the reader leeway to accept or rebuke the image of female achievement. This third gaze, which Patrice Petro has termed "the contemplative look," allows a more active assessment of the image.[65] Despite all the 1930s verbiage about the realism of color, in the final analysis color functions, not as realism, but as an abstracting element that makes it easier to distance the model than to join identities with her. In these early attempts, color makes the construction of the image more, not less, obvious to the reader, much as melodramatic cinema constructed simple polarities (good and evil, rich and poor, happy and sad), obvious types, overdetermined meanings, and easy choices. Such flattening of style and content makes the fiction more obvious.

But the overreliance on typecasting and the inate repetition of the melodramatic mode in advertisements undercut their effectiveness. Steichen's work sometimes disintegrated into formulaic repetitions of imagery for advertising and fashion. His late advertising work executed with less conviction the easy formulas that he had pioneered much earlier. The woman in Plate 11 occupies a shallow space divided horizontally by the chair rail, vertically by candles. Steichen had used this compositional device frequently in his fashion work of the 1920s and 1930s and occasionally in his advertising work (see Fig. 7.15). In the Oneida ad the model moves right, cutting diagonally through the largest background rectangle. The image includes all the generic codes for femininity, financial comfort, and happiness. Consistent with melodramatic representation, her unambiguous representation as a social type—in this case an upper-class woman—is more important to the content of the ad than her identity as an individual. Because she represents a type, there is no need for any construction of personality or psychological complexity. The woman wears a low-cut mustard-colored evening gown and onyx jewelry. The bright yellow tones are repeated in the orchid in her hair and in the candles. The yellows and blacks are set against a glowing cobalt background. The evening motif is continued in the sparkling candleholders, whose crystal teardrops shimmer in the light. Although the product is referenced in the text and represented in a separate photograph at the bottom, Steichen's image illustrates the atmosphere for the product, not its use.

The women in the Oneida series typify one type in the narrow range of 1930s representations of womanhood: the siren or vamp, a sexualized female identity that originated in the sexual freedom and independence of the 1920s flapper. Along with the blissful mothers of the Ivory soap ads (see Plates 3–5) the siren became one of the major types in Steichen's 1930s advertising. She appeared simultaneously in films, where she became a stock figure—superficially more passive than a flapper, but a powerful covert manipulator of men.[66] In Steichen's Oneida images, as in many of his fashion images of the 1930s, the siren projects a tension between her desirability and her inaccessibility; in fact, her inaccessibility makes her desirable. As

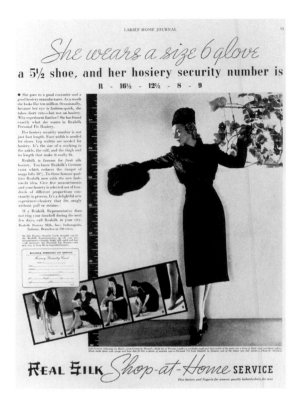

9.12 Advertisement for Realsilk hosiery, *Ladies' Home Journal*, November 1937, p. 73. Edward Steichen, photographer.

Ellen Todd observes in her study of Reginald Marsh's contemporary paintings, it is unclear whether sirens were women "liberated by consumer choice or seduced by the media to transform themselves into visual and sexual commodities."[67]

Certainly the women in Steichen's later advertising photographs seem to accept their own identity as commodities. In a Realsilk hosiery advertisement for 1937, the model stands against a simplified background divided geometrically at heel and chest height by the photographer's signature horizontal elements (Fig. 9.12). The tape measure along the left edge of the photograph, reminiscent of the measuring devices in early anthropometric photographs of non-Western people, reinforces the model's status as a specimen for scrutiny.[68] But in the logic of the picture the tape measure is explained by the inset narrative strip, which describes how to determine which size to order.

Formally, these late photographs speak the modernist language Steichen had brought into figural advertising around 1930 in his Pond's testimonials and his late Jergens romance images: linearity, tonal contrast, and play between organic and

geometric elements. But these photographs seem more stark and harsh, more distanced than his earlier work. In the Oneida ads some of this distancing may result from Steichen's awkwardness with color photography. But the shift to an objectified, unapproachable female may also owe something to the years of economic depression. The rise in fortunes implicit in the Jergens advertisements of the late 1920s no longer seemed easy or inevitable. Although readers might copy the comfortable class by using the same inexpensive products, they could not readily assume the identity of that class.

Ethnographic Advertising

Steichen officially retired from commercial photography at the end of 1937, but he continued producing images, mostly color photographs, for selected advertising campaigns and feature stories in magazines into the early 1940s.[1] Among his favorites were the numerous garden photographs he took to illustrate articles in the *Ladies' Home Journal*; these became the basis of Richard Pratt's *Picture Garden Book and Gardener's Assistant*, published in 1942.[2]

In 1938, while Steichen and his wife, Dana, took a retirement trip to Mexico, the photographer's technical assistant, Noel Deeks, and his gardener and foreman, Rodman Valentine, set up the new darkroom and studio at Umpawaug, Steichen's Connecticut estate. Deeks recalled that "although Steichen was supposedly retired, we seemed to have just as much to do as before. We had frequent sittings, a few at Umpawaug, some at rented or borrowed studios in New York."[3] Only World War II, it seems, put an end to Steichen's commercial career.

HAWAIIAN BEAUTIES OF THE MATSON LINE

Steichen's last ambitious advertising campaign was for the Matson Navigation Company, which had sent him cruising to Hawaii in 1934. The 1934 and 1935 Matson

Line ads focused on shipboard pleasures; only a few pictured Hawaii (see Figs. 9.9, 9.10). Steichen's 1940–41 series for the cruise line, taken just before Pearl Harbor, focused on Hawaii as an exotic destination.

His 1940 series typically pictured pensive native women in exotic settings. In an image that appeared in the November 1940 issues of several magazines, including *House and Garden* and *Vogue*, the model wears a hibiscus flower in her hair, an emblem of Hawaii, and a Western-style dress designed to signify the tropics (Fig. 10.1). She perches high atop the rugged volcanic outcrop, overlooking a picturesque lighthouse, with the wide stretch of sea beyond. The text of the advertisement reinforces the exoticism of the location by warning readers to "prepare to be captivated by the isles of unparalleled charm" but also reassures them that they would "sail in safe American ships, across peaceful seas."

This photograph won an Art Directors' Club medal for color photography in 1941, juried by M. F. Agha, Paul Outerbridge, and Paul Hollister. The image was reproduced in the Art Directors' annual; the caption credited Steichen with "a truthful spiritual interpretation" that "embodies amazing fidelity to Hawaii's restful, Polynesian simplicity."[4] Thus the image was received as it was intended, as a cultural stereotype of the ease and passivity of "primitive" peoples. The jurors, according to Agha, had looked for color photographs that did not echo any painting style but rather emphasized photographic qualities with color. Steichen earned the award because his work "looked merely like a color snapshot and nothing else." The jury's emphasis on simplicity reflected two common yet contradictory trends in photographic theory in 1940. In a throwback to the rhetoric of the 1920s and before, the jury praised "color photography with its realism, its magic ability of arresting time and preserving fragments of real life . . . [with] such vitality and such spontaneous, almost physiological appeal"; reflecting the newer modernist trend, the jury praised Steichen's exploration of "the purely photographic possibilities of color photography in advertising." And indirectly acknowledging all the changes fine art straight photography had brought to the field, particularly the theory of previsualization advanced by Edward Weston and others, the caption also commented on the "invaluable result" of Steichen's "predetermined execution."[5]

Along with this somewhat modernist-influenced vocabulary Steichen brought other Western ideas to his construction of Hawaii as a mythic paradise, including his equation of "primitive" femininity with nature.[6] The woman in Figure 10.2, who has been gathering flowers in the lush forest, pauses, her face framed by broad leaves and a bird-of-paradise flower. The image invites viewers into a private moment in nature otherwise inaccessible to a Euro-American. The caption encourages viewers to believe that through the photographic medium they can experience the referent of the photograph: to "*know* Hawaii," not the one of their fantasies but the "*real* Hawaii," even better than their dreams.

The correlation of woman with nature and exoticism has become a trope in

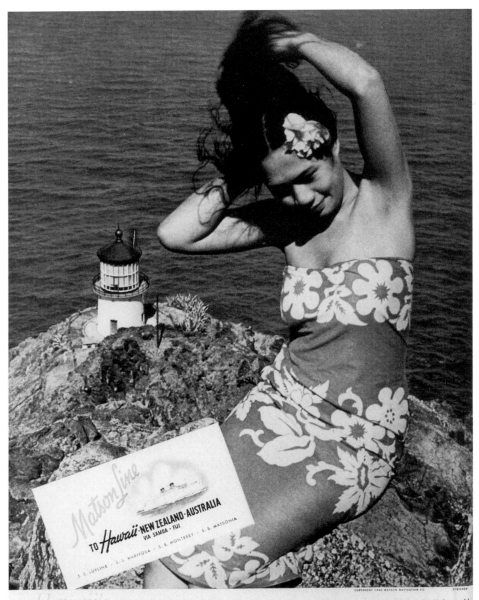

Hawaii's spell is subtle . . . her appeal, infinite . . . her artifices of sun, sea and flowers are without parallel . . . in all the world there is only *one* HAWAII . . . Sail in safe American ships, across peaceful seas . . . prepare to be captivated by these isles of unparalleled charm. ⇨ ⇨ Meet some measure of the experience . . . in the word-and-picture story of HAWAII and the SOUTH SEAS . . . available at TRAVEL AGENTS or the MATSON LINE offices. ⇨ ⇨ ⇨ MATSON NAVIGATION COMPANY ★ THE OCEANIC STEAMSHIP COMPANY

10.1 Advertisement for Matson Line cruises, *Harper's Bazaar,* November 1940, inside back cover.
 Edward Steichen, photographer; Lloyd B. Meyers, art director (Bowman Deute Cummings).

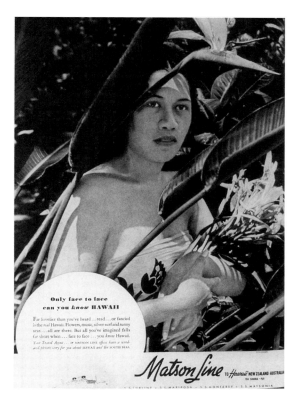

Only face to face
can you *know* HAWAII

Far lovelier than you've heard...read...or fancied
is the real Hawaii. Flowers, music, silver surf and sunny
seas...all are there. But all you've imagined falls
far short when...face to face...you *know* Hawaii.
Your Travel Agent...or MATSON LINE offers have a *word-
and-picture story for you about HAWAII and the SOUTH SEAS.*

Matson Line TO *Hawaii* NEW ZEALAND AUSTRALIA

10.2 Advertisement for Matson Line
cruises, *Harper's Bazaar,* March
1941, inside cover. Edward
Steichen, photographer; Lloyd B.
Meyers, art director (Bowman
Deute Cummings).

advertising. In Western imagery non-Western women had frequently represented difference and otherness. But the subtext is often power. Paul Gauguin, in his paintings of Tahitian maidens, for example, exoticizes the culture and indicates its susceptibility to European possession.[7] When transferred to advertising, such correlations are reinforced in the mass culture.

These images may derive their appeal from a soothing reassurance of the Western worldview. As Judith Williamson has argued, images of exotic women ("actual Otherness") remind us of our own "naturalness," which has been compromised by our highly industrialized capitalist society. At the same time the advertisement packages the non-Western world into both a romantic myth and a commodity.[8]

Steichen made his images for the Matson Line at a time when the Hawaiian economy was beginning a transition from sugar growing to tourism. Although the number of tourists in the 1920s and 1930s was small, the myth of Hawaii as an idyllic and exotic destination was becoming well established.[9] The packaging of Hawaii's exoticism by the advertising and tourist industries accompanied a fad for Hawaiian culture on the mainland prompted by the display at the 1915 Panama-Pacific International Exposition in San Francisco. A Hawaiian "music craze" swept the

country, and movies about Hawaii with stars like Betty Grable and Bing Crosby helped shape lore about the islands. In essence, by the 1930s Hawaii itself had been transformed into a tourist destination—a commodity. And Steichen's photographs helped sell this commodity to a new, potentially rich tourist market.

In an image that appeared in *Vogue,* November 1, 1941, Steichen photographed a native woman engaged in a picturesque and exotic, if obscure, activity, lifting a bundle of long-stemmed flowers onto a basket-weave stage (see Plate 12). Wearing the traditional *ti* (or grass skirt), and lei, with a hibiscus in her hair, she is perhaps the most exotic and mythologized of Steichen's images of native women. She is photographed in a pose and dress deemed alluring to Westerners, and shown against the natural beauty of the island. The effectiveness of the advertisement depends on her seeming happy working close to nature for her livelihood, for it draws on Western romantic connections between women, beauty, nature, and contentment.

Steichen's images depict the indigenous people as passive and complicit with the tourist industry. There is no sense of resistance to the imperial capitalist economy, as is frequently seen in anthropological photographs with more scientific pretenses.[10] As in Steichen's other advertising photographs, the genre does not allow for a complex relationship among the photographer as the producer of the image, the subject, and the viewer, such as that in other photographs where the subject works with the photographer to construct the image. Rather, Steichen relies on his own deft interpretation of the myths of the exotic to generate fantasy and desire on the part of the Western audience. The viewer and the subjects interact only to the extent that the subjects pose for the viewer's enjoyment, and the viewer consumes the image as well as the product.

Earlier Steichen images had been built on the assumption that the female viewer would wish to exchange class, goods, or romantic partners with the model. The ads encouraged their audience to read in a participatory way. The intended audience for this image is still clearly female—the ads were placed in women's magazines and women were credited with planning family travel. But by objectifying the Hawaiian woman as exotic "other," this ad, like earlier anthropological photographs, closes off active identification with the model and forces the viewer into a more consumptive reading.

Cross-cultural advertising photographs such as Steichen's and their accompanying texts are an index of American imperialistic sentiment. In Steichen's image of a tourist reading *Polynesian* magazine (see Plate 13) vivid coloration encourages the viewer to identify with the model and fantasize about her own dream trip to Hawaii. In this image the native woman appears as a photograph on the cover of the magazine, her culture available for purchase and consumption by the Euro-American tourist. By the process of reading, studying, and recording, the dominant culture intellectually defines the native culture and solidifies its status as other—a curiosity to investigate, study, consume but never to join or consider equal. Consumption

is the real interaction. Like all other anthropological photographs, the tourist advertising photograph inscribes the beliefs and values of the maker and here shows Hawaii as the advertising industry wished it to be: verdant, placid, and beautiful. Steichen's images met corporate needs.

Like the great majority of other cross-cultural photographs, whether anthropological, travel, or commercial, the image becomes a powerful site for the construction of fantasy—a fantasy much like Steichen's other advertising images, although the location, characters, and issues are different. However, this reproduction of the dynamics of advertising representation in the context of another culture may have made the inherent objectification and power relations of the advertisement more obvious to the producers and the viewers. From the beginning of his commercial career, through a number of evolutions of style, Steichen used the inherent recording ability of the photographic medium and its facade of credible reporting to obscure its emotive intentions. Whether the issue is racial difference or class and gender, Steichen's advertising constructed popular images that were in dialogue with the self-definition, goals, aspirations, and beliefs of his mass audience.

RETIREMENT

The Matson Line photographs are the exceptions in Steichen's late commercial career. His interest in advertising had waned several years before, he had closed his New York studio, and he had accepted only those commissions that motivated him. In a 1938 article on his retirement he told the interviewer, "I'm tired of taking orders." And, he explained, the technical issues ate up more of his energy than the aesthetic decisions: "The production problems are tremendous in a studio like this. I find myself working on production eighty percent of the time and photographing only twenty percent." [11] The same themes cropped up in later reflections. In a 1955 television interview he remarked, "The work had ceased to be alive—had ceased to be as interesting as it was. I didn't feel I was contributing anything anymore. It was turning out the same thing to the point that it became merchandise. It made no difference how hard I tried to avoid that curious repetitious feeling that you get when you do a thing mechanically . . . so I closed up shop and retired." [12]

Although he had specialized in the age-old strategies of romance, class, beauty, and happiness and, arguably, helped set the trend toward more frequent and explicit uses of such strategies by demonstrating their successful implementation, Steichen complained that "advertising [was] becoming more and more artificial, and I disliked some of the approaches to it that were developing." Surprisingly, considering the core commissions in his career, among those he disliked "were the sex appeal approaches designed to sell lotions or cosmetics or hair preparations by implying that a girl had no chance of finding a mate unless she used these products." But, he

admitted, "the real fault was my own. I had lost interest because I no longer found the work challenging; it was too easy."[13]

It might also have been the times. When Steichen began taking advertising photographs in the early 1920s, the economy was expanding and a sense of optimism about the value of advertising to the national economy surged through the agencies. Almost ten years of depression had taken their toll; it was harder now to sell products, and advertising agencies were less apt to take risks or encourage experimentation.

For almost two decades Steichen was one of the most highly regarded photographers in the advertising industry. He had begun taking advertising photographs just as the commercial demand for print media images exploded. In style and strategy his photographs perfectly met the developing corporate aesthetics and fulfilled the agencies' ideological expectations for photography. Appearing widely in the magazines and newpapers of the 1920s and 1930s, Steichen's photographs affected both consumers' behavior and the work of other commercial photographers. They epitomized American cultural ideals, even as they helped to shape them.

Conclusion

Edward Steichen became the most successful commercial photographer of the 1920s and 1930s because he advanced the most effective visual strategies to showcase his clients' goods. His style evolved with and reflected industry-wide theories. The look of his work resulted from consultation and teamwork with art directors, copywriters, account representatives, and other agency personnel.

While Steichen produced little "fine art" in the 1920s and 1930s, he maintained his stature as an internationally known artist. This was partly because he had established a reputation during his pictorialist years, and partly because he had earned prestige for his work in World War I. Moreover, he continued to show his fashion and portrait work in art exhibitions. Thus in mid-career Steichen cultivated the perception among art directors and other agency personnel that his work, both aesthetically and practically, was unparalleled. This status as a fine art and advertising "genius" translated into money, prestige, and influence in the commercial art world. Eventually, it gave him entrée to the museum world, where, as director of the Photography Department at the Museum of Modern Art, he helped determine how the history of photography would be interpreted and presented to the public.[1]

Advertising constituted only a small portion of Steichen's oeuvre between the world wars. While working for advertising agencies, he was chief photographer for Condé Nast Publications, taking from twenty to forty fashion and portrait photographs each month for publication in *Vogue* and *Vanity Fair*. In addition, he illustrated two children's books and Henry David Thoreau's *Walden* with photographs and designed photographic murals for the Center Theatre at Radio City, for the New York State Building at the 1933–34 Centuries of Progress Exhibition in Chicago, and for exhibition at the Museum of Modern Art.[2] He also actively participated in editing the *U.S. Camera* annuals with Tom Maloney.

Steichen became an arbiter of style in commercial photography because of his influence in the advertising agencies, his many speeches to professional groups, and the coverage he received in the photographic press. Although he spoke out on behalf of commercial photography, Steichen, at least early in his advertising career, seems to have harbored reservations about advertising photography. Carl Sandburg noted in 1929 Steichen's belief that "the only choice for an artist is collaboration or revolution."[3] With his advertising photography, Steichen consciously chose collaboration.

Steichen's statement may be interpreted as a reaction to the insistence of Alfred

Stieglitz and his circle on a strict separation between commercial art and fine art. Most of the earliest photographic images had been created for commercial purposes. Nineteenth-century photographers did not consciously distinguish such productions from "art," any more than painters refused portrait commissions because patronage had commercial overtones. In the twentieth century the commercial and documentary work of photographers like Roger Fenton, Timothy O'Sullivan, and Nadar has been isolated from its context and accorded the status of art.[4]

Steichen challenged Stieglitz's tenet that commercialism precludes fine art. He identified himself as a commercial artist in the company, he argued, of Michelangelo and Leonardo. Along with his art directors, Steichen restructured Stieglitz's argument, placing work created for commercial patrons on a continuum with fine art rather than in opposition to private expression. (In many ways, commercial photography *was* Steichen's personal expression in the 1920s and 1930s.) Thus Steichen reframed the discussion to accentuate the social and cultural nature of imagery, enlarged the scope of art, and situated commercial art within the whole. In the commercial sector Steichen found both a vehicle to expand his own understanding of modernist photography and a medium in which he could develop his greatest photographic talent: to describe beautifully the appearance of people or things and persuade consumers to buy a product.

As an ally of the dominant commercial elements of American society, Steichen made photographs that reveal much about American culture. For example, they reflect the social effects of the Great Depression, consumers' growing faith in science and technology as a result of new commercial products, and the pervasive belief in the modernity of American culture. The vision of America that comes through in his photographs, however, results from a broader negotiation between corporate desires, psychological theory, and perceptions about consumers along with social conditions.

The photographs, by their unflagging insistence on the benefits of owning the products, sought to persuade a mass audience to participate in the new American economic structure as modern consumers. But they must not be read unidimensionally or perceived as all-powerful consumer manipulations, however much the agencies may have hoped ads could shape behavior. Women, who were usually targeted in advertising photographs, certainly read the images in a complex way that was influenced by identities, desires, and aspirations radically different from those of the creators back at the advertising agencies. The result is a print media pervaded by images of ideal middle- and upper-class American life (beautiful women, contented mothers, happy families, desirable products, satisfied consumers). This iconography developed from corporate definitions of consumer desire and fulfillment, rather than the consumer's own self-definition and goals. Steichen was arguably the most influential photographer for visualizing this corporate conception of American consumerism.

Appendix: Documented Advertising Photographs by Steichen

This appendix has been compiled by cross-referencing published advertisements, archival information, and print collections. Advertising agencies' files contain hundreds of thousands of images arranged by client and date. Few of these are signed. The Edward Steichen Archives at the Museum of Modern Art in New York contain numerous tear sheets of photographs by Steichen, not all of which are identified by date and publication. I have identified Steichen's actual or probable clients through the New York Art Directors' Club *Annual of Advertising Art*, the J. Walter Thompson Company's *News Letter* and records of staff meeting minutes, the N. W. Ayer archives (at the New York headquarters and the National Museum of American History, Smithsonian Institution), prints at the International Museum of Photography at George Eastman House, and the Steichen Archives at MoMA. And I have consulted agency tear-sheet files and the magazines to verify publication data. I found other illustrations by systematically searching *Vogue, Ladies' Home Journal, Vanity Fair, Advertising and Selling, Advertising Arts,* and other magazines.

All the images included here have been definitively attributed to Steichen either by his signature, by description in documentary sources, or by their inclusion in the tear-sheet files at the Museum of Modern Art that were compiled from contemporary magazines each month by the photographer's wife, Dana Steichen. In each case, I have attempted to give the original appearance of the image in the mass media. This serves not only as a date and picture reference, but as a guide to the photograph's original layout, caption, and headline. Multiple media references are given when known to suggest the wide distribution of Steichen's images.

The appendix is organized chronologically by product/client. I have been conservative in attributing magazine images to Steichen. I believe this list represents but a fraction of the photographer's advertising images and only suggests the scope of Steichen's advertising work. It is published here as an aid to scholars who may wish to continue this research.

The list that follows uses the following abbreviations:

MAGAZINES AND NEWSPAPERS

ADA	*Art Directors' Annual* (title varies, *Annual of Advertising Art*)
Am Home	*American Home*
BH&G	*Better Homes and Gardens*
Canadian HJ	*Canadian Home Journal*
Cosmo	*Cosmopolitan*
GH	*Good Housekeeping*
HB	*Harper's Bazaar*
H&G	*House and Garden*
House B	*House Beautiful*
LHJ	*Ladies' Home Journal*
Lit Dig	*Literary Digest*
Nat'l Geo	*National Geographic*
NY Ev Jl	*New York Evening Journal*
NYT	*New York Times*
PR	*Pictorial Review*
SEP	*Saturday Evening Post*
VF	*Vanity Fair*
WHC	*Women's Home Companion*

COLLECTIONS

GEH	George Eastman House
MoMA	Museum of Modern Art, Edward Steichen Archives

BOOKS

Aymar	Aymar, Gordon. *An Introduction to Advertising Illustration.* New York: Harper, 1929.
Sandburg	Sandburg, Carl. *Steichen the Photographer.* New York: Harcourt, Brace, 1929.
Steichen	Steichen, Edward. *A Life in Photography.* Garden City, N.Y.: Doubleday, 1963. Reprint, New York: Bonanza Books, 1984.
Young	Young, Frank H. *Modern Advertising Art.* New York: Covici Friede, 1930.

ADVERTISING AGENCIES

Ayer	N. W. Ayer and Son
BDC	Bowman Deute Cummings

JWT	J. Walter Thompson Co.
L&M	Lennen and Mitchell
Y&R	Young and Rubicam

The names of art directors are given when known. My study of agency records at JWT leads me to believe that Gordon Aymar was almost always Steichen's art director in his work for that agency from 1923 to 1929. I have listed his name, however, only for the campaigns in which I came across a specific written reference to Aymar.

Client and Agency/Art Director	Reproduction

1923

Gossard corsets

LHJ, Sept. 1923, p. 201 (see Fig. 3.1) (attributed)

Jergens lotion
The Andrew Jergens Co., JWT/
 Gordon Aymar

LHJ, Nov., p. 101 (see Fig. 3.6); *PR*, Nov., p. 29; *ADA* 4 (1925), p. 99; half-page version: *LHJ*, Oct., p. 68 (hands, towel, & pitcher)

Vogue, Nov. 1, p. 121 (see Fig. 3.7); Sandburg, fig. 23; Steichen, fig. 157 (peeling potatoes)

1924

Jergens lotion
The Andrew Jergens Co., JWT/
 Gordon Aymar

LHJ, Jan., p. 97 (threading needle; split run, only some editions)

WHC, Feb., p. 65 (sewing)

LHJ, Mar., p. 77 (some copies) (see Fig. 3.5); *WHC*, Mar. (washing child's hands)

LHJ, Apr., p. 109 (see Fig. 3.3); *ADA* 4 (1925), p. 99 (hands potting plants)

LHJ, Oct., p. 124; *WHC*, Oct.; half-page version: *LHJ*, Sept., p. 53 (stirring batter)

m*LHJ*, Nov., p. 95; *PR*, Nov., p. 53 (polishing)

LHJ, Dec., p. 83 (see Fig. 3.4); *PR*, Dec., p. 49 (ironing)

Client and Agency/Art Director	Reproduction
Pebeco toothpaste Lehn & Fink, JWT/Gordon Aymar	*LHJ,* Sept., p. 173 (see Fig. 4.1); *Designer,* Sept., p. 43; *American Magazine, Butterick, GH,* Sept.; *Lit Dig,* Sept. 6 and Nov. 29; *SEP,* Dec. 6; *NY Daily News, NYT,* Oct. 1, 1925 (yachting: man & woman at boat wheel)
	SEP, Sept. 27; *Delineator,* Oct., p. 73; *LHJ,* Oct., p. 94; *American Magazine, Butterick, GH,* Oct.; *Chicago Tribune,* Oct. 5; with drawings of small photos: *NYT,* Jan. 26, 1925 (theater: man & woman with opera glasses; prints at GEH)
	American Magazine, Butterick, Designer, GH, Nov.; *SEP,* Nov. 8; *Lit Dig,* Nov. 15; reversed with drawings of small photos: *NY Ev Jl,* Jan. 25, 1925 (bridge playing)
1925	
Jewelry Cartier	*Vogue,* Jan. 1, p. 50 (Kendall Lee modeling jewelry)
Jergens lotion The Andrew Jergens Co., JWT/ Gordon Aymar	*LHJ,* Jan., p. 73 (see Fig. 3.2) (kneading bread)
	LHJ, Feb., p. 113 (see Fig. 3.14); *PR,* Feb., p. 45 (kissing hands)
	LHJ, Mar., p. 213 (pinning carnation)
	LHJ, Oct., p. 215 (placing ring & sewing)
	LHJ, Nov., p. 197; *PR, WHC,* Nov. (holding hands)
	LHJ, Dec., p. 171 (woman's hands touching man's face)

Pebeco toothpaste
Lehn & Fink, JWT/Gordon
 Aymar

LHJ, Jan., p. 141; *Chicago Tribune*, Jan. 25; *American Magazine, Butterick, GH, PR*, Feb.; *Life*, Feb. 5; *Lit Dig*, Feb. 7; *SEP*, Feb. 7; *NYT*, May 11; *Druggists' Circular*, Mar. 1926 (woman touching man's tie)

NYT, Jan. 14; *LHJ*, Mar., p. 45 (man, 2 women)

LHJ, Feb., p. 201; *American Magazine, Butterick, GH, PR*, Mar.; *Lit Dig*, Mar. 7; *Life*, Mar. 19; *SEP*, Mar. 21 (couple dancing)

LHJ, June, p. 201 (couple with beach umbrella; prints at GEH)

Pond's cold cream
The Pond's Extract Co., JWT

LHJ, Jan., p. 43 (see Fig. 7.1); *Vogue*, Jan. 15, p. 34; cropped and no background: *LHJ*, Jan. 1926, p. 45 (Duchesse de Richelieu)

LHJ, June, p. 49; *GH*, July, p. 105; *Motion Picture*, Sept. (Mrs. Livingston Fairbank)

LHJ, May, p. 53 (see Fig. 3.18) (Mrs. Reginald Vanderbilt); also *Vogue*, Feb. 15, 1933, p. 71, with updated portrait

Welch's grape juice
Welch Grape Juice Co., JWT

SEP, May 23, p. 207 (see Fig. 4.5); *ADA* 5 (1926), p. 86; details: *SEP*, July 11, p. 183 (glass pitcher with tulips)

Vogue, June 1, p. 101 (see Fig. 4.3); *ADA* 5 (1926), p. 17; details: *SEP*, June 6, p. 187, and May 29, 1926, p. 172 (place setting with bowl of strawberries)

	SEP, Aug. 8, p. 131, and Apr. 3, 1926, p. 78; *Vogue*, Apr. 15, 1926, p. 170; cropped: *SEP*, May 29, 1926, p. 172 (bottle, 3 glasses, ice cubes, & flowers)
1926	
Fleischmann's yeast The Fleischmann Co., JWT	*GH*, June, p. 124; *LHJ*, July 1928, p. 87; *ADA* 8 (1929), p. 116; Sandburg, fig. 13 (man & boy at table)
	GH, Sept.; *Delineator*, June 1927; *McCall's*, Aug. 1927, p. 49 (couple in garden at breakfast)
Jergens lotion The Andrew Jergens Co., JWT/ Gordon Aymar	*LHJ*, Jan., p. 120 (see Fig. 3.16) (fastening bracelet)
	LHJ, Feb., p. 107 (see Fig. 3.15); *WHC*, Feb., p. 111; *PR*, Feb. (serving tea)
	LHJ, Mar., p. 126 (see Fig. 3.17) (touching hands)
	LHJ, Sept., p. 43; *PR*, *WHC*, Dec.; *ADA* 8 (1929), p. 102; *LHJ*, Jan. 1929, p. 57 (polishing silver)
	LHJ, Oct., p. 82; *PR*, Oct., p. 103; *WHC*, Oct. (holding baby)
	LHJ, Nov., p. 155; *GH*, Jan. 1927, p. 146 (kneading bread)
	LHJ, Dec., p. 58; *PR*, Jan. 1927 (man's, woman's hands & necklace)
Pebeco toothpaste Lehn & Fink, JWT/Gordon Aymar	*SEP*, July 10, p. 119; *Cosmo*, Aug.; drawing of photo: *NY News*, Sept. 30 (golf scene)
	LHJ, Sept., p. 95 (see Fig. 4.2); *SEP*, July 24; *American Magazine*, *Butterick*, *Cosmo*, *PR*, Sept. (equestrian scene)

Pond's cold cream The Pond's Extract Co., JWT	*LHJ*, Mar., p. 53 (see Fig. 7.9); *Vogue*, Mar. 15, p. 125 (Miss Marjorie Oelrichs)
	LHJ, Apr., p. 57 (see Fig. 7.8); *Vogue*, Apr. 15, p. 141 (Miss Camilla Livingston)
	LHJ, July, p. 47 (see Fig. 7.12); *Vogue*, July 15, p. 101; reversed: *Tribune* Nov. 21 (Mrs. Reginald Vanderbilt)
	LHJ, Aug., p. 45; *Vogue*, Aug. 15, p. 89 (still life & portraits: Manners, Matchabelli, Patterson)
	LHJ, Nov., p. 53; *Vogue*, Nov. 15, p. 103 (product & portrait details)
	LHJ, Dec., p. 49 (detail of Vanderbilt with product and drawing)
Welch's grape juice Welch Grape Juice Co., JWT	*LHJ*, June 1927, p. 200; detail: *Vogue*, July 15, p. 106 (bottle, glasses, daisies)

1927

Beds, springs, mattresses The Simmons Co., JWT	*LHJ*, Apr., p. 166 (see Fig. 7.6); *Vogue*, Apr. 15, p. 133 (Mrs. J. Borden Harriman)
	LHJ, May, pp. 210–211 (Mendl, Fairbanks, Roosevelt)
	Vogue, May 15, p. 129 (see Fig. 7.7); (Mrs. Franklin D. Roosevelt)
	LHJ, Aug., p. 97 (Mrs. A. J. D. Biddle)
	LHJ, Sept., pp. 142–143 (Mrs. R. T. Vanderbilt & Mrs. C. Tiffany)
	LHJ, Oct., p. 123 (Mrs. Morgan Belmont)
	LHJ, Dec., p. 55 (Mrs. Franklin D. Roosevelt)

Client and Agency/Art Director	Reproduction
Fleischmann's yeast The Fleischmann Co., JWT	*LHJ*, June, p. 91 (round) (see Fig. 4.13); *Delineator*, June (picnic at lakeside); *McCall's*, June, p. 40 (oval)
	ADA 7 (1928), p. 78 (see Fig. 4.12); *PR*, Sept., p. 56; Aymar, opp. p. 220 (picnic in front of car)
	LHJ, Nov., pp. 158–159 (butler serves people in 18th-century costume)
Jergens lotion The Andrew Jergens Co., JWT	*LHJ*, Jan., p. 115 (see Fig. 6.2) (pouring lotion)
	LHJ, Feb., p. 129 (see Fig. 6.3) (playing cards)
	LHJ, Mar., p. 60 (sewing button)
	LHJ, Apr., p. 54 (holding bottle)
	LHJ, June, p. 52; *ADA* 7 (1928), p. 37 (bride's hands)
	LHJ, Sept., p. 50 (touching sleeve)
	LHJ, Oct., p. 99; *PR*, *WHC*, Oct.; *ADA* 7 (1928), p. 89 (washing dishes)
	LHJ, Nov., p. 103 (pouring lotion, fan)
	GH, Dec., p. 171; *LHJ*, Dec., p. 44 (drying hands)
Lux flakes The Lever Brothers Co., JWT/Gordon Aymar	*Vogue*, Mar. 15, p. 131 (see Fig. 3.22); *Cosmo, Forecast, GH, Motion Picture, Photoplay*, Feb.; *Liberty*, Mar. 12; *PR*, July; *Canadian HJ*, Oct.; *ADA* 8 (1928), p. 95 (box & soap flakes)
Pond's cold cream The Pond's Extract Co., JWT	*LHJ*, Mar., p. 49 (see Fig. 7.4); also March issue of *Canadian HJ, Delineator, Farmer's Wife, GH, HB, Hearst's, Liberty, McCall's, Motion Picture, Photoplay, PR, Redbook, WHC*;

Client and Agency/Art Director	Reproduction
	Vogue, Mar. 15, p. 125; *New Yorker,* Apr. 9 (Mrs. W. K. Vanderbilt)
	LHJ, July, p. 39 (see Fig. 7.10); *HB,* July; *Vogue,* July 15, p. 87; *Liberty,* July 23 (Mrs. Felix Doubleday)
Welch's grape juice Welch Grape Juice Co., JWT	*LHJ,* Mar., p. 178 (see Fig. 4.4); *Hotel Management,* Mar., p. 125, and May, p. 228; *Progressive Grocer,* Apr., p. 123; *ADA* 7 (1928), p. 90; *NYT,* Apr. 22 and May 13, 1928; details: *SEP,* Mar. 19, p. 161; *Hotel Management,* June, p. 292 (ceramic pitchers)
	LHJ, July, p. 141; *ADA* 7 (1928), p. 91; cropped: *SEP,* May 7, p. 220; *LHJ,* Apr. 1928, p. 136, and May 1928, p. 215; detail: *Vogue,* Apr. 1, 1928, p. 136 (bottle with grapes & 3 glasses)
1928	
Beds, springs, mattresses The Simmons Co., JWT	*LHJ,* Sept., p. 130; *Vogue,* Sept. 15 (Mrs. W. H. Vanderbilt)
	LHJ, Oct., pp. 104–105 (Mrs. M. Belmont & Mrs. H. Taft)
	Vogue, Oct. 13, p. 141 (Mrs. Morgan Belmont)
Cleansing cream Pinaud	*Vogue,* Nov. 10, p. 160
Douglass lighters, JWT	*HB,* Nov., p. 128 (see Fig. 5.5); *Vogue,* Nov. 10, p. 144; Sandburg, fig. 43 (3 lighters)
	Vogue, Dec. 8, p. 167 (see Fig. 5.6); *New Yorker,* Oct. 10; *SEP,* Dec. 8, p. 183 (7 lighters)
Fleischmann's yeast The Fleischmann Co., JWT	*LHJ,* Jan., pp. 110–111 (see Fig. 4.14); *GH,* Feb., p. 174 (dinner party)

Client and Agency/Art Director	Reproduction
Jergens lotion The Andrew Jergens Co., JWT	*LHJ*, Jan., p. 94 (see Fig. 6.5) (touching mirror)
	PR, Feb., p. 65, and Nov., p. 57; *LHJ, WHC*, Feb. (hands & bottle)
	GH, Mar., p. 179, and Dec., p. 274; *ADA* 8 (1929), p. 103; *LHJ*, Jan. 1929, p. 57 (hands & round neckline)
	LHJ, Apr., p. 77 (holding bottle)
	PR, LHJ, June; *WHC*, July, p. 74 (hands, bottle, flowers)
	LHJ, Sept., p. 55 (fastening bracelet)
	LHJ, Oct., p. 132 (see Fig. 6.4) (hands folded over bottle)
Sanitary napkins Kotex Co.	*LHJ*, Aug., p. 51; *Vogue*, Aug. 15, p. 20; reversed image: *Vogue*, Feb. 16, 1929, p. 33
	LHJ, Sept., p. 95; *Vogue*, Sept. 15, p. 40
	LHJ, Oct., p. 87; *Vogue*, Oct. 13, p. 36, and Mar. 16, 1929, p. 42
Pond's products The Pond's Extract Co., JWT	*ADA* 7, p. 95; *LHJ*, Oct., p. 125; cropped: *Vogue*, Feb. 15, p. 140, Mar. 15, p. 160, May 15, p. 116 (skin freshener & tissues)
	Vogue, June 15, p. 93 (creams, freshener, tissues)
	Vogue, Oct. 13, p. 140
	Vogue, Nov. 10, p. 16d (dressing tables)
	Vogue, Nov. 10, p. 150
Realsilk hosiery Real Silk Hosiery Mills	*LHJ*, Mar., p. 214

Welch's grape juice Welch Grape Juice Co., JWT	*LHJ*, May, p. 215 (bottle & 3 glasses & oblique view of glass, with sugar cubes to side)
	LHJ, July, p. 138 (3 photos)
	Vogue, July 15, p. 106; *LHJ*, Aug., p. 123; cropped: *NYT*, May 6, rotogravure section (2 bottles)

1929

Beds, springs, mattresses The Simmons Co., JWT	*LHJ*, Mar., p. 158; *Vogue*, Mar. 16, p. 173 (Mrs. Robert R. McCormick)
	LHJ, Apr., p. 141; *Vogue*, Apr. 13, p. 187 (Mrs. Frederic Cameron Church, Jr.)
	LHJ, Sept., p. 155; *Vogue*, Sept. 14, p. 171 (Mrs. John Wanamaker III)
	LHJ, Oct., pp. 142–143 (Belmont, Roosevelt, etc.)
Cleansing cream Pinaud	*Vogue*, Mar. 16, p. 141, and Apr. 13, p. 143
	Vogue, May 11, p. 131
Cutex nail polish Northam Warren Co., JWT	*Canadian HJ*, Oct.; *New Yorker*, Oct. 26; *Cosmo*, Nov., p. 125; *GH, Photoplay, PR, Redbook, WHC*, Nov.; *Montreal Star*, Nov. 16; *McCall's*, Dec.; *Toronto Star, Montreal Star*, Apr. 5, 1930, and Sept. 27, 1930; only reproduction not cropped: Sandburg, fig. 38 (hands of Mrs. Michael Arlen)
Jergens lotion The Andrew Jergens Co., JWT	*LHJ*, Jan., p. 57 (polishing silver & round neckline from 1926 & 1928)
	LHJ, Feb., p. 111 (see Fig. 6.1), and Feb. 1930, p. 95 (opera glasses & fan)

Client and Agency/Art Director	Reproduction
	LHJ, Mar., p. 47; *PR*, Mar., p. 47 (watch & Bermuda brochure)
	LHJ, Apr., p. 65 (hands with roses & clippers)
	LHJ, June, p. 54 (see Fig. 6.17); *GH*, June, p. 195; *McCall's*, Sept., p. 37; Young, p. 107; *ADA* 9 (1930), p. 77; *GH*, June 1931, p. 113; Sandburg, fig. 10 (tennis racket)
	GH, July, p. 179; *LHJ*, Sept., p. 80; *PR*, *WHC*, Oct. (pouring lotion)
	LHJ, Oct., p. 81 (bottle, jeweled hands & neck)
	LHJ, Nov., p. 97 (hands & white wool scarf)
	LHJ, Dec., p. 77; *PR*, Dec., p. 47 (hands over embroidery)
Sanitary napkins Kotex Co.	*Vogue*, Aug. 17, p. 32; *LHJ*, Sept., p. 55
Lux toilet soap The Lever Brothers Co., JWT	*LHJ*, July, p. 72 (Clara Bow)
Pond's products The Pond's Extract Co., JWT	*LHJ*, Jan., p. 29 (see Fig. 7.15); *Vogue*, Jan. 5, p. 93 (Mrs. George Grant Mason, Jr.)
	LHJ, Feb., p. 39; *Vogue*, Feb. 2, p. 98 (Mrs. Adrian Iselin II)
	LHJ, Apr., p. 41; *Vogue*, Apr. 27, p. 109 (products on glass shelf)
	LHJ, July, p. 31 (see Fig. 7.16); *Vogue*, July 20, p. 89 (Jane Kendall Mason)
	LHJ, Aug., p. 29; *Vogue*, Aug. 17, p. 99 (portrait details)
	LHJ, Aug., p. 112; *Vogue*, Aug. 3, p. 79 (model applying products)

LHJ, Sept., p. 43; *Vogue*, Sept. 14, p. 127 (Mrs. Gifford Pinchot II)

LHJ, Sept., p. 91; *Vogue*, Sept. 14, p. 163 (model applying products, variation)

LHJ, Oct., p. 105; *Vogue*, Oct. 12, p. 135 (model applying products)

LHJ, Nov., p. 41; *Vogue*, Nov. 9, p. 123 (picture story, product use)

LHJ, Nov., p. 104; *Vogue*, Nov. 9, p. 128 (model applying product)

Realsilk hosiery,
Real Silk Hosiery Mills,
JWT/Charles Prilik

LHJ, Feb. (Harford, McMein, Fontanne, Patterson)

Woodbury's facial soap
The Andrew Jergens Co., JWT

Vogue, Jan. 19, p. 87 (model applying soap)

LHJ, Mar., p. 40; *Vogue*, Mar. 16, p. 121 (Natica de Acosta, color)

LHJ, Apr., p. 85 (see Fig. 7.19); *Vogue,* Apr. 13, p. 123 (Lilias Moriarty)

LHJ, May, p. 43; *Vogue,* May 11, p. 121 (Mrs. George Franklin Hester, color)

LHJ, June, p. 71 (see Fig. 7.18); *Vogue,* June 8, p. 97; Sandburg, fig. 46 (Helen & Lois Dodd, color)

LHJ, July, p. 29 (see Plate 6); *Vogue,* July 6, p. 79 (Mrs. Richard O'Connor, color)

LHJ, Aug., p. 65; *Vogue*, Aug. 3, p. 75 (series illustrating product use)

LHJ, Sept., p. 41 (see Plate 7); *Vogue,* Aug. 31, p. 69 (Julia Evans, color)

Client and Agency/Art Director	*Reproduction*
	Vogue, Sept. 28, p. 93 (Thelma Harris)
	Vogue, Oct. 26, p. 97; *LHJ,* Nov., p. 39 (Lolita Gelpi, color)
	Vogue, Nov. 23, p. 99; *LHJ,* Dec., p. 29 (details of portraits, color)
1930	
Beds, springs, mattresses The Simmons Co., JWT	*LHJ,* Apr., p. 71; *Vogue,* Apr. 12, p. 115 (Mrs. John Hays Hammond, Jr.)
Billfolds Buxton, Inc., JWT	*New Yorker,* Nov. 2, p. 49; *SEP,* Nov. 22; *VF,* Dec., p. 97; *Vogue,* Dec. 8, p. 149; *NY Sun,* Dec. 12 (wallets on diagonal)
	Collier's, Dec. 13, p. 69; *New Yorker,* Dec. 15, p. 49 (wallets in fan shape)
Jergens lotion The Andrew Jergens Co., JWT	*LHJ,* Jan., p. 85 (see Fig. 6.9) (black lace dress)
	Vogue, Jan. 4, p. 87 (models using product)
	Vogue, Feb. 15, p. 103 (product, facial details, couple)
	LHJ, Mar., p. 84 (see Fig. 6.8) (woman holding opera glasses)
	LHJ, May, p. 70 (pinning brooch)
	LHJ, July, p. 53 (sunsuit)
	LHJ, Oct., p. 81 (jewels in box)
	LHJ, Nov., p. 93 (couple dancing)
	LHJ, Dec., p. 100 (woman at vanity)
Pond's cold cream The Pond's Extract Co., JWT	*LHJ,* Feb., p. 39 (see Fig. 7.20); *Vogue,* Feb. 1, p. 89 (Mrs. John Davis Lodge, sitting)

	LHJ, Mar., p. 43; *Vogue*, Mar. 1, p. 97 (model using product, color)
	LHJ, Apr., p. 43 (see Fig. 7.17); *Cosmo*, June, p. 105; *Redbook*, June (Miss Virginia Carter Randolph, standing)
	Vogue, Apr. 26, p. 85; *GH*, *Photoplay*, June; *New Yorker*, June 14, p. 31; *True Story*, July; *ADA* 9 (1930), p. 66; Sandburg, fig. 30 (Miss Virginia Carter Randolph, sitting)
	LHJ, July, p. 29 (see Fig. 7.21); *HB*, July, p. 103; *Vogue*, July 19, p. 81 (Miss Elizabeth Altemus)
	LHJ, Aug., p. 27; *Vogue*, Aug. 16, p. 85 (Mrs. Adrian Iselin II)
	Vogue, Sept. 15, p. 107 (Mrs. Biddle Stewart)
	Vogue, Nov. 24, p. 107 (details of portraits)
Sterling silverware The Gorham Company, JWT	*HB*, Mar., p. 143; *H&G*, *Vogue*, Mar.
	Vogue, Apr. 12, p. 131; *Am Home*, *H&G*, *HB*, *House B*, April
	VF, May, p. 87 (see Fig. 5.9); *Am Home*, *H&G*, *HB*, *House B*, May; *Vogue*, May 10, p. 112 (diagonal pattern)
	VF, June, p. 89 (see Fig. 5.8); *Country Life*, June, p. 70 (vertical pattern)

1931

Film The Eastman Kodak Co., JWT	*LHJ*, Dec., p. 101 (man & woman with camera)

Hexylresorcinol solution Sharpe & Dohme, JWT	*LHJ*, Sept., p. 106 (see Fig. 9.5); *ADA* 11 (1932), p. 33 (mother & infant)
Jergens lotion The Andrew Jergens Co., JWT/ James Yates	*LHJ*, Jan., p. 72 ("witchery in hands")
	LHJ, Feb., p. 102 (snuggle)
	LHJ, Mar., p. 151 (see Fig. 6.15); *Advertising Arts*, July, p. 9; *ADA* 11 (1932), p. 30 (man with woman wearing necklace)
	LHJ, Apr., p. 64 (couple snuggle, diamond bracelet)
	LHJ, Oct., p. 93 (couple, dream, woman with closed eyes; print at GEH)
	LHJ, Nov., p. 162 (couple in profile)
	LHJ, Dec., p. 48 (see Fig. 6.10); *ADA* 11 (1932), p. 31 (man & woman with lei)
Pond's products The Pond's Extract Co., JWT	*LHJ*, Feb., p. 33 (see Fig. 7.22); *HB*, Feb.; *Vogue*, Feb. 15, p. 91 (Mrs. Alexander Hamilton)
	Vogue, Mar. 15, p. 111 (Belmont, Drexel, Du Pont)
	Vogue, Apr. 1, p. 96 (McCormick, Iselin, Choate)
	LHJ, Mar., pp. 92–93 (the two entries above, combined)
	LHJ, May, pp. 70–71; *Vogue*, May 15, pp. 98–99 (3 women, Morgans)
	LHJ, July, p. 27; *Vogue*, July 15, p. 73 (Mrs. Norman Ogden Whitehouse)
	LHJ, Aug., p. 29 (see Fig. 7.24); *Vogue*, Aug. 15, p. 77 (Mrs. Potter D'Orsay Palmer)

GH, Sept., p. 107; *Motion Picture, Redbook*, Sept.; *ADA* 11 (1932), p. 34; *Vogue*, Nov. 15 and Jan. 15, 1932, p. 81; *NYT*, Feb. 14, 1932 (hands & products)

LHJ, Sept., pp. 96–97 (sepia-tone photo of 4 products)

Vogue, Sept. 15, p. 105 (Mrs. Morgan Belmont)

Vogue, Oct. 1, p. 95 (Hamilton, Vanderbilt, Hamilton)

Vogue, Dec. 1, p. 84; cropped: *LHJ*, Dec., p. 63 (Whitehouse)

Vogue, Dec. 15, p. 79 (Mrs. Alfred Victor Du Pont)

Scott tissue
Scott Paper Co., JWT/James
 Yates

LHJ, Feb., p. 145 (see Fig. 9.3); *ADA* 11, p. 32 (nurse & doctor in operating room)

1932

Hexylresorcinol solution
Sharpe & Dohme, JWT

LHJ, Sept., p. 99 (see Fig. 9.8) (operating room)

Jergens lotion
The Andrew Jergens Co., JWT

LHJ, Jan., p. 52; *WHC*, Jan., p. 57; *LHJ, McCall's, PR*, Jan.; *Chatelaine*, Apr., p. 43; *McCall's, WHC*, Dec.; *ADA* 11 (1932), p. 32; *McCall's, WHC*, Jan. 1936; reversed: *LHJ*, Dec., p. 90; *McCall's, WHC*, Dec. (woman covering man's eyes with hands)

LHJ, Feb., p. 63; *McCall's*, Feb., p. 95 (woman touches man's ear)

LHJ, Mar., p. 47 (woman in smocked dress touches man's head)

LHJ, Apr., p. 56 (couple)

LHJ, Oct., p. 52 (couple)

Client and Agency/Art Director	*Reproduction*
	LHJ, Nov., p. 90; *McCall's, WHC,* Nov. (woman touching man's head)
	LHJ, Dec., p. 65
Ladies' Home Journal Curtis Publishing Co., JWT	*ADA* 11 (1932), p. 28 (woman & boy golf caddy)
Pond's products The Pond's Extract Co., JWT	*LHJ*, Feb., p. 29; *McCall's,* Feb., p. 29; *Vogue,* Feb. 15, p. 85 (Mrs. James J. Cabot)
	LHJ, Mar., p. 33; *Vogue,* Mar. 15, p. 91 (Mrs. Pierpont Morgan Hamilton)
	LHJ, May, p. 30; *Vogue,* May 15, p. 89 (products, mirror, portrait details)
	LHJ, Aug., p. 39 (Lupé Velez)

1933

Automobile Packard Motor Car Co., Y&R	*ADA* 12 (1933), p. 42 (man in top hat speaks to woman in car)
	VF, Apr., p. 60a; *SEP*, Apr. 1, inside cover (color, man reading magazine)
	HB, June, inside cover (woman in baroque costume)
Beautyrest mattress The Simmons Co., JWT	*McCall's* ?, p. 125 (MoMA no. 1275-40); double-page variation: *LHJ*, Mar., pp. 80–81 (woman tired & rested)
Ivory soap Procter & Gamble Co.	*McCall's,* July (mother, baby on blanket)
	LHJ, Sept., inside cover (see Plate 5); tear sheet at MoMA no. 1331-10 (mother, baby in chair)
Jergens lotion The Andrew Jergens Co., JWT	*LHJ*, Jan., p. 48 (see Fig. 6.16) (couple, dress with sequined sleeves)
	LHJ, Feb., p. 46 (couple, woman in petal dress)

	WHC, Mar., p. 59; variation: *LHJ,* Mar., p. 69 (couple on chair)
	WHC, Nov., p. 55; *McCall's,* Nov.; detail: *LHJ,* Nov., p. 66 (contemplative couple)
	LHJ, Dec., p. 38 (couple embrace)
Pond's cold cream The Pond's Extract Co., JWT	*LHJ,* Feb., p. 31; *Vogue,* Feb. 15, p. 71 (Mrs. Reginald Vanderbilt)
Scott tissue Scott Paper Co., JWT	*LHJ,* Feb., p. 114; *PR,* Feb., p. 53 (woman in lace dress looking over shoulder)
	LHJ, Mar., p. 133 (woman in chair)
	LHJ, Apr., p. 121; *McCall's,* Apr., p. 105 (woman in robe with ruffled sleeves)
	LHJ, Aug., p. 48 (see Fig. 9.4) (mother & child talking)
Train travel New York Central System	*SEP,* Aug. 10, p. 87 (woman in flowered hat)
Verichrome film Eastman Kodak, JWT/John Scott	*LHJ,* June (bearded grandfather & girl; print at GEH)
	Collier's, June 3 (2 men with snapshots; print at GEH)
	Collier's, July 8 (7 people after tennis; variation at GEH)
	BH&G, Sept., p. 29; *ADA* 13 (1934), p. 45 (3 boys on car bumper)
	LHJ, Sept., p. 79; with speech bubbles: *Beacon Journal,* Akron, Ohio (see Fig. 6.14), and other newspapers, June 8; cropped: *Cosmo,* Sept., p. 141 (3 women on couch with snapshots)
	SEP, Sept. 23 (young couple seated on porch; print at GEH)

LHJ, June 1934, p. 136 (see Plate 2); Steichen, fig. 161 (dated); *Fortune*, June 1934; *ADA* 14 (1935), p. 38 (couple with baby in basket)

SEP, June 30, 1934 (see Fig. 4.18); Steichen, fig. 160 (dated); *Atlanta Journal* and other newspapers, May 31, 1934; *Time*, June 11, 1934; *Redbook*, July 1934; *Motion Picture, Movie Classics*, Aug. 1934 (young couple looking at snapshots)

Unidentified JWT tear sheet, dated 1933 (2 men at desk, 1 with cigar; print at GEH)

Unidentified JWT tear sheet, dated 1933 (couple look at photos in kitchen, woman with ladle; print at GEH)

1934

Automobile
Packard Motor Car Co., Y&R/
 Gene Davis

ADA 13 (1934), p. 45 (woman & car in front of house)

Cruise
Matson Navigation Co., BDC/
 G. Bristow Richardson

Vogue, Sept. 15; *VF*, Sept., p. 5; *HB*, Sept. (2 couples beside elaborate column)

Vogue, Oct. 1; *VF*, Oct., p. 9; *H&G*, Oct. (woman standing at banquet table)

VF, Nov., p. 9; *ADA* 14 (1935), pp. 62–63 (female tourist arriving on ship, ribbons streaming)

Vogue, Dec. 1; *Nat'l Geo*, Dec.; *ADA* 14 (1935), p. 18 (native placing leis on arriving female tourist)

Client and Agency/Art Director	Reproduction
Ivory soap Procter & Gamble Co.	*LHJ*, Jan., inside cover (see Plate 3); *McCall's*, Feb., inside cover (mother drying baby)
	LHJ, Feb., p. 2 (cropped), variation of whole photo in unidentified tear sheet at MoMA no. 1343-13N (mother, baby in tub)
	LHJ, Feb., p. 2 (2 women with negligee on mannequin)
	LHJ, Mar., inside cover (see Plate 4); *McCall's*, Apr., back cover (mother playing with baby in towel)
Jergens lotion The Andrew Jergens Co., JWT	*LHJ*, Jan., p. 34 (couple embrace)
	LHJ, Feb., p. 51 (couple in profile)
	LHJ, Mar., p. 58 (couple seated on couch)
	LHJ, Apr., p. 52 (couple admire engagement ring)
	LHJ, June, p. 86 (2 photos: woman applies lotion, man admires woman's hands)
	LHJ, Aug., p. 68 (couple apply lotion at beach)
	LHJ, Oct., p. 71 (couple, woman with 2 diamond bracelets)
	LHJ, Nov., p. 67 (couple)
	LHJ, Dec., p. 60 (man admires woman's hands)
Pond's cold cream The Pond's Extract Co., JWT	*LHJ*, May, p. 75; *HB*, May (Whitney Bourne, color)
Scott tissue Scott Paper Co., JWT	*LHJ*, June, p. 60 (nurse, mom, & baby in maternity ward)

	LHJ, Oct., p. 107 (woman, tissue to face)
	PR, Dec., p. 83; half page: *LHJ*, Dec., p. 80 (woman looking up, tissue to face)
Verichrome film Eastman Kodak Co., JWT/ William Strosahl	*LHJ*, May, p. 129; *Cosmo, Dream World, Modern Magazines, Movie Classics, Movie Mirror, Photoplay, Redbook, Screenland, Screen Romances, True Experiences, True Romances, True Story*, June; *ADA* 14 (1935), p. 24 (woman at dressing table holds picture to heart)
	BH&G, July (older woman, girl; print at GEH)
	American Magazine, Aug., p. 99 (older couple on couch; print at GEH)
	Time, Aug. 13; *American Magazine*, Sept., p. 105; *LHJ*, Sept., p. 77; *BH&G*, Sept. (couple & 2 toddlers; print at GEH)
	ADA 14 (1935), p. 60; unidentified JWT tear sheet, dated (old man & young girl with snapshots)
1935	
Ciné Kodak "K" Eastman Kodak	*VF*, July (couple under tree, near beach; print at GEH)
Cruise Matson Navigation Co., BDC/ G. Bristow Richardson	*Vogue*, Mar. 15; *VF*, Mar., p. 6 (people in evening dress on deck)
	VF, Apr., p. 4a (see Fig. 9.10) (group with cocktails & hors d'oeuvres)
	VF, May, inside cover (see Fig. 9.9) (woman in white in stateroom)
	HB, Sept. (group at poolside)

Client and Agency/Art Director	Reproduction
Face powder Coty, Ayer	*LHJ,* Oct., p. 135 (model & powder box)
Federation of Jewish Philanthropies, JWT	Steichen, fig. 164 ("The Matriarch," reused for Kodak, 1936 and 1939)
Jergens lotion The Andrew Jergens Co., JWT	*LHJ,* Jan., p. 67 (couple, woman in dotted dress)
	LHJ, Feb., p. 58 (couple with champagne glasses)
	LHJ, Mar., p. 82 (couple)
	LHJ, Apr., p. 73 (contemplative couple)
	LHJ, June, p. 52 (couple at pool)
	McCall's, Nov., p. 27; detail: *LHJ,* Nov., p. 58 (couple on brocade couch)
	LHJ, Dec., p. 55 (couple)
	McCall's tear sheet, undated (headline from 1935 campaign), MoMA no. 1434-27 (couple)
Lipstick Coty, Ayer	*Vogue,* Feb. 28; *HB,* Apr., p. 127; *Cosmo, Photoplay, McFadden Women's Group, Screenland Unit, True Story,* May
	American Hebrew, May 24; *Vogue,* June 15; *HB,* July
Towels Cannon Mills, Inc., Ayer/Paul Froelich and Charles T. Coiner	*Vogue,* Feb. 28, and *HB,* Mar., inside cover; *ADA* 14, pp. 42–43 ("Cannon Towel Talks" No. 1, a series of sepia-toned nudes and brightly colored towels)
	No ID, MoMA tear sheet ("Cannon Towel Talks" No. 2)
	Vogue, May 1, inside cover; *ADA* 15 (1936), p. 48 ("Cannon Towel Talks" No. 3)

	HB, June; *Vogue*, June 15, inside cover; *ADA* 15 (1936) ("Cannon Towel Talks" No. 4)
	Unidentified tear sheet, Ayer archives ("Cannon Towel Talks" No. 5)
	HB, Sept.; *Vogue*, Sept. 15, inside cover ("Cannon Towel Talks" No. 6)
	Vogue, Oct. 1, inside cover ("Cannon Towel Talks" No. 7)
Train travel New York Central Lines	*SEP*, July 13, p. 67 (man with pencil)
	SEP, Nov. 2, p. 91 (man gazing)
1936	
Community Plate silverware Oneida Ltd.	*Community Jeweler*, Oct., cover (woman holding roses at waist)
	LHJ, Dec., p. 93 (see Fig. 9.11); MoMA tear sheet of same dated to Nov. (woman in white fur, spoons)
Furs A. Hollander & Son	*Vogue*, Oct. 15 (Hudson seal)
	Vogue, Oct. 15 (Persian lamb)
	Vogue, Dec. 15 (pony)
Ivory soap Procter & Gamble Co.	*SEP*, Sept. 19, p. 4; *LHJ*, Dec., p. 50 (mother looking at baby)
Jergens lotion The Andrew Jergens Co., JWT	*LHJ*, Feb., p. 58 (see Fig. 6.12) (3 photos)
	LHJ, Mar., p. 90; *McCall's*, *WHC*, Mar. (3 photos)
	LHJ, Apr., p. 83 (4 photos)
	LHJ, May, p. 72 (3 photos)

Client and Agency/Art Director	Reproduction
Pianos Steinway, Ayer/Charles T. Coiner	*GH*, Mar.; *Child Life, Music Clubs Magazine, Music Educators' Journal,* Apr.; *Piano Trade Magazine*, July (piano from bottom back)
	Vogue, Mar. 1, p. 109 (see Fig. 5.10); *H&G, House B,* Mar.; *SEP*, Mar. 7; *GH,* Apr.; *Music Educators' Journal,* May (piano from bottom right)
	H&G, Vogue/VF, Apr. and May; *GH,* May (piano from top right)
	House B, Oct.; *GH,* Nov.; *New Yorker,* Nov. 14; *NYT,* Dec. 15, 1940 (parents & girl at piano)
	NYT, Oct. 11, rotogravure section (6 young people around piano)
	GH, House B, New Yorker, Dec.; *SEP,* Dec. 12 (man watching woman at piano)
	Baltimore Museum, *Steichen,* 1938, n.p. (5 young people around piano)
Towels Cannon Mills, Inc., Ayer/Paul Darrow and Charles T. Coiner	*HB,* Jan., inside cover; *Vogue,* Jan. 15, inside cover ("Cannon Towel Talk" No. 8; series of sepia-toned nudes & brightly colored towels, continued)
	HB, Feb.; *Vogue,* Feb. 15 ("Cannon Towel Talk" No. 9)
	Vogue, Mar. 1, inside cover (see Plate 9); *HB,* Mar., inside cover ("Cannon Towel Talks" No. 10)
	Vogue, June 15, inside cover (see Plate 8); *HB,* June ("Cannon Towel Talk" No. 12)

	Vogue, July 1, inside cover ("Cannon Towel Talk" No. 13)
	Vogue, Sept. 15, inside cover ("Cannon Towel Talk" No. 14)
Train travel New York Central System	*SEP,* Feb. 8, p. 95 (man with elbow on desk)
	Time, Feb. 24, p. 2; *SEP,* Mar. 7, p. 111 (smiling man)
	Time, Apr. 27, p. 35; *SEP,* May 2, p. 35 (woman holding her hat)
Verichrome film The Eastman Kodak Co., JWT/ William Strosahl	Dated by unidentified JWT tear sheet; *ADA* 19 (1940), p. 79; Steichen, fig. 164 ("The Matriarch," 1935 photo for Jewish Philanthropies)
Woodbury's facial soap John H. Woodbury, Inc., L&M/ Myron C. Perley	*LHJ,* Apr., pp. 62–63 (see Fig. 8.4); *McCall's, PR,* April (nude & sundial, color)
	Vogue, May 15, p. 119 (nude & large urn)
	NYT, June 28, rotogravure section; *ADA* 16 (1937), p. 50 (woman in swim cap soaping back)
	LHJ, July, p. 41 (see Fig. 8.3); *Vogue,* July 15, p. 73 (nude on stairs, facing away)
	LHJ, Sept., p. 53; *Vogue,* Sept. 15, p. 113 (nude reclining)
	GH, Oct., p. 101; cropped: *NYT,* Oct. 25, rotogravure section (nude sitting with feet in pool)
	LHJ, Nov., p. 45; *PR,* Nov., p. 46; *Vogue,* Nov. 15, p. 119 (woman lying on back)

Client and Agency/Art Director	Reproduction
	No ID, MoMA tear sheet (nude with feet in pool, looking away)
1937	
Community Plate silverware Oneida Ltd.	*SEP*, Feb. 27, p. 4 (woman on chaise longue)
	SEP, Mar. 27 (woman looking over right shoulder)
	Cosmo, June, p. 135 (woman seated in chair)
	SEP, Sept. 11 (woman holding rose to chin)
	SEP, Oct. 9 (woman holding orchids)
	LHJ, Dec., p. 83 (see Plate 11) (color); *SEP*, Nov. 6 (b&w); cropped: *LHJ*, Nov., p. 96 (woman, orchid in hair, candles)
	SEP, Dec. 4; *LHJ*, Jan. 1938, p. 45 (see Plate 10), and June 1938 (color) (woman in red V-necked gown)
Ladies' Home Journal Curtis Publishing Co.	*NY Herald-Tribune*, Jan. 8, p. 37 (drama: "Should you kiss him good night?")
	NY Herald-Tribune, Sept. 10, p. 44 (drama: "Rolfe freed in murder")
	NY Herald-Tribune, Oct. 8, p. 44 (drama: "Yes! I will take a Wassermann test")
	NY World-Telegram, Nov. 10, p. 39 (see Fig. 9.1) (drama: "I know that you killed him")
Pianos Steinway and Sons, Ayer/ Charles T. Coiner	*NYT*, Sept. 12, rotogravure section (in color); *GH*, *H&G*, *House B*, Oct.; *New Yorker*, *SEP*, Oct. 16 (woman at piano)

	NYT, Oct. 10, rotogravure section (in color); *GH, H&G, House B, New Yorker,* Nov.; *Music Trade Review,* Mar. 1938 (young couple at piano)
	NYT, Nov. 27, rotogravure section; *NY Herald-Tribune,* Dec. 4 (in color); *GH,* Dec.; *New Yorker,* Dec. 11 (woman at piano)
Realsilk hosiery Real Silk Hosiery Mills	*LHJ,* Nov., p. 73 (see Fig. 9.12) (measuring for stockings)
	LHJ, Dec., p. 79

1939

The Eastman Kodak Co. JWT/William Strosahl	*ADA* 19 (1940), p. 79, "The Matriarch," rpt. of image for Federation of Jewish Philanthropies, 1935
Woodbury's facial soap John H. Woodbury, Inc.	*LHJ,* July, p. 49 (see Fig. 8.5) (sleeping woman, 3 star insets)
	LHJ, Sept., p. 45 (sleeping woman, 2 star insets)

1940

American Tobacco Co. Lord & Thomas/Joseph Hochreiter	*ADA* 19, mentioned, not reproduced
Cruise Matson Navigation Co., BDC/ Lloyd B. Meyers	*ADA* 19, p. 38 (pensive native woman resting on plank)
	Vogue, Jan. 15, inside cover; *ADA* 19, p. 38 (color) (female tourist, native woman, & leis)
	Vogue(?), Feb., p. 79; unidentified MoMA tear sheet (color) (pensive native woman, large leaves & hibiscus)

HB, Mar., inside back cover (see Plate 13); dated proof (MoMA) (color) (female tourist reading *Polynesian* magazine)

Dated proof (MoMA) (color) (female tourist reading map)

HB, Nov., inside back cover (see Fig. 10.1); *H&G*, Nov., inside cover; *Vogue*, Nov. 1, inside cover; *ADA* 20 (1941), pp. 26–27 (color) (native woman on cliff, lighthouse)

HB, Dec., inside back cover; *Vogue*, Dec. 15, inside cover (color) (woman, child, basket at iron gate)

1941

Condé Nast Engravers

Cruise
Matson Navigation Co., BDC/
　Lloyd B. Meyers

ADA 20, p. 182 (fashion studio)

ADA 20, p. 117 (native woman picking coral from basket)

HB, Jan., inside back cover; *Vogue*, Jan. 1, inside back cover; *H&G*, Feb., inside cover (color) (child with oar)

HB, Mar., inside cover (see Fig. 10.2); *ADA* 20, p. 116 (color) (woman, large leaves, bird-of-paradise flower)

Vogue, Mar. 1, inside back cover; *HB*, Apr., inside back cover (color) (tourist at beach)

H&G, Nov., inside cover (color) (female tourist on departing ship)

Vogue, Nov. 1, inside cover (see Plate 12) (color) (native woman holding flowers)

Client and Agency/Art Director	*Reproduction*
	HB, Dec., inside back cover (color) (woman sitting on beach with basket)
1942	
Cruise Matson Navigation Co., BDC/ Lloyd B. Meyers	*ADA* 21, p. 85 (female native looking into basket of string)
Stromberg-Carlson Telephone Mfg. Co., M-E/John H. Tin- ker, Jr., and Herbert Noxon	*ADA* 21, p. 101 (boy) *ADA* 21, p. 103 (man & newspaper)
Vogue magazine, Condé Nast Publications, M.F. Agha	*ADA* 21, p. 156 (speakers lined up on stage)

Notes

INTRODUCTION

1. Scholars in both art history and American Studies have been concerned with how representations reflect society. Rozsika Parker and Griselda Pollock see fine art functioning much as I have argued for commercial art; art "mediates and re-presents social relations in a schema of signs which require a receptive and preconditioned reader in order to be meaningful" (Parker and Pollock, *Old Mistresses: Women, Art and Ideology* [New York: Pantheon, 1981], p. 119). Roland Marchand has conceptualized advertisements as a *Zerrspiegel,* or distorting mirror, of American society rather than a true reflection (Marchand, *Advertising the American Dream: Making Way for Modernity, 1920–1940* [Berkeley and Los Angeles: University of California Press, 1985], particularly introd. and chapters 2 and 3).

2. The theories of Tanya Modleski, Fredric Jameson, Laura Mulvey, and others are discussed in Chapters 6 and 8.

CHAPTER ONE

1. Edward Steichen, *A Life in Photography* (Garden City, N.Y.: Doubleday, 1963; rpt., New York: Bonanza Books, 1984), chapter 1, n.p. My summary of Steichen's life and work up to 1914 is synthesized from this work as well as Carl Sandburg, *Steichen the Photographer* (New York: Harcourt, Brace, 1929); William Innes Homer, *Alfred Stieglitz and the Photo-Secession* (Boston: Little, Brown, 1983); Dennis Longwell, *Steichen: The Master Prints, 1895–1914* (New York and Boston: Museum of Modern Art and New York Graphic Society, 1978); Paula Steichen, "The Life and Works of Carl Sandburg," in *Carl Sandburg Home. Handbook 117* (Washington, D.C.: U.S. Department of the Interior, National Park Service, 1982), pp. 22–111; Margaret Sandburg, ed., *The Poet and the Dream Girl: The Love Letters of Lilian Steichen and Carl Sandburg* (Urbana: University of Illinois Press, 1987); Penelope Niven, *Carl Sandburg: A Biography* (New York: Scribner, 1991); and letters from Steichen to his parents, sister, and brother-in-law in the Carl Sandburg Collection, University of Illinois at Urbana-Champaign, photocopies in the Edward Steichen Archives, Museum of Modern Art, New York. I thank Penelope Niven for discussing Steichen's early years.

2. Longwell, *Steichen: The Master Prints,* esp. pp. 12, 14, and 22 n.3. Longwell sees a similarity between Steichen's photographic aesthetic and the ideas of the art critic Charles H. Caffin. He considers both men symbolists, in part because both ascribed to "the Neo-Platonic idea that the ultimate 'reality' a picture communicates is *suggested* by but is more than and different from its subject matter" (emphasis in original, p. 14). William Homer, while not specifically classifying Steichen's work as symbolist, places it in the context of "the fin-de-siècle aesthetic of mystery and mood, much in the spirit of the writings of [the Belgian symbolist playwright] Maeterlinck" (Homer, *Alfred Stieglitz and the Photo-Secession,* p. 87).

Lucy Bowditch has developed the link between Steichen's work and a symbolist aesthetic in "Steichen and Maeterlinck: The Symbolist Connection," *History of Photography* 17, no. 4 (winter 1993): 334–342.

3. Steichen, *A Life in Photography*, chapter 2.

4. Two good discussions of Steichen's technique are found in Longwell, *Steichen: The Master Prints*, pp. 173–174; and Charles H. Caffin, "Progress in Photography (With Special Reference to the Work of Eduard J. Steichen)," *Century Magazine* 75, no. 4 (Feb. 1908): 482–498.

5. For a detailed discussion of the exhibition policy of 291 and the working relationship between Stieglitz and Steichen, see William Innes Homer, *Alfred Stieglitz and the American Avant-Garde* (Boston: New York Graphic Society, 1977).

6. Undated letter (after 1906) from Edward Steichen to Alfred Stieglitz, quoted in Longwell, *Steichen: The Master Prints*, p. 68.

7. Although Lilian's name is most frequently spelled Lillian in the art-historical literature on Steichen and in some of his own late writing, the spelling I have adopted here is the one she used in signing her letters. Lilian is also sometimes referred to as "Paula," the name Sandburg gave her in 1908. According to her granddaughter, Lilian Steichen's political activities consisted of marching as a suffragette, translating editorials from German newspapers for the Social-Democratic Party, and handing out leaflets (Paula Steichen, "The Life and Works of Carl Sandburg" [as in n. 1], pp. 53, 60).

8. For a good brief biography of Sandburg, see the essay by his granddaughter, Paula Steichen, "The Life and Works of Carl Sandburg" (as in n. 1), pp. 22–111. A far more thorough treatment is presented in Niven, *Carl Sandburg: A Biography* (as in n. 1). Paula Steichen quotes an early leaflet Sandburg wrote in which he defined socialism: "[Socialism] does not mean the passing of private property. Socialism holds that your hat, your house, your books, your piano, your carpets, your toothbrush, shall be your own as your private property. But the great tools of production that are necessary to the life and well being of all, these should be owned by all. . . . Today men are lucky if they have a chance to 'earn a living.' What the Socialist wants for every man is the chance to live a life." Paula Steichen does not discuss Sandburg's views on ownership of the means of production and therefore minimizes Sandburg's radicalism. She recasts him as an antiracist liberal attracted to socialist politics because he desired "a decent life for the worker" and reacted against the "wrongs of society," campaigning for antitrust legislation, child labor laws, workers' compensation, minimum wage levels, retirement security, and health care. Margaret Sandburg, in *The Poet and the Dream Girl* (as in n. 1), also characterizes Sandburg's socialism as a desire for gradual reform (p. 1).

Despite Paula Steichen's assertions that Sandburg, unlike other socialists at the time, feared the Bolshevik revolution, both Sandburg and Steichen seem to have sympathized with it. Only later did they harbor regrets. Robert Hunter, whom Sandburg aided with his 1908 book *Socialists at Work*, expressed the change in attitude: "I can hardly believe that the divine child we were expecting in 1917–1918, should now have become the monstrous slayer of nearly everything we held dear" (letter from Hunter to Carl Sandburg, Mar. 17, 1940, from Illinois Historical Society, photocopy in Steichen Archives). Hunter's book was illustrated with a number of portraits of prominent socialists that Steichen took in Milwaukee and at the 1907 socialist convention in Stuttgart; this book is the only record of some of them. See Robert Hunter, *Socialists at Work* (New York: Macmillan, 1908); Paula Steichen, "The Life and Works of Carl Sandburg," pp. 51, 53; Margaret Sandburg, ed., *The Poet and the Dream Girl*, pp. 12–13.

Sandburg's own cold war/McCarthy–era memoir of his early years, *Always the Young*

Strangers (New York: Harcourt, Brace, 1953), functions almost as an apology for his early politics. It describes how his socialism grew out of early experiences of social injustice—his father's long work hours, debilitating physical labor, and financial struggles—but his home-spun tone makes his early fervor seem unsophisticated and almost childlike.

9. Letter from Lilian Steichen to Carl Sandburg, Feb. 15, 1908, in Margaret Sandburg, ed., *The Poet and the Dream Girl*, p. 12.

10. Letter from Carl Sandburg to Esther Sandburg, May 25, 1908, in ibid., p. 238.

11. Carl Sandburg, *Chicago Poems* (Chicago: Holt, 1916). Immediate critical reaction to this book was divided between those on the left, who praised its merger of politics and art (Louis Untermeyer in the *Masses*), and the establishment critics who were uneasy with the specificity of the political, but valued the "universal" and "eternal" human conditions in Sandburg's Imagist poems (Amy Lowell in *Tendencies in Modern American Poetry*, William Aspenwall in the *Dial*). The reappraisal of Sandburg's *Chicago Poems* and an analysis of its critical reception is set out in Mark Van Wienan, "Taming the Socialist: Carl Sandburg's *Chicago Poems* and Its Critics," *American Literature* 63, no. 1 (Mar. 1991): 89–103. Wienan also notes that at least four of Sandburg's more political poems were softened before publication, at the suggestion of his editor, Arthur Harcourt.

12. Melinda Boyd Parsons, "Edward Steichen's Socialism: 'Millennial Girls' and the Construction of Genius," *History of Photography* 17, no. 4 (winter 1993): 319.

13. Ibid., pp. 317–333.

14. Letter from Steichen to Lilian Steichen Sandburg, 1910, Carl Sandburg Collection (as in n. 1).

15. Letter from Steichen to Lilian, Jean-Pierre, and Marie Kemp Steichen, 1905, Carl Sandburg Collection (as in n. 1).

16. Letter from Steichen to Jean-Pierre and Marie Kemp Steichen, 1914, ibid.

17. Letter from Flora Small (Lofting) to Alfred Stieglitz, Oct. 15, 1914, quoted in Sue Davidson Lowe, *Stieglitz: A Memoir/Biography* (New York: Farrar Straus Giroux, 1983), p. 183.

18. Letter from Edward Steichen to Jean-Pierre and Marie Kemp Steichen and Lilian and Carl Sandburg, 1914, Carl Sandburg Collection (as in n. 1). Steichen apparently resided at Obermeyer's apartment for some time, since he wrote to his sister again from the same address on May 21, 1916.

19. Lowe, *Stieglitz: A Memoir/Biography*, p. 183.

20. For example, Steichen, disturbed by the breakdown of politics that led to the war, wrote in his statement for *Camera Work* on the question "What is 291?" that he was "ready to put an art movement such as futurism with anarchy and socialism into the same bag as Church and State to be labeled 'Dogma' and relegated to the scrap heap—History" (Eduard J. Steichen, "291," *Camera Work*, no. 47 [July 1914]: 65–66).

21. Sandburg went through a similar evolution. Paula Steichen reports that "when many Socialists officially took the view of non-involvement—he openly differed with the old leaders he had admired before" ("The Life and Works of Carl Sandburg" [as in n. 1], p. 53). Sandburg was never anti-interventionist. He enlisted in the Spanish-American War and supported the effort for both world wars through his writing.

22. Steichen, "291" (as in n. 20).

23. Steichen's mother typically wrote her letters in German (Margaret Sandburg, ed., *The Poet and the Dream Girl*, p. 86).

24. For Stieglitz's views on the war see Lowe, *Stieglitz: A Memoir/Biography* (as in n. 17), pp. 191–192.

25. Although Steichen used his baptismal name, Eduard, professionally throughout his early career, his naturalization papers of 1900 had legally changed his name to Edward, and his sister's letters to him from before the war use the Anglicized version. See Longwell, *Steichen: The Master Prints* (as in n. 1), p. 22 n.4; and Margaret Sandburg, ed., *The Poet and the Dream Girl.*

26. This definition and the sequence of events are derived from Bonnie Yochelson, "Clarence H. White Reconsidered: An Alternative to the Modernist Aesthetic of Straight Photography," *Studies in Visual Communication* 9 (fall 1983): 29.

The emphasis on interpretation and metaphysical content seems to have grown stronger as the literature of straight photography developed and the philosophical tenets of modernism became clearer. Both Beaumont Newhall and John Szarkowski quote Strand's famous 1917 statement that the photographer must have "a real respect for the thing in front of him." Newhall interprets this as a reference to the confrontational qualities of Strand's work, which Stieglitz described as "brutally direct, pure and devoid of trickery." Szarkowski expands on Newhall's analysis, interpreting Strand's statement to signify a "photographic morality" that is "perhaps the real cornerstone of belief in straight photography." Sarah Greenough's later essay describes Strand's insistence on a moral component in his earliest straight photography, demonstrating that during the 1920s this evolved into a desire for realism and an intensive study of details to build up a portrait of a region from its parts.

Allan Sekula, by contrast, sees Strand's straight photography as a formalist stance without the metaphysical references. Sekula states that Strand's work published in the final issue of *Camera Work* in 1917 "represented a polemical, fully developed modernist position. His [Strand's] 1917 statement on photography is an archetypal formulation of Clement Greenberg's demand that a truly modernist art determine 'through the operations peculiar to itself, the effects peculiar and exclusive to itself.' Strand's insistence on the 'complete uniqueness of means,' on the 'absolute unqualified objectivity' of hard focus, was a repudiation of pictorial photography, which had achieved its high place in the world through an earlier, systematic repudiation of modernism."

See Paul Strand, "Photography," *Seven Arts* 2 (Aug. 1917): 524–525, reprinted in *Photography: Essays and Images,* ed. Beaumont Newhall (New York and Boston: Museum of Modern Art and New York Graphic Society, 1980); Beaumont Newhall, *The History of Photography* (New York: Museum of Modern Art, 1964), p. 114; John Szarkowski, *Looking at Photographs: One Hundred Pictures from the Collection of the Museum of Modern Art* (New York: Museum of Modern Art, 1973), p. 96; Sarah Greenough, *Paul Strand: An American Vision* (Washington, D.C.: Aperture Foundation, in association with the National Gallery of Art, 1990); and Allan Sekula, "The Instrumental Image: Steichen at War," *Artforum* 14 (Dec. 1975): 34.

27. For example, John Pultz and Catherine B. Scallen, *Cubism and American Photography, 1910–1930* (Williamstown, Mass.: Clark Art Institute, 1981), pp. 32, 34.

28. This narrative of the history of photography in the Army Air Service and Steichen's contributions to aerial photography is derived from documents in the National Archives of the United States, Washington, D.C., esp. Record Group 120, the Records of the American Expeditionary Forces, 1917–1923; and Record Group 18, Records of the Army Air Force. Many of these records are organized and reproduced in Col. Edgar S. Gorrell, *History of the Army Air Service,* Microfilm M-990, 58 rolls of 282 bound volumes. Gorrell includes original memos, reports, and cable correspondence as well as narratives written by Sections specifically for the history. Most of the official World War I photographs are in the Still Pictures Branch of the National Archives of the United States, College Park, Md. Hundreds of thousands of similar photographs from that war are in the collections of the Pentagon, Bolling Air

Force Base, and the Air Force Museum in Alexandria, Va. A more detailed study of Steichen's World War I experience and the Photographic Section and quotations from many original documents can be found in my dissertation, "Edward Steichen's Advertising Photography: The Visual Strategies of Persuasion," Boston University, 1988.

29. Because graphic descriptions of American casualties were banned by the censors on the grounds that they "caused needless anxiety" and "foster[ed] the anti-war spirit," World War I photographs are remarkably static. See Susan Moeller, *Shooting War: Photography and the American Experience of Combat* (New York: Basic Books, 1989), pp. 85–152; quotation above from Lt. Col. Kendall Banning, *Military Censorship of Pictures in World War I* (Washington, D.C., ca. 1919–1930), cited in Moeller, p. 136.

For overviews of war photography, see Jorge Lewinski, *The Camera at War: A History of War Photography from 1948 to the Present Day* (New York: Simon and Schuster, 1980); and Frances Fralin and Jane Livingston, *The Indelible Image* (Washington, D.C.: Corcoran Gallery, 1986).

30. In his autobiography Steichen credited his interest in aerial photography to the influence of a British officer, Maj. C. D. M. Campbell, who was sent to Washington to aid the embryonic American efforts (*A Life in Photography,* chapter 5).

31. [Edward J. Steichen], "History of Hdqrs. Office, Photographic Section, Air Service, U.S.A., 1918," p. 7, RG 120, box 3348, National Archives; also Gorrell (as in n. 28), vol. G-1, roll 24, frames 31–39.

32. Maj. Edward J. Steichen, "American Aerial Photography at the Front," *U.S. Air Service* 1 (June 1919): 34.

33. Ibid., p. 36.

34. Szarkowski, *Looking at Photographs* (as in n. 26), p. 70.

35. Steichen, *A Life in Photography,* chapter 5; and Carl Sandburg, *Steichen the Photographer* (as in n. 1), pp. 36–38.

36. Maj. James Barnes, "Photography Section," p. 11, in Gorrell (as in n. 28), vol. G-1, roll 24, frames 14–15; and [Capt. F. F. Christine], "History of the Photographic Supply Section," p. 1, in Gorrell, vol. G-2, roll 24, frame 254.

37. Maj. James Barnes, "Photography Section," p. 18, in Gorrell, vol. G-1, roll 24, frame 21; Maj. Edward J. Steichen, "The Photographic Section, Air Service, A.E.F.," pp. 3–4, in Gorrell, vol. A-16, roll 4, frames 896–897.

38. The tension between Barnes and Steichen probably developed because Barnes was the only photographic officer with a higher rank than Steichen. When the Photographic Section was desperate for officers after Barnes returned to the United States, Steichen convinced Pershing to prevent Barnes's return to Europe, even though Barnes was one of the few experienced officers available (cablegram from Maj. Gen. John J. Pershing to Lt. Col. John S. Sullivan, July 17, 1918, para. 1476-12B, RG 18, series 152, National Archives). Steichen disparagingly described the major's experience: "All he knew about photography was what he had learned on a hunting safari when he made a motion picture of wild animals" (*A Life in Photography,* chapter 5). In his official reports, however, Steichen praised Barnes's "valuable work. . . . The result of his large vision and whole hearted efforts during the early struggle of this service have made themselves clearly felt" (Steichen, "The Photographic Section, Air Service, A.E.F.," p. 3, in Gorrell, vol. A-16, roll 4, frame 896).

39. Lt. W. O. Farnsworth, "The Photographic Section, Headquarters A.C.A.S. [Assistant Chief Air Service], Zone of Advance and First Air Depot," Dec. 20, 1918, p. 4, in Gorrell, vol. A-8, roll 2, frame 1229. These sections should not be confused with the Photo Sections organized in the States.

40. [Steichen], "History of Hdqrs. Office," pp. 1–4, in Gorrell, vol. G-1, roll 24, frames

31–39. In this final report Steichen characteristically pointed out his own contributions and subtly hinted at the lack of recognition for his work sent out under the signature of a higher ranking officer, all the while praising his superior officers: "As the Section was still under the Balloon Section in the organization of the Air Service the more important reports and letters from the Chief [Steichen] were signed by Colonel C. DeF. Chandler, A.S., as Chief of Balloon Section. Col. Chandler's advice and direction on the correct form of military correspondence was of great value as nobody in the Photographic Section had his intimate knowledge of these important matters. Major Steichen was free however to make all decisions on matters of photographic technique and policy, and this resulted in a great increase of power and vitality in the section."

41. [Steichen], ibid., pp. 3–4.

42. This was the title Steichen used in Europe. The personnel records in the Washington office of the Photographic Section listed him as "Officer in Charge of Aerial Photography" (memo from 1st Lt. Hugo J. Odenthal to Executive Officer, Photographic Branch, Feb. 13, 1919, RG 18, series 151, box 4, National Archives).

43. Most of the journalistic reports can be traced back to Carl Sandburg's romantic description of Steichen's World War I service in *Steichen the Photographer* (as in n. 1), pp. 36–37:

Steichen . . . is sent to France with the first group of American air corps as a technical advisor in the organization of the entire aerial photographic service. During the second battle of the Marne he is made chief of the photographic section, placed in command of all the photographic operations in the American sector of the front. General William Mitchell recognizes Steichen's ability and is responsible for his rapid advancement. . . . The photographic section under Captain Steichen's command comprised 55 officers and 1000 troops. Five biplanes made reconnaissances daily, going twenty to twenty-five miles in enemy territory opposite the American sector. A series of photographs was made each day and assembled so as to give a complete picture, from the air, of the enemy terrain occupied or perhaps to be traversed, to troops.

Sandburg's report, which ignores the bureaucratic realities that constituted most of Steichen's war experience, was echoed in "Steichen," *Time,* Dec. 2, 1929, pp. 31–32; Lillian Sabine, "Edward J. Steichen," *Commercial Photographer* (May 1932): 307; and Rosa Reilly, "Steichen—the Living Legend," *Popular Photography* (Mar. 1938): 90.

44. Maj. Edward J. Steichen, "Notes on Aerial Photography," Memo to the Chief of Air Service, Dec. 26, 1918, in Gorrell (as in n. 28), vol. G-1, roll 24, frame 171. Personnel estimates varied. The official final report was 1,111 soldiers, 56 officers (Steichen, "The Photographic Section," pp. 10–11, in Gorrell, vol. A-16, roll 4, frames 903–904. Lt. Farnsworth counted 414 enlisted men and 22 officers in the Zone of Advance (Lt. W. O. Farnsworth, "The Photographic Section," p. 22, in Gorrell, vol. A-8, roll 2, frame 1247.

45. Although some of Steichen's memos make it seem his own idea to preserve a historical photographic record, it was, in fact, one of the priorities of the military. See Timothy K. Nenninger's introduction to Gorrell.

46. Cited in Edgar S. Gorrell, "Brief Review of Work Done by Photographic Section, Air Service, with the A.E.F., Based on the Documents Involved," in Gorrell, vol. G-5, roll 24, frames 653–1035.

47. Capt. Edward Steichen to Chief of Air Service and Col. Edgar S. Gorrell, Nov. 9, 1918, in Gorrell, "Brief Review," ibid., frame 808. The mechanics of this project are de-

scribed in a memo from Steichen to the Chief of Air Service, "Photographic Project," Nov. 20, 1918, pp. 1–2, in Gorrell, "Brief Review," frames 806–807.

48. Capt. Edward J. Steichen, Memo to Chief of Air Service, "Systematic Photo Reconnaissance," July 12, 1918, in Gorrell, vol. G-1, roll 24, frames 198–199; and Steichen, "Notes on Aerial Photography," in Gorrell, ibid., frame 185. Steichen may have been influenced by the Germans, who photographed the entire western front every two weeks.

49. Capt. Edward Steichen, Memo to Chief of Air Service, "Development of Aerial Photography," July 12, 1918, in Gorrell, ibid., frame 196.

50. Steichen, "Notes on Aerial Photography," in Gorrell, ibid., frames 169–170.

51. Lt. W. O. Farnsworth, "The Photographic Section," p. 5, in Gorrell, vol. A-8, roll 2, frames 1226–1248.

52. Maj. Edward J. Steichen, "Aerial Photography: The Matter of Interpretation and Exploitation," Dec. 26, 1918, p. 7, in Gorrell, vol. A-15, roll 4, frame 727. Steichen also envisioned practical peacetime uses of aerial photos: for detailed mapping, natural resource assessment, agriculture, and other "commercial and educational purposes" (Steichen, "American Aerial Photography at the Front" [as in n. 32], p. 39).

53. Steichen, "Notes on Aerial Photography," in Gorrell, vol. G-1, roll 24, frame 168.

54. Steichen, "American Aerial Photography at the Front," p. 34.

55. Steichen, "Notes on Aerial Photography," in Gorrell, vol. G-1, roll 24, frame 195.

56. Steichen, "American Aerial Photography at the Front," p. 34.

57. Two of these aerial photographs are discussed in Szarkowski, *Looking at Photographs* (as in n. 26), pp. 70–73. Additional photographs that found their way from Steichen's collection to the auction block are discussed in Sekula, "The Instrumental Image" (as in n. 26), pp. 26–35. Sekula argues forcefully that Steichen's gift to the Museum of Modern Art and later auctions from Steichen's collection represent a modernist appropriation and aestheticizing of these technological images solely because of their origin in Steichen's collection. The Metropolitan Museum of Art has complicated the issue by publishing an aerial photograph (incorrectly) attributed to Steichen, making it seem that they would not have included such an image in a major catalogue unless attributed to a well-known photographer. See Maria Morris Hamburg, *The New Vision: Photography between the World Wars. The Ford Motor Company Collection at the Metropolitan Museum of Art* (New York: Metropolitan Museum of Art and Abrams, 1989), p. 20.

58. Steichen, "American Aerial Photography at the Front," p. 39 (emphasis mine).

59. Edward Steichen, "Photography: Witness and Recorder of Humanity," *Wisconsin Magazine of History* 41 (spring 1958): 159. Steichen describes how during his tenure at the Museum of Modern Art's Photography Department he searched for yet-uncatalogued aerial photographs from World War I: "Here was the kind of history of the war that could not be duplicated. Yet no one knows what became of all those photographs! I know they were packed carefully, section by photographic section with a record of the work of each, and they were shipped to Washington. But since then, no one has been able to find them. They may not be lost: they may turn up in some warehouse someplace, molded, or rotted, or bleached. But it is of importance to historians—a responsibility of historians—to see that such valuable documents are preserved" (159–160). The photographs were catalogued in the 1960s and are now accessible through the Still Pictures Branch of the National Archives.

60. Maj. Edward J. Steichen, "The Photographic Section, Air Service, A.E.F.," p. 10, in Gorrell (as in n. 28), vol. A-16, roll 4, frame 903.

61. Ibid.

62. Margaret Case Harriman, a staff member of *Vanity Fair*, recalled that Steichen, when

he came to the magazine in 1923, "was often spoken of as Colonel Steichen, a title he attained in the American Army during the War. We didn't know whether to address him as Colonel Steichen (American), or as '*Monsieur, le colonel,*' to account for the Edouard. . . . As soon as we saw Steichen, there was no longer any confusion. . . . As for the 'Colonel' business, Steichen never mentioned it; he was too busy doing the next thing to think much about the War that was over" (Harriman, "Steichen," *Vogue,* Jan. 1, 1938, p. 37). Despite this assertion, Steichen did encourage use of the military title in the 1920s and 1930s. Matthew Josephson reported that Steichen listed himself in the Manhattan telephone book as "Steichen, Col. Edward J." until around 1941, and Noel H. Deeks, Steichen's darkroom assistant in the 1930s, remembered that "'Colonel' was how all the members of his staff addressed him." See Josephson, "Profiles: Commander with a Camera," part 1, *New Yorker,* June 3, 1944, p. 34; and letter from Deeks to Grace Mayer, May 30, 1972, Edward Steichen Archives, Museum of Modern Art.

63. Steichen's marital problems made the headlines when he sued his wife for taking art and antiques, and she countersued with an alienation-of-affections charge against a prominent New York socialite (who turned out to be the wrong woman) (*New York Times,* Nov. 9, 1920, p. 17, and Dec. 8, 1920, p. 22). See also Niven, *Sandburg* (as in n. 1), pp. 354, 371–372.

64. Letter from Lt. William D. Wheeler to Capt. Albert Stevens, Nov. 12, 1919, RG 18, series 151, National Archives. Steichen's address upon discharge was the Camera Club, 121 West Sixty-eighth Street, New York. Most of his letters written in the United States from the end of his service until 1923 list the club as his return address.

65. Steichen, *A Life in Photography* (as in n. 1), chapter 5.

66. Sandburg, *Steichen the Photographer* (as in n. 1), pp. 38–40.

67. On the technical aspects of Steichen's photography between the wars, see Ralph Steiner, "Steichen's Secret Formula," *Camera Arts* 1 (July–Aug. 1981): 109; Nicholas Haz, "Steichen," *Camera Craft* (Jan. 1936): 4; and Gilbert I. Stodola, "Colonel Steichen Talks to Students," *American Photography* 18 (Apr. 1924): 217–218.

68. Sandburg, *Steichen the Photographer,* p. 40.

69. Steichen, *A Life in Photography,* chapter 5.

70. Letter from Edward Steichen to Lilian Steichen Sandburg, ca. 1920, Carl Sandburg Collection (as in n. 1).

71. Letter from Edward Steichen to Lilian Steichen Sandburg, 1922, ibid.

72. In 1923 Steichen told Paul Strand that he was "sick and tired of being poor" and was going to join Condé Nast Publications for two years of commercial photography, then return to Voulangis to paint. Paul Strand told this to Grace Mayer in 1974 (memo in the Steichen Archives).

CHAPTER TWO

1. This summary of social and cultural conditions in the 1920s is based on Frederick Lewis Allen's *Only Yesterday: An Informal History of the 1920s* (New York: Harper and Row, 1931; rpt., 1964).

Michael Schudsen has succinctly analyzed the literature on emerging consumerism and the various claims for its beginnings, which range from the late eighteenth century to after World War II. See his *Advertising, the Uneasy Persuasion: Its Dubious Impact on American Society* (New York: Basic Books, 1984), p. 268 n.1 and pp. 178–179 and his bibliography.

2. Alfred D. Chandler, Jr., *The Visible Hand: The Managerial Revolution in American Business* (Cambridge: Harvard University Press, Belknap Press, 1977), pp. 464–468, 499–500.

3. Ibid., pp. 79–239; Chandler comprehensively describes the development of modern business structures. Susan Strasser describes the emergence of modern retailing in *Satisfaction Guaranteed: The Making of the American Mass Market* (New York: Pantheon, 1989).

4. Chandler, *The Visible Hand*, pp. 285–344, 450–456, 499. Chandler notes the Sherman Anti-Trust Act helped concentrate capital because it encouraged incorporations as a legal alternative to the prohibited cartels, yet the law generally kept this oligopolistic state of affairs from developing into literal monopoly capitalism.

5. On the impact of the Ford Motor Company's modernism on the visual arts, see Terry Smith, *Making the Modern: Industry, Art, and Design in America* (Chicago: University of Chicago Press, 1993).

6. See Harry Braverman, *Labor and Monopoly Capital: The Degradation of Work in the Twentieth Century* (New York: Monthly Review Press, 1974); on the impact of scientific management, see pp. 85–123, esp. p. 114.

7. Chandler, *The Visible Hand* (as in n. 2), pp. 473–476 and 233–236. Literature on these mergers and chain stores proliferated as well. For example, see John Allen Murphy, *Merchandising through Mergers* (New York: Harper, 1930); William R. Basset, *Operating Aspects of Industrial Mergers* (New York: Harper, 1930); and William J. Baxter, *Chain Store Distribution and Management* (New York: Harper, 1928). The trade paper *Chain Store Age* was published through the 1930s, and the advertising press actively covered attempts to regulate chain stores; see, for example, "Anti-Chain Laws," *Tide* 10, no. 4 (July 1936): 26–27; "Chain's Case," *Tide* 7, no. 4 (Apr. 1933): 19–20; and "Chains and Taxes," *Tide* 7, no. 1 (Jan. 1933): 15–16.

8. Roy Durstine, *This Advertising Business* (New York: Scribner, 1928), p. 35.

9. Donald C. Foote, "More Readers for Fewer Newspapers," *JWT News Letter* 10, no. 17 (1928): 3 and no. 141 (July 15, 1926): 171–172. See also Theodore Peterson, *Magazines in the Twentieth Century* (Champaign-Urbana: University of Illinois Press, 1956); Frank Luther Mott, *A History of American Magazines*, 5 vols. (Cambridge: Harvard University Press, 1930–1968); and Cynthia L. White, *Women's Magazines, 1693–1968* (London: Michael Joseph, 1970).

10. "Is the Pen Mightier Than the Camera?" *JWT News Letter*, no. 184 (July 15, 1927): cover.

11. In a total of 131 campaigns, in magazines, 29 used drawings only, 47 used photographs only, 4 had a drawing as the main illustration with a photograph as a minor element, 10 had a photograph as the main illustration with a drawing as a minor element; in newspapers, 18 used drawings only, 20 used photographs only, none had a drawing as the main illustration with a photograph as a minor element, and 3 had a photograph as the main illustration with a drawing as a minor element. The lower ratios in newspapers were due to the much poorer quality of reproduction (Gordon C. Aymar, "An Analysis of Our New York Office Present Use of Drawings and Photographs," *JWT News Letter* [July 15, 1929]: 3).

12. *JWT News* (Apr. 1930): 2.

13. Richard W. Pollay, "The Subsiding Sizzle: A Descriptive History of Print Advertising, 1900–1980," *Journal of Marketing* 49 (summer 1985): 29.

14. References to Steichen in popular magazines gave him a widespread reputation prior to his commercial career. For example, see Charles H. Caffin, "Progress in Photography (With Special Reference to the Work of Eduard J. Steichen)," *Century Magazine* 75, no. 4 (Feb. 1908): 482–498; "We Nominate for the Hall of Fame," *Vanity Fair* (Jan. 1918): 48, and (Oct. 1924): 69.

15. On the neutrality and transparency of the image, see John Tagg, *The Burden of Representation: Essays on Photographies and Histories* (Amherst: University of Massachusetts

Press, 1988), esp. pp. 98–99; and Allan Sekula, "On the Invention of Photographic Meaning" (1974), reprinted in *Photography against the Grain: Essays and Photo Works, 1973–1983* (Halifax: Press of the Nova Scotia College of Art and Design, 1984), esp. p. 6.

16. On the professionalization of advertising, see Daniel Pope, *The Making of Modern Advertising* (New York: Basic Books, 1983); and Quentin J. Schultze, "Advertising, Science, and Professionalism, 1885–1917," Ph.D. diss., University of Illinois, 1978.

17. *Digest of Principal Research Departmental Studies, Volume I (1911–1925)* (Philadelphia: Curtis Publishing Company, 1946), p. 4; and Ralph Hower, *The History of an Advertising Agency: N. W. Ayer and Son at Work, 1869–1949*, 2d ed. (Cambridge: Harvard University Press, 1949), p. 301; see also Strasser, *Satisfaction Guaranteed* (as in n. 3), pp. 124–161.

18. On Starch's work as an academic psychologist, see Chapter 4. Starch later became director of research at the American Association of Advertising Agencies before starting his own consulting company in 1932. Gallup completed his dissertation at the State University of Iowa in 1928 on methods of determining reader interest in the content of newspapers; he discovered that readers preferred pictures to written copy. He began his career as a professor of advertising and journalism at Drake University in Des Moines and then moved to Northwestern University, where he conducted research on audience memory of advertising appeals. As director of research at the advertising firm of Young and Rubicam he developed methods of opinion polling, afterward establishing his business as a political pollster. For further information on Gallup's research, see Jean M. Converse, *Survey Research in the United States: Roots and Emergence, 1890–1960* (Berkeley and Los Angeles: University of California Press, 1987); and Stephen Fox, *The Mirror Makers: A History of American Advertising and Its Creators* (New York: Morrow, 1984), pp. 127, 138–139.

Hotchkiss, a copywriter with the George Batten Company from 1912 to 1914, started the Department of Advertising and Marketing at New York University in 1915. With R. B. Francken, a professor of psychology at NYU, he published *The Measurement of Advertising Effects* (New York: Harper, 1927).

Borden wrote on the economics of advertising and marketing strategies and developed the Harvard Advertising Awards, which were bestowed from 1924 to 1930 for an advertisement's effectiveness rather than its aesthetics. Borden believed that better writing and art increased effectiveness. In his *Problems in Advertising* (Chicago: A. W. Shaw Company, 1927), which presented numerous case studies of advertising used to stimulate demand, he developed empirical methods to verify effectiveness.

19. Examples of Progressive Era reform surveys include Charles Booth's social surveys of London (1889–1903), B. Seebohm Rowntree's study of York (published 1901), the *Hull House Maps and Papers* (Chicago, published 1895), W. E. B. Du Bois's study of the Philadelphia Negro (published 1899), and the Pittsburgh Survey (published 1914). For an analysis of the methodology of these early surveys and an overview of the development of public opinion surveys, see Converse, *Survey Research*, pp. 11–25.

20. Perhaps the best-known exponent was Harvard's Hugo Muensterberg, who wrote the pathbreaking text *Psychology and Industrial Efficiency* (Boston: Houghton Mifflin, 1913). Others soon followed: Lillian E. M. Gilbreth, *The Psychology of Management: The Function of the Mind in Determining, Teaching, and Installing Methods of Least Waste* (New York: Sturgis and Walton, 1914); George R. Eastman, *Psychology for Business Efficiency* (Dayton, Ohio: Service Publishing Company, 1916); James Drever, *The Psychology of Industry* (New York: Dutton, 1921); Donald A. Laird, *The Psychology of Selecting Men* (New York: McGraw-Hill, 1927); Harold E. Burtt, *Psychology and Industrial Efficiency* (New York: Appleton, 1929).

21. On the state of psychology during World War I, see Kerry W. Buckley, *Mechanical Man: John Broadus Watson and the Beginnings of Behaviorism* (New York: Guilford Press, 1989), pp. 85–120.

22. Dorothy Ross, *The Origins of American Social Science* (New York: Cambridge University Press, 1991), pp. 219–256, 311, 388, 400, 471.

23. Converse, *Survey Research* (as in n. 18), pp. 38, 43, 54.

24. Ross, *The Origins of American Social Science,* pp. 405, 429.

25. James Webb Young, *The Diary of an Ad Man* (Chicago: Advertising Publishing, 1944), p. 130.

26. Converse, *Survey Research,* pp. 91, 441 n.5. Converse believes that later researchers, who sought to distinguish their own work, underestimated the achievements of the early market researchers.

27. Charles Goodrum and Helen Dalrymple, *Advertising in America: The First Two Hundred Years* (New York: Abrams, 1990), pp. 12–33.

28. Daniel Starch, "What Makes an Advertisement Sell Goods?" *Advertising and Selling,* Nov. 27, 1929, p. 57. The survey was conducted by Henry L. Doherty and Company in 1929. A survey a decade before had concluded that photos and drawings were about equal in attention value; see George B. Hotchkiss and R. B. Franken, *The Attention Value of Advertisements* (New York: New York University Bureau of Business Research, 1920), p. 31. The 1903 survey is described in Jackson Lears, *Fables of Abundance: A Cultural History of Advertising in America* (New York: Basic Books, 1994), p. 211.

29. Young, *The Diary of an Ad Man,* p. 139.

30. *JWT News* (Apr. 1930): 2; and "History of Jergens Lotion," unpublished ms., 1926, JWT Archives; Carroll Rheinstrom, *Psyching the Ads: The Case Book of Advertising* (New York: Covici Friede, 1929), pp. 37–39.

31. *JWT News* (Apr. 1930): 2.

32. Steichen typically received $500 for a photograph; Helen Dryden, for her drawings for the Lux toilet soap campaign of 1927–28 received an average of about $800 per advertisement (Report of Mr. [William] Esty, "Minutes of the Representatives Meetings," Sept. 19, 1928), JWT Archives. A pamphlet entitled *Camera,* produced by N. W. Ayer and Son in 1929 to solicit new business, advocated black-and-white photography to save on reproduction costs. It contended that the photograph's "realism" more than compensated for the lack of immediacy without color.

33. For a comprehensive history of the technology, see Jacob Kainen, "The Development of the Halftone Screen," *Smithsonian Report for 1951,* pp. 409–425 (rpt., Washington, D.C.: Government Printing Office, 1952), publication 4081. For the development of photomechanical reproduction technology in the nineteenth century, see Estelle Jussim, *Visual Communication and the Graphic Arts: Photographic Technologies in the Nineteenth Century* (New York: R. R. Bowker, 1974; rpt., 1983).

34. On fashion photography, see Nancy Hall-Duncan, *The History of Fashion Photography* (Rochester and New York: International Museum of Photography at George Eastman House and Alpine Press, 1979); and Polly Devlin, *Vogue Book of Fashion Photography, 1919–1979* (New York: Simon and Schuster, 1979).

35. Hower, *The History of an Advertising Agency* (as in n. 17), p. 319; Frank Presbrey, *The History and Development of Advertising* (1929; rpt., New York: Greenwood Press, 1968), p. 387.

36. *Advertising and Selling,* May 14, 1930, p. 94. Michael Schudson, in *Advertising: The Uneasy Persuasion,* has written of the frequency with which contemporary advertisements refer to American life and values, thus promoting "patriotic sentiment" and capitalist

values (as in n. 11), pp. 219–221. Advertising for patriotism has a long history; see George R. Creel, *How We Advertised America* (New York: Harper, 1920).

37. Matthew Josephson, "The Great American Billposter," *Broom* 3 (Nov. 1922): 304–312; H. A. L. [Harold A. Loeb], "The Mysticism of Money," *Broom* 3 (Sept. 1922): 115–130; and Matthew Josephson, "Henry Ford," *Broom* 5 (Oct. 1923): 137–142. Other articles, however, such as Malcolm Cowley's "Portrait by Leyendecker," *Broom* 4 (Mar. 1923): 240–247, satirized the pervasiveness of advertising in American culture. See also Susan Fillin Yeh, "Charles Sheeler: Industry, Fashion, and the Vanguard," *Arts Magazine* 54 (Feb. 1980): 158.

38. Lillian Sabine, "Edward J. Steichen," *Commercial Photographer* (May 1932): 312.

39. Hower, *The History of an Advertising Agency* (as in n. 17), pp. 622–632.

40. Egbert G. Jacobson, foreword to *Annual of Advertising Art in the United States* 1 (1921): ix.

41. W. H. Beatty, foreword to *Annual of Advertising Art* 6 (1927): n.p.; and Ben Nash, "What Business Asks of the Artist," *Annual of Advertising Art* 5 (1926), n.p.

42. "Art Directors' Club," *Annual of Advertising Art in the United States* 1 (1921): n.p. There was at least one precedent. In 1908 Earnest Elmo Calkins, of the National Arts Club of Gramercy Park, had organized what was probably the first exhibition of advertising art. Although it was conceived as an annual demonstration that high aesthetic quality promoted sales, no other exhibitions followed until the New York Art Directors' Club started their series. See Calkins, foreword to Frank H. Young, *Modern Advertising Art* (New York: Covici Friede, 1930), pp. 9–12; and Calkins, "Exhibition of Advertising Art," *International Studio* (May 1908): cix–cxi.

43. Letter from Cynthia Swank, JWT Archivist, to the author, Nov. 17, 1986. After De Vries's departure in 1925 the staff at the New York office consisted of Aymar and Johnson plus two associate art directors, John Tarleton and Clarence Beckman, and the studio manager, Frayser Childrey (*JWT News Letter*, no. 90 [July 23, 1925]: 1). For complete documentation of the professionalization in one agency, see Hower, *The History of an Advertising Agency* (as in n. 17). In Birgit Wassmuth's chronology of the development of art departments, "art managers" appear at the Lord and Thomas agency around 1880. By the 1920s all agencies employed art directors; courses in graphic design and commercial art were instituted at Cooper Union and the New York School of Fine and Applied Art; and a number of texts on advertising art were published (Birgit Wassmuth, "Art Movements and American Print Advertising: A Study of Magazine Advertising Graphics, 1915–1935," Ph.D. diss., University of Minnesota, 1983).

44. *JWT News Letter* (Apr. 15, 1929).

45. Calkins, foreword (as in n. 42), pp. 9–11.

46. Edward Steichen, "Photography," *Proceedings of the Conference on Photography* (New London, Conn.: Institute of Women's Professional Relations, 1940), p. 11; Sabine, "Edward J. Steichen" (as in n. 38), p. 312.

47. Merle Thorpe, foreword to *Annual of Advertising Art* 10 (1931), n.p.

48. Quoted in Hower, *The History of an Advertising Agency* (as in n. 17), p. 155.

49. For a typical defense of the indefensible, see the discussion of the Scott tissue campaign, Chapter 9.

50. Lears sees the educational theme in advertising ideology as strongest from the 1890s through the 1920s (T. J. Jackson Lears, "The Uses of Fantasy: Toward a Cultural History of American Advertising, 1880–1930," *Prospects* 9 [1984]: 363).

51. Ann Uhry Abrams dissents from the view that aesthetic quality improved in com-

mercial art. Arguing that it was higher at the turn of the century than in the 1920s, she blames the downturn on an overreliance on scientific theories of persuasive composition and pictorial elements. Abrams's study considers drawn illustrations, not photography. Perhaps more innovative campaigns turned to photographic illustration whereas conservative campaigns stayed with traditional forms of advertising illustration. See Ann Uhry Abrams, "From Simplicity to Sensation: Art in American Advertising, 1904–1929," *Journal of Popular Culture* 10 (winter 1976): 627.

52. Presentation of Edward Steichen, "Minutes of the Representatives Meetings," Jan. 31, 1928, pp. 2–3, JWT Archives. For another Michelangelo reference, see Carl Sandburg, *Steichen the Photographer* (New York: Harcourt, Brace, 1929), pp. 51–52. E. E. Calkins also used the analogy; see Lears, *Fables of Abundance* (as in n. 28), p. 313.

53. Sandburg, ibid.

54. For example, see Lillian Sabine, "Edward J. Steichen" (as in n. 38), pp. 307–313; E. M. K., "Steichen: The Painter Who Found Fame with the Camera," *Photography* 3 (June 1935): Clare Boothe Brokaw, "Edward Steichen, Photographer," *Vanity Fair* (June 1932): 49, 60, 70; and Edward Steichen, "Commercial Photography," in *Annual of American Design, 1931* (New York: Washburn, 1931), pp. 157–159.

55. Sandburg, *Steichen the Photographer,* pp. 9–13, 25, 30–31, 34, 46–47. Sandburg almost certainly inflated Steichen's fees for greater impact.

56. Steichen, quoted in ibid., p. 55.

57. Ibid., p. 53.

58. Interview with Cynthia Swank, JWT Archivist, Oct. 1986. Steichen was pleased with the book and felt Sandburg presented his positions accurately (letter from Steichen to Carl Sandburg, ca. 1928, Carl Sandburg Collection, University of Illinois at Urbana-Champaign, photocopy in the Edward Steichen Archives, Museum of Modern Art, New York).

59. Sandburg, *Steichen the Photographer,* p. 51.

60. Edward Steichen, *A Life in Photography* (Garden City, N.Y.: Doubleday, 1963; rpt., New York: Bonanza Books, 1984), chapter 9.

61. Since Steichen and Edward Weston chose the American selections for *Film und Foto,* they probably represented what Steichen considered his most significant recent production. The omission of Stieglitz and Strand from the American section illustrates how factionalized American photography had become (see Chapter 7). A photocopy of the catalogue for *Film und Foto: Internationale Ausstellung des Deutschen Werkbunds,* May 19–July 7, 1929, is in the Edward Steichen Archives, Museum of Modern Art, New York. See also Beaumont Newhall, "Photo Eye of the 1920s: The Deutsche Werkbund Exhibition of 1929," *New Mexico Studies in the Fine Arts* 2 (1977): 5–12. A photocopy of the catalogue for *Exposition Internationale de la Photographie Contemporaine,* Musée des Arts Décoratifs, Paris, Jan. 16–Mar. 1, 1936, is in the Edward Steichen Archives. George Boas's essay "Steichen's Camera" appears in the catalogue for the exhibition *Edward Steichen,* Baltimore Museum of Art, June 1–30, 1938.

62. Presentation of Edward Steichen (as in n. 52), p. 10. The gold frame reference can also be found in Steichen, "Commercial Photography" (as in n. 54). Many years later Steichen repeated the criticism and the phrase in *A Life in Photography,* chapter 5.

63. Presentation of Edward Steichen, ibid., pp. 5–8.

64. For an analysis of the significance and influence of White's school, see Bonnie Yochelson, "Clarence H. White Reconsidered: An Alternative to the Modernist Aesthetic of Straight Photography," *Studies in Visual Communication* 9 (fall 1983): 24–44. For additional infor-

mation on White's students, see John Pultz and Catherine B. Scallen, *Cubism and American Photography, 1910–1930* (Williamstown, Mass.: Clark Art Institute, 1981), pp. 41–49; and Lucinda Barnes, ed., *A Collective Vision: Clarence H. White and His Students* (Long Beach, Calif.: California State University Art Museum, 1985).

65. Pamphlet "Art Center 1926," cited in Yochelson, ibid., p. 28. The Art Center housed seven local arts and crafts organizations: the Art Alliance, the American Institute of Graphic Arts, the Pictorial Photographers of America, the Society of Illustrators, the Art Directors' Club, the New York Society of Craftsmen, and the Stowaways. See Michele H. Bogart, *Artists, Advertising, and the Borders of Art* (Chicago: University of Chicago Press, 1995), p. 133.

66. Steichen spoke at the White School on Feb. 15, 1923, according to miscellaneous school notes in White's archives at Princeton University; cited in Yochelson, "Clarence H. White Reconsidered," pp. 27, 28, 30 n.44, 43. My assumptions of the content of this talk are based on a study of Steichen's many public talks in the 1920s, which almost always included two themes: the necessity for straight photography and the validity of commercial photography. For example, see Henry Hoyt Moore, "Pictorial Photographers of America," *Bulletin of the Art Center* 1 (Apr. 1923): 163–165; "March Meeting of the P. P. of A.," *Photo-Era Magazine* (Apr. 1923): 229; and Gilbert I. Stodola, "Colonel Steichen Talks to Students," *American Photography* 18 (Apr. 1924): 214–218. All of the reports on Steichen's talks were written in reverential tones, indicating his stature in the field.

67. "The Clarence H. White School of Photography," *Commercial Photographer* (Apr. 1932): 277–278.

68. For further information on Bauhaus photography, see Roswitha Fricke, ed., *Bauhaus Photography* (Cambridge: MIT Press, 1986); Suzanne E. Pastor, *Photography and the Bauhaus* (Tucson: Center for Creative Photography, University of Arizona, 1985); Arthur A. Cohen, *Herbert Bayer: The Complete Work* (Cambridge: MIT Press, 1984); Maud Lavin, "Ringl + Pit: The Representation of Women in German Advertising, 1929–1933," *Print Collector's Newsletter* 16 (July–Aug. 1985): 89–93; and Eleanor M. Hight, *Picturing Modernism: Moholy-Nagy and Photography in Weimar Germany* (Cambridge: MIT Press, 1995).

69. John Heskett, *Industrial Design* (New York: Thames and Hudson, 1980), pp. 94–100.

70. As John Tagg has pointed out, the status of the medium of photography at any one time is particular to the attitudes and tensions of the historical moment. (Tagg, *The Burden of Representation* [as in n. 15], pp. 18–19.)

71. Ralph Steiner, *A Point of View* (Middletown, Conn.: Wesleyan University Press, 1978), p. 16.

72. Thomas Erwin, foreword to *Annual of Advertising Art* 11 (1932), n.p.

73. Report of William Day, "Minutes of the Representatives Meetings," Mar. 26, 1932, p. 17, JWT Archives. For more information on Day, see George H. Allen, "Gallery . . . William L. Day," *Advertising and Selling*, Nov. 10, 1932, pp. 19, 58, 59.

74. Charles T. Coiner, "Recollections of Ayer," oral history interview by Howard L. Davis and F. Bradley Lynce, Mar. 16, 1982, N. W. Ayer and Son Archives, New York.

75. Gordon Aymar, *An Introduction to Advertising Illustration* (New York: Harper, 1929), pp. 18–19.

76. George Butler, "Bush House, Berlin, and Berkeley Square: George Butler Remembers JWT, 1925–1962," p. 6, unpublished ms., JWT Archives.

77. Steiner, *A Point of View* (as in n. 71), p. 16.

78. Erwin, foreword (as in n. 72).

79. Report of William Day, "Minutes of the Representatives Meetings," June 4, 1930, p. 6, JWT Archives.

80. Report of Mr. Whitney, "Minutes of the Representatives Meetings," Dec. 23, 1930, p. 7, JWT Archives. Whitney was an art director at JWT from 1928 to 1943; he was head art director when he resigned to join Foote, Cone and Belding.

81. The trade press's greater attention to copy than to artwork has been perpetuated in most current American Studies scholarship, which has analyzed text strategy more closely and extensively than pictorial narrative. The idea that advertising art only documents or implements a copywriter's concept or idea has also been perpetuated in contemporary photographic history. For instance, John Szarkowski has written that even the best advertising photographs can be only demonstrations of skill: "Advertising . . . is a rigidly conceptual art. The poetry, such as it is, is in the idea. The execution, whether skillful and elegant or amateurish and lumpen, is only documentation" (Szarkowski, *Irving Penn* [New York: Museum of Modern Art, 1984], p. 33).

CHAPTER THREE

1. Letter from Stanley Resor to the Honorable A. L. Gates, Assistant Secretary of the Navy for Air, Jan. 16, 1942, photocopy in the Edward Steichen Archives, Museum of Modern Art, New York.

2. Cynthia G. Swank, "Some Basic Roots of the J. Walter Thompson Company," pp. 1–2, unpublished ms., rev. 1985, JWT Archives. Helen Resor began as a copywriter in the Cincinnati office of JWT in 1907. She came to the New York office in 1911; the Resors married in 1917. For further information about the Resors, see George H. Allen, "This Man Resor," *Advertising and Selling*, Nov. 25, 1931, pp. 20, 21, 57; "J. Walter Thompson Company," *Fortune* (Nov. 1947): 94–101, 202, 205–206; and Stephen Fox, *The Mirror Makers: A History of American Advertising and Its Creators* (New York: Morrow, 1984), pp. 79–94.

3. Letter from Earle Clark, treasurer of JWT, to Edward Steichen, Dec. 6, 1923, photocopy in the Steichen Archives; and Cynthia G. Swank, "Synopsis of Steichen Contracts," unpublished ms., 1986, JWT Archives.

4. "History of Jergens Lotion," unpublished ms., 1926, p. 4, JWT Archives.

5. Steichen's contracts ended in 1931; perhaps not enough work was developing because of either his high prices or the depression. A Jan. 27, 1928, memo from Howard Kohl to Earle Clarke mentions "additional work which Mrs. Resor feels she may be able to get for Mr. Steichen." Helen Resor also arranged for Steichen to take photographs for a number of her favorite charities: the New York Post-Graduate Hospital (1929), Manhattan Eye, Ear and Throat Hospital (1931), Travelers Aid Society (1932), and the Federation of Jewish Philanthropies (1935). Memos in Nov. 1929 and Nov. 1931 state that Steichen would do "work . . . in the office." He agreed to make "several photographs of our office, the cost of these photographs to apply on the 1931 contract" (Cynthia Swank, "Synopsis of Steichen Contracts").

Steichen supposedly boasted that his annual income from advertising alone topped $50,000 in the 1920s. The only corroboration I have found for this amount in the archives is a letter written by Stanley Resor to A. L. Gates (as in n. 1) in support of Steichen's application for a naval commission during World War II: "Some years ago over a period of years we paid Edward Steichen $40,000 a year for his exclusive services for that type of photography. This was only one of a number of sources of income he enjoyed at that time. He was then and is now in a class by himself in the field of photography—both nationally and internationally." I am grateful to Grace Mayer for bringing this letter to my attention.

6. George Butler, "Bush House, Berlin, and Berkeley Square: George Butler Remembers JWT, 1925–1962," unpublished ms., p. 7, JWT Archives.

7.	George Butler, Aymar's assistant during his year at JWT's London office, remembered him as a "sweet man" but said, "He didn't like modern art, I did" (quoted in ibid., p. 19). In 1930, Aymar left JWT for the Blackman Company (see *Advertising and Selling,* Sept. 3, 1930, p. 65). During the 1930s he wrote and designed a number of books on his interests and hobbies, such as *Bird Flight* (New York: Dodd, Mead, 1935) and *A Pictorial Primer of Yacht Racing Rules and Tactics* (New York: Kennedy Brothers, 1938). In the 1950s he retired from graphic design to pursue a full-time career as a portrait painter.

8.	Gordon Aymar, "Steichen—an Artist," *JWT News Letter,* no. 187 (Sept. 1, 1927): 374.

9.	Ibid., p. 376.

10.	*JWT News Letter* 10, New Office Special Edition (Apr. 1928): 2.

11.	Presentation of Edward Steichen, "Minutes of the Representatives Meetings," Jan. 31, 1928, p. 11, JWT Archives.

12.	Gordon Aymar, "$500 for a Photograph?" *Advertising Arts* (Sept. 1931): 49–55.

13.	Presentation of Edward Steichen (as in n. 11), p. 5.

14.	Ibid.

15.	Lillian Sabine, "Edward J. Steichen," *Commercial Photographer* (May 1932): 312. Steichen's concern with the financial value of photography predates his entry into the field of commercial art. In a review of the 1900 Royal Salon in London, Steichen defended the prices artists asked for their works. See Eduard J. Steichen, "British Photography from an American Point of View," *Amateur Photographer* (London), Nov. 2, 1900, pp. 343–345.

16.	Information on this campaign is derived primarily from the "History of Jergens Lotion," unpublished ms., 1926, and two reports by Ruth Waldo, who was later in charge of the Jergens campaign in the agency, in "Minutes of the Representatives Meetings," Oct. 6, 1931, pp. 1–10, and Oct. 26, 1932, pp. 1–6, JWT Archives. Steichen reportedly associated himself with the product to the extent that he named the artificial pond on his Connecticut estate Jergens Lotion, after the people who, he said, had paid for it (interview with Grace Mayer, Dec. 1986).

17.	"Minutes of the Representatives Meetings," Oct. 6, 1931, p. 4.

18.	"History of Jergens Lotion," p. 3.

19.	Ibid.

20.	Ibid., p. 4.

21.	"A Sheaf of Current Advertising Winnowed by a Critic" from *Advertising World* (London), quoted in *JWT News Letter,* no. 80 (May 14, 1925): 5.

22.	"History of Jergens Lotion," p. 3.

23.	See, for example, JWT's *Population and Its Distribution,* first published in 1912 and periodically revised, and N. W. Ayer's annual directory of media outlets and circulation figures, first published in 1910. On the history of American magazines and the demographics of their readership, see Mary Ellen Zuckerman, comp., *Sources on the History of Women's Magazines, 1792–1960: An Annotated Bibliography* (Westport, Conn.: Greenwood Press, 1991); and John A. Lent, comp., *Women and Mass Communications: An International Annotated Bibliography* (Westport, Conn.: Greenwood Press, 1991).

24.	Phillips Wyman, *Magazine Circulation: An Outline of Methods and Meanings* (New York: McCall Company, 1937), p. 6.

25.	Roland Marchand, *Advertising the American Dream: Making Way for Modernity, 1920–1940* (Berkeley and Los Angeles: University of California Press, 1985), pp. 64–65.

26.	Report of Mr. J. Esty, "On the Duplication of Magazine Circulation," "Minutes of the Representatives Meetings," July 21, 1931, p. 3, JWT Archives. In a survey of newspaper

circulation in White Plains, N.Y., JWT classified people into "our regular A, B, C, D grouping" on the basis of "apparent income and standard of living" because they had not developed a "satisfactory scheme using profession or home value." The "very wealthy" A group could afford expensive luxuries. The D group included "poorer families represented by day laborers and foreigners." The target for advertising became "the intermediate B and C classes, with the B class starting just above the level of the skilled workman" ("Minutes of the Representatives Meetings," Nov. 29, 1927, p. 4, JWT Archives). The trade press periodically assessed the buying power of African-Americans. See, for example, "Negro Market," *Tide* 9, no. 2 (Feb. 1935): 20; and "Negro Press," *Tide* 7, no. 6 (June 1933): 19–20.

27. "City A and City B," *Digests of Principal Research Department Studies: Volume II, 1926–1940* (Philadelphia: Curtis Publishing Company, 1946), pp. 8, 22.

28. For example, *Tide* 10, no. 1 (Jan. 1936): 57, and 9, no. 12 (Dec. 1935): 51.

29. *Tide* 8, no. 7 (July 1934): 55, and 9, no. 2 (Feb. 1935): 31.

30. *Tide* 8, no. 8 (Aug. 1934): 33, and 8, no. 2 (Feb. 1934): 77.

31. Marchand, *Advertising the American Dream* (as in n. 25), pp. 52–87.

32. From *Advertising and Selling Fortnightly,* quoted in *JWT News Letter,* no. 52 (Nov. 6, 1924): 1–2.

33. "A Sheaf of Current Advertising" (as in n. 21), p. 5.

34. Advertising schedules are accessible in the Jergens lotion records, microfilm reel 13, JWT Archives.

35. Ruth Schwartz Cowan, "Two Washes in the Morning and a Bridge Party at Night: The American Housewife between the Wars," *Women's Studies* 3 (1976): 150–151. See also her book *More Work for Mother: The Ironies of Household Technology from the Open Hearth to the Microwave* (New York: Basic Books, 1983). Other histories of housework in this period include Susan Strasser, *Never Done: A History of American Housework* (New York: Pantheon Books, 1982); and Glenna Matthews, *"Just a Housewife": The Rise and Fall of Domesticity in America* (New York: Oxford University Press, 1987).

36. "History of Jergens Lotion" (as in n. 4), pp. 3–4.

37. Agency personnel, however, continued to insist the product never developed the individuality they could have built for it by radically restructuring it with a completely different name and product class ("Minutes of the Representatives Meetings," Oct. 6, 1931, pp. 3, 6, JWT Archives).

38. Linda Nochlin, *Realism* (New York: Penguin Books, 1971), pp. 13–14.

39. Raymond Williams, *Keywords: A Vocabulary of Culture and Society* (New York: Oxford University Press, 1976), p. 220.

40. Nochlin, *Realism,* pp. 33–34.

41. Because form and content are not always clearly separated in discussions of the development of realism in advertising, scholars have differed in their accounts of its evolution. For example, Roland Marchand stresses content as the defining characteristic, emphasizing "advertising in overalls" as the primary feature of depression-era advertising. Jackson Lears follows this lead: "Agency needs pressed Steichen and other photographers to move away from the modernistic fetishism of commodities and toward the conventions of bourgeois realism: recognizable scenes, didactic narrative, relentless sentimentality." While this content is indeed more prevalent after the modernist interlude ca. 1930 (see Chapter 5), I am arguing that in Steichen's work the style of realism did not accompany the return of this content. On the contrary, his photographic style became more subjective and manipulative.

In this formulation I also differ with some photographic historians. Robert Sobieszek has proposed an alternate chronology, placing the appearance of modernism in the first decades

of the twentieth century in the photographic advertisements for the Eastman Kodak Company. He wrote: "The Kodak Girl represents the beginnings of early-modern advertising photography: clear illustration, the depiction of everyday events, and an atmosphere of attractive normalcy were all combined and directed to a distinctly upper-middle-class consumer market." I have discussed such images as the introduction of straight photography into advertising, but would stop short at calling them modernist.

Sobieszek discusses 1930s realism as "reactionary" and "an antidote to modernism," tying it to the development of color photography and negative advertising appeals. I will discuss such images in Chapter 9 as melodrama and again see them as part of the general trend toward emotive photography in Steichen's work.

See Marchand, *Advertising the American Dream* (as in n. 25), chapter 9; Jackson Lears, *Fables of Abundance: A Cultural History of Advertising in America* (New York: Basic Books, 1994), p. 327; Robert A. Sobieszek, *The Art of Persuasion: A History of Advertising Photography* (Rochester and New York: International Museum of Photography at George Eastman House and Abrams, 1988), chapters 1–3.

42. Edward Steichen, *A Life in Photography* (Garden City, N.Y.: Doubleday, 1963; rpt., New York: Bonanza Books, 1984), n.p.

43. "History of Cutex Nail Polish," unpublished ms., 1926, p. 8, JWT Archives.

44. Carroll was the subject of at least three features in *Vanity Fair*. He was characterized as "one of the arresting figures in the younger group of American painters—the group immediately following Bellows, Speicher, Kent, and the rest." He "has more or less taken New York, and Woodstock, by storm. His is an original and authentic talent" (*Vanity Fair* [May 1927]: 73). See also *Vanity Fair* (Dec. 1927): 71, and (Aug. 1929): 43.

45. T. J. Jackson Lears, in "The Uses of Fantasy: Toward a Cultural History of American Advertising, 1880–1930," *Prospects* 9 (1984): 368–388, dates the height of reason-why, factual, informative copy to the 1890s and sees the introduction of atmosphere advertising shortly after the turn of the century. Lears reports that by the 1920s "it was a common view that the product could be subordinated to its symbolic attributes." This view was, he notes, balanced by a strong countercurrent of realism. The business historian Merle Curti has traced how advertising strategy evolved in the trade journal *Printers' Ink*. The advertising industry from 1890 to 1910 was dominated by the view of "man as rationalistic" with a strong minority viewpoint that "doubted the rationality and intelligence of men" and "stressed the emotional overtones of egocentricity." But from 1910 to 1930 there was a "reversal of what had been the majority and minority views about the purpose of advertising," with "advertising experts accepting the non-rationality of human nature" (Curti, "The Changing Concept of 'Human Nature' in the Literature of American Advertising," *Business History Review* 41 [winter 1967]: 340–341, 346–347).

46. "History of Jergens Lotion" (as in n. 4), p. 3.

47. Ibid., p. 4.

48. Adrian Head, *JWT News Letter*, no. 189 (Oct. 1, 1927): 430. Head was in charge of JWT's Copenhagen office. Paul Cherington, "Photos Fail to Please," *JWT News Letter*, no. 186 (Aug. 15, 1927): 356. Cherington left a professorship at the Harvard Business School to become director of research for JWT in 1922. He primarily conducted surveys that quantified consumer preferences and studied the effectiveness of advertising media. He wrote *The Consumer Looks at Advertising*, introd. Stanley Resor (New York: Harper, 1928), which defends advertising against the charge that it is an economic waste. For a brief biography see "Untrammeled Cherington," *Tide* 5, no. 6 (June 1931): 28–29.

49. Lou Ingwersen, "Yes, the Lens Lends a Hand!" *JWT News Letter*, no. 186 (Aug. 15, 1927): 357–359.

50. Report of William Esty, "Minutes of the Representatives Meetings," July 21, 1927, p. 2, JWT Archives. The following passage in Esty's report (pp. 2–3) is quoted at length because it gives some idea of the agency's approach to a campaign, the pressure placed on the photographers and agency personnel, and the comparative working styles of the photographers:

> In order not to put all our eggs in one basket we employed several photographers. We selected Steichen and Alfred [Cheney Johnston] and Henry White—the latter for still life. . . . Then we thought we might get a photographer who had moving picture experience, and . . . we finally decided to try out Hiller. . . .
>
> Alfred [Cheney Johnston] is hopeless for any other work except what he ordinarily does—he puts all the lighting emphasis on the girl's head—and incidentally uses very common-place models.
>
> Steichen made two experiments—the first was much too elaborate and did not reduce and was not good for black and white reproduction. The second was used.
>
> Hiller was remarkably ingenious in creating effects—also he is intensely practical, being at the head of a commission studio. It took [Johnston] two weeks to produce two photographs that were even worth considering. Hiller took about 125 photographs in about four days. He got them over and retouched them in an incredibly short time.
>
> Of the 263 photographs taken in all, since the client was unable to visualize by simply seeing the photograph of a typical advertisement, cuts had to be made and pasted up for all the different advertisements. We not only had the problem of selling the effects in black and white, but also had to get the judgement of ten men. Knowing that each of the ten would probably have a different idea of feminine pulchritude, we had every possible type photographed, so we would surely hit them all—and we did.
>
> Of course the job of taking 263 photographs, making cuts, etc., in two weeks required almost superhuman effort on the part of everyone. . . .
>
> [Some photographs] were colored after they were photographed and others . . . were taken with the colored camera. . . . We tried four different types of work. First we took straight color photographs with the color camera and again Steichen was helpful. . . .
>
> If any of our clients want to know anything about movie photography, Hiller is the most expert man in the Country, and his price is very reasonable. For all the work he did, which included a colossal number of exposures and retouching of about 60 photographs and model fees the total charge was $2100. For the work that Steichen did, he charged $2500."

51. "An Achievement in Photography," *JWT News Letter,* July 15, 1927, pp. 326–327.
52. Report of William Esty (as in n. 50), p. 3.
53. Report of William Esty, "Minutes of the Representatives Meetings," Sept. 19, 1928, JWT Archives.

CHAPTER FOUR

1. Stuart Ewen, *Captains of Consciousness: Advertising and the Social Roots of the Consumer Culture* (New York: McGraw-Hill, 1976), p. 14.
2. Christine Frederick, *Selling Mrs. Consumer* (New York: Business Bourse, 1929), pp. 4–5.
3. "Welch's Grape Juice Account History," unpublished ms, 1926, p. 2, JWT Archives; *JWT News Letter,* no. 43 (Sept. 4, 1924): 1; Earnest Elmo Calkins, "Close-Ups," *Advertising and Selling,* Mar. 31, 1932, p. 44.

4. Typical food advertisements in the mid-1920s, following both atmosphere and reason-why strategies, focused on health, appetite, economy, and saving labor. Agency staff began to insist that food advertising rely on "fewer dry facts" and arouse the consumers' desire ("Food Advertising Analyzed," report on a meeting led by Jerry Carson, *JWT News Letter* [Dec. 1, 1927]: 506).

5. "Welch's Grape Juice Account History" (as in n. 3), p. 4.

6. Ibid., p. 5; *JWT News Letter*, no. 115 (Jan. 14, 1926): 12; *JWT News Letter*, no. 127 (Apr. 9, 1926): 93.

7. *JWT News Letter*, no. 127 (Apr. 9, 1926): 93.

8. "Welch's Grape Juice Account History," p. 4.

9. Ibid.

10. Steichen suggestively titled chapter 9 "Introducing Naturalism into Advertising" (*A Life in Photography* [Garden City, N.Y.: Doubleday, 1963; rpt., New York: Bonanza Books, 1984]).

11. The images first appeared in an essay titled "The Railroaders: Work Portraits," *Survey Graphic* 47 (Oct. 29, 1921): 159–166. For Hine's comments on their reuse, see his letter to Paul Kellogg, in *Photo Story: Selected Letters and Photographs of Lewis W. Hine*, ed. Daile Kaplan (Washington, D.C.: Smithsonian Institution Press, 1992), p. 29. I thank Daile Kaplan for information about the original publication of this image.

12. Grancel Fitz (1894–1963) began his career as a commercial photographer in the early 1920s. He took his first photographs in 1914 and won his first medal for amateur photography in 1916. He entered many international pictorialist photography salons over the next four years and received another eighty-eight awards. Fitz began his professional career as an illustrator in 1920, moving his studio from Philadelphia to New York in 1929. He received eight Art Directors' Club medals between 1924 and 1945 and served three terms as president of the Society of Photographic Illustrators. In 1986 his work was recognized in an exhibition at the Museum of Modern Art, *Grancel Fitz: Advertising Photographs, 1929–1939,* curated by Sarah McNear.

13. Gordon Aymar, "The Third Exhibition," *Annual of Advertising Art* 3 (1924): n.p.

14. *Advertising and Selling*, Nov. 10, 1932.

15. Charles T. Coiner, "Recollections of Ayer," oral history interview by Howard L. Davis and F. Bradley Lynce, Mar. 16, 1982, p. 17, N. W. Ayer and Son Archives, New York.

16. *Camera* (New York: N. W. Ayer and Son, 1929), p. 2.

17. Jackson Lears, *Fables of Abundance: A Cultural History of Advertising in America* (New York: Basic Books, 1994), p. 83; see also pp. 84–88, 269.

18. Edward Steichen, "Commercial Photography," *Annual of American Design, 1931* (New York: Washburn, 1931), pp. 158–159.

19. Presentation of Edward Steichen, "Minutes of the Representatives Meetings," Jan. 31, 1928, p. 6, JWT Archives.

20. Ibid. Despite Steichen's vigorous protest against retouching his works, he seems not to have complained when his black-and-white photographs were hand-colored and printed in color, as in the Woodbury's soap campaign in 1929. Some of his color photographs from the mid-1930s are so painterly that it is hard to believe they were not retouched or enhanced. For an explanation of the retouching process during this period, see Morris Germain and Karl A. Barleben, Jr., "The Elements of Retouching Explained," *Photo Era Magazine* 64 (May 1930): 244–251.

21. Presentation of Edward Steichen (as in n. 19), p. 6.

22. Roland Barthes, "Rhetoric of the Image," in *Image-Music-Text*, trans. Stephen Heath (New York: Hill and Wang, 1977), pp. 32–51.

23. The inattention of advertising professionals to the inherent stylistic characteristics of photography paralleled the photographic theory of the time. For example, William M. Ivins, Jr., a curator at the Metropolitan Museum of Art, maintained, in *Prints and Visual Communication* (Cambridge: Harvard University Press, 1953), that photography lacked the visual "syntax"—surface characteristics to forcefully remind viewers they were looking at a rendering rather than reality. Although he did not publish the theory until 1953, it was based on ideas Ivins had developed decades before.

Estelle Jussim has noted that Ivins's definition of syntax "provided the basis for his ensuing thesis, on the reproduction of photography, that the screened process halftone was so subliminal in its effects that it, too, lacked 'syntax.'" Challenging Ivins's position, Jussim examines the channels and codes of nineteenth-century printing technology. Using Marshall McLuhan's terms, she has argued convincingly that *"the medium can interfere so seriously with the message that the only message which is transmitted is that of the medium itself"* (emphasis in original; Jussim, *Visual Communication and the Graphic Arts: Photographic Technologies in the Nineteenth Century* (New York: R. R. Bowker, 1974; rpt., 1983), pp. 76, 308.

24. John Tagg, *The Burden of Representation: Essays on Photographies and Histories* (Amherst: University of Massachusetts Press, 1988), p. 99. As Tagg has observed, in any kind of realism the product (the image) is foregrounded, but the process of its production is repressed. Thus, by submerging the obvious connections between signifier and signified, straight photography enhances credibility.

25. Practicus [pseud.], "Commercial Photography," *British Journal of Photography* 64, no. 2971 (Apr. 13, 1917): 193, cited in Robert A. Sobieszek, *The Art of Persuasion: A History of Advertising Photography* (Rochester and New York: International Museum of Photography at George Eastman House and Abrams, 1988).

26. *JWT News Letter,* no. 31 (Jan. 17, 1917): 5. This is the earliest record I found in an agency's archive of a photograph used in advertising. It has been erroneously called the earliest use of a photograph in advertising (Ferris Buck, "J. Walter Thompson Company Chronology," unpublished ms., 1985, p. 2, JWT Archives).

27. *Camera* (as in n. 16), pp. 1–2; *JWT News Letter,* no. 85 (June 18, 1925): 2.

28. *JWT News Letter,* Apr. 1, 1926, p. 86; see also Gordon C. Aymar, "Three Uses of Good Photography," *JWT News Letter,* Dec. 1, 1929, p. 2.

29. Gordon Aymar, *An Introduction to Advertising Illustration* (New York: Harper, 1929), opposite p. 220.

30. Hiller did commercial work for JWT as early as 1917. By 1927 he was the chief photographer at the large photographic firm of Underwood and Underwood but rarely used the camera himself except for particularly important assignments. His archives are housed at the Visual Studies Workshop, Rochester, New York.

31. *Advertising and Selling,* Nov. 13, 1929, p. 96. The Photographers' Association of America spent $4 million over two years on this advertising campaign.

32. *New York Times,* Mar. 6, 1923; reprinted in Vickie Goldberg, *Photography in Print: Writings from 1816 to the Present* (Albuquerque: University of New Mexico Press, 1988), pp. 293–294.

33. Presentation of Edward Steichen (as in n. 19), p. 3.

34. "Photography vs. Drawing—a Debate: Colonel Steichen Speaks for Photography," *Camera* (Jan. 1932): 75.

35. Edward J. Steichen, "Ye Fakers," *Camera Work,* no. 1 (Jan. 1903): 48.

36. Presentation of Edward Steichen (as in n. 19), pp. 3, 10 (emphasis mine).

37. In his article "'News'-Photography," in *America As Americans See It,* ed. Frederick

Julius Ringel (New York: Literary Guild, 1932), pp. 293–295, Steichen wrote: "The factual image is not without pictorial humor even if the picture is the image of tragedy. The one instance totally devoid of anything but bitter fact is the picture of Ruth Snyder. This picture made with a minute camera attached to the reporter's ankle is one of the great human picture documents of all time." Since this book was intended for a general audience, Steichen once again expounded popular and stereotypical notions such as the rhetoric of realism, arguing for the complete objectivity of the news photograph.

38. Walter Dill Scott, who wrote the first full-length text on advertising psychology, dated the genesis of his field to an 1895 article by Oscar Herzberg, "Human Nature as a Factor in Advertising," *Printers' Ink* 13 (Oct. 2, 1895): 3–5. See Scott, *The Psychology of Advertising* (Boston: Small, Maynard, 1908), p. 2. See also A. Michal McMahon, "An American Courtship: Psychologists and Advertising Theory in the Progressive Era," *American Studies* 13 (1972): 5–18.

39. Additional Wundt students included Hugo Muensterberg, E. W. Scripture, E. B. Titchener, James McKeen Cattell, and G. Stanley Hall, who brought Wundt's theories to Harvard, Yale, Cornell, Columbia, and Johns Hopkins Universities, respectively. See R. G. A. Dolby, "The Transmission of Two New Scientific Disciplines from Europe to North America in the Late Nineteenth Century," *Annals of Science* 34 (1977): 287–310. On Wundt and the beginnings of experimental psychology, see also E. G. Boring, *A History of Experimental Psychology* (New York: Appleton-Century-Crofts, 1950); James McKeen Cattell, "Early Psychological Laboratories," *Science* 67 (1928): 543–548; and Joseph Ben-David and Randall Collins, "Social Factors in the Origins of a New Science: The Case of Psychology," *American Sociological Review* 31 (Aug. 1966): 454–465.

40. Edward W. Scripture discussed the implications of structuralism for advertising in *Thinking, Feeling, Doing* (New York: Flood and Vincent, 1895), but he performed no empirical tests in this area.

41. David P. Kuna, "The Psychology of Advertising, 1896–1916," Ph.D. diss., University of New Hampshire, 1976, pp. 93–141; see also Harlow S. Gale, *Psychological Studies* (Minneapolis: By the author, 1900). Gale was a socialist who was later forced to resign his position over his anti-imperialist position on American intervention in the Philippines and for teaching sex education as part of psychology.

42. Scott, *The Psychology of Advertising* (as in n. 38), pp. 6, 2.

43. For Scott's career in business, the U.S. Army, and academia, see Kuna, "The Psychology of Advertising," pp. 142–210.

44. Kerry Buckley, *Mechanical Man: John Broadus Watson and the Beginnings of Behaviorism* (New York: Guilford Press, 1989), pp. 99–111.

45. David P. Kuna, "The Concept of Suggestion in the Early History of Advertising Psychology," *Journal of the History of the Behavioral Sciences* 12 (1976): 349–350. See also Boris Sidis, *The Psychology of Suggestion* (New York: Appleton, 1898); and James Mark Baldwin, *Mental Development in the Child and the Race: Methods and Processes* (New York: Macmillan, 1894).

46. William James contended, "We do not have to *add* something dynamic to get a movement" (James, *The Principles of Psychology* [1890; rpt., New York: Dover, 1950], vol. 2, p. 526; cited in Kuna, "The Psychology of Advertising" [as in n. 41], p. 62).

47. Kuna, "The Psychology of Advertising" (as in n. 41), pp. 161–167.

48. Walter Dill Scott, *The Theory of Advertising*, p. 29, cited in Kuna, "The Psychology of Advertising" (as in n. 41), p. 153.

49. Scott, *The Psychology of Advertising* (as in n. 38), p. 79.

50. Ibid., pp. 41–42, 47, 136–146, 157–160, 226–248.

51. Ibid., pp. 26, 9–37, 77.

52. Frank Presbrey, *The History and Development of Advertising* (1929; rpt., New York: Greenwood Press, 1968), p. 443.

53. Kuna, "The Psychology of Advertising" (as in n. 41), pp. 211–261.

54. Daniel Starch, *Advertising: Its Principles, Practice, and Technique* (New York: Appleton, 1914), pp. 6, 39–88, 207–216.

55. Ibid., pp. 168, 228, 239.

56. Hollingworth and Strong knew Freud's work through the work of both the British psychologist William McDougall, who was then at Harvard, and their Columbia colleague, Robert S. Woodworth. And their stimulus-response model was derived more from E. L. Thorndike than John B. Watson (Kuna, "The Psychology of Advertising" [as in n. 41], pp. 284–309).

57. Harry Tipper, Harry L. Hollingworth, George B. Hotchkiss, and Frank A. Parsons, *Advertising: Its Principles and Practice* (New York: Ronald Press, 1915), pp. 83–85. On the contributions of Hollingworth and Strong, see Kuna, "The Psychology of Advertising," pp. 262–341.

58. By 1913 Strong had outlined the idea that advertising must create desire, which his theory of want-solution (1925) elaborated. See Edward K. Strong, Jr., "Psychological Methods As Applied to Advertising," *Journal of Educational Psychology* 4 (Sept. 1913): 394–395, and *The Psychology of Selling and Advertising* (New York: McGraw-Hill, 1925).

59. See also Henry Foster Adams, *Advertising and Its Mental Laws* (New York: Macmillan, 1916); and Alfred T. Poffenberger, *Psychology in Advertising* (New York: McGraw-Hill, 1925).

60. Steichen, *A Life in Photography* (as in n. 10), chapter 9.

61. Mr. Stanley Resor to New Members Group, May 4, 1931, JWT Archives. Resor said that Miss Fonda, the original Mr. Thompson's secretary, recalled the meeting and had told him of it.

62. *Advertising and Selling*, Mar. 5, 1930, p. 102.

63. Douglas Collins, *The Story of Kodak* (New York: Abrams, 1990), celebrates Eastman's philanthropy and dividend plans for employees (pp. 189–191).

64. John Allen Murphy, "Ivan Kreuger vs. George Eastman," *Advertising and Selling*, Mar. 31, 1932, p. 18.

65. "Kodak's Fighting Front This Year," *Printers' Ink* 116 (July 28, 1921): 114.

66. Letter from George Eastman to Sturges Dorance, Mar. 1930, cited in Clowry Chapman, "How Ivory and Kodak Insure Markets," *Advertising and Selling*, May 28, 1930, p. 98.

67. *Advertising and Selling*, Mar. 14, 1930, p. 78, reported that Kodak had given away 500,000 cameras in one promotion. A letter to the editor complained, however, that the allotment was too small and went primarily to the relatives and friends of druggists before the campaign began. At a JWT staff meeting William Resor described plans for a typical Kodak amateur photography contest. He was attempting to line up Mussolini, the Prince of Wales, King Albert of Belgium, and Mrs. Calvin Coolidge as judges but as yet had only been able to line up the German Dr. Eckner and the crown princes of Norway and Sweden ("Minutes of the Representatives Meetings," Aug. 5, 1930, p. 3, JWT Archives). See Collins, *The Story of Kodak* (as in n. 63), for information on Verichrome (pp. 222–223) and a history of Kodak products.

68. Steichen was commissioned to do a major Kodak campaign as early as 1930, but few of his works have been identified (none of his work for Kodak appeared with a signature).

See the Appendix for attributed works. William Resor reported that in early 1930 JWT "spent over $7500 for Steichen photographs" ("Minutes of the Representatives Meetings," Aug. 5, 1930, p. 4, JWT Archives).

69. "Humanness" is the term used by Lewis B. Jones, Kodak's advertising manager in the early decades of the twentieth century, quoted in Bruce Bliven, "An Inside View of Kodak Advertising," *British Journal of Photography* 65, no. 3021 (Mar. 29, 1918): 149, cited in Sobieszek, *The Art of Persuasion* (as in n. 25), p. 23. JWT proposed more specific situations, such as the idea, fondly called "The Death Campaign" around the office, to encourage people to take photographs of elderly relatives before they died. Kodak thought the idea to be in poor taste ("Minutes of the Representatives Meetings," Nov. 16, 1932, JWT Archives). Thompson's strategies are also discussed in Report of Mr. Day, Miss Casseres, and Mr. Watkins, "Minutes of the Representatives Meetings," Mar. 26, 1932, p. 15, JWT Archives; and Report of Miss Waldo, Plan Board, "Minutes of the Representatives Meetings," Sept. 15, 1931, JWT Archives.

70. Report of Mrs. Smith, "Minutes of the Representatives Meetings," Feb. 15, 1933, p. 4, JWT Archives.

71. Steichen, *A Life in Photography* (as in n. 10), chapter 9.

72. Report of Mrs. Smith (as in n. 70).

73. Rosa Reilly, "Steichen—the Living Legend," *Popular Photography* (Mar. 1938): 12.

74. Thayer Jaccaci, "Kodak," *JWT Forum*, Dec. 15, 1936, p. 4.

75. See Roland Marchand, *Advertising the American Dream: Making Way for Modernity, 1920–1940* (Berkeley and Los Angeles: University of California Press, 1985), pp. 32–38.

76. The campaigns were run for Ciné Kodak (movie cameras), Kodakolor, Anniversary Camera, film, and chemicals, equipment, and other merchandise ("Report of the Representatives Meetings," Aug. 5, 1930, p. 4, JWT Archives).

77. Jaccaci, "Kodak" (as in n. 74), p. 9.

CHAPTER FIVE

1. Robert R. Updegraff, *The New American Tempo* (1929), cited in Jeffrey Meikle, *Twentieth Century Limited: Industrial Design in America, 1925–1939* (Philadelphia: Temple University Press, 1979), p. 9.

2. Meikle, *Twentieth Century Limited*, p. 9.

3. "Gordon Aymar on Contemporary Art," *JWT News Letter*, Nov. 15, 1929, p. 2.

4. Frank Young, *Modern Advertising Art* (New York: Covici Friede, 1930), p. 15.

5. This argument is advanced in Bonnie Yochelson, "Clarence H. White: Peaceful Warrior," in *Pictorialism into Modernism: The Clarence H. White School of Photography*, ed. Marianne Fulton (New York: Rizzoli, 1996), p. 11–114.

6. Young, *Modern Advertising Art*, p. 15.

7. Earnest Elmo Calkins in his foreword to ibid., pp. 11–12.

8. W. H. Beatty, foreword to *Annual of Advertising Art* 6 (1927): n.p.

9. Young, *Modern Advertising Art* (as in n. 4), p. 14.

10. Calkins, foreword (as in n. 7), p. 12.

11. Arthur J. Pulos, *American Design Ethic: A History of Industrial Design to 1940* (Cambridge: MIT Press, 1983), p. 271.

12. Thomas Crow, "Modernism and Mass Culture in the Visual Arts," in *Modernism*

and Modernity: The Vancouver Conference Papers, ed. B. H. D. Buchloch, Serge Guilbaut, and David Solkin, eds. (Halifax: Press of the Nova Scotia College of Art and Design, 1983), pp. 215–264.

13. Comments on Irwin Wolf, "Style Organization from the Executive's Viewpoint," in *How the Retailer Merchandises Present Day Fashion, Style, and Art* (New York: American Management Association, 1929), p. 8, cited in Meikle, *Twentieth Century Limited,* p. 16.

14. Roy Sheldon and Egmont Arens, *Consumer Engineering* (New York: Harper, 1932), pp. 137, 152.

15. Christine Frederick, *Selling Mrs. Consumer* (New York: Business Bourse, 1929), pp. 248–249.

16. Maria Morris Hambourg, "From 291 to the Museum of Modern Art: Photography in New York, 1910–1937," in *The New Vision: Photography between the World Wars,* ed. Maria Morris Hambourg and Christopher Phillips (New York: Metropolitan Museum of Art and Abrams, 1989), p. 39; see also Edith Morgan King, "Modernism?" *Vogue,* May 11, 1929, pp. 104–105, 162–172; and Pulos, *American Design Ethic,* pp. 301–318.

17. In his recent book, Jackson Lears describes the complexities of the "tortuous engagement between experimental form and familiar content" in advertising. Lears argues that the modernist vocabulary offered, in theory, the opportunity to move beyond dualisms and "find content in form; to celebrate surface as depth; to locate significance in structural relations rather than mimetic correspondences; to return to the things themselves, rejecting endless interpretation and revaluing play." Yet ultimately, in his view, in the "marriage" of avant-garde and kitsch one partner has the upper hand: for, following Lears's formulation, modernism in advertising could only fully animate form; its content could never shake its corporate origins and allow the inner expression of the artist (Lears, *Fables of Abundance: A Cultural History of Advertising in America* [New York: Basic Books, 1994], pp. 299–344).

18. For later examples of this process, see W. Jackson Rushing, *Native American Art in the New York Avant-Garde* (Austin: University of Texas Press, 1995). I am indebted to Arlette Klaric for her careful editing of this chapter and for many discussions about American modernism; see her dissertation, "Arthur G. Dove's Abstract Style of 1912: Dimensions of the Decorative and Bergsonian Realities," University of Wisconsin, 1984, for a discussion of the American roots of Dove's abstraction.

19. Bonnie Yochelson, "Clarence H. White Reconsidered: An Alternative to the Modernist Aesthetic of Straight Photography," *Studies in Visual Communication* 9 (fall 1983): 28.

20. Lucinda Barnes, ed., *A Collective Vision: Clarence H. White and His Students* (Long Beach: California State University Art Museum, 1985), p. 27.

21. Dow's influence is evident in *Pictorial Photography in America,* the journal White edited; see, for example, Alon Bement, "Design," *Pictorial Photography in America* 4 (1926). See also Yochelson, "Clarence H. White Reconsidered" (as in n. 19), esp. pp. 27–30; and Yochelson, "Clarence H. White: Peaceful Warrior" (as in n. 5).

22. Young, *Modern Advertising Art* (as in n. 4), p. 94.

23. Yochelson, "Clarence H. White Reconsidered," p. 34.
Robert Sobieszek sees a widespread modernist influence in advertising agencies only after 1922, citing Paul Outerbridge's *Ide Shirt Collar* and several other advertisements that year. This modernism co-existed with more numerous pictures from "real life" in the 1920s, such as Steichen's *Peeling Potatoes* or Hine's *Railroad Engineer.* Sobieszek discerns a major shift in modernist advertising aesthetics in the spring of 1931 following the exhibition *Foreign Advertising Photography* at the Art Center in New York; when "European modernism was

embraced by American advertising," American ads achieved greater simplicity. See Sobieszek, *The Art of Persuasion: A History of Advertising Photography* (Rochester and New York: International Museum of Photography at George Eastman House and Abrams, 1988), chapters 1–3. For information on the 1931 exhibition, see "What Foreign Advertising Photographers Are Doing," *Printers' Ink* 64 (Feb. 24, 1931): 70–72; and "Awards Announced in Exhibition of Foreign Advertising Photography at Art Center, New York City," *Commercial Photographer* (Apr. 1931): 419.

24. This work is reproduced as *Musical Semi-Abstraction,* in Graham Howe and G. Ray Hawkins, *Paul Outerbridge, Jr.: Photographs,* text by Graham Howe and Jacqueline Markham (New York: Rizzoli, 1980), p. 34, where it is presented as an art photograph without reference to its use in an advertisement. It is reproduced and identified in Margaret Watkins, "Advertising and Photography," *Pictorial Photography in America* 4 (1926): n.p.

25. See Howe and Hawkins, ibid., p. 7. Another problem is exemplified in the catalogue raisonné *Paul Outerbridge: A Singular Aesthetic,* which contains statements to the effect that Outerbridge had "many commercial accounts." Though some plates are labeled as work for such accounts, no attempt is made to enumerate them or assess their impact on either his own work and attitudes or those of other photographers. See Elaine Dines, ed., in collaboration with Graham Howe, *Paul Outerbridge: A Singular Aesthetic,* introd. Bernard Barryte, with Graham Howe and Elaine Dines (Laguna Beach, Calif.: Museum of Art, 1981).

26. Lillian Sabine, "Edward J. Steichen," *Commercial Photographer* (May 1932): 309.

27. Sue Davidson Lowe, "The Falling Out," *Camera Arts* 3 (Mar. 1983): 92. Clare Boothe Brokaw (Luce) wrote that Steichen preferred the work of Diego Rivera to that of Picasso because he thought Rivera more relevant to issues of life and society; he saw Picasso's cubism as too intellectually removed (Clare Boothe Brokaw, "Edward Steichen, Photographer," *Vanity Fair* [June 1932]: 70).

For an example of the cubist technique in Steichen's fashion photographs, see his *Shoes,* in *Vogue,* June 15, 1927, p. 60; reproduced in Yochelson, "Clarence H. White Reconsidered" (as in n. 19), p. 38; and in John Pultz and Catherine B. Scallen, *Cubism and American Photography, 1910–1930* (Williamstown, Mass.: Clark Art Institute, 1981), p. 33.

28. William Engle, "Steichen the Photographer," *Commercial Photographer* (Sept. 1930): 618; excerpted from an article in the *New York Telegram.*

29. See the criticism of Steichen's commercial photography in Pultz and Scallen, *Cubism and American Photography* (as in n. 27), pp. 32–34. Maria Morris Hambourg, "From 291 to the Museum of Modern Art," also considers the style "a rearguard or derivative modernism which might be termed modernistic" (as in n. 16), p. 23.

30. Yochelson has also noticed this spatial ambiguity in the advertising of the period. She writes of one of Anton Bruehl's images that the photographer "deliberately masked junctures within the setup with the objects on display to enhance the spatial ambiguity. While these experiments derive from cubist ideas about space and form, the results are not intended to fragment form or to disrupt reality, but rather to catch the eye and demand a second or third look" ("Clarence H. White Reconsidered" [as in n. 19], p. 34).

31. See illustration 96 in John Heskett, *Industrial Design* (London: Thames and Hudson, 1980), p. 121.

32. Paul W. Darrow, oral history interview with F. Bradley Lynce, May 5, 1986, N. W. Ayer and Son Archives, New York.

33. Paul Strand, "Photography," *Seven Arts* (Aug. 1917); reprinted in *Classic Essays on Photography,* ed. Alan Trachtenberg (New Haven, Conn.: Leete's Island Books, 1980), p. 142.

34. T. J. Jackson Lears, "Uneasy Courtship: Modern Art and Advertising," in *Modernist Culture in America*, ed. Daniel Joseph Singal (Belmont, Calif.: Wadsworth, 1991); orig. pub. as *American Quarterly* 39, no. 1 (spring 1987): 179.

35. M. F. Agha, "A Word on European Photography," *Pictorial Photography in America* 5 (1929): n.p. For information on Agha, see R. Roger Remington and Barbara J. Hodik, *Nine Pioneers in American Graphic Design* (Cambridge: MIT Press, 1989), pp. 8–27.

36. Agha made these comments about Outerbridge, but they apply equally to Steichen (M. F. Agha, "Paul Outerbridge, Jr.," *Advertising Arts* [May 1931]: 44). See also M. F. Agha, "Ralph Steiner," *Creative Art* 10 (Jan. 1932): 34–39; and "Graphic Arts in Advertising; Moderns and Modernists," in *Annual of American Design, 1931* (New York: Washburn, 1931), pp. 139–140.

37. Clive Bell, *Art* (1913; rpt., New York: Putnam, 1958).

38. Carl Richard Greer, *Advertising and Its Mechanical Production* (New York: Crowell, 1931), p. 306.

39. Young, *Modern Advertising Art* (as in n. 4), pp. 24–29. Even such how-to books for aspiring commercial photographers as Leonard A. Williams, *Illustrated Photography in Advertising* (San Francisco: Camera Craft Publishing Company, [ca. 1929]), advocated "modernistic" photography as most representative of the airplane age. Williams had been skeptical about "the modernistic idea" until he saw the world from an airplane. When others had similar experiences, he expected them to "develop a sense of fourth dimension in picture building that we have not had in the past." Williams wanted his students to get "up close to the ceiling in the corner of a room and look down at the floor" to "see the modernistic style developing in your sight sense" (p. 78). Williams's book was based on a series of articles he had written for *Camera Craft*.

40. W. Livingston Larned, "The Camera Gets a New Point of View," *Commercial Photographer* (July 1927): 432–436; reprinted from *Advertising and Selling*.

41. "How May Photography Be Used Most Effectively?" *Commercial Photographer* (July 1932): 388.

42. The graphic designer Frank Young enumerated a typical list of principles of modernist design including, most important, that modernism must be "felt"; it is "simple and direct," "truthful and penetrating," and "not limited by precedent"; it "makes new and daring uses of the materials"; it "omits all trifles, superfluities and irrelevancies"; and it is "a more expressive form" (Young, *Modern Advertising Art* [as in n. 4], pp. 19–29).

43. See Presentation of Edward Steichen, "Minutes of the Representatives Meetings," Jan. 31, 1928, p. 9, JWT Archives.

44. Lejaren à Hiller, "Illustrating Magazine Articles and Advertising by the Use of the Camera," *Commercial Photographer* (Oct. 1927): 18.

45. "Hats—and Photographs That Sell Them," *Commercial Photographer* (Nov. 1925): 43–47.

46. Greer, *Advertising and Its Mechanical Production* (as in n. 38), p. 306.

47. Frederick, *Selling Mrs. Consumer* (as in n. 15), pp. 151, 359, 361.

48. Even before Agha was brought to New York *Vogue* in 1929 to institute "modernist" changes in the layout and typography of the magazine, Nast had commissioned the illustrator Benito to design a dummy giving a new look to the magazine. Caroline Seebohm believes that Nast "knew the continued success of the magazines to a large extent depended on a commitment to modernism," and Agha was chosen as the art director best able to implement these changes (Caroline Seebohm, *The Man Who Was Vogue: The Life and Times of Condé Nast* [New York: Viking Press, 1982], pp. 184, 228–231). In his reminiscences Steichen felt Agha replaced "namby-pamby, meaningless, and conventional layout" with "a fresh, live appear-

ance" at both magazines (*A Life in Photography* [Garden City, N.Y.: Doubleday, 1963; rpt., New York: Bonanza Books, 1984], chapter 7).

49. A memo from Phyllis Abell to Henry Flannery, July 19, 1932, describes a potential layout "if it is agreeable to Mr. Steichen" (Edward Steichen Archives, Museum of Modern Art). For Simmons, see the advertisement with Steichen's portrait of Mrs. John Hays Hammond, Jr., *Ladies' Home Journal* (Apr. 1930): 71; and *Vogue*, Apr. 12, 1930, p. 115. The new typography for the advertisement was discussed at a JWT staff meeting. Mr. Browne reported that the change originated with Steichen, and it "reflected the change in the style in some of the magazines . . . [and] our desire to reflect the latest trend in the treatment of the editorial page." Stanley Resor referred to the new simplified layout designs instituted by M. F. Agha at *Vogue* and the experimentation in using lowercase at *Vanity Fair* as the inspiration. Mr. Kinney noted that the changes were used "in connection with bringing out a popular price mattress. It was desired to emphasize the smartness and quality of Beautyrest, and therefore the style of lettering being introduced by the smartest publications seemed to contribute something of a lift to the campaign" ("Minutes of the Representatives Meetings," May 25, 1930, pp. 7–8, JWT Archives).

50. Lucian Bernhard, "Putting Beauty into Industry," *Advertising Arts,* Jan. 8, 1930, pp. 35–36.

51. Meikle, *Twentieth Century Limited* (as in n. 1), pp. xiii, 3, 36, 39; Americans seemed fascinated by the future. In the 1920s, for example, Hugh Ferriss published his drawings *The Metropolis of Tomorrow* (New York: Washburn, 1929) and the New York World's Fair of 1939 included a World of Tomorrow Pavilion. This subject has been treated in depth in Joseph J. Corn and Brian Horrigan, *Yesterday's Tomorrows: Past Visions of the American Future* (New York: Simon and Schuster and Summit Books, 1984).

52. Walter Dorwin Teague, "Why Disguise Your Product?" *Electrical Manufacturing* 22 (Oct. 1938): 47, cited in *The Machine Age in America, 1918–1941,* ed. Richard Guy Wilson, Dianne H. Pilgrim, and Dickran Tashjian (New York: Brooklyn Museum and Abrams, 1987), p. 43.

53. Dianne H. Pilgrim, "Design for the Machine," in *The Machine Age in America* (as in n. 52), p. 308.

54. The goals of advertising and industrial design were linked in numerous articles in the advertising trade press: Lucian Bernhard, "Putting Beauty into Industry," *Advertising Arts,* Jan. 8, 1930, pp. 35–36; Abbott Kimball, "The Place of the Design Engineer in Business," *Advertising and Selling,* June 11, 1930, pp. 82, 84; Walter Dorwin Teague, "Designing for Machines," *Advertising Arts,* Apr. 2, 1930, pp. 19–23; and Roy Sheldon, "These Packages," *Advertising Arts* (1932): 19–29.

The trade press was also filled with articles seeking to convince manufacturers that better styling increased sales: Earnest Elmo Calkins, "Beauty, the New Business Tool," *Atlantic Monthly* 140 (Aug. 1927): 145–156, "The Dividends of Beauty," *Advertising Arts* (Sept. 1931): 13–18, and "5 and 10," *Advertising Arts* (Mar. 1931): 20–21; [U.S. Assistant Secretary of Commerce] Dr. Julius Klein, "Art in Industry Pays Dividends," *Advertising and Selling,* Mar. 19, 1930, pp. 19–20, 61; and John Cotton Dana, "The Cash Value of Art in Industry," *Forbes* (Aug. 1928): 16–18, 32. For a commentary on Dana's influence, see Meikle, *Twentieth Century Limited* (as in n. 1), pp. 17–20; and Frank Kingdon, *John Cotton Dana: A Life* (Newark, N.J.: Public Library and Museum, 1940).

The message apparently reached the manufacturers. *Business Week,* Jan. 29, 1930, p. 30, reported that in 1929 more than five hundred businesses asked the New York Art Center to recommend "artists who could stylize their products" (cited in Meikle, *Twentieth Century Limited,* p. 17). Advertisements soon appeared for such services; for an example, see the ad

placed by the Industrial Art Council: "How Can You Use Art as a Profit-Maker in Your Business?" *Advertising Arts,* Jan. 8, 1930, pp. 10–11.

55. Vaughn Flannery, "Styling Modern Merchandise," *Advertising and Selling,* Apr. 16, 1930, p. 19.

56. "What Is the Future of Industrial Design? Our Questions: Joseph Sinel's Answers," *Advertising Arts,* July 9, 1930, p. 17.

57. Frederick, *Selling Mrs. Consumer* (as in n. 15), pp. 201, 250.

58. Sheldon and Arens, *Consumer Engineering* (as in n. 14), pp. 7, 52–62. For an analysis of waste and efficiency as cultural metaphors before World War II, see Cecelia Tichi, *Shifting Gears: Technology, Literature, Culture in Modernist America* (Chapel Hill: University of North Carolina Press, 1987).

59. Some of the others were Ralph Barton, Clayton Knight, Katherine Sturges, Charles B. Falls, Neysa McMein, and John Held, Jr. Steichen's were the only photographic designs; samples of his fabrics are in the Edward Steichen Archives, Museum of Modern Art, and in the Newark Museum. Helen Dryden's designs for Stehli are reproduced in Earnest Elmo Calkins, "Art as a Means to an End III," *Advertising Arts,* Apr. 2, 1930, p. 46.

60. Green attended classes at the Art Students League from 1913 to 1917. After some freelance work, he became chief illustrator, then art director, for the Stehli Silk Company from the early 1920s to the early 1930s. He was briefly art director for *Harper's Bazaar* before beginning a career as a commercial photographer in 1933. He is best known for his pioneering works in the three-color carbo process. He took numerous photographs for magazine illustrations and advertising campaigns until his death in 1956 (see Keith Douglas de Lellis, "Profile of Ruzzie Green: Photographer," undated unpublished ms., photocopy in Edward Steichen Archives, Museum of Modern Art, New York). Steichen also acknowledged Green's role and his interest in the project in his autobiography (*A Life in Photography* [as in n. 48], chapter 7).

61. Carl Sandburg, *Steichen the Photographer* (New York: Harcourt, Brace, 1929), pp. 55–56.

62. Kneeland L. Green, "Modern Life, Ordinary Things, Design: Americana Fabrics," *Creative Art* 4 (Feb. 1929): 104, 107.

63. Young, *Modern Advertising Art* (as in n. 4), p. 95, commented that Steichen's "interesting design" proved "that common objects creatively arranged and lighted will assume artistic importance when viewed from a different angle."

64. On other occasions Steichen was less gracious in acknowledging Green's contribution, displaying his characteristic egotism. He told the art directors and executives at JWT that "the Stehli people had the idea of using the camera for their designing. Their biggest idea was to come to me for it. It proved to you what a mess the others made of it. Cheney [another silk company] had silk designs from all over the country, and not one other had enough brains or imagination to use tacks, mothballs, and things like that. But wait until next year. There will be something new to imitate" (Presentation of Edward Steichen, "Minutes of the Representatives Meetings," Jan. 31, 1928, p. 11, JWT Archives).

65. "An Artist Discovers a New Way of Designing Silk," *Vanity Fair* (Mar. 1927): 63.

66. Marguerite Tazelaar, "Portrait of a Pioneer," *Amateur Movie Makers* 2 (July 1927): 19. Steichen's force of personality also impressed the interviewer Lillian Sabine. In "Edward J. Steichen," *Commercial Photographer* (May 1932): 310, 313, she sketched their meeting in admiring tones:

It was an impressive moment—Steichen in his gray clothes, the red ribbon of his Legion of Honor in his lapel, smoking there by the window, looking out over a city in hushed

holiday mood, looking into the beauty of Bryant Park and the Public Library—but seeing so far beneath them and beyond, talking of today but in a language that reaches ages back and far, far into the future.

Steichen the photographer had gone; it was Steichen, the philosopher, the seer, sitting by the window. . . .

As we rose to go, he was still speaking of America's opportunities, talking in that vivid way, forcefully. Then, as we parted, he commented on the present.

"It is a grand moment," he said thoughtfully.

67. Tazelaar, "Portrait of a Pioneer," pp. 18–19.

68. Sandburg, *Steichen the Photographer* (as in n. 61), p. 56.

69. Hardman, Peck and Company sales catalogue for the pianos, cited in "Decorative Art Notes," *Arts* 13 (May 1928): 296–297.

70. "Hardman, Peck and Co. Bring Out New Modern Art Line," *Music Trade Review* 86 (Apr. 14, 1928): 21.

71. In 1928 Steichen was one of "Five Famous Americans" who endorsed the Pine Tree silverware pattern (International Silver Co.) for its exemplary modernism: "Industrial processes have brought design and production into intelligent collaboration with prevailing commercial requirements" ("Announcing the Pine Tree Pattern" [advertisement], *Vanity Fair* [Mar. 1928]: 10).

72. "Hardman, Peck and Co. Bring Out New Modern Art Line," p. 21.

73. Ibid. All the period descriptions that mention *Vers Libre* by name conform to the color description given here. There is an example, however, of the piano and matching bench in gold and silver leaf and robin's-egg blue in a private collection in New York. This was acquired originally in 1931 or 1932 from Decorators' Studios, self-described in their promotional materials as "an Art Moderne Salon devoted exclusively to the interest of the interior decorator." Therefore at least two color variations of the same design were produced. A color transparency of the blue version is available for study at the Edward Steichen Archives, Museum of Modern Art. Grace Mayer has identified this piano as the one described, without attribution to Steichen, in an article on the Decorators' Studios: "The light walnut case of one piano . . . has been lightly rubbed over with silver and wax, so that it possesses a soft gray effect. A band pattern composed of closely placed lines of silver, with a narrow line of blue lacquer, is the sole ornamentation" (Walter Rendell Storey, "Wicker Furniture for Year-Round Use," *New York Times Magazine*, Nov. 8, 1931, p. 14).

74. "Hardman, Peck and Co. Bring Out New Modern Art Line," p. 21. I have not been able to locate a picture of *Lunar Moth*.

75. For a discussion of varying approaches to industrial design, see Meikle, *Twentieth Century Limited* (as in n. 1). Of the six designs for the Hardman, Peck company, only Simonson attempted to alter the piano's basic shape in his *Death of a Simile*, but it can be argued that he simply applied the modern form of the skyscraper to the piano casing instead of re-interpreting the piano's form to reflect its internal mechanisms or function.

76. "Decorative Art Notes" (as in n. 69), p. 297.

77. "Hardman, Peck and Co. Bring Out New Modern Art Line" (as in n. 70). The exhibit was covered in newspapers and magazines and was also advertised. It was reported that eleven thousand visitors came to the showroom on one day (Clifford Hendel, "The 'Modernique Tour,'" *Musical Courier*, Dec. 6, 1928, p. 56).

78. Hendel, "The 'Modernique Tour,'" p. 56.

79. R. L. Leonard and C. A. Glassgold, introd., *Annual of American Design, 1931* (New York: Washburn, 1931).

80. Dianne Pilgrim contends that because of the depression, "the debate over modernism—its existence, its appropriateness for America, and the merits of its aesthetic qualities—became secondary to the need for economic recovery. The means to economic recovery was the machine in its many manifestations. This meant that America had accepted, if begrudgingly, modernism" (Pilgrim, "Design for the Machine," in *The Machine Age in America* [as in n. 52], p. 303).

CHAPTER SIX

1. Advertisement insertion schedules, 1929, Jergens lotion proof sheet records, microfilm reel 13, JWT Archives.

2. Helen Resor suggested the agency try out the services of Margaret Bourke-White because she believed the photographer could correct the artificiality of many ads and would be successful in "doing beautiful ladies just as strikingly as she does peasants, colored people, etc." Although Bourke-White made a presentation to the agency staff, there is no evidence she was ever hired ("Minutes of the Representatives Meetings," Oct. 5, 1932, and Feb. 1, 1933, JWT Archives).

3. On this point see Stuart Ewen, *Captains of Consciousness: Advertising and the Social Roots of Consumer Culture* (New York: McGraw-Hill, 1976), especially pp. 42–43.

4. *Photo-Era Magazine* 50 (Apr. 1923): 229, summarized the "March Meeting of the P. P. of A.": "In his talk, Mr. Steichen said he did not think pictorial photography has progressed much since the Photo-Secession days. Although he had been guilty of doing soft-focus work, he had concluded that work being done with soft-focus lenses is not pictorial or artistic. He conceded that a very few workers were turning out pictorial work with them. He said the work he is doing now could not get sharp enough. . . . His talk was most interesting; but left his hearers puzzled, most of whom have been striving for pictorial quality in their work, by using entirely different methods." The substance of Steichen's speech that evening was also reported in Gilbert I. Stodola, "Colonel Steichen Talks to Students," *American Photography* 18 (Apr. 1924): 214–218; and Henry Hoyt Moore, "Pictorial Photographers of America," *Bulletin of the Art Center* 1 (Apr. 1923): 163–165. The unworkability of soft focus as a formal element was a recurrent theme in Steichen's interviews and speeches well into the 1930s.

5. "Minutes of the Representatives Meetings," Oct. 6, 1931, p. 10, and June 9, 1931, JWT Archives.

6. F. T. Kimball, "Chemistry and Physiology Supply New Themes for Advertising Copy," *JWT News* (Dec. 1930): 7.

7. Report of Mr. [Lloyd] Baillie, "Minutes of the Representatives Meetings," Nov. 2, 1932, p. 1, JWT Archives. Baillie was a vice president from 1919 to 1949; after 1933 he was a director of the company. Most of his responsibilities were as an account representative.

8. Report of Mr. [Lloyd] Baillie, "Minutes of the Representatives Meetings," Oct. 27, 1931, JWT Archives.

9. "J. Walter Thompson Company," *Fortune* (Nov. 1947): 101, 202.

10. Gordon Aymar, "When the Copy Writer Comes to the Art Director," *JWT News Letter*, no. 110 (Dec. 10, 1925): 7. Aymar also argued that a close relationship had financial benefits for the company because it would result in fewer layouts being rejected for incorrectly representing the selling principle ("Minutes of the Representatives Meetings," May 10, 1927, p. 5, JWT Archives).

11. Aymar, "When the Copy Writer Comes to the Art Director," ibid. An unusual docu-

ment, written as stockholders' affidavits, provides full descriptions of jobs in the agency at the time. John T. De Vries, a JWT art director from 1917 to 1925, recorded that he was "responsible for the visual results of the advertisements of our various accounts. . . . This work consists of complete drafting of paintings to present to the client, also the designing of other advertising material, such as booklets, signs, posters, car cards, packages and labels, letterheads, store cards, window trims, etc. The amount of units to be designed runs around five hundred pieces in a large advertising campaign. All these units require someone to compose them and put them into the semblance of finished form to be submitted as well as guide them through to completed form" (De Vries, *Stockholders' Affidavits* [1924], pp. 82–83, JWT Archives).

Art directors' responsibilities gradually changed between the world wars. When De Vries and Aymar began their careers soon after World War I, art directors frequently produced finished drawings themselves. As the number and extent of campaigns grew, agencies employed freelance artists more frequently. By the late 1920s, a significant part of the art director's job was to look for and cultivate new talent. The JWT art director C. O. Woodbury reported that every week "a score or more artists bring samples of their work to our Art Department for consideration. Some . . . have very rare individuality . . . and [some have] reached that stage of popularity where it becomes somewhat less fascinating" (Woodbury, "Art Work of Unusual Interest," *JWT News Letter*, no. 10 [Nov. 15, 1928]: 2). A report on efforts to cultivate artists in Germany, France, and England is described in the *JWT News Letter* (Aug. 8, 1928), p. 5.

The responsibilities of art directors varied somewhat by company. Charles T. Coiner recalled that when he came to Ayer in 1924, his title was art supervisor, and he was in charge of "layout designers, lettering artists, sketch artists, and a whole bevy of young people who assisted the supervisors. In this way one supervisor could handle quite a few accounts" (Coiner, "Recollections of Ayer," oral history interview by Howard L. Davis and F. Bradley Lynce, Mar. 16, 1982, p. 7, N. W. Ayer and Son Archives, New York).

12. *Annual of Advertising Art* 2 (1922): 9. The collaboration between artist and art director is a constant theme in the Art Directors' Club annuals. See, for example, Henry Eckhardt, "Appreciation," *Annual of Advertising Art* 9 (1930): n.p.

13. Gordon Aymar, *An Introduction to Advertising Illustration* (New York: Harper, 1929), pp. 30, 34, 58. Ralph Hower described this process at the N. W. Ayer and Son advertising agency. Hower reported that while the artist might be given considerable latitude, the "job is essentially to finish a rough sketch prepared by the agency's art director and layout man. After numerous conferences with the client's advertising manager, the agency's account representatives and the copywriter, whatever art emerges from the composition and design depends upon its functional fitness" (Hower, *The History of an Advertising Agency: N. W. Ayer and Son at Work, 1869–1949* [Cambridge: Harvard University Press, 1949], p. 331).

14. Aymar, *An Introduction to Advertising Illustration*, p. 185.

15. "How Pebeco Photographs Were Taken," *JWT News Letter*, no. 131 (May 6, 1926): 111.

16. "Minutes of the Representatives Meetings," May 24, 1927, p. 1, and May 31, 1927, p. 5, JWT Archives.

17. "Minutes of the Representatives Meetings," May 31, 1927, p. 5, JWT Archives. The request pertained to the Welch's grape juice account, but Steichen never did succeed in having his signature appear with any work he did for that campaign. Michele H. Bogart locates similar inconsistencies with the use of illustrators' signatures within agency debates about the artistic merits of advertising imagery. See her *Artists, Advertising, and the Borders of Art* (Chicago: University of Chicago Press, 1995), pp. 143–147.

18. The *JWT News* reported on "the opening of the first experimental photographic studio ever to operate with an advertising agency" in Nov. 1930. At the time, the studio was considered

the realization of the art department's long and fervent ambition to experiment with lights, angles, people and objects to their hearts' content until they get a photograph of the utmost dramatic power and subtlety for a given layout.

Besides the art directors, who will create the photographs for their own accounts, the studio will have Mr. H. Foster Ensminger, a photographic technician of long and varied experience, to guide its activities.

J. Walter Thompson will not go into the photographic business. The new studio is simply a laboratory where an illustrative problem will be experimented with, until the most perfect solution has been worked out. The final experiment, o.k.'d by the client, will be turned over to the commercial photographer best equipped to make the finished illustration.

See "JWT N.Y. Office Installs Photographic Equipment for Use of Art Department," *JWT News* (Dec. 1930): 3. At the staff meeting of Jan. 5, 1932, Stanley Resor announced the closing of the photographic studio. It had originally been intended to assist art directors with layout. So many of the art directors' photographs were used as the completed advertising art and billed to clients, however, that a business conflict was created. Since Resor believed that it was inconsistent with company policy to have a financial interest in a material service of any kind, he sold the studio to Harry Watts, with the agreement that it could be used as company needs required ("Minutes of the Representatives Meetings," Jan. 5, 1932, p. 21, JWT Archives).

19. "Meeting of Creative Organization Staff," Feb. 15, 1933, p. 11, JWT Archives. The prizes refer to inclusion in the New York Art Directors' Club *Annual of Advertising Art* almost every year Steichen worked on the Jergens campaign. Yates was an art director at JWT from 1929 to 1931. He left the company to become an art director for Curtis Publications' *Saturday Evening Post* and later *Holiday*. He returned to advertising to work for the Ted Bates and Leo Burnett advertising agencies and had some freelance accounts. Yates rejoined JWT from 1958 to 1961 (letter from Cynthia Swank, JWT Archivist, to the author, Nov. 17, 1986).

20. Report of James S. Yates, "Minutes of the Representatives Meetings," May 5, 1931, p. 11, JWT Archives.

21. Presentation of Edward Steichen, "Minutes of the Representatives Meetings," Jan. 31, 1928, pp. 6, 9, JWT Archives.

22. Ibid., p. 9.

23. Lillian Sabine, "Edward J. Steichen," *Commercial Photographer* (May 1932): 312.

24. "Transcript of a conversation between Edward Steichen and Wayne Miller as filmed for the National Broadcasting Company" [ca. 1955], pp. 9, 12, Edward Steichen Archives, Museum of Modern Art, New York. The reliance on formula Steichen alluded to is especially noticeable in his fashion and advertising photographs from the middle and late 1930s.

Measured by post–World War II standards, early commercial photographers had a great deal of freedom. Those who continued their careers into the 1950s complained of tighter agency instructions. Anton Bruehl recalled that when he took his first advertising photographs in the mid-1920s, "the art directors were often fine artists in their own right," and they gave him "a pretty free hand." But "later on it became much more cut and dried. The agency would come in with a complete layout and you had to pretty much stick to it. That's

when the fun went out of things." Louise Dahl-Wolfe reported that such restrictions led her to leave the field, and Horst complained that by the 1950s the compositional sketches given him were so rigid that he could not fit his photographic images into them. By contrast, during the 1920s the only instruction Aymar had given Steichen was a discussion of the concept that the final photograph should contain (Casey Allen, "Bruehl," *Camera* 35 [Oct. 1978]: 76; Louise Dahl-Wolfe, *A Photographer's Scrapbook* [New York: Saint Martin's/Marek, 1984], pp. 143, 145; and Valentine Lawford, *Horst: His Work and His World* [New York: Knopf, 1984], pp. 315, 343).

25. James S. Yates, "Copy from an Art Director's Standpoint," in "Minutes of Representatives Meetings," May 5, 1931, p. 8, JWT Archives.

26. See Mabel Jewett Crosby, "Just How to Carve the Thanksgiving Turkey," *Ladies' Home Journal* (Nov. 1924): 129; and "Frying to Perfection: You Can Do This in Deep Fat with a Thermometer," *Ladies' Home Journal* (Oct. 1924): 142; S. Josephine Baker, M.D., "A New Way to Dress the Baby," *Ladies' Home Journal* (May 1928): 154 (photographs by Nikolas Muray), and "The Youngest Generation, II: The Happy Bath Hour," *Ladies' Home Journal* (Nov. 1929): 37 (photographs by Nikolas Muray). (This instructional genre continued, though with lessening frequency, into the 1930s; see Grace L. Pennock, "Spring Fever in the Laundry," *Ladies' Home Journal* (Apr. 1936): 40. For the effect on the housewife's role of books using photomontage to describe the scientific household management, see Sally A. Stein, "The Composite Photographic Image and the Composition of Consumer Ideology," *Art Journal* 41 (spring 1981): 39–45.

27. Nicholas Haz, "Steichen," *Camera Craft* (Jan. 1936): 12; Marguerite Tazelaar, "Portrait of a Pioneer," *Amateur Movie Makers* 2 (July 1927): 18–19, 46.

28. Presentation of Edward Steichen (as in n. 21), p. 4.

29. Ibid., p. 9.

30. Leonard A. Williams, *Illustrated Photography in Advertising* (San Francisco: Camera Craft Publishing Company [ca. 1929]), p. 85. Ann Uhry Abrams has traced narrative structure in American advertising to nineteenth-century American genre painting and early-twentieth-century Ashcan school painting ("From Simplicity to Sensation: Art in American Advertising, 1904–1929," *Journal of Popular Culture* 10 [winter 1976]: 622–623).

31. T. J. Jackson Lears, "The Uses of Fantasy: Toward a Cultural History of American Advertising, 1880–1930," *Prospects* 9 (1984): 349–405.

32. Report of William Esty, "Minutes of the Representatives Meetings," Sept. 30, 1930, p. 15, JWT Archives.

33. Richard W. Pollay has noted that the "use of multiple images to communicate story lines" peaked in the 1930s at 17 percent of his sample ("The Subsiding Sizzle: A Descriptive History of Print Advertising, 1900–1980," *Journal of Marketing* 49 [summer 1985]: 31–32). For analysis of the use of fine art and advertising montages in Europe and America, see Matthew Teitelbaum, ed., *Montage and Modern Life, 1919–1942* (Cambridge: MIT Press, 1992).

34. "Minutes of the Representatives Meetings," Oct. 6, 1931, pp. 4–5, JWT Archives.

35. "Minutes of the Representatives Meetings," Jan. 19, 1932, pp. 13–14, JWT Archives.

36. Allan Sekula, "Dismantling Modernism, Reinventing Documentary (Notes on the Politics of Representation)," 1978; reprinted in *Photography against the Grain: Essays and Photo Works, 1973–1983* (Halifax: Press of the Nova Scotia College of Art and Design, 1984), pp. 53–54.

37. Christine Frederick, *Selling Mrs. Consumer* (New York: Business Bourse, 1929), pp. 44–45.

38. John B. Watson, *Animal Education: An Experimental Study on the Psychical Development of the White Rat, Correlated with the Growth of Its Nervous System* (Chicago: University of Chicago Press, 1903). Watson's dissertation is discussed in Kerry Buckley, *Mechanical Man: John Broadus Watson and the Beginnings of Behaviorism* (New York: Guilford Press, 1989), pp. 33–45; and David Cohen, *John B. Watson: The Founder of Behaviorism* (London: Routledge and Kegan Paul, 1979), pp. 25–41. For further information about Watson, see Lucille T. Birnbaum, "Behaviorism: John Broadus Watson and American Social Thought, 1913–1933," Ph.D. diss., University of California, Berkeley, 1964, and Watson's own voluminous writings listed in the bibliographies of Buckley and Cohen.

39. John B. Watson, "Psychology As the Behaviorist Views It," *Psychological Review* 20 (Mar. 1913): 158, 167, 176. Like all philosophical and theoretical statements, Watson's theory of behaviorism reflected the culture in which it was constructed and wove together threads from the discipline and related areas, whether acknowledged or not. On the intellectual roots of Watson's ideas see David Bakan, "Behaviorism and American Urbanization," *Journal of the History of the Behavioral Sciences* 2 (Jan. 1966): 5–28; John C. Burnham, "On the Origins of Behaviorism," *Journal of the History of the Behavioral Sciences* 4 (Apr. 1968): 143–151; and John M. O'Donnell, *The Origins of Behaviorism: American Psychology, 1870–1920* (New York: New York University Press, 1985). Quotation from John B. Watson, "The Origin and Growth of Behaviorism," *Archiv für systematische Philosophie* 30 (1927): 248, cited in Bakan, "Behaviorism and American Urbanization," p. 7.

40. Bakan, "Behaviorism and American Urbanization," pp. 5–28; see also Harry Braverman, *Labor and Monopoly Capital: The Degradation of Work in the Twentieth Century* (New York: Monthly Review Press, 1974).

41. Bakan, "Behaviorism and American Urbanization," p. 12.

42. Watson, "Psychology As the Behaviorist Views It" (as in n. 39), pp. 158, 168; and Buckley, *Mechanical Man* (as in n. 38), p. 77.

43. Dorothy Ross, *The Origins of American Social Science* (New York: Cambridge University Press, 1991), p. 311.

44. "The Behaviorist's Utopia," a manuscript in the Watson papers at the Library of Congress, was published as "Should a Child Have More Than One Mother?" *Liberty*, June 29, 1929, pp. 31–35. Watson's utopianism is insightfully analyzed in Buckley, *Mechanical Man*, pp. 144–146, 155–156, 161–170.

45. John B. Watson, "Should a Child Have More Than One Mother?"

46. Buckley, *Mechanical Man* (as in n. 38), pp. 164–165.

47. John B. Watson, "The Ideal Executive," 1922 speech, quoted in Buckley, *Mechanical Man*, p. 137.

48. Robert M. Yerkes, "Report of the Psychological Committee of the National Research Council," *Psychological Review* 26 (Mar. 1919): 148–149, cited in Buckley, *Mechanical Man*, p. 111.

49. John B. Watson, "Dissecting the Consumer—an Application of Psychology to Advertising," undated typescript, cited in Buckley, *Mechanical Man*, p. 137.

50. Presentation of Edward Steichen (as in n. 21), p. 5.

51. John B. Watson and Rosalie Rayner, "Conditioned Emotional Reactions," *Journal of Experimental Psychology* 3 (Feb. 1920): 1–14. Problems with the study pointed out by later critics include the use of only one subject and the subjectivity of the observers in recording responses. See Ben Harris, "Whatever Happened to Little Albert?" *American Psychologist* 34 (Feb. 1979): 151–160; and Franz Samelson, "J. B. Watson's Little Albert, Cyril Burt's Twins, and the Need for a Critical Science," *American Psychologist* 35 (July 1980): 619–625.

52. Kerry W. Buckley, "The Selling of a Psychologist: John Broadus Watson and the Application of Behavioral Techniques to Advertising," *Journal of the History of the Behavioral Sciences* 18 (July 1982): 211.

53. Buckley, *Mechanical Man* (as in n. 38), pp. 122–123.

54. T. J. Jackson Lears, *Fables of Abundance: A Cultural History of Advertising in America* (New York: Basic Books, 1994), p. 43; Roland Marchand, *Advertising the American Dream: Making Way for Modernity, 1920–1940* (Berkeley and Los Angeles: University of California Press, 1985), p. 314; quotation from Stuart Chase and F. J. Schlink, *Your Money's Worth: A Study in the Waste of the Consumer's Dollar* (New York: Macmillan, 1927), p. 260.

55. Arthur Kallet and F. J. Schlink, *One Hundred Million Guinea Pigs: Dangers in Everyday Foods, Drugs, and Cosmetics* (New York: Vanguard Press, 1933).

56. Mary C. Phillips, *Skin Deep: The Truth about Beauty Aids—Safe and Harmful* (New York: Vanguard Press, 1934), p. 168.

57. James Rorty, *Our Master's Voice: Advertising* (New York: John Day, 1934), p. 11; see also Helen Woodward, *Through Many Windows* (New York: Harper, 1926).

58. See Max Horkheimer and Theodor W. Adorno, *Dialectic of Enlightenment* [1944], trans. John Cumming (New York: Continuum Books, 1969); and Max Horkheimer, "Art and Mass Culture," *Studies in Philosophy and Social Science* 9, no. 2 (1941): 290–304. For discussion of the Frankfurt School and mass culture, see Lillian S. Robinson, "Criticism: Who Needs It?" in *Sex, Class, and Culture* (Bloomington: Indiana University Press), pp. 69–94; Hans Magnus Enzensberger, *The Consciousness Industry: On Literature, Politics, and the Media* (New York: Continuum Books, 1974); Tania Modleski, ed., *Studies in Entertainment: Critical Approaches to Mass Culture* (Bloomington: Indiana University Press, 1986), esp. pp. ix–xix, Tania Modleski, *Loving with a Vengeance: Mass-Produced Fantasies for Women* (New York: Methuen, 1986), pp. 26–27; and Fredric Jameson, "Reification and Utopia in Mass Culture," *Social Text* 1 (1979): 130–148. For approaches to advertising and mass culture influenced by the thinking of the Frankfurt School, see Stuart Ewen, *Captains of Consciousness* (as in n. 3); Stanley Aronowitz, *False Promises: The Shaping of American Working-Class Consciousness* (New York: McGraw-Hill, 1973), pp. 51–134, 285; and T. J. Jackson Lears, "Uneasy Courtship: Modern Art and Advertising," in *Modernist Culture in America*, ed. Daniel Joseph Singal (Belmont, Calif.: Wadsworth, 1991; originally published in *American Quarterly* 39, no. 1 [spring 1987]).

59. Jameson, "Reification and Utopia in Mass Culture," p. 141.

60. The income levels, outlooks, and other demographics of the typical admen analyzed by Marchand (*Advertising the American Dream* [as in n. 54], pp. 25–51) seem to fit the comfortable middle-class families between the wars described by Ruth Schwartz Cowan, *More Work for Mother: The Ironies of Household Technology from the Open Hearth to the Microwave* (New York: Basic Books, 1983), pp. 172–181. Marchand has argued that advertisements represent the class values of their creators far more than those of the intended audience (see introd. and chapters 2 and 3).

61. For its antecedents in classical literature and its reappearance in contemporary popular culture, see Modleski, *Loving with a Vengeance* (as in n. 58), p. 16.

62. Presentation of Edward Steichen (as in n. 21), p. 7.

63. Walter Dill Scott, *The Psychology of Advertising* (Boston: Small, Maynard, 1908), pp. 87, 111, 138.

64. Daniel Starch, *Advertising: Its Principles, Practice, and Technique* (New York: Appleton, 1914), pp. 264–265.

65. Harlow S. Gale, *Psychology of Advertising*, pp. 67–68, cited in David P. Kuna, "The

History of Advertising Psychology 1896–1916," Ph.D. diss., University of New Hampshire, 1976, p. 104.

66. Harry L. Hollingworth, *Advertising and Selling: Principles of Appeal and Response* (New York: Appleton, 1913), pp. 289–292, cited in Kuna, ibid., p. 309.

67. Lillian G. Glenn, "Business Unfits Women for Matrimony Says Dr. John B. Watson," *Everyweek Magazine* (ca. 1931), cited in Buckley, *Mechanical Man* (as in n. 38), p. 163.

68. There is a vast literature on the development of "separate spheres." See, for example, Cowan, *More Work for Mother* (as in n. 60); Carl Degler, *At Odds: Women and the Family in American History* (New York: Oxford University Press, 1980); Nancy Cott, *Bonds of Womanhood: Women's Sphere in New England, 1780–1835* (New Haven, Conn.: Yale University Press, 1977); Ann Douglas, *The Feminization of American Culture* (New York: Knopf, 1978).

69. Watson, "Should a Child Have More Than One Mother?" (as in n. 44), pp. 34–35.

70. John B. Watson, "The Weakness of Women," *Nation* 125 (July 6, 1927): 10.

71. Olive Banks, *Faces of Feminism: A Study of Feminism as a Social Movement* (New York: Saint Martin's Press, 1981), pp. 180–196.

72. *Vogue*, Feb. 15, 1925, p. 67.

73. Banks, *Faces of Feminism*, pp. 155–156.

74. *Vogue*, Aug. 1, 1932.

CHAPTER SEVEN

1. For example, see *Ladies' Home Journal* (July 1929): 72.

2. Arthur Kallet and F. J. Schlink, *One Hundred Million Guinea Pigs: Dangers in Everyday Foods, Drugs, and Cosmetics* (New York: Vanguard Press, 1933), p. 166.

3. "Minutes of the Representatives Meetings," Apr. 4, 1928, p. 17, JWT Archives. On the testimonial at JWT, see also Stephen Fox, *The Mirror Makers: A History of American Advertising and Its Creators* (New York: Morrow, 1984), pp. 88–90; and Kerry Buckley, *Mechanical Man: John Broadus Watson and the Beginnings of Behaviorism* (New York: Guilford Press, 1989), p. 140. On the Fleischmann campaign, see Roland Marchand, *Advertising the American Dream: Making Way for Modernity, 1920–1940* (Berkeley and Los Angeles: University of California Press, 1985), pp. 16–18.

4. Report of Mr. [Stanley] Resor to New Members Group, May 4, 1931, JWT Archives.

5. Carroll Rheinstrom, *Psyching the Ads: The Case Book of Advertising* (New York: Covici Friede, 1929), pp. 37, 39; see also Carl A. Naether, *Advertising to Women* (New York: Prentice-Hall, 1928), pp. 104–108.

6. *Druggists' Circular* (May 1927): 487.

7. *Ladies' Home Journal* (Feb. 1924): 65; see also Fox, *The Mirror Makers*, pp. 88–89.

8. On Johnston, see Bonnie Yochelson, *Alfred Cheney Johnston: Women of Talent and Beauty, 1917 to 1930* (Malvern, Pa.: Charles Isaaccs Photographs, 1987).

9. Rheinstrom, *Psyching the Ads*, p. 39.

10. Naether, *Advertising to Women*, pp. 104–108.

11. The circulation of *Ladies' Home Journal* at the time was about 2.5 million (Rheinstrom, *Psyching the Ads*, p. 39).

12. *JWT News Letter*, no. 108 (Nov. 27, 1925): 1. Manners reappeared in *Ladies' Home Journal* (Apr. 1933): 39, during a campaign that revisited early endorsers to demonstrate that Pond's had helped them retain youth and beauty.

13. *JWT News Letter,* no. 117 (Jan. 28, 1926): 23.

14. Judith Williamson, "Royalty and Representation," in her *Consuming Passion* (London: Marion Boyar, 1986), pp. 74–89.

15. Marchand discusses using endorsements by prominent figures to sell inexpensive beauty aids under the rubric "parable" of the "Democracy of Goods" (Marchand, *Advertising the American Dream* [as in n. 5], pp. 206–207).

16. Howard Dickinson, *Printers' Ink* 149 (Oct. 10, 1929): 138, cited in Marchand, p. 218.

17. Marchand, pp. 220–221, 337.

18. Ibid., p. 194.

19. Ibid., pp. 194–195.

20. T. J. Jackson Lears, "From Salvation to Self-Realization: Advertising and the Therapeutic Roots of Consumer Culture," in *The Culture of Consumption, 1880–1930,* ed. Richard Wrightman Fox and T. J. Jackson Lears (New York: Pantheon Books, 1983), pp. 1–38, 213–218.

21. On the "re-personalization of American life," see Marchand, *Advertising the American Dream* (as in n. 3), pp. 352–359.

22. Stuart Chase and F. J. Schlink, *Your Money's Worth: A Study in the Waste of the Consumer's Dollar* (New York: Macmillan, 1927), p. 266.

23. Mary C. Phillips, *Skin Deep: The Truth about Beauty Aids—Safe and Harmful* (New York: Vanguard Press, 1934), pp. 30, 46.

24. *Printers' Ink* 136 (Aug. 26, 1926): 197, quoted in Marchand, *Advertising the American Dream,* p. 97. For examples of controversial testimonials, see Marchand, pp. 96–100.

25. The trade papers from 1934 (for example, *Printers' Ink* and *Advertising and Selling*) gave full coverage to proposed legislation for controlling the industry.

26. Christine Frederick, *Selling Mrs. Consumer* (New York: Business Bourse, 1929), pp. 345–346.

27. On the demographics of U.S. domestic workers and the visual representation of "French maids," see Marchand, *Advertising the American Dream,* pp. 201–205.

28. Inquiries to the Simmons Company were unable to discover why Harriman and Roosevelt were chosen.

29. The editor Frank Crowninshield wrote in the May 1914 issue of *Vanity Fair* that the magazine was addressed to "people of means, who cultivate good taste, read good books, buy the best pictures, appreciate good opera, love good music and build distinguished houses" (quoted in John Russell, introduction to *Vanity Fair: Photographs of an Age, 1914–1936* [New York: Clarkson N. Potter, 1982], p. xii).

30. "Pulling Power of Names Used on Ponds in 1925," *JWT News Letter,* no. 132 (May 13, 1926): 119–121; and *JWT News Letter,* no. 60 (Jan. 1, 1925): 2.

31. "Giving Still Life a Modern Touch," *Printers' Ink Monthly* (Aug. 1928).

32. Despite her obscurity and youth (she was eighteen), Mason wrote an article for the *Ladies' Home Journal,* "What Every Bride Should Know about Planning Her Trousseau" (Sept. 1927): 6–7. It was illustrated with seven Nikolas Muray photographs of Mason modeling her new clothes. Mason reappeared when the Pond's campaign of 1933 revisited its models of the mid-1920s to assess the effects of long-term Pond's usage (*Ladies' Home Journal* [June 1933]: 35).

33. "Minutes of the Representatives Meetings," June 8, 1932, p. 4, JWT Archives.

34. "Minutes of the Representatives Meetings," Sept. 26, 1928, JWT Archives.

35. "Minutes of the Representatives Meetings," June 8, 1932, p. 4, JWT Archives.

36. On Huené, see William A. Ewing, *The Photographic Art of Hoyningen Huene* (New York: Rizzoli, 1986).

37. Frank Young, *Modern Advertising Art* (New York: Covici Friede, 1930), p. 14.

38. Joanna T. Steichen's 1979 centennial gift of a large number of Edward Steichen's fine art and commercial photographs to the George Eastman House is described in *Image* 26 (Sept. 1983). Since the collection was particularly rich in portraiture, its subsequent partial dispersion to twenty-three institutions served as a catalyst for exhibitions and catalogues devoted primarily to Steichen's portraits. See, for example, Esther I. Persson, "Steichen," *Pharos '83* 20 (July 1983): 4–25, published by the Museum of Fine Arts, St. Petersburg, Fla.; Christian A. Peterson, *Edward Steichen: The Portraits* (Minneapolis: Minneapolis Institute of Arts and the Art Museum Association of America, 1984); and Anne W. Tucker, *Edward Steichen: The Condé Nast Years* (Houston: Museum of Fine Arts, 1984).

39. Harold B. Nelson, foreword to Peterson, *Edward Steichen: The Portraits*, p. 5.

40. Beaumont Newhall, *The History of Photography*, 5th ed. (New York: Museum of Modern Art, 1982), p. 263.

41. John Tagg, *The Burden of Representation: Essays in Photographies and Histories* (Amherst: University of Massachusetts Press, 1988), pp. 18–19.

42. Peterson, *Edward Steichen: The Portraits*, pp. 6–10.

43. Edward Steichen, "Concerning Portraiture," in *The Bausch and Lomb Souvenir* (Rochester and New York: Bausch and Lomb, 1903), p. 5.

44. For example, see Ben Maddow, *Faces: A Narrative History of the Portrait in Photography* (Boston: New York Graphic Society, 1977).

45. John A. Tennant, "The Technique of Portraiture," *Photo-Miniature* 17, no. 195 (Sept.–Dec. 1924): 132–133. Later discussions focused on updating technique, advising simplicity, and concentrating on the subject. See John A. Tennant, "Home and Studio Portraiture," *Photo-Miniature* 18, no. 205 (May 1932): 9–48.

46. On celebrityhood, see Richard Schickel, *Intimate Strangers: The Culture of Celebrity* (New York: Doubleday, 1985). Schickel argues that because of the mass media, especially television, celebrities can be made or unmade quickly. See also Christine Gledhill, ed., *Stardom: Industry of Desire* (London: Routledge, 1991; and Jib Fowles, *Starstruck: Celebrity Performers and the American Public* (Washington, D.C.: Smithsonian Institution Press, 1992).

47. Edward Steichen, *U.S. Camera* (Oct. 1938): 15–16, quoted in Newhall, *The History of Photography* (as in n. 40), p. 263.

48. Presentation of Edward Steichen, "Minutes of the Representatives Meetings," Jan. 31, 1928, p. 5, JWT Archives.

49. Peterson, *Edward Steichen: The Portraits* (as in n. 38), p. 13.

50. Helen Lawrenson, *Stranger at the Party* (New York: Random House, 1975), p. 81.

51. Samuel M. Kootz, "Edward J. Steichen," *Creative Art* 10 (May 1932): 361.

52. Paul Rosenfeld, "Carl Sandburg and Photography," *New Republic,* Jan. 22, 1930, p. 252. See Chapter 8 for further discussion of Steichen's conflicts with art photographers in the Stieglitz article.

53. "We Pause to Honor," *Advertising Arts* (Jan. 1931): 24.

54. Clare Boothe Brokaw, "Edward Steichen, Photographer," *Vanity Fair* (June 1932): 60.

55. Rosenfeld, "Carl Sandburg and Photography," p. 252.

56. Kootz, "Edward J. Steichen" (as in n. 51), pp. 361, 363.

57. Report of Mr. Esty, "Minutes of the Representatives Meetings," Dec. 3, 1929, pp. 5, 8, JWT Archives; and Stanley Resor, quoted in *Advertising and Selling,* Apr. 17, 1929, p. 27.

58. "Minutes of the Representatives Meetings," Mar. 29, 1933, p. 8, JWT Archives.

CHAPTER EIGHT

1. The contracts were probably terminated because during the depression the agency could not convince enough clients to pay Steichen's high prices to reimburse them for his minimum salary. Steichen, however, seems to have amply made up the difference when he went freelance. He told an interviewer in 1932: "There isn't a high spot in this day of unemployment where there isn't more demand than can be met. . . . We could use fifty of the best photographers. I turn enough away to keep five studios busy" (Lillian Sabine, "Edward J. Steichen," *Commercial Photographer* [May 1932]: 312).

2. Steichen's known commissions executed for these agencies are listed in the Appendix.

3. I am indebted to Joanne Lukitsh for many discussions about the functioning of the gaze and frame in this campaign and for her astute reading of this chapter.

4. Charles T. Coiner, "Recollections of Ayer," oral history interview by Howard L. Davis and F. Bradley Lynce, Mar. 16, 1982, p. 15, N. W. Ayer and Son Archives, New York. Coiner's archives are at Syracuse University.

5. Coiner was a full Academician of the National Academy of Design, but he is best known for his logo design of the blue eagle for Roosevelt's National Recovery Act. (The Ayer agency advised the administration on publicity.) Coiner worked for the Chicago office of the Erwin, Wasey agency from 1918 to 1924, and he came to Ayer as an art supervisor in 1924. When Vaughn Flannery left for Young and Rubicam in 1929, Coiner became head of the Art Department (*Advertising and Selling,* Nov. 27, 1929, p. 99). See also R. Roger Remington and Barbara J. Hodik, *Nine Pioneers in American Graphic Design* (Cambridge: MIT Press, 1989), pp. 54–69; and Michele H. Bogart, *Artists, Advertising, and the Borders of Art* (Chicago: University of Chicago Press, 1995), pp. 157–169.

6. Coiner, "Recollections of Ayer"; and Paul W. Darrow, untitled, undated reminiscences, N. W. Ayer and Son Archives, New York.

7. For information on this account, see Martina Roudabush Norelli, *Art, Design, and the Modern Corporation,* essay by Neil Harris (Washington, D.C.: National Museum of American Art, Smithsonian Institution, 1985).

8. Coiner, "Recollections of Ayer" (as in n. 4).

9. Alexey Brodovitch, "Charles Coiner, Art Director," *Portfolio* 1 (summer 1950): n.p.

10. In 1983 Coiner mused ("Recollections of Ayer," p. 54):

There should be a place for fine artists in advertising. It's not an easy thing to do. For instance, we would commission a very good fine artist to do a painting for an advertisement, and half the time the fine artist will try his best to do a piece of *commercial art* and they'll fall on their face, you know—you have to protect the artist from doing that. We would tell him what we wanted was not a piece of commercial art. We can get that from anybody and we wouldn't want to have their name on a piece of ordinary commercial art because it will be seen by hundreds of thousands of people and do him more harm than good. So, if you don't mind doing it again and just doing your thing in your own style, that would be great. Forget about trying to please us with commercial art. Sometimes they could do it and sometimes they might make a half a dozen paintings and never be able to do a thing that was actually usable and that would enhance their reputation and satisfy us.

11. Ibid., pp. 14–15.

12. Harford Powel, "And Now Concerning Copy," *Advertising and Selling,* May 23, 1935, p. 28. The Cannon towels series was considered both an aesthetic and a popular success. Requests for reprints of the ads came from all over the country and abroad, and one store reportedly ordered one hundred thousand of them.

13. Coiner, "Recollections of Ayer" (as in n. 4), pp. 14–15.

14. Christine Frederick, *Selling Mrs. Consumer* (New York: Business Bourse, 1929), p. 350.

15. Rosemary Betterton, "How Do Women Look? The Female Nude in the Work of Suzanne Valadon," in *Looking On: Images of Femininity in the Visual Arts and Media,* ed. Betterton (London: Pandora Press, 1987), p. 218. Betterton looked at whether nudes painted by a female artist might escape reinscribing the male creator's power over his model.

16. A number of theorists during the 1970s and 1980s fully developed these theories in a more nuanced way. My purpose here is simply to outline their ideas. Laura Mulvey is usually considered to have invented this genre of writing with her influential work "Visual Pleasure and Narrative Cinema," *Screen* 16, no. 3 (autumn 1975): 6–18, reprinted in Constance Penley, ed., *Feminism and Film Theory* (New York: Routledge, Chapman and Hall, 1988), pp. 57–68. Mulvey theorizes that classic Hollywood cinema leaves little space for the female spectator because the active process of looking (the gaze) is essentially constructed for males, while females are the passive objects to be looked at. When women attempt to participate in the process of viewing, they enter into a culturally inhospitable space where they alternate between identifying with the gaze and with the image gazed upon. When women assume the position of spectator, they are forced into a transvestite identification with the male spectator of women's bodies. The only other choice is an equally uncomfortable identification with the object of the gaze—the spectacle. Mulvey uses such psychoanalytic concepts as scopophilia, voyeurism, and fetishization to develop her ideas. In "Afterthoughts on 'Visual Pleasure and Narrative Cinema' Inspired by *Duel in the Sun,*" *Framework,* nos. 15–17 (1981): 12–15, reprinted in Penley, ed., *Feminism and Film Theory,* pp. 69–79, Mulvey allows for greater mobility of the gaze. The spectator need not simply subscribe to either a male or female process of viewing but might take up one or both at different times or simultaneously. The later essay also moves away from essentialism to recognize social and historical influences on the gaze.

Later film theorists have refined Mulvey's conception of the trap for female viewers. Teresa de Lauretis sees how women may *simultaneously* identify with the gaze, the object of the gaze, and the elements of the narrative process that overlays the image. De Lauretis also begins to examine the process of social construction of gender (*Alice Doesn't: Feminism, Semiotics, Cinema* [Bloomington: Indiana University Press, 1984], esp. pp. 143–144).

Mary Ann Doane, in her study of "women's films" of the 1940s, argues that they offer the female spectator a space different from that of the male gaze and an identity other than that of the hero—but ultimately the substitutes are unsatisfactory. "Women's films" de-eroticize the gaze, but in the process they disembody and immobilize the spectator (Doane, *The Desire to Desire: The Woman's Film of the 1940s* [Bloomington: Indiana University Press, 1987], pp. 6–7, 19). Doane's other major concern is that the female spectator who views herself as a spectacle is in that process encouraged to participate in her own objectification and oppression. Women are encouraged to become overconcerned with appearance and social position, and to satisfy this desire through consumerism. Following Stuart Ewen, Doane argues that "any dissatisfaction with one's life or any critique of the social system" is reoriented onto the woman's body, "which is in some way guaranteed to be at fault" (p. 32).

17. Rozsika Parker and Griselda Pollock have explained that psychoanalysis is useful

because bourgeois patriarchal ideology operates on unconscious levels (*Old Mistresses: Women, Art, and Ideology* [New York: Pantheon, 1981], p. 132). However, the heavy reliance by the early theorists on psychoanalytic concepts—especially those developed by Freud and Lacan—proved methodologically problematic since so much of psychoanalytic theory is essentialist and ahistorical, downplaying cultural constructions. As Jane Gaines has pointed out, Freudian analysis often "theorizes femininity as silence"; women are always relegated to the spaces around and between male cultural ideas and representations (Gaines, "Women and Representation: Can We Enjoy Alternative Pleasure?" in *American Media and Mass Culture: Left Perspectives,* ed. Donald Lazare [Berkeley and Los Angeles: University of California Press, 1987], p. 360).

Because of some cultural resistance to Freud in the United States, it is surprising to encounter the acceptance of psychoanalytic models of spectatorship among theorists seeking to explain representation and spectatorship in American films and other cultural products. (Tellingly, much of this feminist film theory was first generated in Britain and then transplanted to the United States.) Although Freud has appeared in popular magazines and has informed introductory psychology courses in the century since he began publishing his ideas, American industrial psychology has been little swayed by Freudian ideas. As I have argued, American businesses concerned with the mass production of imagery—particularly advertising—may have dabbled in Freud and other, competing, psychoanalytic models, but they have relied most heavily on seemingly pragmatic behaviorist concepts for the construction and marketing of popular images.

18. For example, in her study of the female spectator in Weimar Germany, Patrice Petro found evidence that female viewers brought to cinematic melodramas a highly concentrated gaze—one neither passively feminine nor actively male—that allowed for a heightened sensory experience, which compensated for the ordinariness of everyday life. Petro related this gaze to historical determinants—Weimar modernity, with its instability of gender expectations that restructured women's experience (Petro, *Joyless Streets: Women and Melodramatic Representation in Weimar Germany* [Princeton, N.J.: Princeton University Press, 1989], pp. 69–77). On the active gaze see also Jackie Stacey, "Desperately Seeking Difference," pp. 112–129, and Avis Lewallen, "*Lace:* Pornography for Women?" pp. 86–101, both in *The Female Gaze: Women as Viewers of Popular Culture,* ed. Lorraine Gamman and Margaret Marshment (Seattle: Real Comet Press, 1989). Stacey attempts to come to terms with women looking at women in films. Lewallen finds feminist content in otherwise ideologically conservative sexually explicit romance novels. Lesbian theory provides another positive alternative to the pessimism of psychoanalytic film theory. In these studies the female gaze is usually theorized as active rather than passive.

19. This phenomenon continues, despite all the recent theory on the multiple meanings generated by a single text when it is read by a variety of readers. In a seminar on pedagogy one of my (male) colleagues once asked the female literature professors whether it was true they had learned to read novels like a man. To his astonishment they replied: Of course—how else does one survive graduate school?

20. For Mulvey's comments on the frame, see "Visual Pleasure and Narrative Cinema" (as in n. 16).

21. "Stimulus," *Advertising Arts* (July 1932): 24. An article commemorating the fiftieth anniversary of the association between the manufacturer and the agency quoted an industry insider on the sales strategy and success of the product: "The big thing that Cannon did was taking a utility product that was used until it wore out and making it into a decorative thing. . . . The company took towels out of the commodity class and helped to make it into a

branded product" (Leonard Sloane, "Advertising: A Fifty-Year Cannon-Ayer Tie," *New York Times,* Aug. 20, 1970).

22. Charles T. Coiner, "Towels by Cannon * Nude by Steichen," *Advertising Arts* (May 1935): 8–9. Although Coiner is discussed as the art director in this section, in fact he was the chief member of a team. He consulted with the art directors Paul Froelich and Paul Darrow, who were responsible for the layouts and the final preparation of the ads.

23. Ibid.

24. Coiner, "Recollections of Ayer" (as in n. 4), pp. 14–15.

25. For example, see the ad for the Standard Sanitary Manufacturing Company's bathtubs reproduced in *Printers' Ink* 167 (Apr. 19, 1934): 16; an advertisement for water heaters in the shower in *Advertising and Selling,* Mar. 1, 1934, p. 21; and an advertisement to account managers to sell space in *Redbook* in *Advertising and Selling,* May 10, 1934, p. 6. In all three examples the woman was represented either standing in the shower or sitting in a bathtub. The Cannon images did not reference the essential need for nudity so obviously.

26. Stephen Fox, *The Mirror Makers: A History of American Advertising and Its Creators* (New York: Morrow, 1984), p. 87.

27. See *Vogue,* Sept. 15, 1936, p. 113; and *Good Housekeeping* (Oct. 1936): 101.

28. *Tide* 10, no. 8 (Aug. 1936): 15.

29. *Vogue,* May 15, 1936, p. 119.

30. "Nude and Sundial," *Tide* 10, no. 8 (Aug. 1936): 7.

31. Roland Marchand, *Advertising the American Dream: Making Way for Modernity, 1920–1940* (Berkeley and Los Angeles: University of California Press, 1985), p. 53.

32. *Tide* 10, no. 8 (Aug. 1936): 15.

33. *Advertising Age,* July 20, 1936, cited in Fox, *The Mirror Makers* (as in n. 26), p. 120.

34. *Tide* 9, no. 4 (Apr. 1935): 20. Despite their praise, the old boys at the magazine could not describe the campaign, in which each image was to "spot some part of the body which comes in touch with Cannon towels," without a smirk: "Not all parts, but some." For other suggestive remarks: *Tide* 10, no. 9 (Sept. 1936): 78, on Gold Stripe hosiery; *Tide* 10, no. 6 (June 1936): 70, on *Delineator.*

35. *Tide* 9, no. 7 (July 1935): 70.

36. *Tide* 10, no. 4 (Apr. 1936): 14.

37. "Nude and Winchell," *Tide* 10, no. 8 (Aug. 1936): 8–9.

38. *Ladies' Home Journal* (Sept. 1939): 45.

39. John Berger, *Ways of Seeing* (New York: Viking Press, 1973), p. 47.

40. See Rachel Bowlby, *Just Looking* (New York: Methuen, 1985), esp. p. 13; and Tania Modleski, *Loving with a Vengeance: Mass-Produced Fantasies for Women* (New York: Methuen, 1986).

41. For a full account, see Sue Davidson Lowe, "The Falling Out," *Camera Arts* 3 (Mar. 1983): 32–33, 87–93. Referring to Steichen's early portrait commissions, Lowe reports that Stieglitz's "reaction to Steichen's professional success was, in fact, amusing and irritatingly ambiguous. On the occasions when he himself took part in helping Steichen to get paid work, he first praised Steichen's ability to make money without sacrificing high artistic standards, and then castigated him for building new opportunities on the foundation of those assignments favorably concluded." Lowe also reports, but disputes, Stieglitz's claim that his introduction of Steichen to Frank Crowninshield launched the photographer's long association with Condé Nast Publications.

42. Egmont Arens, "We Acquire New Eyes," *Advertising Arts,* July 9, 1930, p. 22.

43. Paul Rosenfeld, "Carl Sandburg and Photography," *New Republic,* Jan. 22, 1930, pp. 251–253. For more information on Rosenfeld, see Wanda M. Corn, "Apostles of the New American Art: Waldo Frank and Paul Rosenfeld," *Arts Magazine* 54 (Feb. 1980): 159–163; and Sue Davidson Lowe, *Stieglitz: A Memoir/Biography* (New York: Farrar Straus Giroux, 1983).

44. Rosenfeld, "Carl Sandburg and Photography," p. 252. Superficially, Steichen seems not to have been fazed by Rosenfeld's negative review of Sandburg's 1929 monograph. On the day it was published, he sent a telegram to Sandburg informing him of the review and telling him to read it for his amusement. (Steichen to Carl Sandburg, Jan. 22, 1930, Carl Sandburg Collection, University of Illinois at Urbana-Champaign, photocopy in Steichen Archives).

45. Paul Strand, "Steichen and Commercial Art," *New Republic,* Feb. 19, 1930, p. 21.

46. Mike Gold, *New Masses* (May 1930), quoted in Penelope Niven, *Carl Sandburg: A Biography* (New York: Scribner, 1991), p. 772.

47. Walker Evans, "The Reappearance of Photography," *Hound and Horn* 5 (Oct.–Dec. 1931): 126–127.

48. Steiner, who also took commercial photographs while maintaining a fine arts career, was more charitable. See Ralph Steiner, *A Point of View* (Middletown, Conn.: Wesleyan University Press, 1978), p. 16.

49. Lesley K. Baier, *Walker Evans at Fortune, 1945–1965* (Wellesley, Mass.: Wellesley College Museum, 1977).

50. *Paul Strand: Sixty Years of Photographs,* profile by Calvin Tomkins (Millerton, N.Y.: Aperture, 1976), p. 22. Through most of the 1920s Strand made his living as a filmmaker and had little time for art photography. See also Sarah Greenough, *Paul Strand: An American Vision* (Washington, D.C.: Aperture Foundation in association with the National Gallery of Art, 1990).

51. Margaret Watkins, "Advertising and Photography," *Pictorial Photography in America* 4 (1926): n.p. On Watkins at the White School, see Lucinda Barnes, ed., *A Collective Vision: Clarence H. White and His Students* (Long Beach: California State University Art Museum, 1985), p. 28.

52. Lillian Sabine, "Paul Strand, New York City," *Commercial Photographer* (Jan. 1934): 107–108.

53. On Stieglitz's socialism, see Edward Abrahams, *The Lyrical Left and the Origins of Cultural Radicalism in America: Randolph Bourne, Alfred Stieglitz* (Charlottesville: University of Virginia Press, 1986).

CHAPTER NINE

1. The genre of melodrama emerged with the rise of the middle class in eighteenth-century Europe: along with shifting class formations came the conjunction of a number of diverse cultural expressions, including sentimental stage dramas, popular traditions, musical performances, and visual spectacles (the new galleries and museums, storefronts, and public monuments). These merged into a new melodramatic theatrical form that was designed originally to appeal to a wide range of social classes. By the end of the nineteenth century, well after its transmission across the Atlantic, the melodramatic mode had lost its spectrum of class appeal. In the late nineteenth century, divisions into high and low culture were solidified. "Realism" in staging, dialogue, and character development became the goal of high-culture

theatrical productions. Melodrama was relegated to popular and provincial entertainment. It became a widely derided art form, usually associated with women's cultural domain, perhaps because in melodrama so often the plot or moral easily identified and sympathized with the innocent, the powerless, or the oppressed.

Theatrical conventions of melodrama were easily transformed into early cinema. Silent movies exploited the obviousness of the gestural, visual, and musical expressions. As the classic Hollywood tradition was becoming established in the 1930s, melodrama developed as a popular film genre, primarily perceived as a form to allow women to view (and perhaps identify with or repress) fears, desires, tensions, and frustrations.

My discussion of melodrama is based on Christine Gledhill's synthesis, "The Melodramatic Field: An Investigation," in *Home Is Where the Heart Is: Studies in Melodrama and the Woman's Film*, ed. Gledhill (London: British Film Institute Publishing, 1987), pp. 5–39. See also Peter Brooks, *The Melodramatic Imagination: Balzac, Henry James, Melodrama and the Mode of Excess* (1976; rpt., New York: Columbia University Press, 1985); Lawrence W. Levine, *Highbrow/Lowbrow: The Emergence of Cultural Hierarchy in America* (Cambridge: Harvard University Press, 1988).

2. Patrice Petro, *Joyless Streets: Women and Melodramatic Representation in Weimar Germany* (Princeton, N.J.: Princeton University Press, 1989), p. 27.

3. A 1934 debate in *Commercial Photographer* demonstrates how late the rhetoric of realism survived. W. R. DeLappe, director of the Artists' League in San Francisco, echoed the complaints of the 1920s: "The excessive use of the photograph has imparted a dreary sameness to the appearance of much modern advertising." The photograph "tells so much that it tells nothing. It cannot interpret or suggest—it can only state the detailed concrete facts." James N. Doolittle, defending the creativity of advertising photography, never challenged the premise of photography's realism. He attributed the current popularity of photography in the advertising industry to just this characteristic. He argued that the advertising man no longer desires idealizing or fantasy: "With attractive packaging, improved quality, and general enhancement of the appearance of the articles merchandised, the literalness of the photograph is, in a manner of speaking, right down his alley. *The greatest asset of the photograph is in direct line . . . with the whole modern trend of advertising—HONESTY AND BELIEVABILITY*" (emphasis in original; see W. R. DeLappe, "Counting Sheep," and James N. Doolittle, "A Rejoinder for Photographs," both in "Photographs in Advertising—Pro and Con," *Commercial Photographer* (April 1934): 195, 208.

4. In some melodramas the content is quite close to these mainstream films, frequently emphasizing only the spheres "conventionally assigned to women—the home, family relations, domestic trivia, consumption, fantasy and romance, sentiment," all of which, Christine Gledhill has noted, reinforce "equivalence between the 'feminine' and bourgeois ideology." But the subjects of other melodramas are frequently characters who rupture the ideal social order—sadistic mothers, violent men, difficult children—even though the situations in which these characters are involved typically resolve in favor of dominant social values. It is the stylistic and content excesses of melodrama that, some have argued, allowed its female audience to read it against the grain, as a resisting force that described women's pleasures and fantasies, revealed patriarchal values more clearly, and created space for women to view and react. Thus melodramas encourage greater active participation by women in the narrative (Gledhill, "The Melodramatic Field: An Investigation" [as in n. 1], pp. 9–12).

5. Mary Ann Doane, *The Desire to Desire: The Woman's Film of the 1940s* (Bloomington: Indiana University Press, 1987), p. 1.

6. For more information on these campaigns, see Roland Marchand, *Advertising the*

American Dream: Making Way for Modernity, 1920–1940 (Berkeley and Los Angeles: University of California Press, 1985), pp. 16–21, 289–290; and Stephen Fox, *The Mirror Makers: A History of American Advertising and Its Creators* (New York: Morrow, 1984), pp. 87–88, 98–99.

7. Cited in Marchand, *Advertising the American Dream*, p. 102. For other campaigns threatening death, see "Little Boy Blue," *Tide* 2, no. 7 (July 1928): 16.

8. Helen Woodward, *Through Many Windows* (New York: Harper, 1926), pp. 203–204.

9. For example, see the *Ladies' Home Journal* (Feb. 1928): 175.

10. When the Scott Paper Company brought its campaign to radio, its advertisements discussed only price, not use, probably for fear of offending consumers ("Wedge," *Tide* 8, no. 10 [Oct. 1934]: 70).

11. Gledhill, "The Melodramatic Field: An Investigation" (as in n. 1), p. 30; and Thomas Elsaesser, "Tales of Sound and Fury: Observations on the Family Melodrama," in *Home Is Where the Heart Is* (as in n. 1), pp. 66–67.

12. "JWT N.Y. Office Installs Photographic Equipment for Use of Art Department," *JWT News* (Dec. 1930), p. 3.

13. As the primary account representative for the Johnson and Johnson's baby powder campaign of the mid-1920s, Watson designed a strategy to sell "purity," "cleanliness," and protection from the dangers of infection to infants along with the product. As historian Kerry Buckley has pointed out, "Watson hoped to stimulate an anxiety, or fear, response on the part of young mothers by creating doubts as to their competence in dealing with questions of infant hygiene." Watson called on medical experts to testify to the quality of the product and its value for infant care, thus undermining women's self-confidence and promoting the value of expert advice (Buckley, *Mechanical Man: John Broadus Watson and the Beginnings of Behaviorism* [New York: Guilford Press, 1989], pp. 141–142).

14. John B. Watson, "Should a Child Have More Than One Mother?" *Liberty*, June 29, 1929, p. 31.

15. John B. Watson and Rosalie Rayner Watson, *Psychological Care of Infant and Child* (New York: Norton, 1928), p. 12. Watson's ideas on motherhood are outlined and analyzed in Buckley, *Mechanical Man*, pp. 161–164.

16. Arthur Kallet and F. J. Schlink, *One Hundred Million Guinea Pigs: Dangers in Everyday Foods, Drugs, and Cosmetics* (New York: Vanguard Press, 1933), pp. 103–113, 172. Kallet and Schlink reported that in tests Hexylresorcinol did not perform as promised; they found common hydrogen peroxide did better.

17. Adrian Forty, *Objects of Desire: Design and Society from Wedgwood to IBM* (New York: Pantheon Books, 1986), pp. 159–161, 168.

18. Roland Marchand, *Advertising the American Dream* (as in n. 6), p. 67. Marchand contends that the constant repetition of statistics, such as those documenting the low I.Q. of average Americans, "had a cumulative effect upon the consciousness of advertising writers," leading to this low opinion of their audience.

19. Ibid., pp. 52–87.

20. Paul Cherington, "Photos Fail to Please," *JWT News Letter*, no. 186 (Aug. 15, 1927): 356.

21. James Rorty, *Our Master's Voice: Advertising* (New York: John Day, 1934), p. 100.

22. Marchand, *Advertising the American Dream* (as in n. 6), p. 69.

23. Marchand makes this observation about Frederick's book in ibid., p. 80.

24. For example, see Sara Hamilton Birchell, "A Plea for Emotion in Copy," *Advertising and Selling*, Sept. 16, 1931, pp. 24–25, 40.

25. Esty built up one of the largest private libraries in the country on abnormal psychology, believing that every psychosis magnified an element of the mass personality, which could be accessed with an effective appeal. After employment as a vice president at JWT, Esty went on to found his own agency, William Esty and Co., announced as the 2001st agency ("Camel Change," *Tide* 6, no. 12 [Dec. 1932]: 21–22).

26. "Rising Value of Emotional Appeal Seen in Advertising Copy Trends," *JWT News* (Nov. 1930): 5.

27. Ibid.

28. W. K. Nield, "The Disloyal Art Director," *Advertising and Selling,* Aug. 18, 1932, p. 21.

29. Ralph Hower, *The History of an Advertising Agency: N. W. Ayer and Son at Work, 1869–1949,* 2d ed. (Cambridge: Harvard University Press, 1949), p. 332.

30. "Rising Value of Emotional Appeal Seen in Advertising Copy Trends" (as in n. 26), p. 5.

31. "Minutes of the Creative Organization Staff Meeting," Feb. 7, 1937, pp. 1–2, JWT Archives.

32. "Minutes of the Representatives Meetings," May 21, 1930, p. 3; and reports of Henry Legler, "Minutes of the Representatives Meetings," Sept. 1, 1931, p. 9, and Sept. 28, 1932, pp. 1–9, JWT Archives.

33. Kallet and Schlink, *One Hundred Million Guinea Pigs* (as in n. 16), p. 63.

34. Ibid., p. 176.

35. Report of Henry Legler, "Minutes of Creative Organization Staff," Feb. 4, 1936, p. 7, JWT Archives.

36. Report of Lloyd Baillie, "Minutes of Representatives Meetings," Nov. 2, 1932, p. 1, JWT Archives.

37. Marchand, *Advertising the American Dream* (as in n. 6), pp. 300–306.

38. Ansel Adams's 1933 visit to Steichen's busy studio is described in Nancy Newhall, ed., *Ansel Adams: Volume One, The Eloquent Light* (San Francisco: Sierra Club, 1963), p. 85. Henry J. McKeon is most frequently referred to as "Mac" in the literature by and about Steichen. Steichen calls him James McKeon in his autobiography, but articles published in the 1930s use the name Henry J. McKeon. See Steichen, *A Life in Photography* (Garden City, N.Y.: Doubleday, 1963; rpt., New York: Bonanza Books, 1984), chapter 7; and Lillian Sabine, "Edward J. Steichen," *Commercial Photographer* (May 1932): 307–313.

39. Letter from Noel H. Deeks to Grace Mayer, May 30, 1972, Edward Steichen Archives, Museum of Modern Art. Deeks came to work for Steichen in Oct. 1934 and, after Steichen closed his New York studio, moved with him to Connecticut in Jan. 1938. He remained in Steichen's employ until Steichen left for military service in 1942. Excerpts from his diaries, which he sent to Grace Mayer, are in the Edward Steichen Archives, Museum of Modern Art, New York. Steichen's studio was located at Fortieth Street and Sixth Avenue until April 1935, when he moved to 139 East Sixty-ninth Street.

40. For example, Steichen wrote about Lumière autochromes Lippman heliochromes. See Eduard J. Steichen, "Color Photography," *Camera Work,* no. 22 (Apr. 1908): 13–24. See also "A Revolution in Color Photography," an interview with Steichen by Child Bayley, *Photographer* 7 (July 30, 1907): 215, 217, 220.

41. Other hand-colored examples from this campaign may be found in the following 1929 issues: Mar., p. 40; May, p. 43; June, p. 71; July, p. 29; Nov., p. 41; and Dec., p. 29. All of these also appeared in *Vogue,* in black and white. See Appendix.

42. "Minutes of the Representatives Meetings," Dec. 2, 1930, pp. 13–14, JWT Archives.

43. Rosa Reilly, "Steichen—The Living Legend," *Popular Photography* (Mar. 1938): 11. In the early 1930s Steichen and his studio employees continually experimented with technical processes for color. At first Steichen used a camera that shot two color negatives (red and blue) at once, but this required his technician to make the necessary third yellow negative from the first two with the new Eastman Wash-off Relief process (Edward Steichen, "Color Printing," *Vanity Fair* [Apr. 1935]: 11). Steichen also employed a specially made 8 × 10 "one-shot" color camera, which simultaneously shot three plates with each recording a separate color, and a "repeating back" camera, which made three exposures through three different filters quickly one after another (letter from Noel H. Deeks to Grace Mayer, May 30, 1972, Edward Steichen Archives, Museum of Modern Art). Portrait photography was extremely difficult, and color photography was best suited to still life imagery. For further technical information on color photography, see Louis Walton Sipley, *A Half Century of Color* (New York: Macmillan, 1951); and Robert A. Sobieszek, *The Art of Persuasion: A History of Advertising Photography* (Rochester and New York: International Museum of Photography at George Eastman House and Abrams, 1988), pp. 68–79.

44. Carl Richard Greer, *Advertising and Its Mechanical Production* (New York: Crowell, 1931), p. 212. Because of the depression, after 1930 spending on color advertising slipped to only $34 million by 1934; the first department store to run a four-color page in a newspaper was Abraham and Strauss in 1936, for a luxury item—fur coats ("Color," *Tide Supplement* 10 [Feb. 1936]: 6, and [Aug. 1936]: 13).

45. "An Exhibit of Applied Photography," *Commercial Photographer* (Dec. 1932): 80–84.

46. Perry L. Mahaffey, "Helping the Advertising, Publicity, and Sales Promotion Departments by Photography," *Commercial Photographer* (June 1930): 465.

47. Daniel Starch, *An Analysis of Five Million Inquiries* (New York: 1930), p. 12.

48. Mahaffey, "Helping the Advertising, Publicity, and Sales Promotion Departments," p. 465.

49. "Minutes of the Representatives Meetings," May 5, 1931, pp. 3–4, JWT Archives.

50. Greer, *Advertising and Its Mechanical Production* (as in n. 44), p. 213.

51. Roy Sheldon and Egmont Arens, *Consumer Engineering* (New York: Harper, 1932), p. 104.

52. "Research," *Tide* 6, no. 3 (Mar. 1932): 48.

53. Anton Bruehl and Fernand Bourges, *Color Sells* (New York: Condé Nast Publications, 1935), n.p.

54. Walter Dill Scott, "Psychology of Advertising," *Atlantic Monthly* 93 (Jan. 1904): 29–36. An early study of the effectiveness of advertising by the Curtis Publishing Company listed five "advantages of color": its ability "to display the package or product; to make the illustration realistic; to attract by its decorative quality; to focus the attention on a certain point or points; and to emphasize a certain quality in the product" (quotation from an abstract of the study [undated, but 1925 or earlier] "Two Color Advertising," in *Digests of Principal Research Department Studies, Volume I, 1911–1925* [Philadelphia: Curtis Publishing Company, 1946], p. 70).

55. Bruehl and Bourges, *Color Sells* (as in n. 53), n.p.

56. "Margaret Bourke-White on Color Photography and Photo-Murals," *Commercial Photographer* (Apr. 1934): 193.

57. Ibid.

58. Mabel J. Stegner, "The Art of Advertising Food," *Commercial Photographer* 3 (June 1928): 405.

59. "Publishing Parade," *Advertising and Selling*, Apr. 11, 1935, p. 88.

60. W. G. Raffee, "Color Is Killing Color Photography," *Commercial Photographer* (Nov. 1934): 46–47.

61. "Minutes of the Representatives Meetings," May 5, 1931, pp. 3–4, JWT Archives.

62. Ibid.

63. "Margaret Bourke-White on Color Photography" (as in n. 56), p. 194.

64. "Minutes of the Representatives Meetings," May 5, 1931, p. 304, JWT Archives. For a discussion of the poster movement in illustration, see Michele H. Bogart, *Artists, Advertising, and the Borders of Art* (Chicago: University of Chicago Press, 1995).

65. Petro, *Joyless Streets* (as in n. 2), p. 183.

66. E. Ann Kaplan, "Mothering, Feminism, and Representation: The Maternal Melodrama and the Woman's Film, 1910–1940," in *Home Is Where the Heart Is* (as in n. 1), p. 130. See also Andrew Bergman, *We're in the Money: Depression America and Its Films* (New York: New York University Press, 1971); and Robert Sklar, *Movie-Made America: A Social History of American Movies* (New York: Random House, 1975).

67. The image of the siren is discussed in Ellen Wiley Todd, *The "New Woman" Revised: Painting and Gender Politics on Fourteenth Street* (Berkeley and Los Angeles: University of California Press, 1993), pp. xxxi, 196–200.

68. See, for example, the photographs reproduced in David Green, "Classified Subjects: Photography and Anthropology, the Technology of Power," *Ten.8*, no. 14 (n.d.), pp. 30–37.

CHAPTER TEN

1. See, for example, "Career, Camera, Corn," *Time*, Jan. 10, 1938, pp. 36–37. Notices in the magazines Steichen worked for include the tribute by Margaret Case Harriman, "Steichen," *Vogue*, Jan. 1, 1938, pp. 38–41, 92, 94; and "Perennials on Parade," *Ladies' Home Journal* (June 1938): 21.

2. Richard Pratt, *The Picture Garden Book and Gardener's Assistant.* With color photography by Edward Steichen (New York: Howell, Soskin, 1942). Steichen's garden photographs appeared in the *Ladies' Home Journal* almost monthly beginning in 1937; during the late 1930s he also produced a number of food, fashion, and home interior features for the magazine. Most of these were in color. On Steichen's aesthetic interest in flowers, see Ronald J. Gedrim, "Edward Steichen's 1936 Exhibition of Delphinium Blooms: An Art of Flower Breeding," *History of Photography* 17, no. 4 (winter 1993): 352–363.

3. Letter from Noel H. Deeks to Grace Mayer, Apr. 4, 1975, Edward Steichen Archives, Museum of Modern Art.

4. *Annual of Advertising Art* 20 (1941): 26–27. See also T. J. Maloney, ed., *U.S. Camera 1940* (New York: Random House, 1940), p. 69; *Annual of Advertising Art* 21 (1942). Steichen discussed his tourist experience on his earlier trip in Edward Steichen, "Impressions of Hawaii," *Vogue*, July 15, 1934, p. 32.

5. *Art Directors' Annual of Advertising Art* 20 (1941): 26–27.

6. Anton Bruehl (for the Matson Line) and Toni Frissell (for the Hawaiian Tourist Board) made similar commercial images that appeared in advertisements marketing Hawaii in upscale magazines in the late 1930s and 1940s. For a study of the prephotographic imagery of the South Seas, which established the conventions later assimilated into photographic imagery, see Bernard W. Smith, *European Vision and the South Pacific,* rev. ed. (New Haven, Conn.: Yale University Press, 1985).

7. See, for example, Abigail Solomon-Godeau, "Going Native: Paul Gauguin and the Invention of Primitivist Modernism," in *The Expanding Discourse,* ed. Norma Broude and Mary Garrard (New York: Icon Editions, 1992), pp. 313–329.

8. Judith Williamson, "Woman Is an Island: Femininity and Colonization," in *Studies in Entertainment: Critical Approaches to Mass Culture,* ed. Tania Modleski (Bloomington: Indiana University Press, 1986), p. 112.

9. In Hawaii, trade with the West, first in sandalwood, then in services for whaling ships, introduced capitalism in the early nineteenth century and began the breakdown of the traditional strict social structures. Protestant missionaries from New England arrived by the 1820s and seeded divisions over religious practices. By midcentury the Western-pressured monarchy allowed the sale and private ownership of land, thus opening the door to large-scale capital investment and the establishment of sugar plantations. Taxation and the end of communal land management forced most Hawaiians into the wage economy. Concurrently, there was rapid depopulation of the islands due to disease; some estimate the number of native Hawaiians fell from perhaps five hundred thousand when the British explorer Cook arrived in 1778 to fewer than sixty thousand a hundred years later. Chinese, Japanese, and Filipino workers were brought in to labor on the plantations. Sugar interests had no tolerance for native resistance, and a United States–backed overthrow of Queen Liliuokalani in 1893 ended Hawaiian self-rule. Five years later the United States formally annexed Hawaii as a territory, thus recognizing that, by definition, Hawaii was a colony and subservient to the mainland. The same year, 1898, as another expression of its imperial intentions, the United States acquired Cuba, Puerto Rico, Guam, and the Philippines as a result of the Spanish-American War. By then, the system of colonial capitalism was firmly entrenched in Hawaii. The emergence of the tourist industry began a transition from colonial to corporate capitalism. See Elizabeth Buck, *Paradise Remade: The Politics of Culture and History in Hawai'i* (Philadelphia: Temple University Press, 1993).

10. Like many of the earliest photographs of people from other cultures, Steichen's images are commercial ones, created for no other reason than to encourage tourism or to serve as mementos for the traveler. Cross-cultural photographs were made right from the very beginning of photographic history. Some French and British photographers set off to document their country's imperial interests in the Near and Far East; others sought to make a profit back home on the sale of exotic commercial tourist imagery. With the rise of anthropology as a science, such cross-cultural travel photographs took on scientific goals for the study and documentation of other cultures. Such images frequently demean their subjects by turning them into objects of scrutiny. Once viewed as an objective tool for cultural documentation, anthropological photographs fell into disrepute by the 1920s, as more rigorous standards of field observation developed and anthropologists began to recognize the racial stereotyping and political agendas embedded in the photographs. Certainly it is more accurate to say that such photographs reveal more about the intentions and needs of the culture holding the camera than the culture in front of the lens.

For a summary of the theoretical and political issues in the scholarly literature on anthropological photographs, see Iskander Mydin, "Historical Images—Changing Audiences," pp. 249–252, and James C. Faris, "A Political Primer on Anthropology/Photography," pp. 253–263, both in *Anthropology and Photography, 1860–1920,* ed. Elizabeth Edwards (New Haven, Conn., and London: Yale University Press in association with the Royal Anthropological Institute, 1992); and David Green, "Classified Subjects: Photography and Anthropology, the Technology of Power," *Ten.8,* no. 14 (n.d.), pp. 30–37. On the theme of resistance and the self-construction of the image in cross-cultural photography, see Victoria

Wyatt, "Interpreting the Balance of Power: A Case Study of Photographer and Subject in Images of Native Americans," *Exposure* 28, no. 3 (winter 1991–92): 21–31.

11. Rosa Reilly, "Steichen—the Living Legend," *Popular Photography* (Mar. 1938): 11–12.

12. Transcript of a conversation between Edward Steichen and Wayne Miller, filmed for the National Broadcasting Company [ca. 1955], p. 12, Edward Steichen Archives, Museum of Modern Art.

13. Edward Steichen, *A Life in Photography* (Garden City, N.Y.: Doubleday, 1963; rpt., New York: Bonanza Books, 1984), chapter 11.

CONCLUSION

1. See Christopher Phillips, "The Judgment Seat of Photography," *October* 22 (fall 1982): 27–63.

2. The children's books, conceived by Steichen's daughter Mary Steichen Martin [later Dr. Mary Calderone], were *The First Picture Book: Everyday Things for Babies* (1930) and *The Second Picture Book* (1931), both published by Harcourt, Brace. This was not Steichen's first foray into children's book design. Around 1921 he did a series of geometric paintings of children's book characters called the Oochens. These are discussed in Edward Steichen, *A Life in Photography* (Garden City, N.Y.: Doubleday, 1963; rpt., New York: Bonanza Books, 1984), chapter 5; and in Carl Sandburg, *Steichen the Photographer* (New York: Harcourt, Brace, 1929), pp. 43–45. Steichen's photographs illustrated Henry David Thoreau, *Walden, or Life in the Woods*, introd. Henry Seidel Canby (Boston: Limited Editions Club, 1936). Newspaper reviews of Steichen's photomurals are cited and quoted in Grace M. Mayer, "Biographical Outline," in *Steichen the Photographer* (New York: Museum of Modern Art, 1961), p. 72. See also Nicholas Haz, "Edward Steichen's Photo-Murals," *Commercial Photographer* (Oct. 1933): 14–18.

3. Sandburg, *Steichen the Photographer*, p. 53.

4. This point is discussed in Robert Sobieszek's introduction to *The Art of Persuasion: A History of Advertising Photography* (Rochester and New York: International Museum of Photography at George Eastman House and Abrams, 1988). On the recontextualization of nineteenth-century photographs, see also Rosalind Krauss, "Photography's Discursive Spaces: Landscape/View," *Art Journal* 42 (winter 1982): 311–319.

Photographic Credits

Andrew Jergens Company, a KAO Group Company: Figs. 3.2, 3.3, 3.4, 3.5, 3.6, 3.7, 3.8, 3.13, 3.14, 3.15, 3.16, 3.17, 6.1, 6.2, 6.3, 6.4, 6.5, 6.7, 6.8, 6.9, 6.10, 6.12, 6.15, 6.16, 6.17, 7.18, 7.19, 8.3, 8.4, 8.5, Plates 6, 7.

Chesebrough-Pond's Inc.: Figs. 3.9, 3.10, 3.11, 3.12, 3.18, 3.19, 7.1, 7.2, 7.3, 7.4, 7.5, 7.8, 7.9, 7.10, 7.12, 7.13, 7.14, 7.15, 7.16, 7.17, 7.20, 7.21, 7.22, 7.24.

Condé Nast Publications Inc.: Figs. 5.4, 7.11, 7.25 courtesy Vanity Fair, copyright © 1921, 1929, 1933 (renewed 1949, 1957, 1961). Fig. 5.11 courtesy Vogue, copyright © 1927 (renewed 1955).

Duke University Special Collections Library: Selections from the J. Walter Thompson Co. Archives.

Eastman Kodak Company: Figs. 4.18, 4.19, 4.20, 4.21, 6.14, Plate 2.

Fieldcrest Cannon, Inc.: Figs. 8.1, 8.2, Plates 8, 9.

Gorham, Inc.: Figs. 5.8 and 5.9.

Johnson & Johnson: Fig. 9.7.

Lancaster Colony Company: Fig. 4.9.

Lehn & Fink Products, a division of Sterling Winthrop, Inc.: Figs. 4.1, 4.2.

Lever Brothers Company: Figs. 3.20, 3.21, 3.22, 6.13.

Merck & Co., Inc.: Figs. 9.5, 9.8.

Meredith Corporation: Figs. 6.11, 9.1.

Museum of Modern Art: Fig. 1.5.

Oneida Ltd. Figs. 4.7, 9.11, Plates 10, 11.

Procter & Gamble: Plates 3, 4, 5.

Simmons Company: Figs. 7.6, 7.7.

Steinway & Sons: Fig. 5.10.

Warner-Lambert Company: Fig. 4.15.

Welch's Grape Juice Company: Figs. 4.3, 4.4, 4.5, 4.6, Plate 1.

William Carter Company: Fig. 6.6.

Index

Abrams, Ann Uhry, 298–99n51
Abstraction, 106, 121, 122, 154
Académie Julian, 8
Adams, Wayman, 170, 171 (fig. 7.3)
Admen: as educators, 35; fine artists as, 326n10; low opinion of consumers by, 234–35, 332n18; positivist worldview of, 84–85; race and sex make-up of, 102
Advertising: atmosphere strategy in, 60, 93, 95, 96, 97, 132, 163, 304n45; authority used in, 230, 231–33; changing view of human rationality in, 304n45; cinematic narrative in, 4, 147–50, 160–61; from collective to singular language in, 151–52, 154; color in, 75, 78, 237–47; drawing and photography together in, 54, 66, 68–71; drawing vs. photography in, 53–54, 66–68; effectiveness of illustrations in, 30; emotion strategy in, 95, 235–36; fine art in, 205–6, 207, 217–19; inaccurate representation of class of reader in, 136; as indigenous American art, 32; laws of, 95–96; magazine readership and, 50–52; market research and, 28–30; melodrama in, 223–30, 231, 233, 236, 237, 245; modernism in, 82, 106–7, 311–12n23; modified to class of reader, 210–11, 212, 213–14; nationalism and, 32; negative, 224, 226–28; nudes in, 205, 206, 207–8, 211, 213, 214–17; pictorialism in, 80; promise of social mobility in, 65; reason-why (informational) strategy in, 60, 95; role of, 27; shift from modernism to realism in, 303n41; shift from reason-why to atmosphere strategy in, 304n45; Steichen's promotion of, 35–39; stereotype American family in, 102; traditional gender roles in, 159–63, 164–65; why it works, 159; *See also* Admen; Art direc-

tors; Class appeal; Color; Commercial art; Modernism; Photography; Psychology; Realism; Testimonials; Women
Advertising Age, 216
Advertising and Selling Fortnightly, 52, 91 (fig. 4.16), 92 (fig. 4.17), 235
Advertising Arts, 202, 211
Advertising World, 52
Aerial photography: selling to the military, 20–21; Steichen's work with, 14–19; symbolic significance of, 21
Agha, Mehemed Fehmy, 121, 123, 249, 313–14n48
Altemus, Elizabeth (Mrs. John Hay Whitney), 192–93, 194 (fig. 7.21), 195
American Bankers Association Journal, 104 (fig. 4.21)
American Fine Art Company, 7, 8
American Medical Association, 226, 236
Annual of Advertising Art (New York Art Directors' Club), 33, 81 (fig. 4.7), 82 (fig. 4.8), 109 (fig. 5.1); Steichen photographs in, 88 (fig. 4.12), 205, 215, 249
Arens, Egmont, 107, 219
Army Air Service: aerial photography, 14–15, 16 (fig. 1.3), 17 (fig. 1.4), 18 (fig. 1.5), 19–21
Art deco, 113, 121, 133
Art directors: added to advertising agencies, 33; collaboration with artists, 144–45, 146; duties of, 318n11. *See also specific individuals*
Art Directors' Club. *See* New York Art Directors' Club
Art et Décoration, 10
Aymar, Gordon, 33, 39, 105; Jergens lotion campaign of, 47, 140; on photography in advertising, 82–83, 88; on relationship of artist and art director, 145,

Gender roles: psychology of, 162–64, 165; traditional, supported by advertising, 159–63, 164–65
Gledhill, Christine, 331n4
Gold, Mike, 220
Good Housekeeping, 52, 78, 135–36, 168, 216
Gorham silver. *See under* Steichen, Edward, advertising campaigns
Gossard corsets and brassieres, 43 (fig. 3.1)
Gorrell, Edgar S., 19
Gramont, Duchesse de, 172
Grape-Nuts, 230, 231 (fig. 9.6)
Graves, Morris, 206
Green, Kneeland (Ruzzie), 126–27, 315n60
Greenough, Sarah, 290n26
Greer, Carl, 122, 123
Grenet, Malaga, 67 (fig. 3.19)

Hamilton, Mrs. Alexander, 193, 195 (fig. 7.22)
Hardman, Peck and Company, 37, 124, 129–30, 316n73
Harper's Bazaar, 114 (fig. 5.5), 210, 250 (fig. 10.1), 251 (fig. 10.2), plate 13
Harriman, Margaret Case, 293–94n62
Harriman, Mrs. J. Borden, 175–76, 177 (fig. 7.6)
Hartley, Marsden, 108
Hawaii, 248–49, 250 (fig. 10.1), 251 (fig. 10.2), 252–53, 336n9
Haz, Nicholas, 148
Head, Adrian, 67
Hexylresorcinol solution. *See under* Steichen, Edward, advertising campaigns
Hill, Ira L., 58, 59 (fig. 3.10), 60, 80
Hiller, Lejaren à: Listerine antiseptic photographs of, 90, 91 (fig. 4.15), 98; Lux soap photographs of, 68, 69 (fig. 3.21), 70, 71; on modernistic photography, 122; pictorialist style of, 80; working methods of, 305n50
Hine, Lewis, 38, 81, 82 (fig. 4.8), 112
Holland furs, 237
Hollingworth, Harry L., 97, 163
Hollister, Paul, 249
Homer, William, 287n2
Hospital Progress, 102, 103 (fig. 4.20)

Hotchkiss, George B., 29
House and Garden, 249
Howe, Graham, 112
Hower, Ralph, 31, 32, 235, 318n13
Huené, George Hoyningen, 197, 199 (fig. 7.25)
Hunter, Robert, 288n8

Industrial design: modernism in, 124–31; obsolescence in, 125; Steichen's interest in, 123–24, 126–31
Ingres, Jean-Auguste-Dominique, 197
Ingwersen, Lou, 67
Ivins, William M., 307n23
Ivory soap, 162, 245, plates 3–5

Jacobson, Egbert G., 33
James, William, 95
Jameson, Fredric, 159
Jergens lotion. *See under* Steichen, Edward, advertising campaigns
Johnson, Pierce, 33
Johnson & Johnson baby powder, 230, 232 (fig. 9.7)
Johnston, Alfred Cheney, 80, 168, 170 (fig. 7.2), 305n50
Jussim, Estelle, 307n23
J. Walter Thompson Company: advertising policy, 87; art directors' responsibilities, 318n11; backing of *Steichen the Photographer,* 36, 201–2; behavioral psychology used by, 154–55, 156, 157; celebrity portraits sponsored by, 167; decision making at, 144–47; earliest use of photographs by, 31; increased use of photographs by, 27; influence of cinema on, 147, 149, 161; photo studio at, 319n18; *Population and Its Distribution,* 28, 50; posterization strategy of, 243; professionalization of, 33; revival of testimonials by, 167; Steichen's association with, 24, 42–44; target audience, classification of, 303n26
J. Walter Thompson Company, advertising campaigns: Carter's underwear, 139 (fig. 6.6); Conaphore headlights, 86, 87 (fig. 4.11); Cutex nail polish, 58 (fig. 3.9), 59 (figs. 3.10–11), 60 (fig. 3.12), 161; Douglass lighters, 113, 114 (fig. 5.5),

115 (fig. 5.6), 116 (fig. 5.7); Fleischmann's yeast, 88 (fig. 4.12), 89 (figs. 4.13–14), 90; Gorham silver, 116, 117 (fig. 5.8), 118, 119 (fig. 5.9); Grape-Nuts, 230, 231 (fig. 9.6); Hexylresorcinol solution, 229, 230 (fig. 9.5), 233 (fig. 9.8); Jergens lotion, 45, 46 (fig. 3.2), 47, 48 (fig. 3.3), 49 (fig. 3.4), 50, 51–52, 53 (fig. 3.5), 54 (fig. 3.6), 55, 56 (fig. 3.7), 57, 60, 61 (fig. 3.13), 62 (fig. 3.14), 63 (fig. 3.15), 64 (fig. 3.16), 65 (fig. 3.17), 66, 72, 97, 132, 134 (fig. 6.1), 135 (fig. 6.2), 136 (fig. 6.3), 137 (fig. 6.4), 138 (fig. 6.5), 139, 140, 141 (fig. 6.8), 142 (fig. 6.9), 143 (fig. 6.10), 147–48, 149 (fig. 6.12), 150, 151, 152 (fig. 6.15), 153 (fig. 6.16), 154, 160, 161 (fig. 6.17), 168; Johnson & Johnson baby powder, 230, 232 (fig. 9.7), 332n13; Kodak products, 98, 99 (fig. 4.18), 100 (fig. 4.19), 101–2, 103 (fig. 4.20), 104 (fig. 4.21), 150, 151 (fig. 6.14), 309n67, 310n69, plate 2; Listerine antiseptic, 90, 91 (fig. 4.15); Lux soap, 68 (fig. 3.20), 69 (fig. 3.21), 70 (fig. 3.22), 71, 161, 168, 305n50; Pebeco toothpaste, 72, 74 (fig. 4.1), 75 (fig. 4.2), 145; Pond's cold cream, 66 (fig. 3.18), 67 (fig. 3.19), 68, 161, 168, 169 (fig. 7.1), 170 (fig. 7.2), 171 (fig. 7.3), 172, 174, 175 (fig. 7.4), 176 (fig. 7.5), 179 (fig. 7.8), 180 (fig. 7.9), 181 (fig. 7.10), 183 (fig. 7.12), 184 (fig. 7.13), 185 (fig. 7.14), 186 (fig. 7.15), 187 (fig. 7.16), 188 (fig. 7.17), 189, 192, 193 (fig. 7.20), 194 (fig. 7.21), 195 (fig. 7.22), 197; Scott tissue, 204, 224, 226, 227 (fig. 9.2), 228 (fig. 9.3), 229 (fig. 9.4), 233; Simmons mattresses, 175–76, 177 (fig. 7.6), 178 (fig. 7.7), 314n49; Welch's grape juice, 73, 75, 76 (fig. 4.3), 77 (fig. 4.4), 78 (fig. 4.5), 79 (fig. 4.6), 80, 236, plate 1; Woodbury's soap, 189, 190 (fig. 7.18), 191 (fig. 7.19), 192, plates 6–7

JWT News, 30, 69, 319n18

Karp, Leon, 39
Kent, Rockwell, 39
Kepes, Gyorgy, 206
Kodak products, 304n41, 309n67. *See*

also under Steichen, Edward, advertising campaigns
Kootz, Samuel, 202

Ladies' Home Journal: cinematic narrative in, 147, 148 (fig. 6.11); non-Steichen advertising photographs in, 58 (fig. 3.9), 59 (figs. 3.10–11), 79 (fig. 4.6), 139 (fig. 6.6), 140 (fig. 6.7), 150 (fig. 6.13), 170 (fig. 7.2), 171 (fig. 7.3), 184 (fig. 7.13), 186 (fig. 7.15), 187 (fig. 7.16), 188 (fig. 7.17), 210, 211 (fig. 8.1), 212 (fig. 8.2); promotion of women's domestic roles in, 52; Steichen advertising photographs in, 43 (fig. 3.1), 46 (fig. 3.2), 48 (fig. 3.3), 49 (fig. 3.4), 53 (fig. 3.5), 54 (fig. 3.6), 62 (fig. 3.14), 63 (fig. 3.15), 64 (fig. 3.16), 65 (fig. 3.17), 66 (fig. 3.18), 74 (fig. 4.1), 75 (fig. 4.2), 77 (fig. 4.4), 78, 89 (fig. 4.14), 132, 134 (fig. 6.1), 135 (fig. 6.2), 136 (fig. 6.3), 137 (fig. 6.4), 138 (fig. 6.5), 141 (fig. 6.8), 142 (fig. 6.9), 143 (fig. 6.10), 149 (fig. 6.12), 152 (fig. 6.15), 153 (fig. 6.16), 161 (fig. 6.17), 169 (fig. 7.1), 175 (fig. 7.4), 177 (fig. 7.6), 179 (fig. 7.8), 180 (fig. 7.9), 181 (fig. 7.10), 183 (fig. 7.12), 186 (fig. 7.15), 187 (fig. 7.16), 188 (fig. 7.17), 190 (fig. 7.18), 191 (fig. 7.19), 193 (fig. 7.20), 194 (fig. 7.21), 195 (fig. 7.22), 197, 198 (fig. 7.24), 215 (fig. 8.3), 216 (fig. 8.4), 218 (fig. 8.5), 223, 228 (fig. 9.3), 229 (fig. 9.4), 230 (fig. 9.5), 231 (fig. 9.6), 232 (fig. 9.7), 233 (fig. 9.8), 236, 239, 244 (fig. 9.11), 246 (fig. 9.12), 248, plates 1–7, 10–11; advertising photograph for, 225 (fig. 9.1); use of advertising photographs in, 27, 168; use of color photographs, 239–40

Lasker, A. D., 30
Laurencin, Marie, 206
Lawrenson, Helen, 201
Lears, Jackson: on admen as educators, 35; on modernism, 118, 311n17; on positivist worldview of admen, 84–85; on shift from modernism to realism in advertising, 303n41; on shift from reason-why to atmosphere strategy in advertising, 304n45

Nast, Mrs. Condé, 170 (fig. 7.2)

Nationalism, and advertising, 32

Naturalism, 98, 101, 103–4

Newhall, Beaumont, 198, 290n26

New York Art Directors' Club, 33, 109, 145, 249. *See also* Annual of Advertising Art

Nochlin, Linda, 55

Noguchi, Isamu, 206

N. W. Ayer and Son: Cannon towel campaign, 205, 206–8, 209–10, 211 (fig. 8.1), 212 (fig. 8.2), 213–14, 328–29n21, plates 8–9; commissioning of fine art by, 39; Container Corporation campaign, 206; Dole pineapple juice campaign, 206; first use of photographs by, 31; Fostoria glass campaign, 82, 83 (fig. 4.9); marketing research by, 28–29; 1930 photo exhibition by, 31–32; professionalization of, 33; promotion of photography by, 84, 87; Steinway piano campaign, 118, 120 (fig. 5.10)

Nudes. *See under* Advertising

Obermeyer, Joe, 12

O'Connor, Mrs. Richard, 190–91, plate 6

Oelrichs, Marjorie, 180 (fig. 7.9)

O'Keeffe, Georgia, 22, 39, 118, 206

Oneida silver, 80, 81 (fig. 4.7). *See also under* Steichen, Edward, advertising campaigns

O'Sullivan, Timothy, 256

Outerbridge, Paul, Jr., 37, 249, 312n25; *Bracelets,* 111 (fig. 5.3); *Ide Shirt Collar,* 110 (fig. 5.2), 111; modernist photographs by, 108, 112; Pyrex glassware campaign, 81–82

Oxford Paper Company, 109 (fig. 5.1)

Palmer, Mrs. Potter D'Orsay, 172, 197, 198 (fig. 7.24)

Paris Exposition of Modern Decorative and Industrial Arts, 107

Parker, Rozsika, 287n1

Parsons, Melinda Boyd, 11

Patrick, Gen. Mason, 19

Patronage, art: commercial, 33; private, 12; Steichen on, 35, 36

Pebeco toothpaste, 158. *See also under* Steichen, Edward, advertising campaigns

Peterhans, Walter, 38

Petro, Patrice, 245, 328n18

Phillips, Mary, 158

Photo-Era Magazine, 317n4

Photographers' Association of America, 90, 91 (fig. 4.16), 92 (fig. 4.17)

Photographic styles: in advertising, 80–85; atmospheric, 3, 61, 72, 79, 93, 132; documentary, 112, 113. *See also* Modernism; Pictorialism; Realism; Straight photography

Photographs: dual realism of, 73; as historical documents, 21; as "universal language," 96

Photography: as American medium, 31–32; contrasted with drawing, 30, 53–54, 66–68, 142, 144; cross-cultural, 336n10; as fine art, 28; ideology of modernity and, 28; increased use in advertising in 1920s and 1930s, 1, 27–28, 30–32; news, 87–88, 308n37; objectivity of, 92; persuasive potential of, 133; stylelessness of, 96; syntax of, 307n23; technical advances in reproducing, 31. *See also* Aerial photography; Color; Modernism; Straight photography

Photo-Secession, 2

Picasso, Pablo, 53, 206, 312n27

Pictorial Review, 52, 135, 168, 216

Pictorialism: advertising shunned by followers of, 221; contrasted with documentary style, 112, 113; in 1920s advertising, 80; return to in late 1920s by Steichen, 132, 134 (fig. 6.1), 135 (fig. 6.2), 136, 137 (fig. 6.4), 138 (fig. 6.5), 139; shift to modernism from, 82–83, 106; in Steichen's early work, 8, 9 (fig. 1.2), 11; Steichen's transition to modernism from, 85, 179 (fig. 7.8), 180 (fig. 7.9), 181 (fig. 7.10), 182, 183 (fig. 7.12), 184–85, 186 (fig. 7.15), 187 (fig. 7.16), 188 (fig. 7.17), 189; to suggest atmosphere, 140

Pilgrim, Dianne, 317n80

Pinchot II, Mrs. Gifford, 172

Pollock, Griselda, 287n1

Polynesian, 252, plate 13

Pond's cold cream. *See under* Steichen, Edward, advertising campaigns

Pratt, Richard, 248
Presbrey, Frank, 31, 96, 226
Psychology: behavioral, 154–58, 163–64; and early advertising, 93–97; of gender roles, 162–65; industrial, 29; structuralist, 94, 96
Pure Food and Drug Act, 158
Pyrex glassware, 81–82

Randolph, Viginia Carter, 188 (fig. 7.17), 189
Ray, Man, 197
Realism, 2; admen's definition of, 55, 86–88, 90, 92–93; alternative views of development of, 303–4n41; art-historical, 55; color photography and, 242; contrasted with modernism, 122; dual characteristics of, 72–73; late survival of rhetoric of, 331n3; 1930s definition of, 236–37
Realsilk hosiery, 246 (fig. 9.12)
Redbook, 51
Reinsel, Walter, 39
Resor, Helen Lansdowne: Jergens lotion campaign of, 47, 55, 136; recommends Margaret Bourke-White, 317n2; support for Steichen by, 42, 44; Woodbury's soap caption of, 214
Resor, Stanley: closing of J. Walter Thompson Company's photo studio by, 319n18; and corporate goals of consensus and mass appeal, 146; enthusiastic receipt of behavioral psychology by, 156; Jergens lotion campaign of, 47; on Steichen's income, 301n5; support of Steichen by, 42, 44
Rheinstrom, Carroll, 171
Richelieu, Duchesse de, 169 (fig. 7.1), 170, 171, 181, 183
Rivera, Diego, 312n27
Rodchenko, Alexander, 114
Roosevelt, Mrs. Franklin D., 176, 178 (fig. 7.7)
Rorty, James, 159
Rosenfeld, Paul, 202, 219–20
Ross, Dorothy, 156
Roy, Pierre, 206
Ruskin, John, 85

Sabine, Lillian, 147, 315–16n66
Sandburg, Carl, 10–11; *Chicago Poems*, 11, 289n11; as interventionist, 289n21; on socialism, 288n8; *Steichen the Photographer*, 16, 35, 36, 57, 115, 129, 189, 190, 202, 219–20, 255, 292n43
Sargent, John Singer, 170, 191
Saturday Evening Post, 78 (fig. 4.5), 239
Scandlin, Horace, 58 (fig. 3.9), 60, 80, 139
Schoen, Eugene, 129
Scott, Walter Dill, 29, 93, 94–96, 162–63, 242
Scott tissue, 204, 233. *See also under* Steichen, Edward, advertising campaigns
Scripture, Edward W., 94
Seebohm, Caroline, 313n48
Sekula, Allan, 152, 290n26, 293n57
Shahn, Ben, 206
Shattuck, Ross, 39
Sheeler, Charles, 38, 107
Sheldon, Roy, 107
Simmons mattresses. *See under* Steichen, Edward, advertising campaigns
Steinway pianos. *See under* Steichen, Edward, advertising campaigns
Simonson, Lee, 129
Sinel, Joseph, 125
Small, Flick, 12
Smith, Homer, 207
Snyder, Ruth, 92–93, 308n37
Sobieszek, Robert, 303–4n41, 311–12n23
Socialism, German-American, 11
Spectatorship, 208–10, 328nn17–18
Spreter, Roy, 90
Starch, Daniel, 29, 93; on effectiveness of color, 240; on effectiveness of illustrations, 30, 96–97; laws of advertising of, 96; on suggestibility of women, 163
Stehli Silk Company, 37, 124, 126, 127 (fig. 5.11), 128–29, 315n64
Steichen, Clara, 10
Steichen, Dana, 248
Steichen, Edward, advertising campaigns: Cannon towels, 205, 206–8, 209, 210, 211, 212–14, 216, plates 8–9; Coty lipstick, 36; Douglass lighters, 36, 108, 111, 113, 114 (fig. 5.5), 115 (fig. 5.6), 123, 128; Fleischmann's yeast, 3, 88 (fig. 4.12),

89 (figs. 4.13–14), 90, 98; Gorham silver, 108, 113, 116, 117 (fig. 5.8), 118, 119 (fig. 5.9); Gossard corsets and brassieres, 43 (fig. 3.1); Grape-Nuts, 230, 231 (fig. 9.6); Hexylresorcinol solution, 36, 229, 230 (fig. 9.5), 232, 233 (fig. 9.8); Holland furs, 237; Ivory soap, 162, 245, plates 3–5; Jergens lotion (1923–26), 3, 36, 45, 46 (fig. 3.2), 47, 48 (fig. 3.3), 49 (fig. 3.4), 50, 51–52, 53 (fig. 3.5), 54 (fig. 3.6), 55, 56 (fig. 3.7), 61, 62 (fig. 3.14), 63 (fig. 3.15), 64 (fig. 3.16), 65 (fig. 3.17), 66, 72, 96, 133; Jergens lotion (1927–29), 132, 134 (fig. 6.1), 135 (fig. 6.2), 136 (fig. 6.3), 137 (fig. 6.4), 138 (fig. 6.5), 140, 141 (fig. 6.8), 142 (fig. 6.9), 143 (fig. 6.10), 247; Jergens lotion (1930s), 147–48, 149 (fig. 6.12), 151, 152 (fig. 6.15), 153 (fig. 6.16), 154, 160, 161 (fig. 6.17), 166, 211; Johnson & Johnson baby powder, 230, 232 (fig. 9.7); Kodak products, 36, 98, 99 (fig. 4.18), 100 (fig. 4.19), 101–2, 103–4, 150, 151 (fig. 6.14), 162, 237, plate 2; Lux soap, 68, 69, 70 (fig. 3.22); Matson Line, 237, 239, 240 (fig. 9.9), 241 (fig. 9.10), 248–49, 250 (fig. 10.1), 251 (fig. 10.2), 252, plates 12–13; Oneida silver, 133, 237, 243, 244 (fig. 9.11), 245, 247, plates 10–11; Pebeco toothpaste, 72, 74 (fig. 4.1), 75 (fig. 4.2), 145, 147; Pond's cold cream (1920s), 66 (fig. 3.18), 67–68, 133, 166, 169 (fig. 7.1), 170, 172, 174, 175 (fig. 7.4), 179 (fig. 7.8), 180 (fig. 7.9), 181 (fig. 7.10), 183 (fig. 7.12), 184–85, 186 (fig. 7.15), 187 (fig. 7.16), 188 (fig. 7.17); Pond's cold cream (1930s), 192, 193 (fig. 7.20), 194 (fig. 7.21), 195 (fig. 7.22), 203; Realsilk hosiery, 246 (fig. 9.12); Scott tissue, 224, 226, 227 (fig. 9.2), 228 (fig. 9.3), 229 (fig. 9.4), 232; Simmons mattresses, 124, 133, 175–76, 177 (fig. 7.6), 178 (fig. 7.7), 314n49; Steinway pianos, 36, 108, 113, 118, 120 (fig. 5.10), 237; Welch's grape juice, 3, 73, 75, 76 (fig. 4.3), 77 (fig. 4.4), 78 (fig. 4.5), 79–80, 86, 96, 104, 113–14, 118, plate 1; Woodbury's soap, 3, 133, 189, 190 (fig.

7.18), 191 (fig. 7.19), 214, 215 (fig. 8.3), 216 (fig. 8.4), 217, 218 (fig. 8.5), 238–39, plates 6–7

Steichen, Edward, commercial photography career (1923–1942): advertising photographs by year and client, 257–86; advocacy of commercial art by, 28, 32, 35–39; celebrity portraits by, 167, 182 (fig. 7.11), 195, 196 (fig. 7.23), 197, 198, 200–201, 202; challenged separation of commercial and fine art, 256; cinematic conventions used by, 147–48, 149 (fig. 6.12), 150, 160–61; class appeal used by, 166–67, 169 (fig. 7.1), 175 (fig. 7.4), 177 (fig. 7.6), 178 (fig. 7.7), 179 (fig. 7.8), 180 (fig. 7.9), 181 (fig. 7.10), 183 (fig. 7.12), 185, 186 (fig. 7.15), 187 (fig. 7.16), 188 (fig. 7.17), 189; color advertising photographs of, 237, 238, 239, 240 (fig. 9.9), 241 (fig. 9.10), 243, 244 (fig. 9.11), 245, 246 (fig. 9.12), 247, 249, 250 (fig. 10.1), 251 (fig. 10.2), 252–53, plates 12–13; color experimentation by, 334n43; contradictory views on realism in photography, 90, 92–93; criticized by fine arts community, 219–22; on cubism, 312n27; disagreements with Stieglitz, 12–13, 219, 221, 255–56; effectiveness and appeal of photographs of, 30, 78; endorses silverware pattern, 316n71; enters commercial photography, tired of being poor, 294n72; everyday people used as models by, 101; evolution of photographic style of, 2–3; exclusive contracts with J. Walter Thompson Company, 42–44, 326n1; exotic photographs of, 249, 250 (fig. 10.1), 251 (fig. 10.2), 252–53, plates 12–13; exposure to behaviorist psychology, 157, 165; force of personality of, 315–16n66; on futurism, 289n20; hand-colored black-and-white photographs by, 238–39, 306n20; income, 301n5; industrial design by, 37, 123–24, 126, 127 (fig. 5.11), 128–30, 315n64, 316n73; on interference from art directors, 146–47; melodrama and fantasy in advertisements of, 104, 141–42, 152 (fig. 6.15), 160, 223, 224, 226, 228

Steichen, Edward, commercial photography career (*continued*)
(fig. 9.3), 229 (fig. 9.4), 230 (fig. 9.5), 231 (fig. 9.6), 233 (fig. 9.8), 245; modernism in advertising portraits of, 192, 193 (fig. 7.20), 194 (fig. 7.21), 195 (fig. 7.22), 197, 198 (fig. 7.24); on modernist photography, 122; modernist still lifes of, 108, 113, 114 (fig. 5.5), 115 (fig. 5.6), 117 (fig. 5.8), 118, 119 (fig. 5.9), 120 (fig. 5.10), 123; naturalism of, 98, 99 (fig. 4.18), 100 (fig. 4.19), 102, 103–4; on news photography, 308n37; non-advertising work of, 255, 335n2, 337n2; photographers not encouraged to go into commercial work, 40; photographs targeted female buyers, 3–4, 5, 133; on photo quality and price, 34; pictorialism used for emotional appeal, 135 (fig. 6.2), 136–37, 138 (fig. 6.5); posterization used in color photographs of, 243, 244 (fig. 9.11); portrait methods of, 200–201; prices of, 44–45; realist photographs of, 73; reinforcement of traditional gender roles by, 160–62, 165; retirement of, 248, 253–54; signature advertising photographs of, 145, 318n17; on soft-focus, 317n4; staff of, 238; on straight photography, 85; transition from pictorialism to modernism in advertising portraits of, 179, 180 (fig. 7.9), 181 (fig. 7.10), 183, 184–85, 186 (fig. 7.15), 187 (fig. 7.16), 188 (fig. 7.17), 189; use of "colonel," 22, 294n62; use of light by, 113; work judged differently by commercial and art worlds, 217–19
Steichen, Edward, fine art photography career: and aerial photographs, 21; collaboration with Stieglitz, 9; early artistic career of, 7–10; family of, 10; friendship with Carl Sandburg, 11; influence of aerial photography on, 21–22; in Paris, 8, 10; photographic processes used by, 8–9; pictorialist work of, 8, 9 (fig. 1.2), 11; in post-war period, 22–24; progressive politics of, 11–12; shift to straight photography by, 13–14, 21; as symbolist, 23, 287n2; at Voulangis, France, 23–24
Steichen, Edward, military photography of:

aerial photographs, 14, 20, 21, 293n52, 293n59; in Army Air Service, 2, 14–21, 291n38, 292n40, 292n43; and differences with Stieglitz, 12–13; and shift to straight photography, 13–14, 21
Steichen, Edward, art works: *Balzac,* 35; *Diagram of Doom*—2, 23; *Lotus,* 13; *The Pool,* 8 (fig. 1.1), 13; *Self-Portrait with Brush and Palette,* 8, 9 (fig. 1.2); *Wheelbarrow with Flower Pots,* 23
Steichen, Lilian, 10–11, 288n7
Steichen, Paula, 288n8, 289n21
Steiner, Ralph, 37, 38, 108, 109 (fig. 5.1), 220
Steiner-Fowler, 240
Steuben Company, 37, 124
Stieglitz, Alfred: association with Steichen, 9, 10, 200; differences with Steichen, 12–13, 219, 221, 255–56; elitism of, 221; as exemplar of fine artist as individualist, 28; reaction to Steichen's success, 329n41
Straight photography: to convey information, 140; defined, 13; Steichen on, 85; in Steichen's first advertising photographs, 47, 69, 70 (fig. 3.22), 73, 75, 76 (fig. 4.3); Steichen's transition to, 13–14, 21; transition from pictorialism to, 80, 82–83
Strand, Paul, 22; commercial photography of, 220–21; criticism of Steichen's work, 219–20; straight/modernist photography of, 13, 106, 118, 290n26
Strong, Edward K., Jr., 97
Surrealism, 133
Symbolism, 8, 21, 23
Symbolists, 287–88n2
Szarkowski, John, 290n26, 301n81

Tagg, John, 200
Talbot, William Henry Fox, 31
Tamayo, Rufino, 206
Taylor, Frederick Winslow, 26
Tazelaar, Marguerite, 128–29
Teague, Walter Dorwin, 124, 130
Testimonials: class appeal of, 166–67, 173; by debutantes, 179–81, 189, 192–93; effectiveness of, 172–73, 203; by high-society women, 168, 174–78, 192, 193–95, 197; by non-high-society women, 170–71, 184–89, 190–92; photographic